THE PAINTING OF MODERN LIFE

Paris in the Art of Manet and His Followers

ALFRED A. KNOPF NEW YORK 1985

THE PAINTING *of* MODERN LIFE

PARIS IN THE ART OF MANET AND HIS FOLLOWERS

T. J. CLARK

THIS IS A BORZOI BOOK

PUBLISHED BY ALFRED A. KNOPF, INC.

Grateful acknowledgement is made to the following for permission to reprint previously published material: Excerpt from "Marie Lloyd" in *Selected Essays* by T. S. Eliot, copyright 1950 by Harcourt Brace Jovanovich, Inc.; renewed 1978 by Esme Valerie Eliot. Reprinted by permission of the publisher.

LIBRARY OF CONGRESS CATALOGING IN PUBLICATION DATA

Clark, T. J. (Timothy J.)
 The painting of modern life.

 Bibliography: p. 319
 Includes index.
 1. Impressionism (Art)—France—Paris. 2. Painting, French—France—Paris. 3. Painting, Modern—19th century—France—Paris. 4. Paris (France) in art. 5. Manet, Edouard, 1832–1883—Influence. I. Title.
ND550.C55 1984 758'.9944361 84-5670
ISBN 0-394-49580-2

MANUFACTURED IN THE UNITED STATES OF AMERICA
FIRST EDITION

A travers la fumée de son cigare, il regarde
l'horizon sinistre et brumeux.

—CHARLES BAUDELAIRE,
Le Peintre de la vie moderne

CONTENTS

ILLUSTRATIONS

BLACK-AND-WHITE ILLUSTRATIONS

ACKNOWLEDGEMENTS

I am not entirely sure why this book took such a time to write, but the fact that it did so means that a list of all those who helped along the way would be ridiculously bulky. There are three people whose comments contributed most, thank goodness, to the book's delay—John Barrell, Thomas Crow, and Anne Wagner. I am immensely grateful to all three. My whole view of Haussmann's rebuilding of Paris was altered and enriched by the conversations I had with Andrew Lincoln. I tried to respond to specific criticisms of chapter two made by Donald Nicholson-Smith, and of chapter one by Charles Harrison.

Even the briefest set of thank-yous ought to include Phyllis Winning and Hilary Diaper at Leeds University, Peggy Clarke at Princeton, and Deanna Dalrymple at Harvard, who gave such excellent practical assistance at various stages. In the search for illustrations, Paul Tucker and Jane Montgomery were especially generous and helpful.

I am indebted to the Leverhulme Trust for a Research Fellowship which enabled me to study in Paris; to the School of Social Science at the Institute for Advanced Study in Princeton, for a year's Fellowship in 1979–80; to the Research Funds of the University of California at Los Angeles and of Leeds University; and to the Clark Fund of Harvard University.

Finally, I should like to thank all those at Knopf who subjected the book to such painstaking scrutiny, especially Susan Ralston, for her patience and good sense.

THE PAINTING OF MODERN LIFE

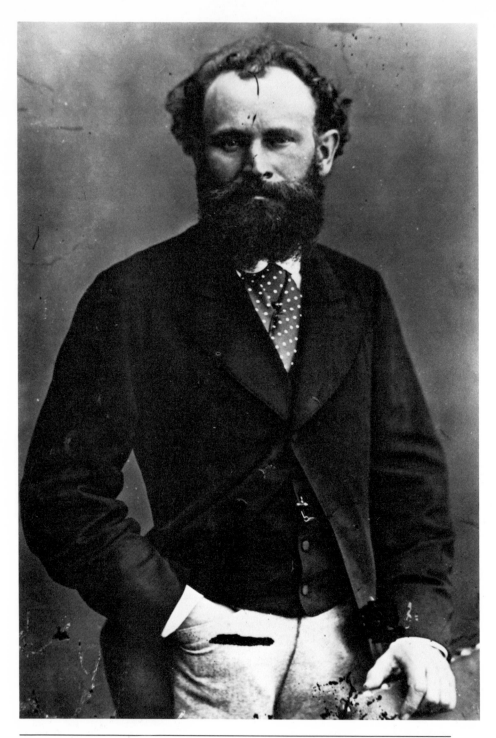

Nadar, photograph of Manet, c. 1875.

INTRODUCTION

This book is about Impressionist painting and Paris. It had its beginnings, as far as I can tell, in some paragraphs by Meyer Schapiro, published first in January 1937 in a short-lived journal called *Marxist Quarterly*. Early Impressionism, wrote Schapiro, depended for its force on something more than painterly hedonism or a simple appetite for sunshine and colour. The art of Manet and his followers had a distinct "moral aspect," visible above all in the way it dovetailed an account of visual truth with one of social freedom.

Early Impressionism . . . had a moral aspect. In its discovery of a constantly changing phenomenal outdoor world of which the shapes depended on the momentary position of the causal or mobile spectator, there was an implicit criticism of symbolic social and domestic formalities, or at least a norm opposed to these. It is remarkable how many pictures we have in early Impressionism of informal and spontaneous sociability, of breakfasts, picnics, promenades, boating trips, holidays and vacation travel. These urban idylls not only present the objective forms of bourgeois recreation in the 1860's and 1870's; they also reflect in the very choice of subjects and in the new aesthetic devices the conception of art as solely a field of individual enjoyment, without reference to ideas and motives, and they presuppose the cultivation of these pleasures as the highest field of freedom for an enlightened bourgeois detached from the official beliefs of his class. In enjoying realistic pictures of his surroundings as a spectacle of traffic and changing atmospheres, the cultivated rentier was experiencing in its phenomenal aspect that mobility of the environment, the market and of industry to which he owes his income and his freedom. And in the new Impressionist techniques which broke things up into finely discriminated points of color, as well as in the "accidental" momentary vision, he found, in a degree hitherto unknown in art, conditions of sensibility closely related to those of the urban promenader and the refined consumer of luxury goods.

As the contexts of bourgeois sociability shifted from community, family and church to commercialized or privately improvised forms—the streets, the cafés and resorts—the resulting consciousness of individual freedom involved more and more an estrangement from older ties; and those imaginative members of the middle class who accepted the norms of freedom, but lacked the economic means to attain them, were spiritually torn by a sense of helpless isolation in an anonymous indifferent mass. By 1880 the enjoying individual becomes rare in Impressionist

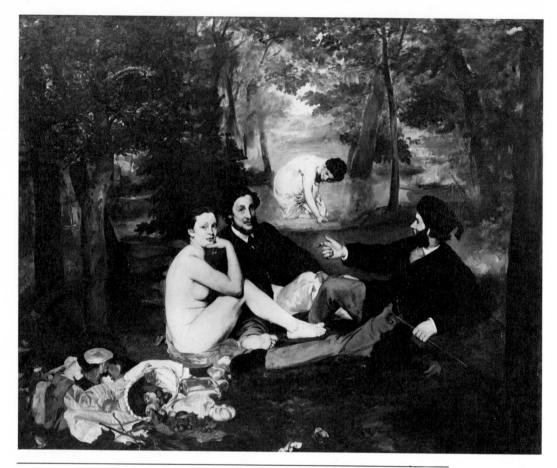

1. Edouard Manet, *Déjeuner sur l'herbe*, 1863.

art; only the private spectacle of nature is left. And in neo-Impressionism, which restores and even monumentalizes the figures, the social group breaks up into isolated spectators, who do not communicate with each other, or consists of mechanically repeated dances submitted to a preordained movement with little spontaneity.[1]

The argument in these paragraphs has some strange shifts, and I have done my share of quibbling with them. For instance, the actual bourgeois's being brought on to enjoy Impressionist painting, and to revel in its consonance with his day-to-day experience, is no doubt marvellous; but it does not seem to me much more than a metaphor, and is surely not warranted by what we know of this painting's first purchasers and enthusiasts. Equally, it is not clear if Schapiro believes that once upon a time the bourgeoisie, or at least its enlightened members, really did delight in an "informal and spontaneous sociability," and that only later did estrangement and isolation

come to characterize the pleasures on offer in these "commercialized or privately improvised forms." If that is the argument, we might ask how informal and spontaneous is the sociability depicted already in Manet's *Déjeuner sur l'herbe*, or for that matter in Monet's, with its anxious regard for the latest fashions and its discreet servant (in livery?) crouched on the other side of the tree.

But these objections are small beer. Schapiro's "Nature of Abstract Art" was an essay, after all; and the few lines it devoted to Impressionist painting still seem to me the best thing on the subject, simply because they suggest so tellingly that the form of the new art is inseparable from its content— those "objective forms of bourgeois recreation in the 1860's and 1870's."

That is the suggestion which this book takes up. The reader will find that discussing it in any detail—and trying to get at least a little way beyond suggestion and metaphor—involves me in repeated use of the terms "class," "ideology," "spectacle," and "modernism." Therefore it might be helpful if I offered straightaway some definitions of concepts which may appear obscure, or at any rate disputable. The trouble is that defining any one of them, especially the first, entails a string of very general, not to say banal, propositions on the nature of society as such. Nevertheless I shall proceed, with only the standard proviso that the definitions which follow are not worth much apart from the instances given in the text.

2. Claude Monet, *Déjeuner sur l'herbe*, 1865–66.

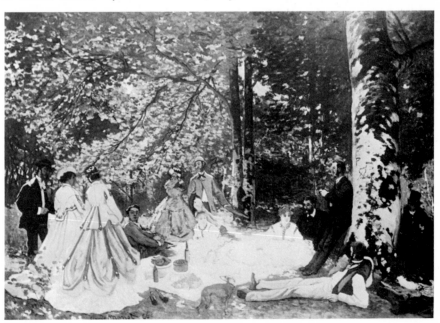

It sounds right—it corresponds to normal usage—to say that any social order consists primarily of classifications. What else do we usually mean by the word "society" but a set of means for solidarity, distance, belonging, and exclusion? These things are needed pre-eminently to enable the production of material life—to fix an order in which men and women can make their living and have some confidence that they will continue to do so. Orders of this sort appear to be established most potently by representations or systems of signs, and it does not seem to me to trivialize the concept of "social formation"—or necessarily to give it an idealist as opposed to a materialist gloss—to describe it as a hierarchy of representations. That way one avoids the worst pitfalls of vulgar Marxism, in particular the difficulties involved in claiming that the base of any social formation is some brute facticity made of sterner and solider stuff than signs—for instance, the stuff of economic life. It is one thing (and still necessary) to insist on the determinate weight in society of those arrangements we call economic; it is another to believe that in doing so we have poked through the texture of signs and conventions to the bedrock of matter and action upon it. Economic life—the "economy," the economic realm, sphere, level, instance, or what-have-you—is in itself a realm of representations. How else are we to characterize money, for instance, or the commodity form, or the wage contract?

I believe it is possible to put this kind of stress on representation and remain, as I want to, within the orbit of historical materialism. Everything depends on how we picture the links between any one set of representations and the totality which Marx called "social practice." In other words, the notion of social activity outlined so far can be sustained only if we simultaneously recognize that the world of representations does not fall out neatly into watertight sets or systems or "signifying practices." Society is a battlefield of representations, on which the limits and coherence of any given set are constantly being fought for and regularly spoilt. Thus it makes sense to say that representations are continually subject to the test of a reality more basic than themselves—the test of social practice. Social practice *is* that complexity which always outruns the constraints of a given discourse; it is the overlap and interference of representations; it is their rearrangement in use; it is the test which consolidates or disintegrates our categories, which makes or unmakes a concept, which blurs the edge of a particular language game and makes it difficult (though possible) to distinguish between a mistake and a metaphor. (And in case the imagery of plenitude which creeps in at this point should be misread, I shall add that it too—social practice itself—is analyzable, at least in its overall structures and tendencies.)

In capitalist society, economic representations are the matrix around which all others are organized. In particular, the class of an individual— his or her effective possession of or separation from the means of production—is the determinant fact of social life. This is not to say that from it can be read off immediately the individual's religious beliefs, voting habits, choice of clothes, sense of self, aesthetic preferences, and sexual morality. All of these are articulated within particular, separate worlds of representation; but these worlds are constricted and invaded by the determining nexus of class; and often in the nineteenth century the presence of class as the organizing structure of each separate sphere is gross and palpable: only think of the history of bourgeois costume, or the various ways in which the logical structure of market economics came to dominate the accounts on offer of the self and others. This makes it possible to expand the concept of class to include facts other than the economic: for instance, to talk of certain forms of entertainment or sexuality as "bourgeois." There seems to me no harm in doing so: it registers a connection which was perceived by the actors themselves, and it would be pedantry to avoid the usage altogether; but we should be clear about the liberties being taken and beware, for example, of calling things "inherently bourgeois" when what we are pointing to is relation, not inherence. This caution has more of a point, perhaps, when we turn from the bourgeoisie to its great opposite in the nineteenth century, since here we are so clearly dealing with a class and a set of "class characteristics" still in the making—as evinced by the simple instability of vocabulary in the case, from *peuple* to *prolétariat*, from *classes laborieuses* to *classe ouvrière*.

Class will in any case necessarily be a complex matter: to make the simplest point, there is never only one "means of production" in society for individuals to possess or be denied: any social formation is always a palimpsest of old and new modes of production, hence old and new classes, and hybrids born of their mating. Notably, for the purposes of this book, it is clear that the reality designated at the time—in the 1870s, say—as *petit bourgeois* included men and women whose trades had previously allowed them a modicum of security in the city's economic life, but who had been robbed of that small safety by the growth of large-scale industry and commerce; but it also included new groups of workers—clerks, shop assistants, and the like—who were the products, offensively brand-new and ambitious, of the same economic changes, and whose instability had nothing to do with the loss of bygone status but, rather, with the inability of the social system to decide what their situation, high or low, might be in the new order of things. To call these different people petits bourgeois was not wrong: it may strike us now as profound of contemporaries to

have seen from the start how the various fractions would be made, by monopoly capitalism, into one thing. But the one thing, in the case of class, is regularly made out of the many and various.

It is somewhat the same with ideology, since I use the word to indicate the existence in society of distinct and singular bodies of knowledge: *orders* of knowing, most often imposed on quite disparate bits and pieces of representation.[2] The sign of an ideology is a kind of inertness in discourse: a fixed pattern of imagery and belief, a syntax which seems obligatory, a set of permitted modes of seeing and saying; each with its own structure of closure and disclosure, its own horizons, its way of providing certain perceptions and rendering others unthinkable, aberrant, or extreme. And these things are done—I suppose this is the other suggestion carried in the word—as it were *surreptitiously*. Which is to say that ideologies, like any forms of knowledge, are constructs; they are meanings produced in a special and partial social practice; they are most often tied to the attitudes and experiences of a particular class, and therefore at odds, at least to some extent, with the attitudes and experience of those who do not belong to it. (This is a cautious statement of the case: in fact there is often a positive antagonism between the ideological frames of reference belonging to different and conflicting classes; it is hard to avoid the sense of bourgeois ideology actively struggling in the nineteenth century to include, invert, or displace the meanings of those classes the bourgeoisie sought to dominate. I shall point to such a struggle taking place, for example, in the café-concert, or in the attempts made to stabilize an image of prostitution.) But in any case, the function of ideology is as far as possible to dispose of the very ground for such conflicts. Ideologies tend to deny in their very structure and procedures that they have any such thing: knowledge, in ideology, is not a procedure but a simple array; and insofar as pictures or statements possess a structure at all, it is one provided for them by the Real. Ideologies naturalize representation, one might say: they present constructed and disputable meanings as if they were hardly meanings at all, but, rather, forms inherent in the world-out-there which the observer is privileged to intuit directly.

Therefore one ought to beware of a notion of ideology which conceives it merely as a set of images, ideas, and "mistakes," for its action on and in the process of representation is different from this: it is more internal, more interminable. Rather, an ideology is a set of limits to discourse; a set of resistances, repetitions, kinds of circularity. It is that which closes speech against consciousness of itself as production, as process, as practice, as subsistence and contingency. And of necessity this work of deletion is never done: it would hardly make sense to think of it finished.

About the concepts of "spectacle" and "spectacular society" it is not so easy to be cut and dried. They were developed first in the mid-1960s as part of the theoretical work of a group called the Situationist International, and they represent an effort to theorize the implications for capitalist society of the progressive shift within production towards the provision of consumer goods and services, and the accompanying "colonization of everyday life."[3] The word "colonization" conjures up associations with the Marxist theory of imperialism, and is meant to. It points to a massive *internal* extension of the capitalist market—the invasion and restructuring of whole areas of free time, private life, leisure, and personal expression which had been left, in the first push to constitute an urban proletariat, relatively uncontrolled. It indicates a new phase of commodity production—the marketing, the making-into-commodities, of whole areas of social practice which had once been referred to casually as everyday life.

The concept of spectacle is thus an attempt—a partial and unfinished one—to bring into theoretical order a diverse set of symptoms which are normally treated, by bourgeois sociology or conventional Leftism, as anecdotal trappings affixed somewhat lightly to the old economic order: "consumerism," for instance, or "the society of leisure"; the rise of mass media, the expansion of advertising, the hypertrophy of official diversions (Olympic Games, party conventions, *biennales*). The Situationists were primarily interested, in ways which have since become fashionable, in the possible or actual crisis of this attempt to regulate or supplant the sphere of the personal, private, and everyday. They described the erosion of family controls in later capitalist society, and derided their febrile replacements— the apparatus of welfare, social work, and psychiatry. They put great stress on, and a degree of faith in, the signs of strain in just this area: the question of Youth, the multiplication of delinquent subcultures, the strange career of "clinical depression," the inner-city landscape of racism and decay. The concept of spectacle, in other words, was an attempt to revise the theory of capitalism from a largely Marxist point of view. The most celebrated of Situationist metaphors—it comes from a book by Guy Debord—is meant more soberly than it may seem at first sight: "The spectacle is *capital* accumulated until it becomes an image."[4]

There are various problems here: for instance, deciding when exactly the spectacular society can be said to begin. One is obviously not describing some neat temporality but, rather, a shift—to some extent an oscillation— from one kind of capitalist production to another. But certainly the Paris that Meyer Schapiro was celebrating, in which commercialized forms of life and leisure were so insistently replacing those "privately improvised," does seem to fit the preceding description quite well. And it will be argued

in chapter one that the replacement was not a matter of mere cultural and ideological refurbishing but of all-embracing economic change: a move to the world of *grands boulevards* and *grands magasins* and their accompanying industries of tourism, recreation, fashion, and display—industries which helped alter the relations of production in Paris as a whole.

The other kind of problem is more intractable but had better be referred to in passing. The notion of spectacle, as I hope will be clear from even my dry summary, was designed first and foremost as a weapon of combat, and contains within itself a more or less bitter (more or less resigned) prediction of its own reappearance in some such form as this, between the covers of a book on art. Although I shall not wrestle in the toils of this contradiction too long, I wish at least to alert the reader to the absurdity involved in making "spectacle" part of the canon of academic Marxism. If once or twice in the text my use of the word carries a faint whiff of Debord's chiliastic serenity I shall be satisfied.

"Modernism," finally, is used here in the customary, somewhat muddled way. Something decisive happened in the history of art around Manet which set painting and the other arts upon a new course. Perhaps the change can be described as a kind of scepticism, or at least unsureness, as to the nature of representation in art. There had been degrees of doubt on this subject before, but they had mostly appeared as asides to the central task of constructing a likeness, and in a sense they had guaranteed that task, making it seem all the more necessary and grand. Certain painters in the seventeenth century, for example, had failed to hide the gaps and perplexities inherent in their own procedures, but these traces of paradox in perception—these markers in the picture of where the illusion almost ended—only served to make the likeness, where it was achieved, the more compelling, because it was seen to exist in the face of its opposite, chaos. There is no doubt that Manet and his friends looked back for instruction to painters of just this kind—to Velásquez and Hals, for example—but what seemed to impress them most was the evidence of palpable and frank inconsistency, and not the fact that the image was somehow preserved in the end from extinction. This shift of attention led, on the one hand, to their putting a stress on the material means by which illusions and likenesses were made (in this sense, my previous accounts of society and ideology are modernist in some of their emphases); on the other, to a new set of proposals as to the form representation should take, insofar as it was still possible at all without bad faith. "The scope and aim of Manet and his followers," we shall find Mallarmé saying in an article in 1876, "(not proclaimed by authority of dogmas, yet none the less clear) is that painting shall be steeped again in its cause. . . ."[5] This is really very close to the more familiar form

of words which we owe to Clement Greenberg, where each art in the new age is thought obliged "to determine, through the operations peculiar to itself, the effects peculiar and exclusive to itself";[6] otherwise it declines into entertainment or edification. It is clear that Mallarmé already had a sense of Manet's art as a turning point of culture, which is presumably why, at the very end of his 1876 article, he felt entitled to make the Painter—the representative voice of the whole profession—put the case of Art in such Manichaean terms: "when rudely thrown at the close of an epoch of dreams in front of reality, I have taken from it only that which properly belongs to my art, an original and exact perception which distinguishes for itself the things it perceives with the steadfast gaze of a vision restored to its simplest perfection."[7] (I shall come back to Mallarmé's account of the epoch of dreams and its close in my conclusion.)

3. Paul Cézanne, *Le Viaduc à l'Estaque*, c. 1882.

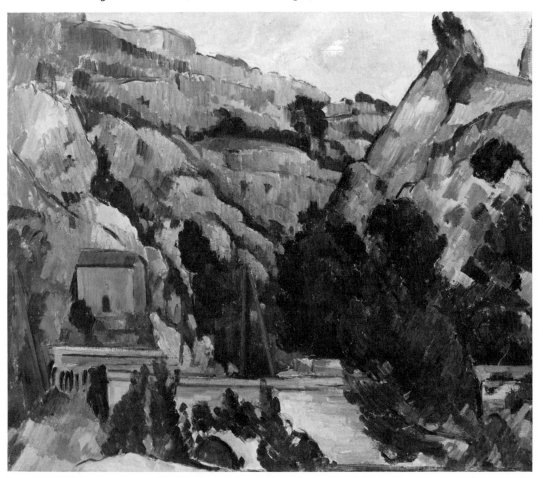

Mallarmé's statement of the modernist case is primitive, and therefore optimistic and clear-cut—perhaps misguidedly so—in its picture of the future. The stress on exactness, simplicity, and steadfast attention is something which was to recur in the next hundred years, but it can hardly be said to be characteristic of the art to which Manet gave birth. The steadfast gaze rather quickly gave way to uncertainty (in this the case of Cézanne is exemplary). Doubts about vision became doubts about almost everything involved in the act of painting; and in time the uncertainty became a value in its own right; we could almost say it became an aesthetic. A special and effective rhetoric was devised—it is in full possession of the field by the time one encounters it in the art criticism of the Symboliste magazines of the late 1880s—in which the preference of painting for the not-known, the not-arranged, and the not-interpreted was taken largely as an article of faith. Painting has a subject, these critics say, and it is rightly that area of experience we dismiss in practical life as vestigial and next to nothing.[8] Art seeks out the edges of things, of understanding; therefore its favourite modes are irony, negation, deadpan, the pretence of ignorance or innocence. It prefers the unfinished: the syntactically unstable, the semantically malformed. It produces and savours discrepancy in what it shows and how it shows it, since the highest wisdom is knowing that things and pictures do not add up.

This is an approximate definition of modernism, and it is not meant to suggest that modern art is incapable of criticizing its own assumptions or exceeding this one frame of reference. A proper treatment of Picasso's *Demoiselles d'Avignon*, say, or Eliot's *Ash Wednesday*, would be concerned with the hold of conventions of uncertainty in such cases, but also with the degree to which both works succeed in turning the conventions against themselves, so that Picasso might be said to end up with an image of the female body which is not simply a tissue of fragments (it is more solid and whole than most others he painted in less refractory modes), and Eliot eventually to state the grounds of Christian belief with a kind of orderly plainness.

In general, the terms of modernism are not to be conceived as separate from the particular projects—the specific attempts at meaning—in which they are restated. An example of that truism would be the notorious history of modernism's concern for "flatness." Certainly it is true that the two dimensions of the picture surface were time and again recovered as a striking fact by painters after Courbet. But I think that the question we should be asking in this case is *why* that literal presence of surface went on being interesting for art. How could a matter of effect or procedure seemingly stand in for value in this way? What was it that made it vivid?

The details of an answer will of course be open to argument as to emphasis, evidence, and so forth; but surely the answer must take approximately this *form*. If the fact of flatness was compelling and tractable for art—in the way it was for Manet and Cézanne, for example—that must have been because it was made to stand for something: some particular and substantial set of qualities which took their place in a picture of the world. So that the richness of the avant-garde, conceived as a set of contexts for art in the years between, say, 1860 and 1918, might best be redescribed in terms of its ability to give flatness such complex and compatible values— values which necessarily derived from elsewhere than art. On various occasions, for instance, flatness was imagined to be some kind of analogue of the "Popular" (a curious fiction whose history is partly traced in chapter four). It was therefore made as plain, workmanlike, and emphatic as the painter could manage; loaded brushes and artisans' combs were held to be appropriate tools; painting was henceforth honest manual labour. (A belief of this kind underlies even Mallarmé's argument: earlier in the 1876 text he can be found describing the Impressionist as "the energetic modern worker" about to supplant "the old imaginative artist,"[9] and greeting the development on the whole with glee.) Or flatness could signify modernity, with the surface meant to conjure up the mere two dimensions of posters, labels, fashion prints, and photographs. There were painters who took those same two dimensions, in what might seem a more straightforwardly modernist way, to represent the simple fact of Art, from which other meanings were excluded. But during this period that too was most often an argument about the world and art's relation to it—a quite complex argument, and stated as such. Painting would replace or displace the Real, accordingly, for reasons having to do with the nature of subjectivity, or city life, or the truths revealed by higher mathematics. And finally, unbrokenness of surface could be seen—by Cézanne par excellence—as standing for the evenness of seeing itself, the actual form of our knowledge of things. That very claim, in turn, was repeatedly felt to be some kind of aggression on the audience, on the ordinary bourgeois. Flatness was construed as a barrier put up against the viewer's normal wish to enter a picture and dream, to have it be a space apart from life in which the mind would be free to make its own connections.

My point is simply that flatness in its heyday *was* these various meanings and valuations; they were its substance, they were what it was seen *as*; their particularity was what made flatness a matter to be painted. Flatness was therefore in play—as an irreducible, technical fact of painting—with all of these totalizations, all of these attempts to make it a metaphor. Of course, in a way it resisted the metaphors, and the painters we most admire

insisted also on its being an awkward, empirical quiddity; but "also" is the key word here: there was no fact without the metaphor, no medium without its being made the vehicle of some sense or other.

In other words, the terms of modernism—even or especially those that seemed to be given in the simple act of painting—were also constructs; and part of the purpose of this book is to describe the circumstances in which they first crystallized out. Those last two words are intended to suggest a sort of sealing and congealing as well as a simple assumption of order, since at the same time that the terms were arrived at there was a closure against consciousness of them *being* terms, and therefore against an awareness of modernism having circumstances—apart from the tautologous one of modernity. That blanking out of history is hard to escape from. It is not enough to say, as we all do now, that the terms of modernism and the facts of Parisian life are somehow linked. Such an insight too easily leads to our asserting not much more than the tautology I just referred

4. Pierre-Auguste Renoir, *Les Parapluies*, 1881–86.

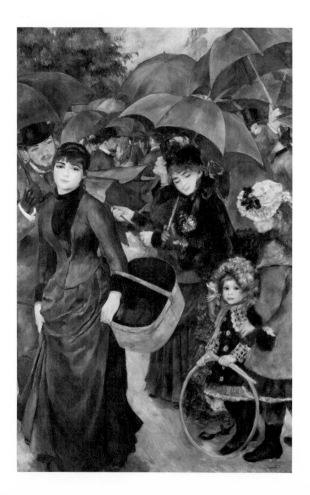

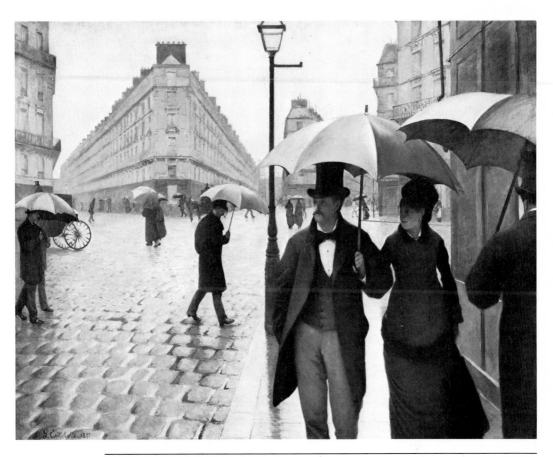

5. Gustave Caillebotte, *Rue de Paris, temps de pluie,* **1877.**

to. The argument I go on to make in this book is somewhat less watertight, I hope: I wish to show that the circumstances of modernism were not modern, and only became so by being given the forms called "spectacle." On the face of things it seems that Impressionist painting was one of those forms, but the question is: How completely? Are we to take Impressionism's repertoire of subjects and devices as merely complicit in the spectacle—lending it consistency or even charm—or as somehow disclosing it as farce or tragedy? Is the truth of the new painting to be found in Renoir's *Parapluies* or in Caillebotte's *Rue de Paris, temps de pluie*—in the sheer *appeal* of modernity, or its unexpected desolation? Are they grand and poetic still, these people in their cravats and patent-leather shoes, "these millions . . . who do not need to know one another" and who lead their modern lives accordingly?[10] Or has something occurred to make the very idea of heroism in modern life—even one as hedged in with ironies as Baudelaire's had been—already seem the relic of a simpler age?

There are surely readers who right from the start of this introduction found Schapiro's account overheated, and have been wondering since where the traditional notion of Impressionism has gone. Are we supposed these days to give up believing in the "painting of light" and the simple determination of these artists to look and depict without letting the mind interfere too much? The answer to that question is obviously no. The problem, on the contrary, is to rediscover the force of these terms—light, looking, strict adherence to the facts of vision—since they have nowadays become anodyne. Here, for example, is Jules Laforgue's description of the Impressionist at work, in an article written in 1883:

In a landscape bathed with light, in which entities are modelled as if in coloured grisaille, the academic painter sees nothing but white light spreading everywhere, whilst the Impressionist sees it bathing everything not in dead whiteness, but in a thousand conflicting vibrations, in rich prismatic decompositions of colour. Where the academic sees only lines at the edges of things, holding modelling in place, the Impressionist sees real living lines, without geometrical form, built from thousands of irregular touches which, at a distance, give the thing life. Where the academic sees only things set down in regular, separate positions within an armature of purely theoretical lines, the Impressionist sees perspective established by thousands of imperceptible tones and touches, by the variety of atmospheric states, with each plane not immobile but shifting.

. . . The Impressionist sees and renders nature as she is, which is to say solely by means of coloured vibrations. Neither drawing, nor light, nor modelling, nor perspective, nor chiaroscuro: these infantile classifications all resolve in reality into coloured vibrations, and must be obtained on the canvas solely by coloured vibrations.

In this small and limited exhibition at Gurlitt's, the formula is clearest in Monet . . . and Pissarro . . . where everything is obtained by means of a thousand small touches, dancing off in all directions like so many straws of colour—each struggling for survival in the overall impression [*en concurrence vitale pour l'impression d'ensemble*]. No more isolated melodies, the whole thing is a symphony, which itself is life, living and changing, like the "forest voices" of Wagner's theories each struggling for existence in the great voice of the forest, just as the Unconscious, the law of the world, is the great melodic voice resulting from the symphony of consciousnesses of races and individuals. Such is the principle of the Impressionist school of *plein air*. And the eye of the master will be the one which will discern and render the keenest gradations and decompositions, and that on a simple flat canvas. This principle has been applied in France, not systematically but by men of genius, in poetry and in the novel.

This description will probably strike the late-twentieth-century reader as outlandish, at least in its final paragraph. We are not used to accounts of unprejudiced looking which lead so precipitately to Wagner's theories of symphonic form and Hartmann's of the Unconscious. Impressionism

for us is a domestic and charming style, and excesses of enthusiasm or derogation in the face of it seem equally far from the truth. Were not those writers in 1877 simply facetious when they recoiled from Renoir's *Balançoire*—of all pictures!—with the epithets "bizarre," "apocalyptic," and "sublime de grotesque"?[11] Are we supposed to take any more seriously Laforgue's Darwinian straws of colour, his forest voices, or those brush-strokes of Renoir's which one critic perceived as leaving light behind them like "grease spots on the clothing of his figures"?[12]

I am not sure. These epithets and analogies are foreign to us now, but it seems safe to assume that there was something in the paintings that originally provoked them. (There is no better writing on Impressionism than Laforgue's: his excess seems bound up with his powers of description.* He was, after all, a master of understatement where he thought it appropriate). These critics' original sense of things can be retrieved, I think, only if we try to unlearn our present ease with Impressionism—above all our conviction that its dealings with the world are somehow specially direct.

This will be partly a matter of looking at Impressionist pictures again and being struck by their strangeness. Let us take, for example, a landscape Pissarro showed at the same exhibition in which Renoir's *Balançoire* ap-

* Laforgue's description of the Impressionist project—the passage I quoted was collected in his *Mélanges posthumes*, pp. 136–38—brings Cézanne to mind. In Cézanne's art, "seeing" is certain that it takes possession not just of straws of colour but of objects made out of them; it believes that it *has* the world, in all its fullness and articulation, and that the world is present *in seeing, strictly and narrowly conceived*. Yet at the same time it seems to grow progressively uncertain as to how its procedures give rise to the separateness and connection of things. Thus the task of representation comes to be twofold: to demonstrate the fixity and substance of the world out there, but also to admit that the seer does not know—most probably cannot know—how his or her own sight makes objects possible. The more one looks, the more one attends to interruptions and paradoxes in perception, and the more one suspects that the fixity of things is to be found exactly there, at the point where vision gives up the ghost. (The edges of things, to take an example Cézanne mused over in his letters, are undoubtedly *there* in vision, but in a specially perplexing way. A painter can fix them with a final line, but that line should somehow enact its own arbitrariness. Out of the manifold edges of an apple or a shoulder the painter makes one edge, visibly a contrivance, visually nonetheless convincing.)

In Cézanne, we could say, painting took the ideology of the visual—the notion of seeing as a separate activity with its own truth, its own peculiar access to the thing-in-itself—to its limits and breaking point. It is not surprising that this was done in a degree of isolation from the actual community of modernism (since an ideological community can be defined as that set of discursive and institutional constraints which turns its members always away from the edges or inconsistencies of their practice). Nor is it odd that Cézanne's achievement was immediately subject to a series of strong misreadings by those who remained in the avant-garde world—the series culminating in that proposed by the Cubists, whereby Cézanne's art was rendered serviceable for a further round of modernist claims to truth (know-nothing epistemology abruptly giving way to know-everything ontology, the latter more than half pretending to be philosophy, which at least the former had not).

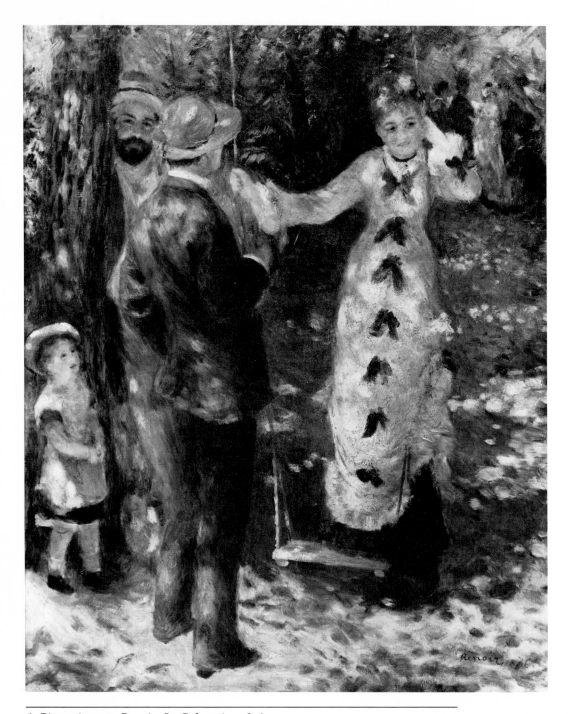

6. Pierre-Auguste Renoir, *La Balançoire*, 1876.

peared, his *Coin de village, effet d'hiver* (Plate I). Pissarro's whole contribution to the show that year came in for rough handling from the critics. "M. Pissarro," wrote one Ernest Fillonneau, "is becoming completely unintelligible. He puts together in his pictures all the colours of the rainbow; he is violent, hard, brutal. From an *effect* which might well have been acceptable, he makes something unbelievable, against seeing and even against reason."[13] It was not enough, some writers thought, for the artist's friends to tell the viewer to stand back and see the pictures from the other side of the room:

We have had enough of them repeating that, to judge the Impressionists, one has to take one's distance. At fifty paces, they assure us, arms bulge, naked legs protrude from skirts, eyes light up, the painting takes on body, ease, movement, each colour asserts itself and each tone leaps to its proper place. Thus it gives the impression of something seen and translated by the feelings rather than with every form defined. One or two of the coterie just about realize this programme; and all of them take pains, the sweat standing out on their brow, to spread their colour all over the canvas, in pursuit of transparency all the while, and, putting green in their shadows, they stay muddy, without freshness or relief.[14]

7. Paul Cézanne, *Une Scène au bord de la mer*, 1877.

Cézanne one knew about: he was clearly mad. But on reflection, Pissarro was almost as wayward:

There is no way to figure out M. Cesanne's [sic] *impressions d'après nature*; I took them for palettes that had not been cleaned. But M. Pissarro's landscapes are no more legible and no less prodigious. Seen close up, they are incomprehensible and awful; seen from afar, they are awful and incomprehensible. They are like rebuses with no solution.[15]

These criticisms are ungenerous, but they point to things in the paintings which truly are odd and ought to be recognized as such. The pattern of brushstrokes which Pissarro uses on the right-hand side of the *Coin de village*—where the branches half obscure the sides of a house, some shuttered windows, and a door—is very near to not being pattern at all (Plate II). If we look at the picture at arm's length (the painter's distance), the various marks which may stand for branches, shadow, scrub, plaster, tiling, the lines of eaves or tree trunks, all do their job of representing in a way which barely makes sense. The individual marks are scratched and spread into one another as if they had been worked over too long or too emphatically; sometimes the surface of the paint is visibly swollen with separate dabs of raw colour, and sometimes it is overlaid, almost cancelled out, with one or two declarative smears of red or green. The purpose of all this is not clear at arm's length: it is hard to see what produced the build-ups and erasures, or the sudden shifts of colour along the line of a branch or the edge of a roof. And presumably these things would have been obscure even to the painter as he put the particular touches down.

Not irretrievably so, of course: if he moved back from his work the marks would eventually congeal and release something seen—the way light falls on a house front or the space between one tree trunk and another. The technique was nonetheless strange, for as Pissarro was painting—I mean the word "painting" in a crude materialist way, as modernist writers might use it—he would have had no very well-formed notion of what the paint could stand for and how effectively. While it was being made the likeness was barely one at all, and at best the justice of it was provisional; no doubt the thing did resolve at a distance, and the painter went back and back to the proper point to look and compare. But the walk back was itself an odd distancing; it was as if a space had to be kept between painting and representing: the two procedures must never quite mesh, they were not to be seen as part and parcel of each other. That was because (the logic here was central to the modernist case) the normal habits of representation must not be given a chance to function; they must somehow or other be outlawed. The established equivalents in paint—between that colour and that shadow or that kind of line and that kind of undergrowth—are always

false. They are shortcuts for hand and eye and brain which tell us nothing
we do not already know; and what we know already is not worth rehearsing
in paint.

So painting put equivalence at a distance. No doubt Pissarro and his
friends believed that the look of the world would be found eventually,
but only in a dance of likenesses guessed at or half glimpsed, and al-
ways on the point of disappearing into mere matter. For it was matter—
paint itself—which was the key to any authentic likeness being redis-
covered.

There is certainly a set of Realist intentions still at work here, and even
the stress on painterly substance could be and occasionally was justified in
empirical terms. "For the sun," said Alfred Sisley, "if it softens certain
parts of the landscape, intensifies others, and these effects of light which
take on an almost material form in nature must be rendered in material
form on canvas."[16] Perhaps Pissarro would have been happy with some such
form of words applied to his painting; but they still would not have
explained the kind of elaborate indirectness I have been pointing to. It
does not seem to follow, after all, from a simple commitment to optical
truth. Painting was now supposed to be about seeing, and the painter
determined to stick to the look of a scene at all costs. But doing so proved
exquisitely difficult: it involved a set of fragile and unprecedented equations
between the painted and the visible, and above all it meant keeping the
two terms of the equation apart, insisting on them as separate quantities.

No wonder a writer in *Le Télégraphe* in 1877 could toy with the idea
of figuration's disappearing altogether from painting of this kind. He
offered the following synopsis for an "Impressionist novel" which would
surely soon replace, he thought, the "excessively minute descriptions" of
Zola:

A white—or black—form, which could be a man unless it be a woman, moves
forward (is it forward?). The old sailor shudders—or is it sneezes?—we can't be
sure; he cries, "Let's go!" and throws himself into a whitish—or blackish—sea
(we can't be sure) which could well be the Ocean.[17]

And did not all this ambiguity have to do at bottom with the character
of modern life? "The Impressionists proceed from Baudelaire," wrote Jules
Claretie.[18] Their exhibition "shows this much, that painting is not uniquely
an archaeological art and that it accommodates itself without effort to
'modernity.' "[19] Well, perhaps "effort" *is* the wrong word for Pissarro's
procedures, or even Cézanne's, but surely this writer's confidence somewhat
misses the point of the pictures he is describing; and the careful scare-
quotes he puts round that final "modernity" rather give the game away.
If it was so delicate a matter to insert the concept into a sentence in 1877,

then getting it into a picture promised to be no easy task. "Yes or no, must we allow art to effect its own naturalization of the costume whose black and deforming uniformity we all suffer? In other words, must we paint the stovepipe hat, the umbrella, the shirt with wing collar, the waistcoat, and the trousers?"[20] It remained to be seen what the attractive new category meant when it was reduced to such particulars, and what kind of accommodation art could make with it.

The VIEW FROM
NOTRE-DAME

Je suis un éphémère et point trop mécontent citoyen d'une métropole crue moderne parce que tout goût connu a été éludé dans les ameublements et l'extérieur des maisons aussi bien que dans le plan de la ville. . . . Ces millions de gens qui n'ont pas besoin de se connaître amènent si pareillement l'éducation, le métier et la vieillesse, que ce cours de vie doit être plusieurs fois moins long que ce qu'une statistique folle trouve pour les peuples du continent.
—*Arthur Rimbaud*[1]

The Argument

That it is tempting to see a connection between the modernization of Paris put through by Napoleon III and his henchmen—in particular by his prefect of the Seine, Baron Haussmann—and the new painting of the time. A critic unfriendly to that painting, and particularly to its claim to strict optical neutrality, might be disposed to put the connection thus: It seems that only when the city has been systematically occupied by the bourgeoisie, and made quite ruthlessly to represent that class's rule, can it be taken by painters to be an appropriate and purely visual subject for their art. They see it as a space from which mere anecdote and narrative have been displaced at last, and which therefore is paintable; but do they not mean by anecdote and narrative simply the presence—the pressure, the interference—of other classes besides their own? Haussmann's modernity, this critic would say, was philistine and repressive, and it is right that our gorges should rise at Fourcade La Roquette's unctuous reminder, in the 1869 debate over the baron's achievements, that as recently as 1847 "the street lamps were still not lit on nights when the moon shone," and at the "laughter in the House" which greeted the minister's sally at the bad old days.[2] For the House knew well that Haussmann's modernity had been built by evicting the working class of Paris from the centre of the city, and putting it down on the hill of Belleville or the plains of La Villette, where the moon was still most often the only street light available. And what did painters do except join in the cynical laughter and propagate the myth of modernity?

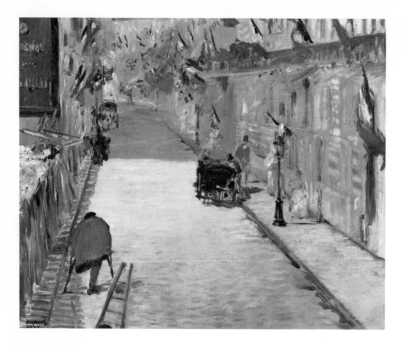

8. Edouard Manet, *Rue Mosnier Pavoisée*, 1877.

A defender, on the other hand, might say that modernist painters, though they showed the new Paris, most often did so in terms which had nothing in common with the official myth. They largely avoided those spaces, perspectives, occasions, and monuments which Haussmann himself would have seen as the essence of Haussmannization. Not until later, in the 1890s, did Pissarro present a full Haussmannian *point de vue* from one end of the Avenue de l'Opéra to the other (Plate III). In the 1860s and 1870s, what seemed to impress the new painting was the city's arbitrary and unfinished character. Manet, for instance, in his painting of the empire's Exposition Universelle of 1867 (Plate IV), was half inclined to outright satire of the city and its small enthusiasts. We should compare his view of the fictional form of Paris here—panoramic, unified, theatrical, spectacular, and flat—with his picture, painted ten years later, of the facts attendant on such exhibitions: the nondescript perspective of a street effaced by the regulation blood-red flag, or the same street containing a one-legged man *en blouse*—a veteran of 1870, say, or, even worse, of 1871.[3]

This chapter tries to mediate between these opposing views by putting a stress on the effort at ideological unity involved in Haussmann's rebuilding, and on the degree to which that effort failed. It therefore suggests that quite special problems are involved in the attempt, within the miniature confines of a canvas, to give that representation form.

It might be best to begin a description of Haussmannization at the edge of Paris, after the baron's work was done. Some time in 1886—let us assume it was subsequent to seeing Seurat's *Dimanche après-midi à l'île de La Grande Jatte* in the artist's studio or the Impressionist exhibition— Vincent van Gogh painted a small picture of the city's northern outskirts. We cannot be sure whether the tract of land he shows us stretches away to the north or the south, but it must be roughly one point of the compass or the other, for we are somewhere in the brief interval of open country between the working suburbs of Clignancourt and the iron-and-steel town of Saint-Denis to the north.

It was not unusual in the 1880s for a painter to choose a subject like this and believe it to be modern and poetical. There was a notion in the nineteenth century that the city divulged its secrets in such places, and that the curious ground between town and country—the *banlieue*, as Parisians

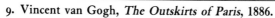

9. Vincent van Gogh, *The Outskirts of Paris*, 1886.

called it—had its own poetry and sharpened the dreaming onlooker's sense of what it meant to be bourgeois or *campagnard*. Victor Hugo put it as follows, in a passage he added to his novel *Les Misérables* for the new edition of 1861:

To wander in a kind of reverie, to take a stroll as they call it, is a good way for a philosopher to spend his time; particularly in that kind of bastard countryside, somewhat ugly but bizarre, made up of two different natures, which surrounds certain great cities, notably Paris. To observe the *banlieue* is to observe an amphibian. End of trees, beginning of roofs, end of grass, beginning of paving stones, end of ploughed fields, beginning of shops, the end of the beaten track, the beginning of the passions [*fin des ornières, commencement des passions*], the end of the murmur of things divine, the beginning of the noise of humankind—all of this holds an extraordinary interest.

And thus, in these unattractive places, forever marked by the passer-by with the epithet *sad*, the promenades, apparently aimless, of the dreamer. [*De là, dans ces lieux peu attrayants, et marqués à jamais par le passant de l'épithète: triste, les promenades, en apparence sans but, du songeur.*][4]

These paragraphs may have left their traces in van Gogh's elaborate, bookish mind. In any case he would have known for certain that the *banlieue* was meant to be melancholy, and that by 1886 there were even specialists—poets and painters—in the new commodity. The *banlieue* was the place where autumn was always ending on an empty boulevard, and the last traces of Haussmann's city—a kiosk, a lamppost, a cast-iron *pissotière*—petered out in the snow. It was the territory of ragpickers, gypsies, and gasometers, the property of painters like Jean-François Raffaëlli and Luigi Loir. The best insult to *La Grande Jatte* that Armand Guillaumin could devise in 1886 was to tell Seurat he was "doing a Raffaëlli."[5] So van

10. Luigi Loir, *La Fin de l'automne*, 1882.

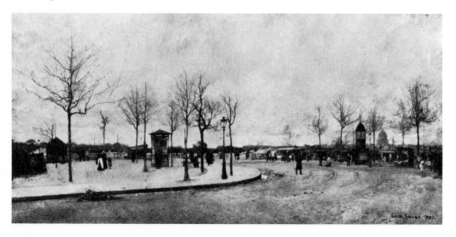

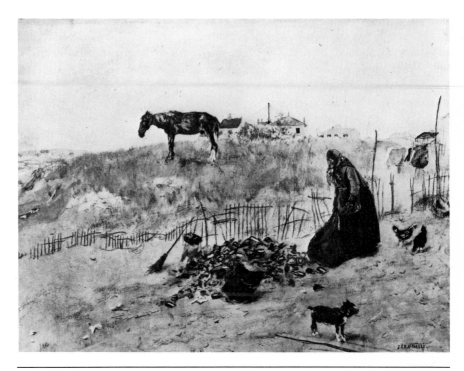

11. Jean-François Raffaëlli, *La Butte des chiffonniers*. From *Les Types de Paris*, 1889.

Gogh would have known that there were various *banlieues* to be avoided if one wished to stay part of the avant-garde.

We might suspect van Gogh of wanting to maintain Hugo's attitude, but of realizing that it would have to be reworked by a consciousness that all the epithets applied to the *banlieue*—sad, grey, desolate, ruined, even the *vague* of *terrain vague*—had been used too often, at least by bourgeois passers-by. Put them in the mouths of a laundress and a metalworker, as Zola did in chapter 8 of *L'Assommoir*, and they might be allowed to rekindle for a moment. Gervaise and Goujet climb the north side of Montmartre:

> With their heads lowered, they made their way along the well-worn path, amid the rumbling of the factories. Then, after two hundred yards, without thinking, as if they had known the place all along, they turned left, still keeping silent, and came out into an empty terrain. There, between a mechanical sawmill and a button works, was a strip of meadow still remaining, with patches of scorched yellow grass; a goat, tied to a post, walked round in circles bleating; further on a dead tree crumbled in the hot sun.
>
> "Really," Gervaise murmured, "you'd believe you were in the countryside." . . .
>
> The two of them said nothing. In the sky, a flock of white clouds swam past as slowly as a swan. In the corner of the field, the goat had turned in their direction and looked at them; from time to time, at regular intervals, it bleated softly. And

holding hands, their eyes brimming with tenderness, they looked into the distance, lost in thought, on the pallid slopes of Montmartre, surrounded by the great forest of factory chimneys blocking out the horizon, in that chalky and desolate *banlieue*, where the green trees shading the cheap taverns moved them to the edge of tears [*dans cette banlieue plâtreuse et désolée, où les bosquets verts des cabarets borgnes les touchaient jusqu'aux larmes*].[6]

It is all hedged in by a sense of absurdity, and the reader is given the option—perhaps too grossly in that final phrase—of finding Gervaise's vision merely foolish. But the vision and the emotion are not there in the novel simply to be denied; Gervaise and Goujet have their moment of freedom, and the landscape of the *banlieue* is the setting that confirms it and marks its limits.

L'Assommoir was part of van Gogh's reading too. He had read it first in The Hague four years earlier, and he may have looked at it again in Paris. But the picture he finally did of the *banlieue* is not a composite image; my network of possible points of reference is not meant to suggest it is. On the contrary, the image he made is saved from merely belonging to one artistic *banlieue* or another by its very emptiness, and the literalness with which the signs of change are spelt out in it unobtrusively.

Of course the picture has its share of desolation. It is mostly laid on or suggested by the unrelieved drabness of the colours, and by having objects and persons reduced to fluid, approximate, almost apologetic smears of paint. The paint is as slippery as the rained-on clay at the crossroads in the foreground, and as liquid as the cloud cover—that waterlogged, tumescent grey in which the very birds seem bloated and lumbering. The *banlieue* was supposed to look like this: the weather is suitably hopeless, and the brushwork insists on the mud-caked, deliquescent character of everything, even the lamppost. Whatever separate forms there are seem half embedded in the general ooze, but nonetheless van Gogh has been at pains to make them readable, and by means of them he draws up a kind of inventory of the edge of Paris—he does so matter-of-factly, bit by bit. There are the birds and the gaslight; there is a windmill in the distance and two or three tall narrow houses with red-tiled roofs, and on either side of the horizon large, lumpish grey buildings with rows of identical windows. There is some ragged grass, a broken fence, weeds, a line which changes from ochre to pink at the right which may be wheat or barley, or perhaps another path, and a trace of vermilion at the left which might be meant for poppies growing on fallow ground. Two men are dressed in workers' smocks, one near, one far, the nearer keeping company with a woman in black; two children dressed in white are being taken for a walk through the fields, and there are half a dozen other figures, tiny, to the

right, working or walking in the distance. On the path in front of the gaslight stands a character with a stick and a cap, a shapeless brown jacket, and a face which is one unworked block of grey paint.

None of these details are innocent, and most of them tell the same story. The factories—for that is what those lumpish buildings are—will replace the windmill, and the villas will march across the mud and cornfields until they reach the premonitory gas standard. This is a working landscape, with anonymous citizens mostly moving fast, going about their business, not stopping or sauntering, not sitting on the grass. There are no dreamers here. It does not appear to be Sunday afternoon, and the Plaine Saint-Denis is not arranged or proffered to the viewer as a *prospect*; neither the dingy line of buildings nor the edges of fields, nor even the five retreating figures on the path, establish much of a sense of scale or demarcation: things are seeping into one another, and the landscape is taking on a single, indiscriminate shape. It is much like the action of water on chalk and clay in the foreground.

There are those who blamed Baron Haussmann directly for all of this— the factories, the mess of fields and paths and stranded gaslights. As early as 1870 the grandest of Haussmann's enemies, Louis Lazare, had accused the baron of building a second industrial Paris on the edge of the old, and waiting for low rents and the promise of work to lure the working class out to it.

Artisans and workers [wrote Lazare] are shut up in veritable Siberias, criss-crossed with winding, unpaved paths, without lights, without shops, with no water laid on, where everything is lacking. . . .

We have sewn rags onto the purple robe of a queen; we have built within Paris two cities, quite different and hostile: the city of luxury, surrounded, besieged by the city of misery. . . . You have put temptation and covetousness side by side.[7]

As a matter of fact Haussmann had taken a personal hand in selling the Plaine Saint-Denis. He had called the great capitalists Cail and Say into his office and had showed them the open land on the map, free from the city's normal taxes, with new sewers and cheap coal guaranteed.[8] He most certainly thought that factories should get out of the imperial city. In time the tax laws and the baron's promises had the intended effect: Monsieur Say moved his refinery from Ivry, Monsieur Cail his steel mill from Grenelle. Others followed, and during the 1870s the plain was steadily filling up: Haussmann had had his way with industry, as with so much else.

It is unquestionably too glib to read van Gogh's picture as simply an image of Lazare's new Siberia. In describing the painting I have been obliged to move between the language of the melancholic *banlieue*—for

some such discourse is still present here, determining the picture's general look—and another language, more pedestrian and empirical, in which the disparate, provisional character of the place is rehearsed quite soberly. This is not to say that the sobriety does not end up producing something pointed, even chilling—it seems to me it does. But the picture is small and in a sense prosaic; it avoids the sociologist's high moral tone. And yet Lazare is after all probably closer to van Gogh's purpose than Victor Hugo. We could say that the landscape in van Gogh's work—and here is the difference from Hugo and Zola—is no longer envisaged as the edge of something else, the definite city of Paris. The plain is not presented, like Hugo's *banlieue*, as the end of one form of life and the beginning of another; there is no town in van Gogh's picture, and no country; the broken line of factories, villas, and warehouses is no more a marker of the city's edge than the gaslight in the field; and our reading of the open land and its agriculture is determined, surely, by the sea of mud in the foreground— it stands for the casual disrepair of this whole territory.

How different it is from van Gogh's sense of town and country a year or so later, when he paints the plain at the edge of Arles! There the fields are crammed with wheat; the picture's foreground is the rich, dry, stippled yellow of the stubble; and the factories and railway line beside the old city are drawn as a single bounding line—beyond them towers and churches, packed together.

What van Gogh was depicting in 1886 was the aftermath of Haussmannization. I do not think, as I said, that we should make the picture out to be too doom-laden; but there is some doom in it, especially if the edge of Paris is compared with that of Arles. The atmosphere of dissolution and misuse seems unmistakeable, and the suggestion strong that the modern may add up to not much more than the vague misappropriation of things. This, we shall see, is not to be explained as the mere bewilderment of a Dutchman in the big city: it is a characteristic note struck by Parisians when they deal with what had happened to Paris in their own time.

The word most often used to describe that process was "Haussmannization," and it was meant to convey the brutality (the Germanic thoroughness) with which the city has been transformed. At the edges of Paris there might be muddle and suburban sprawl, but these were the obverse— the ancillary conditions—of a city which for the most part was hideously well ordered. The reader should immediately beware, however, of the fiction that modernity, brutal or not, had been achieved once and for all by the baron's rebuilding. Certainly there were Parisians who believed as

12. Vincent van Gogh, *The Mowers, Arles in the Background*, 1888.

much, but the things they blamed on Haussmann—the blankness, the sameness, the regularity of the new buildings and streets—had been held to be true of the capital for thirty years or more before the baron took power. They had been extrapolated, always with a sense of doom, from the merest signs of interruption or drift. In 1830, for example, swooping over Paris from the towers of Notre-Dame and fixing on the repetitious architecture of the Bourse and the Rue de Rivoli, Victor Hugo had dreamt Haussmann's city and conjured up a bitter image of its plan:

Let us add that if it is right that the architecture of an edifice be adapted to its purpose in such a way that the purpose be readable from the edifice's exterior alone, we can never be sufficiently amazed at a monument which can equally well be a royal palace, a house of commons, a town hall, a college, a riding school, an academy, an entrepôt, a tribunal, a museum, a barracks, a sepulchre, a temple, a theatre. For the time being it is a Stock Exchange. . . . We have that colonnade going round the monument, under which on the great days of religious observance there can be developed in majestic style the theories of stockbrokers and commission agents.

Without a doubt these are quite superb monuments. Add to them a quantity of handsome streets, amusing and varied like the Rue de Rivoli, and I do not despair that Paris, seen from a balloon, should one day present that richness of line, that opulence of detail, that diversity of aspect, that hint of the grandiose in the simple and the unexpected in the beautiful, which characterizes a checkerboard.[9]

Hugo's metaphor would be borrowed regularly later, when the battle with Haussmann was on. By the 1840s there were plenty of town councillors and Saint-Simonians to moderate the poet's apocalyptic sarcasms and put his objection in reasonable, practical terms. The problem with Paris, the experts thought, was that its inner core was on the move to the west, following the drift of commerce towards the Bourse and the *grands boulevards*.[10] If something drastic was not done, the city would be left with a dead centre, its streets too narrow, its tradesmen gone in search of the rich. "The old Paris is passing," Balzac had written in *Les Petits Bourgeois*, "following the kings who have passed."[11] The new Paris was struggling to be born; and once again what is striking is the commentators' wish to have it there already, fully fledged.

Let me tell you what threatens everything in Paris: this abrupt efflorescence of bricks and slate, this profusion of building timbers and ashlar, this exuberant vegetation of casement windows, shutters, and *portes cochères*. . . . A craze for building reigns like an epidemic: the tide of houses rises as we look, overflowing the *barrières*, invading the *banlieue* and making its first assault on the outworks of the city's fortifications [in other words, spreading out to the land round Porte de Clichy and Porte de la Chapelle: no more than a stone's throw from van

Gogh's path and lamppost]. Can we stop this fever, this mania for piling stone on stone?[12]

This was Texier's verdict in 1852, before Haussmann had even entered the prefecture; and this was the diagnosis two years earlier in a pamphlet entitled *De la décentralisation des Halles*:

As a result of the transformation of the old Paris, the opening of new streets, the widening of narrow ones, the high price of land, the extension of commerce and industry, with the old slums giving way each day to apartment houses, vast stores, and workshops, the poor and working population finds itself, and will find itself more and more, forced out to the extremities of Paris; which means that the centre is destined to be inhabited in future only by the well-to-do [*ce qui fait que le centre est appelé à ne plus être peuplé dans la suite que par la population aisée*].[13]

None of these descriptions is arbitrary, still less straightforwardly untrue. Paris was drifting west in the 1840s; the Bourse was a special kind of architecture and would have progeny; there was undoubtedly a building boom before Haussmann. (One of the baron's first problems in the western *faubourgs* was that he was obliged, in order to build his new boulevards, to pull down so many fine houses which had been standing for only a handful of years—and whose owners had influence at court.[14]) But all the same these texts, especially Hugo's, *anticipate* modernity: it is as if the various authors needed it to be there, and made believe it was, in order to anathematize it. The most effective conjuration was certainly that hurled from the towers of Notre-Dame, and it should give us pause straightaway that the best description of Haussmannization was written thirty years before the event. Pamphleteers in the 1860s liked to take Hugo's tour de force for an epigraph,[15] and then go on to repeat its basic imagery—discovering a city of straight lines and unreadable façades, in which the stockbroker and commission agent still waxed theoretical on feast days. We might say of these writers that they seem to *want* the city to have a shape—a logic and a uniformity—and therefore construct one from the signs they have, however sparse and unsystematic. They see or sense a process and want it finished, for then the terms in which one might oppose it will at least be clear. The ultimate horror would be to have modernity (or at any rate not to have what had preceded it), to know it was hateful, but not to know what it was.

It is just that latter condition which haunts the most intense of these forebodings—the one in which prediction finally fuses with description—the entry in the Goncourts' journal of 18 November 1860:

I go in the evenings to the Eldorado, a big café-concert on the Boulevard de Strasbourg, a room with columns and very luxurious decor and paintings, something rather like Kroll's in Berlin.

Our Paris, the Paris where we were born, the Paris of the way of life of 1830 to 1848, is passing away. Its passing is not material but moral. Social life is going through a great evolution, which is beginning. I see women, children, households, families in this café. The interior is passing away. Life turns back to become public. The club for those on high, the café for those below, that is what society and the people are come to. All of this makes me feel, in this country so dear to my heart, like a traveller. I am a stranger to what is coming, to what is, as I am to these new boulevards, which no longer smack of the world of Balzac, which smack of London, some Babylon of the future. It is idiotic to arrive in an age under construction: the soul has discomforts as a result, like a man who lives in a newly built house.[16]

Again the date of the entry is important. By the winter of 1860 the new city was manifestly in the making. The Goncourts were seated in a café-concert on the enormous boulevard which Haussmann had laid out a year or so earlier to connect the Cité to the Gare de l'Est. But the baron's improvements were still in progress, and the shape of the *deuxième réseau*— the second, decisive instalment of street improvements and public works— was still not clear. The Rue de Rivoli had been finished, to Hugo's chagrin, in 1858, and the Boulevard Saint-Michel; but the network of grand avenues to the west, which would exacerbate the city's drift in that direction, was only just begun; the spinal cord of the new West End, the great Boulevard Malesherbes, was a wilderness of mud and scaffolding; and the subjection of the eastern, working-class *faubourgs* was mapped out but not yet put into practice. There was some understandable confusion, therefore, about Haussmann's purposes and their effect on Parisian life; the battle against Haussmannization had hardly started, and the word itself was not yet in circulation.

The Goncourts' verdict on this state of affairs is unfriendly but elusive; and whatever splenetic certainty it appears to have at first reading tends to dissipate the more one pays heed to the elliptical imagery and the indecisive tense of so many of the crucial verbs. When Edmond tidied up the text of the *Journal* for publication in 1891, he tried to make the imagery more concrete—or at least more vivid—and to mend his original uncertainty as to what was happening, what had happened, and what the future might hold in store:

I am going this evening to the Eldorado, a café-concert on the Boulevard de Strasbourg, a room with columns and very luxurious decor and paintings.

My Paris, the Paris where I was born, the Paris of the way of life of 1830 to 1848, is passing away. If it is passing in material terms, it is passing in terms of morality. Social life is going through a great evolution, which is beginning. I see women, children, households, families in this café. The interior is going to die. Life threatens to become public. The club for those on high, the café for those

below, that is what society and the people will come to. . . . From this an impression
of passing through these things, like a traveller. I am a stranger to what is coming,
to what is, as I am to these new boulevards without turnings, without chance
perspectives, implacable in their straight lines, which no longer smack of the world
of Balzac, which make one think of some American Babylon of the future.[17]

London would no longer quite do as a point of reference for what
Haussmann was attempting: it was replaced by New York and Chicago.
Paris, after all, was passing away materially as well as morally. The con-
tradictory double time implied in the original phrase, "La vie retourne à
devenir publique"—it is as if the present public life was a regression from
the fierce privacy which had hitherto characterized bourgeois existence,
but also the form of the future—was rewritten as simple threat, "La vie
menace de devenir publique." And the clichés of Haussmann's critics were
now given room in the text: the boulevards as usual became things "with-
out turnings, without chance perspectives, implacable in their straight
lines." (There was joke after joke on this theme in the 1860s, the best
being Edmond About's: his old soldier Colonel Fougas saw the way things
were going in Paris and dreamt of the day when the Seine itself would
be straightened, "because its irregular curve is really rather shocking."[18])

The original version of the Goncourts' text was less formulaic than this.
It did not *have* a Paris, in the way the Hugo had, or the other writers I
have quoted. It was on the verge of recognizing in itself—through de-
ployment of tenses, and production of the narrator as a kind of ghostly,
idiot intruder in the text, having nothing to do with the forms of life he
attempts to describe—the very work of extrapolation which the other
commentators took for granted. Of course the Goncourts' entry amounts
in the end to an offer of knowledge, a picture of Paris, and one made
almost coherent by the simple pressure of disgust—the interior is dying,
whatever was once of value in bourgeois existence is sabotaged or travestied,
and life spills out into the streets and the Eldorados. But "picture" here
is not quite the right word: the Goncourts' Paris—this is its originality—
is only incompletely an image. It is not really visualized, and that reticence
seems to have been exactly true to what was going on in 1860: a city was
being made, vigorously and well, but with no forms of visualization pro-
vided, or none the Goncourts could believe in.

We seem to have reached an impasse. Did Hausmannization give the
city form or not? To many contemporaries the question would have seemed
entirely odd; for what were the boulevards, the squares, and the new street
furniture if not an attempt to make Paris look a certain way—to make it
the image the critics had been anticipating? But it was possible to say—
Lazare said it, and Haussmann sued him for doing so—that the attempt

was turning out a failure.[19] The city was eluding its various forms and furnishings, and perhaps what Haussmann would prove to have done was to provide a framework in which another order of urban life—an order without an imagery—would be allowed its mere existence. (The real doom comes, the Goncourts might have agreed, when there are no images of it, and therefore no sense of it much.) In this perspective—and I suppose its very grimness means that it is not maintained very often, or for long— the whole debate about Haussmann's *aesthetics* has a nostalgic ring. So the baron pined for long straight lines and striking "points of view," and his critics for chance perspectives! But what had either to do with the winding paths of Lazare's Siberia, or the mute efficiency of the speculators around the Parc Monceau? Capital did not need to have a representation of itself laid out upon the ground in bricks and mortar, or inscribed as a map in the minds of its city-dwellers. One might even say that capital preferred the city not to be an image—not to have form, not to be accessible to the imagination, to readings and misreadings, to a conflict of claims on its space—in order that it might mass-produce an image of its own to put in place of those it destroyed. On the face of things, the new image did not look entirely different from the old ones. It still seemed to propose that the city was one place, in some sense belonging to those who lived in it. But it belonged to them now simply *as an image*, something occasionally and casually consumed in spaces expressly designed for the purpose— promenades, panoramas, outings on Sundays, great exhibitions, and official parades. It could not be had elsewhere, apparently; it was no longer part of those patterns of action and appropriation which made up the spectators' everyday lives.

I shall call that last achievement the spectacle, and it seems to me clear that Haussmann's rebuilding was spectacular in the most oppressive sense of the word. We look back at Haussmanization now and see the various ways in which it let the city be consumed in the abstract, as one convenient fiction. But we should beware of too much teleology: the truth is that Haussmann's purposes were many and contradictory, and that the spectacle arrived, one might say, against the grain of the empire's transformations, and incompletely. (The spectacle is never an image mounted securely and finally in place; it is always an account of the world competing with others, and meeting the resistance of different, sometimes tenacious forms of social practice.) Pay heed to the Goncourts' casting round for an image of Paris and not finding one—it points very well to the limits of Haussmannization.

The bare details of destruction speak for themselves. In seventeen years Haussmann remade the city in a quite unprecedented way. On his own

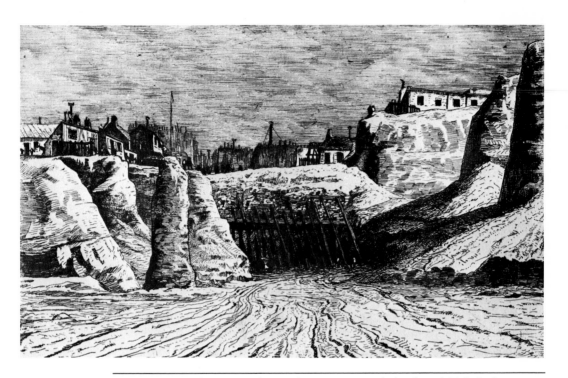

13. A. P. Martial, *Petite Pologne, destruction pour le boulevard Malesherbes,* 1861. Etching.

estimation, the new boulevards and open spaces displaced 350,000 people;[20] 12,000 of them were uprooted by the building of the Rue de Rivoli and Les Halles alone.[21] Statistics are the language of Haussmannization, and capable of a certain rough eloquence in the baron's favour: by 1870 one-fifth of the streets in central Paris were his creation;[22] he had spent 80 million francs on sewers, and 2.5 billion francs on the city as a whole; at the height of the fever for reconstruction, one in five Parisian workers was employed in the building trade.[23]

Boulevards were the heart of the matter: it was they that laid waste the city, and we have photographs, prints, and paintings to indicate how dramatically. There was thus the possibility of a picturesque of demolition: the Boulevard Malesherbes in Martial's print is shown surging through the slums of Petit Pologne like a force of nature, a wave about to burst a flimsy dam, something that could make the city look sublime for a moment if engraved with the right degree of detachment; and there are scores of images from the same decade in which a painter put together out of broken walls and scaffolding a good semblance of a ruin. (Gautier as early as 1856 called Haussmann the new Piranesi in an article entitled "Mosaïque de ruines."[24]) But Haussmannization was much more than the making of streets.

It was laying out new aqueducts along the Dhuis one hundred miles from Paris; it was doubling the acreage of the city by annexation, fitting new lenses on the gas lamps, having Viollet-le-Duc put up a spire of oak and lead on Notre-Dame, declaring open the great collector sewer, providing ways for men to relieve themselves (more or less) in public, putting an outer circle of railways round the city, building the new Opéra and the new morgue. Haussmann's proudest moments included breaking the monopoly of the cab company—the Compagnie des Petites Voitures—in 1866, and promoting that of the makers of street lamps—the Compagnie Parisienne d'Eclairage—in 1856.[25] By the end of the 1860s he could boast that Paris had twice as many trees as in 1850, most of them transplanted full grown;[26] it had policemen and night patrols, bus shelters, tap water, and better access to the cemeteries.

The business of building a modern city was complex and irksome. It is easy to point out the extent to which Haussmann failed, even by his own standards. He was in any case a man whose modernity had its limits: he never believed in electric light, and recoiled in horror from the thought that human feces should go with the rest of the city's debris into his *grand égout collecteur*.[27] His faith in free enterprise was profound, but one of his first acts was to introduce a municipal Caisse des Boulangers to keep the price of bread steady and stave off the possibility of food riots.[28] (That smacked too much of *sans-culotte* politics for his republican successors; they abolished the Caisse in 1872.) Paris in 1870 still had fleets of sedan chairs[29] and public executions at the Barrière Saint-Jacques. The poor still ended in the *fosse commune*, much as Haussmann deplored the fact in his speeches. There had been cholera again in 1867, and tuberculosis was on the increase.[30]

Nevertheless the city had been reconstructed; no one disputed that. There was more disagreement when it came to explaining why. In the black-and-white political climate of the 1860s men chose their reasons for Haussmannization according to their general view of the empire, and Haussmann himself was no exception. Some said that empires always believed (too much) in public works, as a means to employ the unruly populace, as a source of patronage, and as a general provider of goods to the economy.[31] It was certainly true that the emperor himself had arrived back from London in 1848 with various Saint-Simonian dreams of the city, and that he was less quickly disabused of them than of his other utopian hopes. It was he who drew the original rough map of the Paris-to-be which Haussmann pinned up on the wall of his office in the Hôtel de Ville; it was he who received the baron each day at the Tuileries, after the prefect of police, for a personal report on the state of the capital; and in his official portrait

by Flandrin, underneath a brochure on the table entitled *A la France* lies the "Plan de Paris," discreetly displayed as the emperor's handiwork.[32] His dreams said that the city should be clean and light, with parks and churches and lakes, and traffic on the move. They also said that the city should have no more revolutions, or none with a chance of succeeding.

There was no disputing that part of Haussmann's modernity was his wish to put an end to insurrection.[33] He stated as much himself: it was a good argument to lean on when pleading for funds from the Conseil Municipal. Years after the event, he was still musing in his *Mémoires* over the hidden benefits of the Boulevard Sébastopol:

It meant the disembowelling of the old Paris, the *quartier* of uprisings and barricades, by a wide central street piercing through and through this almost impossible maze, and provided with communicating side streets, whose continuation would be bound to complete the work thus begun. The subsequent completion of the Rue de Turbigo made the Rue Transnonain [symbolic capital of the barricades] disappear from the map of Paris![34]

Nor was this merely a matter of hindsight on Haussmann's part. The

14. Hippolyte Flandrin, *Napoleon III*, c. 1860–61.

details of counterrevolution weighed heavily on the planners' minds at the time: Napoleon intervened directly in 1857 to prevent the encirclement of the Faubourg Saint-Antoine from being spoiled by a mere architect's whim: "the construction of arcades on the Boulevard Mazas," he wrote, "would seriously damage the strategic system of Paris."[35] The arcades were quietly dropped from the designs.

The decent adjective "strategic" echoes through the 1860s. Covering the old Canal Saint-Martin was a fine strategy, robbing the *faubourgs* of one of their favourite lines of defence;[36] making wide roads to all the railway stations meant not just that goods went out to the provinces, but that soldiers could more easily be shipped in; the network of new churches was excellent for working-class morale, but hardly more so than the new barracks put up at all the major crossroads.

How the opposition made hay with this aspect of Haussmannization! The baron had done his work "against Paris," said Charles Delon, and Paris in its innocence had not seen what was happening until too late.[37] Writers were eager now to draw back the veil. Consider Victor Fournel, for example, in *Paris nouveau et Paris futur*, published in 1865:

It must be said that what are called the embellishments of Paris are basically nothing but a general system of offensive and defensive armament against uprising, a precaution taken against future revolutions, which has been pursued for twelve years with an indefatigable perseverance, without the ingenuous Parisian's appearing to suspect a thing.[38]

Or the same message in the mouth of a triumphant general (retired), strutting the boards of Eugène Pelletan's *Nouvelle Babylone* in 1862:

This is the reason [the general exults] why Paris has been demolished. We wished to make Paris an armed camp, and the Louvre our quadrilateral; with that and the imperial guard for garrison, the principle of authority can sleep easy. And honest men will no longer see individuals in cotton aprons, carrying pots of paste in their hands, daubing the walls with their brushes and gravely putting up on street corners posters announcing the formation of a new government.[39]

Looking back from the other side of 1870, we are not likely to be impressed by the general's powers of prophecy; and really his whole diagnosis is no more accurate, on its own, than his political soothsaying. Readers may have wanted to believe him in 1862—and Pelletan, the wide-eyed and disapproving visitor from the provinces, was certainly inclined to do so—but again there is pathos in the very wish that Paris amount to one thing. The city ought to have a reason, the streets must be part of a plot. It should not surprise us that Fournel's little book begins with the passage from Hugo on Paris as checkerboard, and ends with the author's own dream of the capital in 1965, swollen to the size of the Seine De-

partment, totally rectilinear and centralized, with the centre taken up by an impenetrable barracks, as big as a city in its own right.[40]

The truth was that Haussmann's rebuilding obeyed various kinds of logic. Counterrevolution was part of it, and so were public works, and the need to do something for the worn-out and distended fabric of the capital. There was the simple wish to have an imperial city to show off to strangers. There was the profit motive (did not Haussmann in retirement end up as director of the Crédit Mobilier and the Magasins Généraux, in frank reward for services rendered?).[41] By 1865, certainly, there was a wish to do something to appease one's critics, to help the *banlieue* and deliver the goods to those who felt themselves excluded from modernity thus far.[42] All of these purposes were real and substantial: they crossed and obstructed one another sometimes, and often they colluded. But what they produced was something, the city, which wholly exceeded any of their arguments; and this too was recognized at the time, not just by Lazare and the brothers Goncourt.

The reader will have noticed how tempting it is to make this chapter out of nothing but the voices of the discontented. There were plenty of them: at times in the later 1860s it seemed as if Haussmann had hardly a single friend, apart from the pamphleteers he paid and the editors of guidebooks, who are obliged to make the best of things. Haussmannization was unpopular in Paris: the defeat of the official slate in the city in the 1869 elections was bound up with that fact, as was the decisive no which Paris gave to the emperor's plebiscite of 1870; so too was the uprising against the empire on 4 September of the same year. Revenge on Haussmann could occasionally be sweet. An American called Sheppard described the scene in the western districts on 4 September as follows: "The busts of the Emperor and Empress were thrown out of the windows of the houses in which they were found; and on one ladder I saw a well-dressed *bourgeois* effacing the street name of the Boulevard Haussmann, and substituting that of 'Victor Hugo.' "[43] One month later, when the mob first invaded the Hôtel de Ville, there was some of the same symbolism: "Furniture is smashed. A splendid plan of Paris, drawn up by Haussmann's engineers and Napoleon's Haussmann, is cut to pieces by the vengeful Reds. They break into the chamber where the twenty mayors are in session. The mayors flee."[44]

Time and again one is struck by the vehemence and diversity of opposition to the new city: vengeful Reds and well-dressed bourgeois in temporary agreement as to what they had suffered at whose hands. It is often hard to make out what the agreement derived from: what was it

exactly that so little endeared Baron Haussmann to his fellow citizens, and persuaded them that public works were the worst part of empire? To answer that question we need more voices and more intimacy still with disaffection.

The critics said that they had lost Paris and were living in someone else's city. This was a figure of speech, and people were not necessarily meant to take it seriously. The playwright Victorien Sardou put on a comedy, *Maison neuve*, in 1866, and seemed to make light of the fears of an elderly haberdasher in the face of progress. The character's nephew and niece are intent on moving to the Boulevard Malesherbes and ask him, laughing, what it is he has against the new Paris, what he thinks will be lost by changing places. He replies in a grand speech:

Dear child! It is the old Paris that is lost, the real Paris! A city which was narrow, unhealthy, insufficient, but picturesque, varied, charming, full of memories. We had our favourite walks a step or two away, and our favourite sights, all happily grouped together! We had our little outings with our own folk: how nice it was! . . . Going for a stroll was not something that tired you out, it was a delight. It gave birth to that eminently Parisian compromise between laziness and activity known as *flânerie!* Nowadays, for the least excursion, there are miles to go! A muddy thoroughfare which women cross without grace, since it no longer has the elasticity of the old paving stones to support them! An eternal sidewalk going on and on forever! A tree, a bench, a kiosk! . . . A tree, a bench, a kiosk! . . . A tree, a bench . . . And on top of all that, the sun! the dust! the mess! the dirt! A crowd of people of all shapes and sizes, cosmopolitans jabbering away in every language, decked out in every conceivable colour. Nothing left of the things which once constituted our own little world, a world apart; a world of expertise, judgement and refinement, an elite of wit and good taste.—What is it we are losing, by God? Everything! This is not Athens any longer, it is Babylon! It is not the capital of France, but of Europe! A wonder, we shall never see the like—a world!— agreed . . . Nevertheless, it isn't Paris . . . and there are no Parisians any longer.

CLAIRE, *in reply*: Come now, uncle, don't you understand how grand it is, how comfortable, how hygienic?

GENEVOIX, *again*: But haven't I told you that I admire it! It was inevitable; they had to do it, they did it! They did well! and altogether, things have turned out for the best! Long live the city! I applaud it heartily—and beg leave to think it fortunate that God himself was ignorant of this marvellous municipal system, and did not choose to arrange the trees in the forest in rows . . . with all the stars above in two straight lines.[45]

We are presumably meant to laugh, and sympathize, and have more than a sneaking feeling that Genevoix may be right. And so it proves: the new house on the Boulevard Malesherbes turns out to be a financial (and moral) disaster, and the comedy ends with the family chastened and reunited in

the draper's shop off the Rue Saint-Denis. Sardou knew his vaudeville audience well: he contrived the denouement he thought they wanted.

The separate heads in the case against Haussmannization—some of which appear in Sardou's monologue—can be rehearsed as follows. First, the business had been done wastefully and dishonestly. The empire was in league with the speculators and the Haute Banque, and the baron had used his power to sell off the richest shares in the new construction work to the brothers Pereire and their unloved Crédit Mobilier.[46] Boulevards and railways were all one in the opposition's eyes: things built too quickly, whose profits went to a secret few, and whose appetite for capital distorted the whole industry of France. The argument was only sharpened by its distance from the truth: in fact the profits of reconstruction had been spread quite wide, to the small proprietors grown rich on compensation, to the landlords making their fortune from inflated rents, to the swarm of men who fattened on the process of rebuilding and found a way to make money out of its side effects. The sight of such fortunes being made enraged those bourgeois who had not been richly expropriated or had somehow missed the chance to buy at the right time.[47] What a howl went up in 1867 when the tinsmith from Fontanges, Lapeyre, was given the contract to demolish the pavilions of the Exposition Universelle and sell them off for scrap! He had caught Haussmann's eye originally in the auctions of rubbish from the slums; had been given key concessions; and when his son was married the baron had sent his card.[48] It was all favours, kickbacks, and corruption, said those who wanted a part of all three.

Second, the city that resulted from this fever was supposed to be regular, empty, and boring. Haussmann had killed the street and the *quartier*; he had made instead "la CITÉ NEUTRE des peuples civilisés."[49] Once upon a time there had "existed groups, neighbourhoods, districts, traditions" but all of them had passed away.[50] There was no more multiformity in Paris, no more surprise, no more *Paris inconnu*. If the old bohemian Privat d'Anglemont, the man who had written the book of that name, could rise again

from his humble grave at Montmartre, and . . . indulge in one of those wild night-walks his spirit loved, he would lose his way at every step: he would be bewildered indeed before the *Collège de France*, and on the ground of the broken-down, dark, dirty and disreputable streets and alleys and wastes, which once had the *Cloître Saint-Jean de Latran* for their centre. Here were the headquarters of wandering Bohemians, street singers and conjurors, the vicious and the criminal and the unfortunate, all afflicted with the common curse of poverty. The Boulevards have broken through all.[51]

"The straight line," need one say it,

has killed the picturesque, the unexpected. The Rue de Rivoli is a symbol; a new street, long, wide, cold, frequented by men as well dressed, affected, and cold as the street itself. . . . There are no more coats of many colours, no more extravagant songs and extraordinary speeches. The open-air dentist, the strolling musicians, the ragpicker philosophers, the jugglers, the Northern Hercules, the hurdy-gurdy players, the sickly snake-swallowers, and the men with seals who said "papa"—they have all emigrated. The street existed only in Paris, and the street is dying. . . .[52]

It would be easy once again to indicate the measure of wish fulfillment in all this gloom. The streets had never been so full as these enthusiasts would have had them, and never so empty as the new Jeremiah prophesied in a pamphlet of 1864:

Man of the house [Haussmann, naturally], you will live to see the city desolate and bleak.

Since you will not believe me, you will continue to build, and marvel will be piled upon marvel. One day, Babylon will be so beautiful that you yourself will be stupefied.

The roads will then become gloomy and deserted, for everything will cost too much.

The family of Landlords will lose their minds.

And solitude, the ancient goddess of the deserts, will come to preside over this new empire. . . .

You will see all this, man of the house.[53]

The part of fantasy and the need for doom to arrive are evidently making and shaping these texts. But let us accept their imagery as such for the time being, and simply point to its insistence. Something had gone from the streets: a set of differences, some density of life, a presence, a use. It may not have been true that in 1870, when the empire fell, the streets were filled again with those previously excluded by Haussmann's police; but it is right that Sheppard, our American in Paris, should reach for the image so automatically as his figure of Paris lost, Paris becoming the Goncourts' again:

The Boulevards have long since lost their old order and decorum; they are now filled with street performances of all kinds and descriptions. Music upon every instrument that can make it; fortune-tellers, conjurors, gymnasts, dancing dogs, mountebanks—every conceivable dance, trick, or sleight-of-hand for entrapping money.

The new policemen are among the delighted lookers-on at these entertainments. . . . Paris has become very like Naples in the character of the entertainment of its streets, and above all in the crowds of greasy and sometimes not unpicturesque beggars.[54]

Third, the enemies of Haussmann said that the baron had meant from

the beginning to evict the working class from its old place in the centre of Paris, and had applied the simple pressures of the market to the job.[55] He had demolished the tenements and tortuous streets of the Ile de la Cité and driven his boulevards all through the sacred *sans-culotte* territory of Saint-Denis, Saint-Antoine, and Sainte-Geneviève. In place of the crumbling houses where the tailors and coppersmiths had lived, the builders of boulevards—avid to recoup their costs—had put up lavish blocks of apartments, with stone mouldings and ironwork balconies and running water to the second floor. The rents of such places were impossibly steep, and the rents of the rest of the neighbourhood followed them upwards. By Haussmann's own estimate, rents in the centre of the city doubled between 1851 and 1857,[56] and they went on climbing thereafter. The working class began to complain. In 1856 the emperor himself received a delegation of workingmen come to protest the cost of accommodation in Paris.[57] He was officially sympathetic. Had he not personally drawn up designs for workers' dwellings and put them on show in the 1855 Exhibition? Did he not still believe—he said as much in a speech a few years later—that the new works were bound to benefit the workers in the end? "We shall see each year," he told his faithful Conseil Municipal, "great arteries being opened, the populous neighbourhoods growing healthy, rents tending to decrease with the multiplicity of construction, the working class enriching itself by labour, poverty diminishing through a better organization of charity, and Paris thus answering increasingly to its high destiny."[58] That speech was still possible in 1858; in another ten years it seemed no one believed it. By that time it was common knowledge, passed on by foreigners even, that the emperor had always wanted "to shut away the poorer classes somewhere else,"[59] and Lazare was charting their exodus from the city, street by street. Belleville and Batignolles were built, of stone sold cheap from the demolitions. The factories were working on the Plaine Saint-Denis. The edge of Paris was an image already, something known and feared: Belleville elected Léon Gambetta and Henri Rochefort in 1869, both in opposition to the emperor, and Belleville was not the worst; beyond it was a hinterland of exiles, half wilderness and half armed camp, peopled by those who knew—they were told so often—that they had lost their city, and might still try to take it back.[60]

Fourth, it was argued that in place of one Paris Haussmann had made two. The accusation was linked with the issue of high rents and the plight of those who had lost a place to live in the city. Haussmann, the critics said, had let the city of the bourgeoisie drift west.[61] He had built the Boulevard Malesherbes as a kind of thoroughfare for speculation; he had laid out the inhuman avenues round the Etoile and furnished the Champs-

Elysées with fountains, candelabra, kiosks, and new cafés-concerts designed by Gabriel-Jean-Antoine Davioud. The site of the Opéra had finally been chosen after long years of debate, and Haussmann had overruled the arguments of those, like Lazare, who wanted it built at the crossroads of Richelieu-Drouot—still straddling the eastern and western halves of the city, that is to say, with avenues leading off from it up the hill to Batignolles and Montmartre.[62] Instead the baron had it put down in the new space which he had provided for pleasure and business, halfway between the Bourse and the Gare Saint-Lazare. And thus the city had finally been segregated along class lines: a middle-class city in the west now looked across the *terrain vague* of distraction and finance to the workingman's strongholds in the east and north. The figure proved irresistible in the empire's final years: there was hardly a worthy republican who did not evince a sudden enthusiasm for the days gone by when worker and bourgeois had lived together in the same street, even the same house, had done business together, exchanged courtesies, and gained some understanding of each other's ways. That time was gone, alas! The new boulevards had cut Paris in pieces: they had marooned the great Faubourg Saint-Antoine and drained away the rich to the Parc Monceau. Paris was all traffic, all "circulation"; and between the great avenues were separate cities, rich and poor, where one could walk for half an hour without seeing a *blouse*, and then another hour in a different direction with never a private carriage or a rolled umbrella, or even the shiniest, most threadbare of *redingotes!* The differences were unmitigated now, bitter and visible; the signs of class were everywhere, and the sense of approaching disaster. "Bismarck finished what Haussmann began," wrote Hugo in *Actes et paroles*. And Sheppard, before the Siege of 1870 gave way to the Commune, wrote in his diary in similar vein: "If there shall be anything done towards . . . averting the doom which impends over this city . . . it will not be done by the *prolétaire* or the *bourgeois*, by the fire-eater of Belleville or the snobs of the Quartier des Champs-Elysées."[63]

Lastly, it was said that the new city Haussmann had made—the city of the west and centre—was given over to vice, vulgarity, and display. It was not, except superficially, a city of the bourgeoisie at all, if one meant by that word the solid men who made their fortunes on the Rue Saint-Denis— men like Genevoix the haberdasher, or Balzac's heroes, or Daumier's. No, what one had instead was "a city where those who do nothing spend their winters, the same who go in the season to promenade their idleness on the fashionable beaches, at the seaside resorts, the spas, the Bois, the little places in the country."[64] If one looked inside the "crinoline architecture" all one would find was rising damp.[65] This was the city of courtesans and bull

markets. Here was ostentation, not luxury; frippery, not fashion; consumption, not trade. And here above all was *uncertainty*—a pantomime of false rich and false poor, in which anyone could pretend to be anything if he or she had money for clothes.

The refrain, need one say it, became tiresome with too much use. But at times—we have seen it happening already, in the case of the Goncourts—the sense of the new city as characterized by shifts and disguises, by too many surfaces and too few lines of demarcation, appeared to be serious and was certainly vivid. It is important for our purposes because it seems, of all the rhetorics just itemized, the one which leads—too conveniently, almost—to the painting of the avant-garde. For did they not adopt the terms of Haussmann's critics and make an aesthetic of them—an aesthetic of the unfixed and unfinished, an art which declared that the modern was the marginal, and that the truth of perception lay in staying on the surface of things and making do with ambiguity?

We have come to the sharpest bone of contention in the debate; the one which reveals the speakers' opinions as to the nature of city life in general, of social life, of capital, of the claim or wish to be modern, and perhaps of perception itself. The disagreement can be summarized as follows. A city, some said, ought to be readable and maintain a certain separation of parts; it ought to contain different functions, different *quartiers*, different kinds of dress; sign languages which established even for the stranger—and certainly for the native—where one belonged in the city and whom one should be with. These languages and separations had to be finely tuned: too much distinction and the city would forfeit the possibility of being read as a whole by all its citizens; too great a commingling of signs and it would be unclear what any one meant and to whom it belonged. The more sophisticated proponent of this point of view would be ready to admit that the city as a form of life was prone to the latter disorder—that was part of its appeal. Cities are places of show and negotiation, and because they provide for more transactions they allow for more mistakes; there is a greater margin of error in most things, but that is all it amounts to. Mistakes do not necessarily threaten the system; and in a well-ordered city there is a system, a great obligatory one of social appearances—for all that they look, in the thick of it, to be chosen and discarded at will.

There are pamphleteers and painters who disagree with this as a description of Haussmann's Paris, and even sometimes as an ideal. They say that the margin of error in urban life has taken the place of the system, and that thus the city is rendered illegible—that that is its chief new characteristic. It has become a mass of edges now, overlapping and interfering with one another; and living in the city is a matter of improvisation,

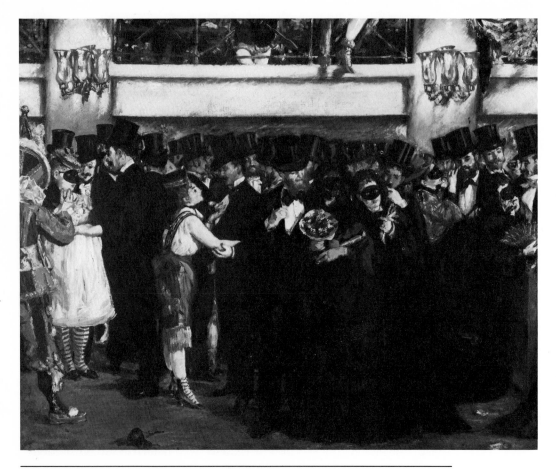

15. Edouard Manet, *Un Bal masqué à l'Opéra*, 1873.

of moving from one marginal area to another, of taking temporary shelter
in one's chosen subculture and risking each evening the uncertainty of the
boulevard or the Eldorado. Something like this is what Manet, for instance,
appears to be concerned to paint in his *Déjeuner sur l'herbe*, or his *Bal
masqué à l'Opéra*, or his *Bar au Folies-Bergère* (Plate XXIV). This ball, this
bar, this picnic; this balcony, this walk outside the Great Exhibition, this rest
with a novel by the railings, this prostitute's bedroom, this day at the seaside,
this café-concert: the list is enough to suggest the territory Manet takes to be
Paris. They all seem to be places laid on for display but also for equivocation;
places where people are hard to make out, their gestures and expressions
unconvincing, their purposes obscure; and it is hereabouts that the city can
be seen most sharply. That fact in turn inflects the new painting's account of
seeing in general: the visible comes to *be* the illegible, and the new city is thus
the perfect place for the painter who trusts to appearances.

This, I should say, is the essential myth of modern life: that the city has become a free field of signs and exhibits, a marketable mass of images, an area in which the old separations have broken down for good. The modern, to repeat the myth once more, is the marginal; it is ambiguity, it is mixture of classes and classifications, it is anomie and improvisation, it is the reign of generalized illusion. None of these statements strike me, or, I hope, the reader, as simply or obviously untrue. But it is surely apparent that they do not match with other things asserted—often by the same writers— about the shape of Haussmann's Paris. Observers agreed that in some important sense the city was more inflexibly classed and divided than ever before; that one was entering the age of the "residential district" and the "industrial suburb," and that those brisk euphemisms disguised an unmistakeable sealing and quarantine of the classes. What the myth of modernity fails to do—what entitles us to call it mythical—is to put together its account of anomie with that of social division; it fails to map one form of control upon another. The question will be asked of modernist painting in the pages that follow: To what extent does it contrive to do some of that mapping, most often in spite of its ideology?

One further point needs defending before I proceed. The sceptical reader may wonder how the argument just outlined could possibly tally with some of those propounded earlier—the one about the Goncourts' happy lack of imagery, for instance. For did I not previously put my stress on the baron's failure to provide any forms of intelligibility for his Paris, and on the forces within the capitalist economy which made for dispersal and fragmentation? There is, however, no contradiction here. It is one thing to argue that the capitalist city lacks intelligible *form*, and has no coherence to speak of; it is quite another to say it lacks *order*, that it is uncontrolled or classless. It does not seem to me that the city in our time is specially unclassed or disorderly, or that everyday life within it is lived most fully by liminal or marginal individuals. Perhaps we believe that to be the case because we have lost, as part of the process called modernity, those modes of political, economic, and ideological representation in which the city had once been constructed, as a contingent unity in and through other social practices. We might say, to adapt a previous formula, that capital devises a set of orders and classifications which makes the *city* unintelligible, but does not therefore make modernity so, or everyday life. On the contrary, everyday life in the residential districts and industrial suburbs is hemmed in by instructions and advertisements as never before: the texture of intimacy and free time has seldom been so fixed and classed and classified. It is part of that fixing that the city itself should vanish, since the city was precisely a site of unfixity—uncontrol—in the previous social order: it was a horizon

of possible collective action and understanding, and all such horizons must
be made invisible in societies organized under the aegis of the commodity.

It should not surprise us, therefore, that Haussmann and his critics were
largely agreed on one main thing. They all wanted the city, in the sense
just given, to survive. They wished to give it back its established forms of
representation or to give it new ones.

The baron badgered his architects for imagery, for scale, for points of
focus.[66] He disliked the neutrality of the Place de la Concorde, with its
indecipherable obelisk, and dreamt of replacing it with something stronger;[67]
he did not seem to realize that there are places in every city which disqualify
themselves from the symbolic order—by the very density of different his-
tories that have claimed the place and spilt blood. He was not above cutting
down the Liberty Tree in the Jardin du Luxembourg, the last survivor
from the great Revolution,[68] and putting Jean-Baptiste Carpeaux's *Quatre
Parties du monde* in its place—imperial messages shouldering out republican
ones. There was glee in building the Préfecture de Police on the very site
of Eugène Sue's thieves' kitchen in the Rue aux Fèves,[69] or putting the lawns
and lake of the Buttes-Chaumont where once had stood the great gibbet
of Montfaucon. On the Place du Château d'Eau the engineers pulled down
a *panorama* (one of the last) to make room for a barracks, and the various
theatres of the old "Boulevard du Crime"—the Cirque, the Folies-Dra-
matiques, the Gaîté, the Funambules, the Délass'-Com', the Petit-Lazari—
were supposed to give way to a single Orphéon on the east side of the
square, where male-voice choirs would harmonize each night for the work-
ing man.[70] Across from the barracks was built a department store, the
Magasins Réunis; from one corner of the square an avenue led off to the
railway station, and from another the way was straight to the Cimetière
du Père Lachaise.

But these were occasional triumphs—and in any case the Orphéon was
never built. Even Haussmann's most hostile critics did not necessarily accuse
him of giving the streets of Paris a *different* symbolic order—one they
disapproved of, one they might still tear down. They said, on the contrary,
that there was no symbolic order left, that the street was dying, and that
Haussmann was simply standing guard at the funeral. We might ask what
a charge of this kind amounted to: What did it mean, in other words, to
say that the street no longer existed?

When the streets had been healthy, the guidebooks agreed, they had
been full of people doing business on the sidewalk. Flower girls and faggot
sellers; water carriers, errand boys, old-clothes dealers, organ grinders,

pedlars, bailiffs, acrobats, wrestlers, rag-and-bone men, bill stickers, lamp-lighters, porters for the market and the shops, porters for hire by the hour; coachmen, window cleaners, dog washers and dog trimmers, knife grinders, booksellers, coal merchants, carters, prostitutes, odd-job men, glaziers, itin-erant plumbers, menders of crockery or shoes; sellers of licorice water and lemon juice, of herbs, of baskets, umbrellas, shoelaces, chickweed, and whips; puppet shows, street singers, somnambulists, dogs that played dom-inoes, Scottish jugglers, baton twirlers, savages with stones round their necks, India-rubber men, and human skeletons.[71] "Sellers of ink, fish, po-tatoes by the bushel, peat, birdseed; chimneysweeps, saltimbanques, char-latans, stone breakers, open-air jewellers, sixpenny stall holders; all of them shouting, singing, modulating their apostrophes and descanting their son-orous invitations on the scale that most sets one's teeth on edge."[72]

These people—how the journalists vied for the longest, most unlikely, most indisputable list of them!—were the signs that all was well with a neighbourhood. They provided entertainment, but not simply that: the services and information they offered formed part of the pattern of trade on which the *quartier*'s economic life depended; they connected in various ways to the life indoors, to the workshops and covered markets, the shops and *salles de réunion*, the bars and arcades where men with a trade swapped gossip and sought work.

Paris in 1870, for all Haussmann's alterations, was still overwhelmingly working-class.[73] In the census of 1866 almost three men in five were listed as making their living from "industry," and only one in ten from "com-merce." The terms were vague and capacious, but by and large "industry" still meant the activity of artisans rather than factory workers. It was something done in forges and workshops with crews of half a dozen men, in back yards of tenements or front parlours where seamstresses kept their newfangled sewing machines. The types of work most commonly pursued in Paris seemed on the surface not to have changed in the course of a century or more: the licensing rolls were full of printers and tailors, hosiers, glass cutters, tinsmiths, gunsmiths, brewers, *bronziers*, bakers of bread and cakes, confectioners and *charcutiers*, carpenters and joiners, metalworkers, tanners, glovers and saddlers, cabinetmakers, bookbinders, shoemakers and *ciseleurs d'art*. These were all apparently traditional trades: the names were the same, roughly, as in 1750 or 1650, while the size of the smithy or the builder's gang had hardly altered, and had sometimes grown smaller.[74] The owner was often and rightly called an "ouvrier-patron." He lent a hand on the workshop floor; he had made his way by effort and dexterity; the pomp and companionship of shared skill were omnipresent, in the way work was discussed and divided or the way a "man" regarded a "master."[75]

The context of industry was the *quartier*. This did not mean, and had never meant, that the neighbourhood was a closed and self-sufficient unit; for what were those people performing in the streets, if not comers and goers from the outside world? But there were matters—on the whole the most important ones—that depended on the *quartier*'s being close-knit, separate, and intimately known. Workshops were small: the same item, be it a cupboard, a shoe, or a stove, was produced in hundreds of different places; and therefore it made sense for those shops to be only a stone's throw apart, so that raw materials could be swapped and traded, prices fixed, and the state of the market discussed in the local wineshop.[76] Business and sociability were bound together. There were kinds of prestige and ingenuity in trade which came, and could only come, from belonging to a single family of streets—and they were the things, very often, that made the difference between an enterprise's surviving or going under: a long-standing deal with a supplier who knew one well enough to help out in the slack season; a network of arrangements with particular odd-job men, itinerant plumbers, coal merchants, and stall holders; a confidence that one's name would be thought of first when it came to that special brand of chair leg or ball bearing.

Each *quartier* had its own shopkeepers and *négociants*, who gave it the access it needed to Paris and the world beyond: they brought in the stuffs and staples from Les Halles, they knew how to talk to the bank and how best to strike a bargain with Monsieur Cail's or Monsieur Say's agents; they were the bourgeois of the neighbourhood, and recognized as such. But that very bourgeoisie derived from their being almost as much a part of the *quartier* as the "ouvrier-patron": a wholesaler's business most often hinged on his local expertise and reputation, and he had to keep up his credit in the street, be able to tell good from bad payers, know how the haggling conventions changed from one side of the Rue Saint-Paul to the other. Of course he attempted at the same time to stand apart from the streets he belonged to: he feared riot and unruliness, and in time of dearth the grocer's shop on the corner must often have been a tense and uncharitable fortress. The bourgeois knew that his credit depended on difference, and his greatest effort was often invested in the fight to keep up appearances and insist on a measure of respect. Yet even these things— the actual day-to-day negotiation of class distinction and authority—were done in the *quartier* and meant nothing apart from its special pattern of work and knowledge.

If the rumours from the 1860s were right, and Haussmann had intended his embellishments to empty these *quartiers* of their working population, then all the figures suggest that he failed.[77] Rents went up inexorably and

the workers complained; but more often than not they hung on to the places where skills were learnt and markets were certain. They stayed because it seemed they had no choice. A tailor was lost without his old clients, those who knew him well and told their friends what he could do with a second-hand suit; a housepainter had to be within walking distance of the Place de Grève, where contractors gave out work each morning; a maker of artificial flowers (not an inconsiderable trade in the 1860s) stuck close to her favourite dealers, for how was one supposed to do the job in Belleville when everything turned on the rush order, the altered deadline, and the new rate agreed upon face to face?[78] By the end of the decade the ancient *quartiers* were bulging at the seams with people: the houses left over from the demolitions had been divided and subdivided; workshop and shopfront were squeezed closer together, and somehow the tailor and the flower girl had found room to stay on. In 1870 there were more workshops than ever before in central Paris, and probably as many inhabitants. It seemed as though the drift to the edge of the city—and there *was* a drift, Lazare had proved it was happening—was no more than accompaniment to a fierce resistance on the part of the working class to any displacement from its old ground. In terms of numbers, the industries of Paris were still in their neighbourhoods, as strong as ever.

Nonetheless these appearances are not to be trusted, and other contradictory signs should be adduced straight away—strikes, for example, and trade unions. The International Working Men's Association, whose most effective French militant was a bookbinder named Eugène Varlin, was recruiting in the Paris trades—so successfully that in 1870 the empire was obliged to haul its leadership through the courts on charges of subversion.[79] Men with skills were among the first to unionize: compositors and *bronziers* alongside mechanics and iron founders. There was a wave of strikes in Paris in 1864 and 1865, and a bigger one beginning in 1867. In 1865 Haussmann's rebuilding itself was stopped for a month by a strike of stonecutters asking for 6 francs 50 an hour (they went back to work without it).[80] At the end of the decade, the bitterest and largest strikes of all were of marble workers and gilders of wood, shop assistants, iron founders, and tanners of white leather.

These were the most dramatic outward signs that the world of traditional industry in Paris was changing. The *quartier* was still there, with its masons' yards and forges in place, but it was less and less the real frame of reference for the work and trade which went on inside its boundaries: the lines that had led from the foundry, say, to the moneylender three streets away, and on to the local dealer in scrap metal and the jobbing plumber or the *marchand de robinets*—these lines were breaking down, or no longer pro-

vided enough work on their own for the foundry to survive.[81] Year by year, industry was increasingly a Parisian matter, done citywide; and that in turn meant it was more visibly and insistently capitalist: it dealt in bigger markets and tighter margins of profit and loss; its dealings were impersonal, or seemed so in contrast to the *quartier* economy; effective ownership and control were in the hands of fewer and fewer men; the lines of command in the labour process were complex and often indecipherable, and the business of work was broken into smaller parts, each of them easier to learn and to mechanize.

When men discussed these matters in the 1860s, they often put the blame on two things: Haussmannization and the *grands magasins*. In a sense they were right. The rebuilding of Paris had proved to be a great industry in itself, the city's biggest and most profitable; it drained off labour from the *quartiers* and had strange effects on wages in general; it fostered whole new kinds of work and put paid to others, making the fortunes of scrap merchants and manufacturers of tar macadam, and breaking those of water carriers and men with property in the wrong place. Yet the industry of rebuilding was nothing on its own: it was meant to be the emblem and agent of a wider economic transformation, and to a great extent it was. This theme was dear to Haussmann's heart and his speeches were full of it: his boulevards and sewers had been laid down as humble servants to industry and trade. The straight lines to the railway stations were meant to express the fact that Paris was henceforth part of a national and international economy; the annexation of the *banlieue* was done to direct modern industry to its rightful place—at the edge of the city and out of sight, but tied in to the stock market and department stores by tree-lined streets and suburban railways.

Haussmann *homogenized* the business of the city. The best symbol of that is the list of omnibus companies that closed down in the 1850s and the names of the firms which replaced them. Gone were the liveries of the Orléanaises and the Hirondelles, the Diligentes, Constantines, Favorites, Montrougiennes, Parisiennes, Dames-réunies, Béarnaises, Citadines, Excellentes, and Batignollaises: in their place the dry equipment of the Compagnie Générale, and the sole rival line, which belonged to Piétri—already the owner of the Compagnie Parisienne d'Eclairage![82] The example is not simply symbolic, for the new buses and identical gas lights were in themselves not a negligible part of the unity—the uninterrupted field for free enterprise—which Haussmann wanted so much. The dealers and *négociants* had access now to the hinterland of Paris, to Grenelle and Batignolles; and on to La Villette, with its new landscape of soapworks and candle factories, its fifteen timberyards and seven salt refineries, its forge which

burnt ten million tons of coal per year, its chemical works, distilleries, and saltworks, its perfume makers and glass blowers, its factories for beer, grand pianos, matches, enamel, freight cars, boneblack, and metal pens.[83]

The shape and pace of production was changing; that much was a commonplace of the time. It was a matter of choice—or perhaps sometimes of experience—whether one stressed in the 1860s the positive or the negative in the new situation: the ruinous effects of the trade treaties and foreign competition, or the marvels in the shopwindows of La Samaritaine; the volume of production, or the shoddiness of the goods; the self-made men, or the bankrupts.

Shopwindows, shoddy goods, and bankruptcy: it regularly came down to these. For an ordinarily gloomy businessman in 1870 they were signs of a new order—the order of the Bon Marché and the Bazar de l'Hôtel de Ville.[84] Genevoix, for instance, knew very well what that system signified:

I know about them, your fashionable shops! Everything done for the sake of display! Ostentation! Instead of high-grade materials, solid and harmonious but costly, your shopwindow will little by little fill up with dubious chiffons—flashy, tasteless, and cheap. Till we arrive at a great music hall of glittering shops, all doing tremendous crooked business, no doubt! . . . but with less profits than in districts like ours, and above all less honour!—For after all, it is something to sell merchandise that is good and sound! and to say to oneself each night at bedtime: "I have got richer, and it wasn't to anyone's detriment!"[85]

I may be forced in what follows to water down Genevoix's rhetoric a little, but I want to persuade the reader of its general sense; for it was certainly true that the *grands magasins* were the signs—the instruments—of one form of capital's replacing another; and in that they obeyed the general logic of Haussmannization. Were they not built (the voice is approximately Genevoix's again, but it could as well be Lazare's or Gambetta's) with profits derived from the new boulevards and property speculation? Were not the Pereires behind them? Had they not usurped the city's best spaces, lining the Rue de Rivoli, facing the barracks across the Place du Château d'Eau and hemming in the Opéra? Did they not depend, with windows all hissing with gas till well past nightfall—till ten o'clock in some cases—on the baron's policemen,[86] his buses and trains, his wide sidewalks, and his passion for "circulation"?

The stores were everything the opposition came to hate and blame on empire. They were the ruin of the small man. They appeared to grow fat on a diet of merger, speculation, and sudden collapse, and in 1870 it was far from clear that these erratic movements of capital had ceased. (The year before, two of the biggest shops in town, the Diable Boiteux and the

Fille Mal Gardée, had combined to form one still larger called La Sa-
maritaine.[87]) The stores were bureaucracies, and the clerks and sales assistants
employed in them were no doubt a shiftless and untrustworthy lot: in 1869
they went on strike, demanding a twelve-hour day and holidays on Sundays.
Varlin himself exulted at the sight of old divisions ending "which had up
to now made workers and shop assistants two different classes."[88] The strike
was broken and the counter-jumpers went back to work on worse terms
than before, but the very fact of the struggle confirmed the worse fears of
honest republicans.

The *grands magasins des nouveautés* depended, as their name was meant
to imply, on buying and selling at speed and in volume. They vied with
one another for a multiplicity of lines and "confections"; their shelves were
cleared from month to month; they staked everything on fixed prices, low
mark-up, and high turnover of stock. They boasted of their ability to
mobilize provincial workshops and call on commodities from England,
Egypt, or Kashmir. The stores, one might say, put an end to the *privacy*
of consumption: they took the commodity out of the *quartier* and made
its purchase a matter of more or less impersonal skill.[89] (No more negotiation
face to face, no more pretence of putting one's reputation in jeopardy each
time one bought a bolt of worsted or a new frying pan!) The great floors
of the Grands Magasins du Louvre were a space any bourgeois could reach
and enter, and many did so for fun. They were a kind of open stage on
which the shopper strode purposefully and the commodity prompted; they
invited the consumer to relish her own expertise and keep it quiet—not
to bargain but to look for bargains, not to have a dress cut out to size but
to choose the one which was somehow "just right" from the fifty-four
crinolines on show.[90]

The effect of these shops on the *quartier* economy was drastic. By the
middle of the 1860s much of the pattern of trade in Paris was organized
around them. Their agents came into the *quartiers* with orders written out
in hundreds and thousands. They were looking for the kind of goods
which it seemed only the artisan workshop could deliver: kitchenware
with a hand finish, a well-turned chest of drawers, or the right twist of
ribbon on the season's hats. But they made it clear that skill alone would
not guarantee the workshop the job. There were ways to economize on
skill or do without it, or buy it cheap elsewhere: an agent nowadays could
range far afield for the products he wanted, and in particular he could go
to the provinces if need be, or to the factories at La Villette. The atelier
most often got the contract in the end, but not before the master and men
had agreed to work precisely to the agent's stipulations, however offensive
these might be. They had to produce the goods post haste and in quantity.

Sometimes the middleman insisted on buying the raw materials himself, and sometimes he set an overall price for the job which forced the workshop to cut costs; in any case, the artisans learnt to use cheaper iron or flimsier paper, and care less for the lasting quality of the result.[91] They worked longer hours and had precious little time to recuperate between jobs: the old regime of breaks and holidays was falling out of favour and the master was more of a stickler for discipline on the workshop floor. The day of rest on *saint lundi* was fast becoming a sign of recalcitrance or disaffection: to keep it too often was to run the risk of being laid off or sent packing.[92]

The nature of the job itself was changing. It made no sense in these new conditions—working against time with shabby materials always deteriorating—for work to be shared out in the old way. The tasks were better broken down into separate stages, and each worker was obliged to make one of them his specialty: he learnt and repeated a single pattern of hammer blows on a skillet or a gun barrel, he knew the glues for a certain kind of joint, he handled that stitch, that binding, that type of burnish.[93] The master was obliged in times like these to take in work from other shops, and the agent came down with "finishing" work from the suburbs. What that meant for the workman was a few touches of the file on confections ready for sale, but needing the artisan's (forged) signature. The agent proposed new tools and techniques, and pressed for their adoption: he offered to lend money to buy a steam press or a mechanical saw, to introduce standard rivets or convert to chemical dyes. The *marchand* and the subcontractor arrived with promises of bigger advances and higher profits still, if the workshop would make things faster and more shoddily, and consent to be specialists in a single "line." The outcome of that logic— it was one easily reached in the last years of the 1860s—was for the workshop to break up altogether and the agent to deal with a hundred different workers, each with a lathe or a sewing machine at home. That way the agent saved on rent and fuel, and the seamstress was left to bargain direct with capital for her chiffon and cotton reels; in return she was told— the agent showed her—what kind of stitching was all the rage that winter, what shape of bustle, what length of hem.

These were the changes, I believe, that underlay the debate about Haussmannization. They can be seen refracted and displaced in all the main images of the city which were current in the 1860s. To call the new city something made by speculators and monopolists, to say the street was ending as a form of life, to talk of the *quartier* as desolate, of a working class hounded from its old places, of a Paris where two great classes had

been separated out on the map—all these were figures, to some extent appropriate ones, of the process I have just spelled out. If I had to sum up these changes in a single phrase I should not hesitate to say, following Genevoix again, that one kind of capitalism was being superseded by another. The spokesmen of the 1860s regularly said something similar, and not just in monologues at the vaudeville, but in the Assembly or *La Revue Contemporaine*. The best way they had of saying it was to blame the city itself for the transformation. They made the city into Capital: it was as if they wanted the whole texture of dispossession, effacement, and interference—the texture I have just described—to be out there on the map, in the form of ashlar and tar macadam. They were doing the same as Zola's Gervaise in *L'Assommoir*, when she wanders the avenues in the final stages of her misery, looks about for an image of her own dissolution, and finds it in the avenues themselves—the new boulevards Magenta and Ornano, breaking through the old *barrière* Poissonière:

Gervaise in her turn was angry at these embellishments, which disturbed the dark corner of the *faubourg* she was accustomed to. Her anger came precisely from the fact that the *quartier* was being embellished just as she herself was on the road to ruin. . . .

This *quartier* where now she felt ashamed, there were so many improvements, was opening up on all sides and letting in the air. The Boulevard Magenta, coming up from the heart of Paris, and the Boulevard Ornano, going off into the countryside, had broken through the ancient *barrière*, the proud old barricade of houses, two vast avenues still white with plaster; the old Rue du Faubourg-Poissonnière and the Rue des Poissonniers ran into them, losing their way, broken and mutilated, as ugly and dark as alleyways. For some time now, since the demolition of the customs wall, the outer boulevards had been widened, with a street at each side and a strip of land in the middle for pedestrians, planted out with four lines of little plane trees. It was all one immense crossroads, with its arms stretching out to the horizon along endless thoroughfares, swarming with people, drowned in a chaos of ruins and new construction. But in among the new houses there was many a tumbledown old hovel still standing; between the sculptured façades there were deep pools of black shadow, gaping slums with rags pinned up at their windows. Underneath the rising tide of luxury from Paris, there was the misery of the *faubourg*, spoiling and befouling this new city in the making, put up in such haste.

Lost in the bustle on the wide footpath alongside the little plane trees, Gervaise felt alone and abandoned. And the open spaces of those avenues stretching away down there made her stomach turn; and to think that in all this flood of people, where there must be so many who were well off, there wasn't a single Christian soul to understand her and slip her a ten-sou piece! Yes, it was too big, it was too beautiful; her head was spinning and her legs were giving way, under this endless surface of grey sky stretched out over such a vast space. The dusk had

that dirty yellow colour of Parisian dusks, a colour which makes you want to die straight off, the life of the streets seems so ugly.[94]

I do not mean to say, finally, that Gervaise and Genevoix were simply wrong to put the blame on Haussmannization. The spaces did appear to swallow up the old signs of life, and the streets to go on for ever with their plane trees. A case could be made against the baron's embellishments, even the strict case that they were the essential form of capitalism in the mid-nineteenth century. It is certain that class had never been inscribed so clearly, so consistently, on acre after acre of the city's space; and rarely had a city been given over to the speculators with such aplomb. In general, it is true that Haussmann's Paris was not a neutral form in which capitalism incidentally happened: it was a form of capital itself, and one of the most effective.[95] Cities were among the best investments available, at least on Baron Haussmann's terms; and from the mass of profits made round the Place de l'Alma and the Rue de Turin came capital to fund new mills in La Villette or to float the issue for La Samaritaine.

All the same, the enemies of Haussmannization meant more and less than this. They had no very precise notion of how the baron's work belonged to capitalism, and they did not interest themselves overmuch in its financial logic—beyond accusations of secrecy and waste. What was vivid with them was the sense of some kind of life which Haussmannization had destroyed. They said they had lost the city, that it had been taken from them. That was their way of saying that capital had invaded and broken the *quartier* economy; that it had become a separate, insistent force inside the world of work, and that what it destroyed was a form of life which had previously *been* Paris, for most of the city's inhabitants.

They said that the city was segregated along class lines; but even that image gained its force from the way it represented and displaced a pattern of class conflict which happened—with increasing intensity as the 1860s drew to an end—*inside* the *quartier*. The strikes and trade unions were the signs of that disorder; they pointed to the way in which the old arrangements and relations between social groups—between shopkeeper and artisan, master and employee, workshop and *négociant*—were changing for the worse. Those arrangements had been in the first place economic, but on them had depended notions of social place and personal identity, and ways of dealing with the detail of everyday life. When writers described the *quartier* as inanimate or empty, it was surely this they were trying to express: that the life in the streets and wineshops of the Faubourg Saint-Antoine had previously been built round distinctions secured, if anywhere, in the process of work; that it was there the peculiar, unhappy claim to bourgeoisie was asserted, and the fabric of accomplishments which made

one man a master and meant another stayed an *ouvrier*. The detail of everyday life had derived from the categories of class; if those categories were now obscure or debatable, or had somehow escaped altogether from the frame of the *quartier*, then there simply was no everyday life remaining—or none with a density deserving the name.

Those who looked back to the life of the *quartier* were fond of calling it the real Paris, which a false one was destroying. Of course their descriptions were formulaic: the appeals to the Paris of 1830 and the world of Balzac and Monsieur Prudhomme became in time as tiresome as the baron's hacks' exulting at modernity. The squalor and smallness of the *quartier* kept appearing round the edges of the myth. Yet the myth was a means of resisting a fantasy which on the whole was worse. Those six-storey houses "sculpted like churches,"⁹⁶ that "CITÉ NEUTRE des peuples civilisés," those shopwindows and policemen and identical benches: they were not Paris. They were something else: an image put in place of a city which had lost its own means of representation.

What that replacing image looked like is suggested well by Manet's painting of the empire's *Exposition Universelle de 1867* (Plate IV). The exhibition's assorted halls and towers are put down in summary notation in the painting's middle distance on the Champ de Mars, and the viewer looks across to them, or up at a tethered balloon in the sky, from the summit of a convenient nearby hill, the Butte de Chaillot. In the foreground, seemingly below us, are a strip of lawn, a flower bed, and a gardener in a straw hat with a hose; a path along which a dandified small boy is being pulled by a dog; a woman on horseback; soldiers standing or sitting on the grass; tourists; a man with binoculars surveying the view; ladies in assorted sizes; and a glimpse of the river at the left, with a crush of people crossing a bridge and a steamboat beside them disgorging still more.

This is all Haussmann's doing, of course: it is how the imperial city was supposed to present itself that year. (The exhibition was, while it lasted, a popular invention, at least with the middle classes. Reports agreed that the war scares and general despondency of the spring abated in the summer months while the show was on, though they revived soon enough when it was over.⁹⁷) Three months before, the exhibition organizers had decided that the Butte de Chaillot was "irregular" and wild, and that therefore the view across the river from the exhibition grounds lacked harmony. They ordered the baron to lower the hill by twenty feet or so and make its profile less untidy.⁹⁸ It was a large demand to make with so little time

left before the emperor was to cut the scarlet ribbon. Haussmann brought in squads of navvies and paid them to work under arc lights through the night; he built a special railway line to cart off the rubble, and used two hundred cars and half a dozen locomotives for the job. The operation attracted sightseers in its own right, and was duly mentioned in *Le Magasin Pittoresque*: "On one side of the river a swarming mass of men, all bent over and armed with picks, was digging trenches and levelling a mountain; on the other was the Champ de Mars, invaded by thousands more workers. . . ."[99] So the hill in the foreground of Manet's painting was built specifically to be regular and provide a view. It was finished just in time, and no doubt the geraniums are doing well under the gardener's watchful eye.

I want to sound a comic note somehow, because it seems to me that that is partly what the picture is doing, with its fat ladies, silhouettes of soldiers, and stray balloons. Its subject is festive and topical—the city containing the world. People are taking their ease on top of the hill, enjoying the exhibition and making sure their enjoyment is noticed; gaping, strolling, sprawling on makeshift grass, pointing things out to one another with umbrellas, looking well on a horse, showing off pets and wearing (they hope) outlandish shades of yellow. This is a comedy of sorts: a picture of people and things in fashion, of crowds crossing bridges in search of the universal, of the power of binoculars and the size of bows. It is a parade of "types" on a suitable stage. The lawns and flower beds may have been planted somewhat hastily, but at least they are not scheduled for dismantling in the fall; most of the picture's middle ground, on the other hand, was not intended to outlast the festivities; the actors move about in front of it as if it were all painted, and what they are pointing to with their umbrellas is no more than a plausible likeness, rattling a bit in the wind— but whose freedom of handling they choose to admire. (No one exactly *believes* in an exhibition, at least not in its claims to represent the world. And yet the illusion is often effective and fetching, the suspension of disbelief quite possible for an afternoon. Some such attitude seems to apply here, not just to the exhibition but to Paris and Parisians in general.)

There are clearly rather different kinds of comedy mixed up in this occasion, and the way they fit together or fail to is the picture's sharpest subject. We are expected to enjoy the gallery of tourists and *cocottes*, and register the details of class, profession, and up-to-dateness. But what is comic in the painting exceeds that pantomime, and has to do with what these figures are engaged in and how it relates to the painter's presentation of the scene. The comedy quite often comes from the business of seeing itself, in its various aspects: not just how people look as they look at the view, but what that looking consists of—the artifice involved in having a

city thus available to vision, focussed and framed as a unity for the man
with binoculars:

> *Meantime you gain the height, from whose fair brow*
> *The bursting prospect spreads immense around.*[100]

The man with binoculars abstracts and selects with his small machine; the
painter gains some further height, outside the scene itself (hovering above
it, apparently), and puts the bursting prospect into order.

The city does look well from here; that lost twenty feet makes all the
difference. Yet its looking well, as we have seen, is a fragile achievement
on the empire's part, something put together in the nick of time. The
painting itself—in its general makeup and handling—provides a kind of
equivalent for that fact. It is a large-scale piece of work, over six feet wide
and three feet high, but—uniquely, I think, for a painting this size by
Manet—it is quite insistently *sketchy*. The sketch may be improbably big
and overfull of matter, but it pretends all the same to be not quite a picture,
not quite finished. The paint is put on in discriminate, sparse patches which
show off their abbreviation—puffs of smoke eat into the dome of Les
Invalides, streamers and flags blend with the foliage, the shape of a dog
is left shadowed and blurred, water hisses from the gardener's hosepipe
in neat, dry strokes of colour (as if the hose were the handle of a giant
paintbrush), and the hooves of the Amazon's horse are moving just too
fast for us to see them. There is even a passage at the left-hand side,
between the geraniums and the river, where abbreviation frankly becomes
absence of sense, and a sequence of scratchy blue-grey strokes on primed
canvas fails to become an image, however hard the viewer tries to make
it one.

The picture presented of Paris is approximate, therefore, but not vague.
The strollers on the hill would not settle for vagueness; their minimum
requirement is that Paris have landmarks and offer up, as cities ought to,
some definite and reassuring points of reference—social as well as topo-
graphic. Part of the pleasure in taking a walk is to be reminded, in the
course of it, of what it means to be Parisian—to see other Parisians and
be able to spot their type. These people want the Paris that goes with such
transparent citizens; they want it spread out in front of them, a stone's
throw away, like a gas-lit picture in a diorama.

And so it is in Manet's painting. The types in the park are drawn for
easy reading and do not seem to detain one another's attention too long;
they are spiky, dapper, and articulate, picked out on a neutral ground,
floating past one another slightly out of scale. The city beyond is these
persons' property; the distance between the hilltop and the view is simply

declared not to exist or not to matter: it is a part of the image that does not interest the painter or the pedestrians. The path in the foreground supports its dogs and horses, and then grows tenuous—it peters out into the river at the left and is last seen sliding unresistant through the Pont de l'Alma. The great open space which lies between the Butte de Chaillot and the Champ de Mars—the Seine itself, and the long hinterland leading down to the Pont d'Iéna—is hidden behind the brow of the hill. The grass ends sharply, with soldiers, children, and horses silhouetted along its edge; behind them the exhibition begins, equally brightly; the one world passes into the other without a break. There is a glimpse of the Pont d'Iéna, in fact, on either side of the man with binoculars and his companion: two unmodulated patches of grey, and some dashes and squiggles which stand for the bridge's equestrian statues on their plinths. These are the strongest indices of a middle ground that the viewer is provided. They are too few and too cryptic, and even when—or if—they are recognized for what they are, they do not make the exhibition seem farther off. The towers and pavilions still overlap the bridge, and the distant flags and foliage blend in with Antoine-Auguste Préault's *Gallic Horseman*, perched there at the picture's centre as a noble (and illegible) reminder of the republic.[101] These things are all part of the same disembodied flat show, the same spectacle.

What is meant by the word "spectacle" should be coming into focus by now. Part of its meaning is obvious: it points to the ways in which the city (and social life in general) was presented as a unity in the later nineteenth century, as a separate something made to be looked at—an image, a pantomime, a panorama. But this should straightaway be qualified if we wish to prevent the notion of spectacle from declining into a half-baked means of "understanding media" or anathematizing the society of leisure. To call the city "spectacular" is not to describe it as possessing or improvising entertainments, as all cities do, or even to be impressed unduly by its electing times and places for the fashionable to congregate and eye one another. These things can be done—and still were in the 1860s—as *part* of a city's more substantial life; they can derive what intensity they have from the crush of signs, the exchange of signals, in a special overcrowded space. When a city has a public life in this sense—it is regularly organized around entertainments—what mostly impresses the observer is the sheer density of signals conveyed and understood, and the highly coded nature of the conveyance. Public life of this kind is both elliptical and formalized, and also risky: it involves contact and transaction, contests of nuance and misreading, the kind Proust chronicled in his surviving "society." Everything depends on the lady and gentleman's skill with the signs of class, sex, age, and individual character; there is no surer path to ridicule or

oblivion than not to understand, in such places, the way these previous kinds of belonging inflect the comedy of manners.

The behaviour that derives from such dealings can be odious or grand (and surely Proust's description does not incline one to enthusiasm over its normal achievements), but it cannot be called "spectacular" because social identities are still a matter for complex negotiation in the public realm. The essential separation of public life from private, and the thorough invasion of both by capital, has not yet been effected. The public idiom is not standardized satisfactorily, not yet available to anyone with the price of a newspaper or this season's hat. In this sense the 1860s are notably an epoch of transition. The great categories of collective life—for instance, class, city, neighbourhood, sex, nation, place on the "occupational ladder"— have not yet been made over into commodity form, though the effort to do so is impressive. And therefore the spectacle is disorganized, almost hybrid: it is too often mixed up with older, more particular forms of sociability and too likely to collapse back into them. It lacks its own machinery; its structures look flimsy alongside the orders and means of representation they are trying to replace.

This seems to me the implication of Manet's earlier picture of public gathering, *La Musique aux Tuileries*, most likely painted in 1862 (Plate V).[102] If we put this curious half-miniature alongside *L'Exposition Universelle*— it is just over half the later picture's size—it will appear, in what it shows and how it shows it, to be strikingly the opposite of its companion: hardly a picture of modernity at all, as it is sometimes supposed to be, but, rather, a description of "society's" resilience in the face of empire.

The public realm in the Jardin des Tuileries is still narrow and definite, composed of particular portraits, professions, and uniforms. It is a realm in which one recognizes friends and relations, and knows precisely how they would wish to be shown. Such knowledge depends in turn on the great protocols of class, which everyone here obeys scrupulously; and it is class itself—the pure category, the disembodied order of appearances— which ends up invading every square inch between the trees. The music is pretext for this more serious counterpoint: the raising of hats, the lifting of veils (if one is a young lady) and the lowering of them (if one is not), the minding of children, the exchange of literary judgements, the saying hello to one's aunt.

Likewise the lithograph entitled *Le Ballon*, done the same year and showing another part of the same park. The distractions in this case are more obtrusive than music from a bandstand, but even so, what matters— what the painter takes as the subject to be faced—is less the balloon and the puppet shows than the greasy press of people in the foreground, lined

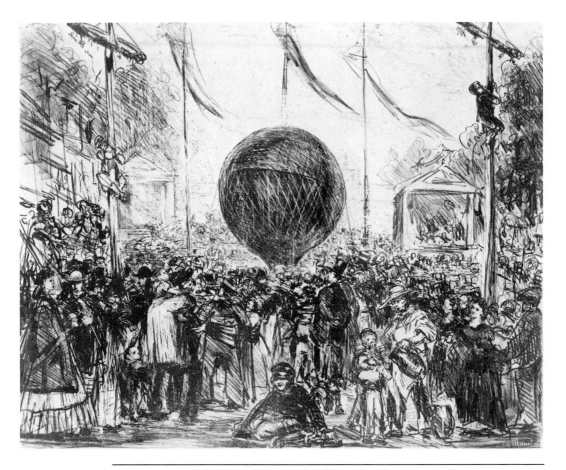

16. Edouard Manet, *Le Ballon*, 1862. Lithograph.

up across the narrow stage, usurping it, embarrassing the spectacle behind—ladies in crinolines having to come in contact with legless beggarboys on trolleys.

 In the picture of the exposition, by contrast, there is no embarrassment because there is no contact; that is what makes it modern. The crowd is thinned out into individual, slightly vulgar (or slightly elegant) consumers; the marks of class and sex and so forth are broadly handled, and meant as amusement. Everything is held in place by mere vision and design, as opposed to the actual, stifling crush among the iron chairs in the Tuileries—those people obliged to touch one another and recoil, listening, jostling, being polite, pushing their trolleys, making mud pies out of the real earth, taking frightened little ones on their knees, selling lemonade, and climbing flagpoles—as much for the fun of it as for a better view of the balloonist.

That list of activities amounts, as Manet's images do, to a description of a *crowd*: it suggests the way its view of things is necessarily bound up with other kinds of interest and behaviour. The view in *L'Exposition Universelle*, we could almost say, might as well be the balloonist's: does not the neat hypotenuse of his guy rope serve to tie down the image as a whole, and is he not seated in a gondola which looks on second glance like nothing so much as a giant camera, swinging full circle over the Champ de Mars—giving back the gaze of the man with binoculars? The balloon in both cases most probably belonged to the photographer Nadar. Thus the conceit could be pursued one step further, bearing in mind that photograph and spectacle go together (though the one does not amount to the other). It is as if Manet's lithograph is out to show us everything that is supposed not to register on the photographer's plate—the press of relations and identities that cannot be stopped by a shutter (that cannot simply be "seen"); and as if *L'Exposition Universelle* concedes on the contrary that a city exists—it may be temporary, it may be here to stay—which the camera can show quite adequately. There are parts of Paris in which it appears that there *are* no relations, only images arranged in their place.

What is it I have been trying to establish in this chapter so far? Two things, essentially, which may seem on the surface not to go together well, and perhaps even seem to contradict each other. First, that ever since 1830, and undoubtedly before, men and women had believed that their Paris was disappearing and a new one springing up complete upon its ruins; and that that belief is best understood as a fantasy, almost a wish fulfilment, for all it was accompanied very often by anxiety or fear. What is fantastic in this case is not the consciousness of change, or even the sense that some fabric of social practice which had previously constituted Paris was unravelling or wearing thin. It is the wish to *visualize* that process, and have the modern city be an image. But, second, I have argued that Haussmann's work for the most part colluded in that fantasy or tried to. Part of Haussmann's purpose was to give modernity a shape, and he seemed at the time to have a measure of success in doing so: he built a set of forms in which the city appeared to be visible, even intelligible: Paris, to repeat the formula, was becoming a spectacle.

The phrase would not have seemed outlandish to newspaper readers in the 1860s, for formulas quite like it were applied at every turn. Paris was *parade*, phantasmagoria, dream, dumbshow, mirage, masquerade. Traditional ironies at the expense of metropolis mingled with new metaphors of specifically visual untruth. They were intended to stress the sheer os-

tentation and flimsiness of the new streets and apartment blocks, and beyond that to indicate the more and more intrusive machinery of illusion built into the city and determining its use. Exhibitions were the great sign of that development, along with *grands magasins*; restaurants spilling out onto the sidewalks and posting their menus for passers-by to read; parks planted with pampas grass and tobacco, giant-leaved plants which looked well from a distance across the *pelouse interdite*;[103] 30,000 billiard tables in 12, 543 cafés.[104] "When a man has the spleen, in no matter what language, it is here he comes to make his peace with existence,"[105] and the peace consisted most often of looking and strolling. Contemporaries could be acerbic about such matters. Victor Fournel, for example, took a turn in the new Bois de Boulogne and allowed this much homage to the gardener:

> . . . he has often imitated nature very well. It is almost a good likeness. . . . One comes across notaries posed like exclamation marks at every corner, and photographers recording the view. . . . And all of this, moreover, is topped off with painted boats, neat little bridges, chalets, kiosks, café-restaurants, and other objects nature does not provide.[106]

The Goncourts described the change in characteristic fashion:

> The whole revolution in the streets of Paris is indicated well by the transition from the Taverne de Lucas to the Taverne de Peters. One of them used to be, and the other now is, the place Parisians dine out. Well! The Parisian of twenty years ago, the man about town, unmarried and not particularly rich, interested in everything, keen on taking part, the man who went to Lucas's—he was an artist, a senior civil servant, an officer, a bourgeois, a sporting gentleman with an income of six thousand pounds. Nowadays at Peters's, the Parisian diner is almost always a stock-exchange speculator or photographer.[107]

Paul de Kock in 1867 described the city as having built itself a whole new centre—an "equator" populated by consumers, shop assistants, and bureaucrats.[108] Those workers who christened the boulevards "the shores of the New World"—the phrase crops up in the pages of Denis Poulot[109]—were presumably meaning much the same thing.

Once again I should like to separate out two elements from the list of charges: First, the fact that the critics so often seized on the idea that Paris was no longer *plural*, something produced in a series of neighbourhoods, made and remade in social practice, but instead had become a single, separate entity, passively consumed.[110] And second, the way they assumed that entity to be visual, an appearance of some sort standing at an indeterminate distance from the exclaiming notary and the patient photographer.

I have tried in this chapter to strike a balance between an awareness that claims like these are themselves images, attempts at representation,

and a wish to avoid simply looking through them, once they are recognized as such, in search of some other (founding) reality. I shall try to do that once more by way of conclusion. These claims are images, by means of which it was suggested that everyday life was being robbed in the 1860s of its established forms, that it had less and less of an order and substance of its own, and therefore less resistance to those forces which bound it to the market.[111] The laws of motion within that market were clear to anyone acquainted with the *grands magasins* and the great exhibitions. Their logic was expansive and inclusive, and seemed to say that nothing much could be allowed to exist apart from capital—certainly not the motives and appearances of people in their daily, humdrum production of themselves. People must have their forms and values provided for them, manufactured elsewhere, and sold at a steady rate and a rising price. There must *be* no everyday life any longer; or, rather, that life must be made a matter of consumption as opposed to "industry"—this last word understood in the peculiar, extended sense of the 1866 census takers.

To picture the process in these terms is once again to imagine it completed—putting an end, as it were, to social practice. There was no such apocalypse in the 1860s: the processes in question were barely beginning. The working class, for example, was starting to imitate the bourgeoisie in the way it organized its meals, but much less so in the way it dressed.[112] Those workers who ventured onto the "shores of the New World" were impressed by what Gaillard calls, with good reason, the "spectacle des nourritures"[113] provoked by Haussmann's rebuilding—the *prix fixe* menus in the streets, the sight of people sitting on the sidewalk eating their separate courses. It had never been clear before how the bourgeois dined, and now it was, the whole thing seemed worth imitating; slowly, at much the same rate as meat and greens grew dearer, the working-class housewife tried to adapt her mealtimes to those in evidence on the boulevard. But the same woman did not shop for clothes or kitchenware at the Bon Marché: the prices there were simply beyond her reach, and the kinds of commodities designed for a different clientele. Likewise, the working class was only partially captivated by the great exhibitions. The workers at Cail's demanded and were given the day off to see the phantasmagoria of machines; but the reports of the various trades, drafted as part of the exhibition's official literature, were thoroughly sceptical of the same spectacle, and rightly doubted its relevance to problems in the workplace.[114]

These kinds of resistance and disparity could be duplicated in every sphere of social life in the decade: the history of Haussmannization is quite largely one of incompleteness, opposition, and simple refusal to move. The Commune suggests the degree of recalcitrance, on the part

of Parisians, at having Paris provided in doses by the powers that be.

Yet the Commune was defeated, and the images of the commentators—all that emptiness and uniformity, that dying of the street—were not simply hyperbole. Paris in some sense was being put to death, and the ground prepared for the "consumer society." Part of that groundwork was the change in the *quartier* economy I have described at such length: it is surely reasonable to expect that the working class would not be made into consumers of commodities until they had become fully producers of them—until their world of work had been broken and reconstructed by capital. It was the pace and force of that reconstruction in the 1860s, and the fact that it was not finished—that there was as yet no other fixed pattern of buying and behaviour to take the place of the one disintegrating—which gave the discourse on Haussmann's work its urgency.

It was urgent and to a great extent accurate. The commentators were right, I think, to put the stress they did on the physical, visual changes made in the city. They were correct in strictly economic terms, for public works were the motor of capitalism in the mid-nineteenth century (they were the avant-garde of the economy to come). And they were right in more interesting and complex ways. What they wished to describe, in a word, was capitalism coming to determine the main motions of social life—altering the ways in which men and women worked, bought, sold, set up house, and arranged their day. Capitalism was assuredly visible from time to time, in a street of new factories or the theatricals of the Bourse; but it was only in the form of the city that it appeared as what it was, a shaping spirit, a force remaking things with ineluctable logic—the argument of freight statistics and double-entry bookkeeping. The city was the *sign* of capital: it was there one saw the commodity take on flesh—take up and eviscerate the varieties of social practice, and give them back with ventriloqual precision.

To picture the city as a separate thing, as a free field for the shop assistant and consumer, as a sphere of controlled and standardized appearance: these were metaphors for what would happen when everyday life was finally colonized. They were ways of imagining the future in the present. There would come a time, the writers said, when the whole of Paris would be like the Butte de Chaillot or the Bois de Boulogne. In a sense, that time had already arrived. Were not the streets deserted and even the *marchands forains* provided with identical booths at holiday time by the municipality?[115] Had not the bourgeois, the artist, the racing gentleman, the soldier, and the civil servant—those types of a form of bourgeois life which had once thrived on difference, on varieties of power and exchange—been replaced by the servants of illusion, the *boursier* and the *photographe?* The Goncourts,

17. Claude Monet, *Le Boulevard des Capucines*, 1873.

of course, were ironists and pessimists, and anyway out of date. Yet their vision of the future should strike the twentieth-century reader as erring largely on the side of mildness. They could not have envisaged a time when the broker was replaced in the restaurants by an infinity of *petits cadres*, and every man was encouraged to become his own photographer. That state of affairs is spectacular. There were too many anticipations of it in the 1860s for anyone to feel at ease.

It should go without saying that this situation—Haussmann's work and its aftermath—presented painting with as many problems as opportunities. Naturally it offered occasions for a meretricious delight in the modern, or proposals in paint that the street henceforward would be a fine and dandy place. (I cannot see, for example, that Monet's two pictures of *Le Boulevard des Capucines* in 1873 do more than provide that kind of touristic enter-

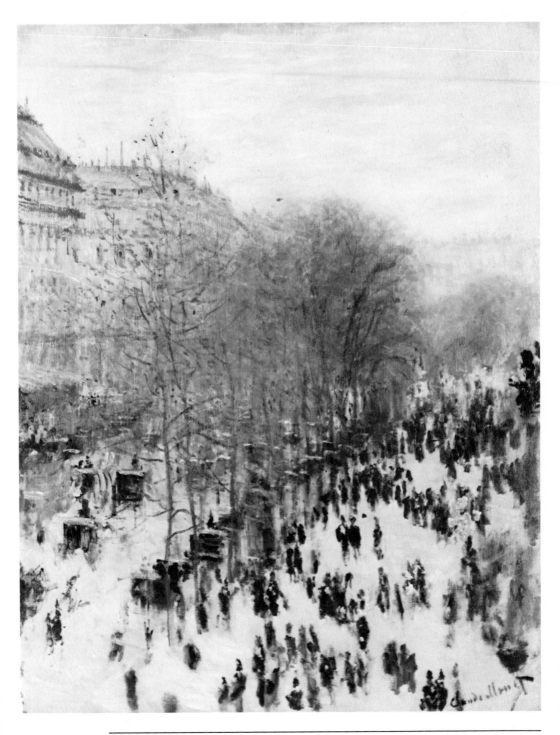

18. Claude Monet, *Le Boulevard des Capucines,* 1873.

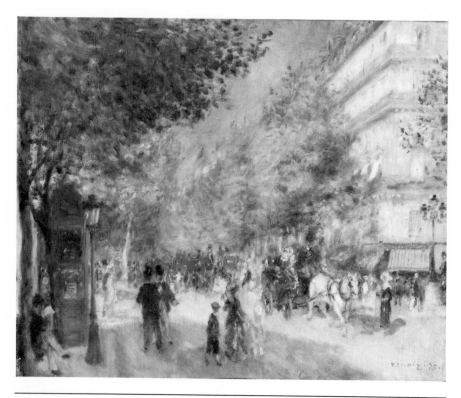

19. Pierre-Auguste Renoir, *Les Grands Boulevards*, 1875.

tainment, fleshed out with some low-level demonstrations of painterliness. Where Monet went, Renoir inevitably followed: his image of the *grands boulevards* in 1875 is untroubled by its subject's meanings, and not helped by this innocence.) For painting of a more serious cast—the kind which took Manet's example to heart, and sought to emulate *L'Exposition Universelle* or the *Déjeuner sur l'herbe*—the unsettling of meaning I have described was the matter of modern art, its main concern, but also the devil to handle in paint.

Seriousness was not enough, nor even a measure of class consciousness. Norbert Goeneutte's intentions in *La Distribution de la soupe aux pauvres à la porte du restaurant Brébant*[116] were probably impeccable—Manet's and Courbet's examples loom large—but his painting of poverty and charity will rightly strike us as old-fashioned, because the street itself is presented as if untouched by the travail of previous decades. It is still a stage, a closed and focussed foreground on which the established transactions of class take place and are easily read. A hand reaches out for alms and receives them, an old *clochard* shares his bowl with a dog, faces are pitiful, grim, suspicious, pinched with cold, hunger, or age. History is full of *subjects* here, full of

expressions; we are far from the man without a face in the field beside the gaslight, or the gardener averting his gaze from the view on the Butte de Chaillot.

The choice in such cases is not necessarily between indirection and guardedness, revealed as the truth of modernity after all, and Goeneutte's more pointed sign language. One might have sign language of a legible and pungent kind and still retain the sense that part of Haussmann's Paris—part of its new class system—was the infrequency of such touching scenes as Goeneutte chose to paint. The typical scene—this the new painting certainly suggested—was likely to be one in which the classes coexisted but did not touch; where each was absorbed in a kind of dream, cryptic, turned in on itself or out to some spectacle, giving off equivocal signals: the worker looking out of the street without sides in Caillebotte's *Le Pont de l'Europe*, and the bourgeois engaged in mysterious transaction with a woman—his wife, his mistress, a passer-by, a prostitute, who knows? Class exists, but Haussmann's spaces allow it to be overlooked. It is like the lady streetsweeper in de Nittis's sketch of the *Place des Pyramides*: something

20. Norbert Goeneutte, *La Distribution de la soupe aux pauvres à la porte du restaurant Brébant*, 1880.

21. Gustave Caillebotte, *Le Pont de l'Europe*, 1876.

22. Giuseppe de Nittis, *Place des Pyramides*, c. 1875.

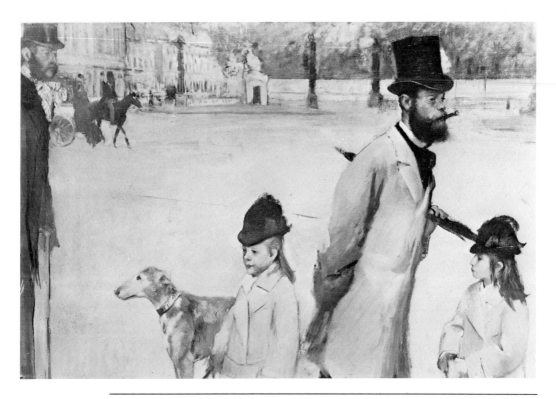

23. Edgar Degas, *Place de la Concorde, Paris*, c. 1873.

in the foreground, less important than the oranges and the Tuileries: class as *repoussoir*. History exists, but Haussmann's spaces have room for it to be hidden. It lurks behind the Viscount Lepic's top hat, for example, in Degas's *Place de la Concorde*, where the statue of Strasbourg stands all smothered in wreaths and flowers,[117] the place where Paris mourned Alsace, so recently lost to the Hun.

What does the viscount care for history, even recent history, with a good cigar wedged firmly between his teeth and an umbrella under one arm at a forty-five-degree angle? As little as his children do; no more than the passing, abstract stroller. Their inattention is *provided for* by the empty spaces and the stream of sights—in that sense, Renoir's boulevard pastoral, or Monet's bird's-eye view, is a product indeed of Haussmann's labours:

So, step by step, you reach the Place de l'Opéra. It is here that Paris makes one of its grandest impressions. You have before you the façade of the Théâtre, enormous and bold, resplendent with colossal lamps between the elegant columns, before which open rue Auber and rue Halévy; to the right, the great furnace of the Boulevard des Italiens; to the left, the flaming Boulevard des Capucines, which stretches out between the two burning walls of the Boulevard Madeleine, and

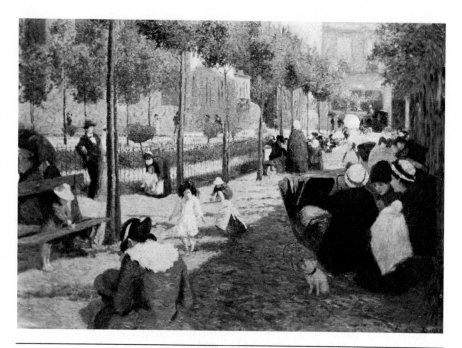

24. Pierre Zandomeneghi, *Square d'Anvers, Paris*, 1880.

turning around, you see three great diverging streets which dazzle you like so many luminous abysses: rue de la Paix, all gleaming with gold and jewels, at the end of which the black Colonne Vendôme rises against the starry sky; the Avenue de l'Opéra inundated with electric light; rue Quatre Septembre shining with its thousand gas jets, and seven continuous lines of carriages issuing from the two Boulevards and five streets, crossing each other rapidly on the square, and a crowd coming and going under a shower of rosy and whitest light diffused from the great ground-glass globes, which produce the effect of wreaths and garlands of full moons, colouring the trees, high buildings and the multitude with the weird and mysterious reflections of the final scene of a fancy ballet. Here one experiences for the moment the sensations produced by Hasheesh. That mass of gleaming streets which lead to the Théâtre Français, to the Tuileries, to the Concorde and Champs-Elysées, each one of which brings you a voice of the great Paris festival, calling and attracting you on seven sides, like the stately entrances of seven en-chanted palaces, and kindling in your brain and veins the madness of pleasure.[118]

The street, the street! How it rose like a phoenix out of Haussmann's fire, and how much it still delighted the foreigner—the foreign artist—and the visitor from Fontenay-aux-Roses! There was something like a crowd again, and something like charm, in Zandomeneghi's small painting of the *Square d'Anvers*, with its mothers in earnest conversation in the shade, its pets and perambulators, its occasional dandy, its nursemaid help-ing a baby piss on the parterre; or in Bonnard's pneumatic, impalpable

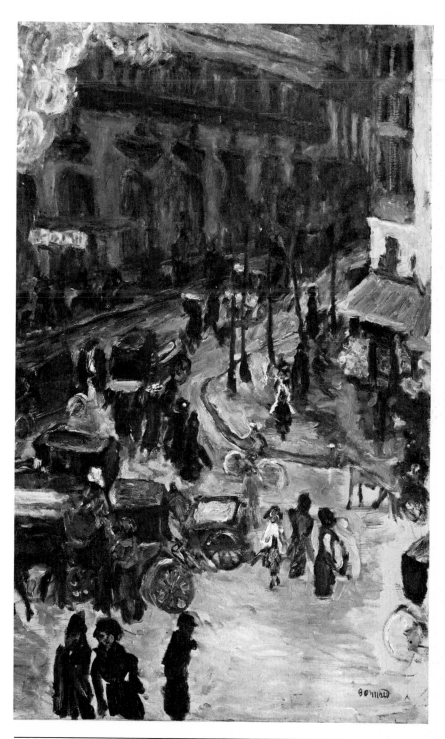

25. Pierre Bonnard, *Boulevard de Clichy*, 1911.

Boulevard de Clichy, or even old Pissarro's views from his hotel window!*
But modern art in its first manifestations—in the painting of Manet above
all—did not accept the boulevards as charming. It was more impressed
with the queerness of those who used them—the prostitutes, the street
singers, the men of the world leaning out of their windows, the beggars,
the types with binoculars. It wanted to paint Haussmann's Paris as a place
of pleasure, particularly for the eye, but in such a way as to suggest that
the pleasures of seeing involved some sort of lack—a repression, or alter-
natively a brazenness. The prostitute was seemingly an ideal figure for
things of this kind, for she concentrated them in her person; and Manet
like others took her to represent the truth of the city Haussmann had built.

* This last page or so of descriptions is not meant, incidentally, to amount to a judgement
of the relative merit of the pictures passed in review (still less to insinuate such a judgement
without daring to state it out loud). The Caillebotte, for example, is in my view a lesser
painting than the Degas, however much I may sympathize with its thoughtfulness. The
requisite clichés are brought on stage a bit less glibly, but that does not save the picture
from having the look of a rehearsal as opposed to a real performance. The value of a
work of art cannot ultimately turn on the more or less of its subservience to ideology; for
painting can be grandly subservient to the half-truths of the moment, doggedly servile,
and yet be no less intense. How that last fact affects the general business of criticism is
not clear. But one thing that does not follow from it, as far as I can see, is that viewers
of paintings should ignore or deny the subservience, in the hope of thereby attaining to
the "aesthetic." It matters what the materials of a pictorial order are, even if the order is
something different from the materials, and in the end more important than they are.

OLYMPIA'S CHOICE

"We shall define as prostitute only that woman who, publicly and without love, gives herself to the first comer for a pecuniary remuneration; to which formula we shall add: and has no other means of existence besides the temporary relations she entertains with a more or less large number of individuals."

From which it follows—and it seems to me the truth—that prostitute implies first venality and second absence of choice.

Ah! I know very well that by thus restricting the scope of the word, we end up reserving all our indulgence for those women-without-virtue who are the most fortunate, the privileged, the inexcusable, and at the same time we sanction the existence of a sort of proletariat of love over whom can be exercised with impunity all kinds of harshness and tyranny.

—Henri Turot[1]

The Argument That in depicting a prostitute in 1865, Manet dealt with modernity in one of its most poignant and familiar, but also difficult aspects: difficult because it had already become a commonplace in the 1860s that women of this kind, formerly confined to the edges of society, had more and more usurped the centre of things and seemed to be making the city over in their image. Thus the features defining "the prostitute" were losing whatever clarity they had once possessed, as the difference between the middle and the margin of the social order became blurred; and Manet's picture was suspected of revelling in that state of affairs, marked as it was by a shifting, inconsequential circuit of signs—all of them apparently clues to its subject's identity, sexual and social, but too few of them adding up. This peculiar freedom with the usual forms of representation was later held to be the essence of *Olympia* (Plate VI), as Manet's picture was called, and made it the founding monument of modern art; and certainly it was a painting which revealed the inconsistencies of its manufacture and breathed a kind of scepticism at the ways that likeness was normally secured. This went hand in hand, as the critical reaction at the time testifies, with a seeming displacement of the spectator from his accustomed imaginary possession

of the work. Like any other picture, *Olympia* provided various places from which the viewer might appropriate its main fiction, but those places ended by being precisely too various; I shall argue they were contradictory and largely uninhabitable; and to a great extent they remained so for later viewers, so that instead of the fictive body on the bed, a more limited fiction called "the picture" was consumed and imagined—it seemed the best on offer. Yet even this fact is open to contrary interpretations, and eager discussion of "the free play of the signifier" may on the whole be premature. It is true that *Olympia* makes hay with our assumptions as spectators, and may lead us to doubt the existence on canvas of three dimensions, the female body, and other minds; but this very negation is pictured as something produced in the social order, happening as part of an ordinary exchange of goods and services. The painting insists on its own materiality, but does so in and through a prostitute's stare, a professional and standardized attentiveness, with the self reserved from the purchaser's looking; though the possible grimness of that reflection on the painter's task was hardly understood in 1865, let alone approved of.

Towards the end of March 1865 Manet wrote a letter to Baudelaire in Brussels, outlining his plans for the salon that year:

My dear Baudelaire, you were right, I was miserable for no reason, and just as I was writing to you my picture was accepted. From the word I'm getting it actually seems this year won't go too badly; I've done a *Jesus Insulted by the Soldiers*, and I think it's the last time I'll take on this kind of subject; but obviously you didn't know that Th. Gautier was on the jury. I didn't send him your letter, it's unnecessary now, and it's wrong to use up good recommendations when there's no need.

The other day I had quite a surprise. Monsieur *Ernest Chesneau* bought one of my pictures, two flowers in a vase, a little thing I showed at Cadart's; perhaps he'll bring me luck.

I just finished your *Mystery of Marie Roget*—I started from the end, I'm always so curious—and I'm amazed that imbecile Villemassant doesn't want it. It's remarkable and amusing.[2]

Manet seems always to have worried a great deal about the salon, and there is no reason not to take at face value the writer's relief at having a picture get past the jury, and even his optimism as to how the public would react. It is rare to have the least hint of Manet's reading habits, and good to think of him reading Baudelaire's translation of Edgar Allan Poe. (What Manet was reading was a detective story, in fact: one of the early classics of the genre, whose sedentary hero, Auguste Dupin, solves the mystery in

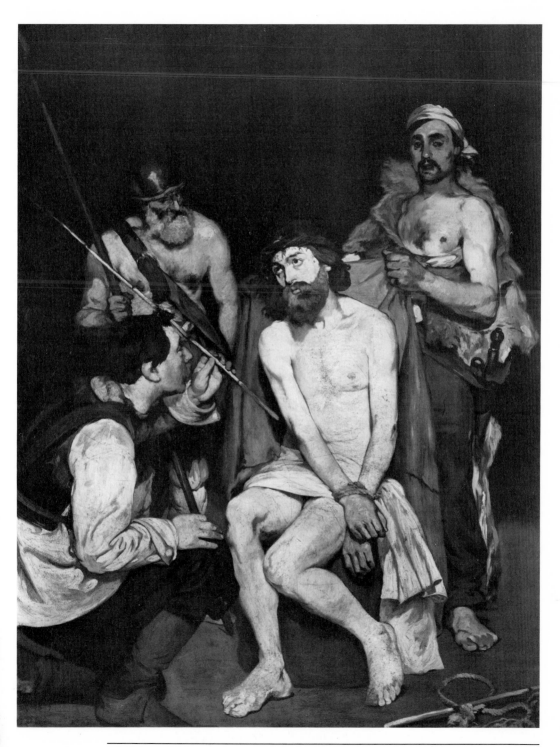

26. Edouard Manet, *Jésus insulté par les soldats*, 1865.

question—the murder of a Parisian *grisette*—without leaving his study, on the basis of clues he gleans from reports in the newspapers.)

The optimism of Manet's March letter did not last long. The salon opened early in May, and the picture of Jesus was hung close by Manet's other entry—which he had not mentioned to Baudelaire—the painting entitled *Olympia*.[3] Within a week or so Manet wrote to Baudelaire as follows:

I really would like you here, my dear Baudelaire; they are raining insults on me, I've never been led such a dance. . . .

I should have liked to have your sane verdict on my pictures, for all these cries have set me on edge, and it's clear that someone must be wrong; Fantin has been charming, he defends me, and that's all the more praiseworthy because his picture this year, though full of excellent things, makes less of an effect than last year's (what's more, he knows it). . . .

In London, the academy has rejected my pictures.[4]

To which Baudelaire addressed this kind and annihilating reply:

So once again I am obliged to speak to you about yourself. I must do my best to demonstrate to you your own value. What you ask for is truly stupid. *People are making fun of you; pleasantries* set you on edge; no one does you justice, etc., etc. Do you think you're the first to be placed in this position? Have you more genius than Chateaubriand and Wagner? And did people make fun of them? They did not die of it. And so as not to make you feel too proud of yourself, I shall add that these men were exemplary, each in his own genre, and in a world which was very rich, while you, *you are only the first in the decrepitude of your art*. I hope you don't take offence at my treating you thus, without ceremony. You know the friendship I feel for you.

I wanted the *personal* impression of Monsieur Chorner, at least insofar as a Belgian can be considered a *person*. I must say he was kind, and what he said tallies with what I know of you, and what several intelligent men say about you: *"There are faults, weaknesses, a lack of aplomb, but there is an irresistible charm."* I know all that; I was one of the first to understand it. He added that the picture representing the nude woman, with the Negress and the cat (is it a cat, really?), was much superior to the religious picture.[5]

These are almost the only traces in Manet's correspondence of the scandal surrounding *Olympia* in 1865. There *was* a scandal, and Manet does not seem to have exaggerated its violence very much. The events of 1865 lived on in the public memory, and Manet never wholly escaped from his reputation as the "painter of *Olympia*." Degas waxed sarcastic in the 1870s about Manet's being as famous as Garibaldi, and Jacques-Emile Blanche told the story of "Manet the hero of songs and caricatures . . . followed as soon as he showed himself by rumours and wisecracks; the passers-by on the street turning to laugh at the handsome fellow, so well dressed and

correct, and him the man who 'painted such filth.' "[6] Berthe Morisot recalled that her daughter, spending the summer at Bougival in 1881, once gave her name as Bibi Manet—she was the painter's niece—and made "two *cocottes* out promenading on the riverbank laugh till they cried, since they doubtless took her for the child of the celebrated Manet, put out to nurse in the land of *canotières*."[7]

What happened in 1865 can be briefly stated.[8] The two pictures, as was customary, were hung in the same room, most probably one on top of the other, with *Olympia* below *Jésus*. Manet put the simple title *Jésus insulté par les soldats* in the salon catalogue, but underneath *Olympia* he added five lines of unforgiveable verse by Zacharie Astruc:

> *Quand, lasse de songer, Olympia s'éveille,*
> *Le printemps entre au bras du doux messager noir;*
> *C'est l'esclave, à la nuit amoureuse pareille,*
> *Qui vient fleurir le jour délicieux à voir:*
> *L'auguste jeune fille en qui la flamme veille.*[9]

From the first days of the salon, it seems that Room M was more than usually crowded. "Never has a painting," wrote Louis Auvray in *La Revue Artistique et Littéraire*, "excited so much laughter, mockery, and catcalls as this *Olympia*. On Sundays in particular the crowd was so great that one could not get close to it, or circulate at all in Room M; everyone was astonished at the jury for admitting Monsieur Manet's two pictures in the first place."[10] The crush of spectators was variously described as terrified, shocked, disgusted, moved to a kind of pity,[11] subject to epidemics of mad laughter,[12] "pressing up to the picture as if to a hanged man,"[13] and on the verge of adopting the then fashionable tactics of Mr. Lynch.[14] Once or twice the description was more detailed and pretended to extend its sympathy to all concerned, painter and public alike. Here, for example, is a journalist named Bonnin writing in the republican paper *La France*:

Each day [*Olympia*] is surrounded by a crowd of visitors, and in this constantly changing group, reflections and observations are made out loud which spare the picture no part of the truth. Some people are delighted, they think it a joke that they want to look as if they understood; others observe the thing seriously and show their neighbour, here a well-placed tone, and there a hand which is improper, but richly painted; finally one sees painters whose work was rejected by the salon jury this year—and there is the proof that they *do* exist—standing in front of the picture, beside themselves with spite and indignation. Very probably everyone is right to some extent, and such diverse opinions are authorized by the incredible irregularities of Monsieur Manet's work. He has shown mere sketches. Yet we are not of the opinion, which is too widespread, that this negligence is a *parti pris* on his part, a sort of ironic defiance hurled at the jury and the public. The jury

would certainly have distinguished a studio jape from an unsatisfactory work of art, and would have closed the doors of the Palais des Champs-Elysées against it. From another point of view, an artist cannot treat the public lightly without compromising his reputation, which sometimes never recovers; and Monsieur Manet, who appears at each exhibition, is certainly pursuing something other than the sad celebrity obtained by such perilous procedures. We prefer to think he has made a mistake. And what is his aim? His canvases are too unfinished for us possibly to tell.[15]

This text becomes more sober as it goes on, and ends by being almost too judicious to interest us much; but at least the writer does not seem to be producing the *Olympia* scandal for his readers' easy delectation. Women are not turning their heads from the picture in fright,[16] the crowd is not united by a "unanimity of reprobation and disdainful pity."[17] These were the commonplaces of criticism that wished to be lively in the nineteenth century, and when even this unlively critic toys with the idea that Manet may *intend* to offend, he is taking up and refuting a well-established theme—one Baudelaire could afford to make fun of in his letter the previous month. The bourgeoisie was used to the fiction that great art, new art, would necessarily not conform to its expectations; it had learnt to be ironical about the claims of Realists and bohemians. This, for example, is Francis Aubert in *Le Pays*, discussing the typical inhabitant of the Quartier Latin:

A great drinker of beer and absinthe, a great smoker of black pipes filled from his pocket, cobbling together three or four artistic, literary, or political commonplaces, so out of date that a schoolboy would not dare use them, cursing and swearing every sentence, speaking only the argot of thieves, republican certainly, socialist probably, communist perhaps, but without knowing what any of the doctrines means . . .

His career? His past? The same as his present, which consists of going from boardinghouse to brasserie, dreaming up ways of paying neither; and as capital diversion being insolent to an honest man—which is called *épater le bourgeois*.[18]

Manet in 1865 was suspected of possessing opinions of this kind, and the more intelligent critics were prepared to forgive them as youthful folly. The crowd in front of *Olympia* "was not exclusively composed of *bourgeois*," wrote one;[19] the painter should not offer himself that consolation. Another talked of "armed insurrection in the camp of the bourgeois," and of Manet's going down to a "popular execution,"[20] but the phrases were clearly meant as conceits, or ironic rendition of the common wisdom, and the critic's entry as a whole hardly granted the picture sufficient weight—or weight of the right kind—to justify the metaphors.

But however suspicious one might be about the evidence, it still makes

sense to talk of an *Olympia* scandal. Some critics described the scene in front of the picture with genuine distaste and could hardly be suspected of playfulness: when the grim and lordly Dubosc de Pesquidoux told the Catholic readers of *L'Union* that people were laughing at Christ in Room M, he was surely telling nothing but the truth. In any case, the brouhaha was enough to alarm the administration, always jealous of the salon's precarious dignity. Some time towards the end of May, they moved *Olympia* and *Jésus* out of sight, and stood back to receive the critics' congratulations. Thus Félix Jahyer in his *Etude sur les Beaux-Arts*:

> May I be allowed, on this subject, to thank the commission for having acceded in the four days the salon was closed to the request I made on the subject of Monsieur Manet. At the moment his two canvases are so well hidden above the two doors in one of the end rooms that you need the eyes of a lynx to detect them.
>
> At this height the *August Olympia* looks like an immense spider on the ceiling. She cannot even be laughed at any more, which has quite disappointed everyone.[21]

Olympia, as Baudelaire described it in his letter, was a picture of a nude woman with a Negress and a cat. The poet pretended to doubt the latter detail—"est-ce un chat, décidément?"—which might suggest that it was added to the picture after he left for Brussels, or simply that he raised his eyebrows at the thought of such an overtly Baudelairean signature. It was also a picture of a prostitute, we can be fairly certain of that. And in this too it seems to have derived, at least partly, from Baudelaire: Olympia's hopeless, disabused nobility recalls the kind described—and recommended to the modern artist—in *Le Peintre de la vie moderne*:

> Among these women, some, in whom an innocent yet monstrous fatuity is only too apparent, carry in their faces and in their eyes, which fix you audaciously, the evident joy of being alive (in truth, one wonders why). Sometimes they find, without seeking them, poses both provocative and dignified, which would delight the most fastidious sculptor, if only the sculptor of today had the courage and the wit to seize hold of nobility everywhere, even in the mire; at others, they show themselves in prostrate attitudes of desperate boredom, or adopt the indolent postures of the estaminet, with a masculine cynicism, smoking cigarettes to kill time, with all the resigned fatalism of the Orient; there they lie, sprawling on sofas, skirts ballooning to front and back like two fans, or they balance themselves precariously on stools and chairs; heavy, sad, stupid, absurd, their eyes glazed with brandy, and their foreheads bulging with the force of their own obstinacy.[22]

Zacharie Astruc was a friend and admirer of Baudelaire, and his five lines in the salon *livret* read like an attempt to provide Manet's naked woman with some of the same connotations. *Olympia* was Astruc's choice

of title: it was on the face of it a dignified name, and its formality was emphasized by the phrase in his poem—the much-quoted, much-mocked description—"l'auguste jeune fille." Part of the critics' mockery had to do with Astruc's talents as a poet, and part with their conviction that the appearance of dignity was deliberately flimsy. For Olympia was a pseudonym favoured by prostitutes: it figured in the classic list of names drawn up in 1836 by the trade's first great investigator, Parent-Duchâtelet:[23] the better class of brothel was full of Floras, Aspasias, Lucretias, Delphines, Thalias, Sidonias, Azelinas, Calliopes, Lodoiskas, and—inevitably—Virginias by the score. For readers in 1865 the name Olympia probably also conjured up, as Gautier put it in his *Salon*, "the memory of that great Roman courtesan on whom the Renaissance doted,"[24] by whom he meant La Dona Olympia, villainous heroine of a popular novel by Etienne Delécluze; sister-in-law, mistress, and manipulator of Pope Innocent X; prisoner and harlot, so avid for gold that after Innocent died she refused even to pay for his coffin.[25] Delécluze's romance had been reprinted as recently as 1862; the reference came easily to Gautier, and other critics seem to have echoed it; but even this reference, Gautier argues, is undeserved by the picture itself.[26] For, after all, the great Dona Olympia had been beautiful as well as sordid; Manet's young woman had taken nothing but her predecessor's name, and in that she was one of many. Her title was bogus; and as for Astruc's "auguste jeune fille"! It appeared to the critics a euphemism coined with the same cynical aplomb.

Some of the critics in 1865 were sure that Manet's Olympia was a prostitute and said as much. There was nothing very remarkable in their doing so: it had become an established critical tactic in the 1860s to detect the contemporary, even the bourgeois, *courtisane* beneath the skin of a Venus or Phryne; and in any case, as we shall see, prostitution demanded and received its representations in the salon each year, in forms both ancient and modern. But the words these critics used to indicate Olympia's profession were once or twice less ordinary, the strangeness having to do with their attempt to exceed the concept *courtisane*—its comfortable, general, archaic field of reference—and specify where Olympia came from and whom she could possibly be looking at.

Of course there were writers who did no such thing. Several were happy with the single epithet *courtisane*, and one followed Gautier's lead in calling Olympia "la dame de beauté de la Renaissance."[27] "What is this odalisque with a yellow belly [asked another], ignoble model picked up who knows where, who represents Olympia? Olympia? What Olympia? A courtesan, no doubt."[28] The question was easily answered, in other words. And *courtisanes* came from the Quartier Bréda, the area just north of the Bou-

levard des Italiens, not far from the railway station and felicitously close to the debtors' prison in the Rue de Clichy. Olympia was no exception: "It was said of Pradier," wrote one critic in 1865, "that he set out for Athens each morning and arrived each evening in the Rue de Bréda. Nowadays a certain number of artists go to the Rue de Bréda direct."[29] Manet was certainly one of them: he could be seen in Fantin-Latour's ridiculous painting *Le Toast* paying homage to Truth "in the guise of a redhead from the Quartier Bréda."[30]

These references are essentially normal. Brief and highly coded, they barely interrupt the critics' main business of aesthetic judgement. The same is true of Félix Deriège in *Le Siècle*, who ends his account of *Olympia*—we shall see later on that it was an exceedingly hostile one—with the inevitable jibe at Manet's claim to be painting the truth: "one can be true indeed, if one is able to paint like Goya, even in representing a *manola de bas étage*, lying quite naked on her bed, while a Negress brings her a bouquet."[31] No doubt the phrase *de bas étage* is a sneer at Olympia's presumed place in the social order, or at least in her chosen profession—she is clearly no *grande cocotte*—but the phrase is elliptical, and the writer sees no need to spell out its unpleasant implications.

Some writers were not so reticent. Postwer, for example, writing in an eccentric journal called *La Fraternité Littéraire*, quoted all five of Astruc's limping lines and proceeded to the following fraternal analysis:

What verse! What a picture! Olympia awakes, weary from . . . dreaming. She has had a bad night, that is evident. Insomnia and colic have disturbed her serenity; her colour indicates as much. There are two *"black messengers"*: a cat which has unfortunately been flattened between two railway sleepers; a Negress who has nothing about her that *recalls the amorous night* unless it be a bouquet bought at the florist's on the corner, and paid for by Monsieur Arthur, which tells me a great deal about Olympia. Arthur is certainly in the antechamber waiting.[32]

Monsieur Arthur's identity is obscure now and perhaps always was, but his purpose could hardly have been made plainer. And it was dangerous to talk at all of the real circumstances of prostitution, even in this lugubrious way, since doing so could lead so quickly to the kind of fact which the stately word *courtisane* was intended to obscure. The *courtisane* was supposed not to belong at all to the world of class and money; she floated above or below it, playing with its categories, untouched by its everyday needs. It was not clear that Manet's prostitute did any such thing. To more than one critic in 1865 she seemed to occupy a quite determinate place in the Parisian class system: she was an "Olympia from the Rue Mouffetard,"[33] "the wife of a cabinetmaker,"[34] a "coal lady from Batignolles."[35] All of these references were meant to be funny, of course, but the jokes depended

on Olympia's being placed, to some extent unequivocally, in the world of the *faubourgs* and the working class.

The same is true—though here the tone is more elusive and ironical—of Jean Ravenel's description of *Olympia* in a paper called *L'Epoque*. It has at its centre the following compacted, staccato sentence or two, in which the writer seems to be casting round for categories in which *Olympia* might begin to make sense. The list he provides is brilliant and unexpected:

Painting of the school of Baudelaire, freely executed by a pupil of Goya; the vicious strangeness of the little *faubourienne*, woman of the night from Paul Niquet's, from the mysteries of Paris and the nightmares of Edgar Poe. Her look has the sourness of someone prematurely aged, her face the disturbing perfume of a *fleur du mal*; her body fatigued, corrupted, but painted under a single transparent light. . . .[36]

For the moment let us extract from the pattern of phrases the words "petite faubourienne, fille des nuits de Paul Niquet, des mystères de Paris et des cauchemars d'Edgar Poe." No doubt these descriptions are meant to evoke the painting's dreamlike, literary quality, but for the reader in 1865 they would also have suggested that Olympia belonged to Paris in quite ordinary ways. To call her a *petite faubourienne* was simply to say she was working-class; to have her be a character from Eugène Sue's novel *Les Mystères de Paris* was essentially to make the same point; to imagine her haunting the tables of Paul Niquet's was to place her in the lower depths of prostitution, among the women who catered to the porters of Les Halles. (Niquet's establishment in the Rue aux Fers stayed open all night and "was frequented by a quite special clientele of ragpickers, idlers, drunkards, and women whose sex and age were indistinguishable beneath their mass of rags."[37] For a while the bar had been a stopping place for sightseers of the Parisian underworld, but by 1865 it had returned to its normal obscurity.)

These are descriptions of Olympia's class; and I shall end this chapter by arguing that class was the essence of Olympia's modernity and lay behind the great scandal she provoked. But it seems none of the critics in 1865—not even Jean Ravenel—would have agreed with me. There were over seventy pieces of writing on Manet's picture that year, and they contained, as I have shown, no more than a handful of references to prostitution and a grand total of six attributions of class, all fleeting and formulaic. However one looks at it, this is a strikingly poor haul, and the questions raised by the scarcity can be put as follows: If class was somehow signified in *Olympia*, and sometimes mentioned, what were the signs of it? And why could they not be identified in more detail, even by a critic like Ravenel, who seemed convinced that Olympia was working-class and

27. Théodule-Augustin Ribot, *Saint-Sébastien*, 1865.

that he should say so? The critics were certainly offended by *something* in Olympia: What was it, then, that they believed they saw and thought improper?

We have to do with art critics writing salon reviews in the daily press or monthly magazines. These writers would presumably have liked to discuss Manet's picture as an example of a school or a tendency in art, most probably that of Realism. Was not Manet included, along with Astruc, Whistler, the etcher Félix Bracquemond, and others, in the picture Fantin-Latour had sent to the salon entitled *Le Toast* or *Hommage à la Vérité*? Courbet had a painting in the salon of the anarchist Proudhon; Théodule-Augustin Ribot a study of Saint Sebastian, in his best Spanish manner; and Whistler his odd *Princesse du pays de la porcelaine*. The critics could flesh out their account of Realism in various ways: by including a kitchen scene by Antoine Vollon, for example, or a "metallic" Virgin by Albert Lambron,[38] or by giving encouragement to two beach scenes by Claude Monet, the "young Realist who promises much."[39]

This was already a list of eccentrics and anomalies, and perhaps Manet could be added to it. He was the "self-styled Realist, pupil of Courbet";[40] his *Jésus* was "Raphael corrected by a third-rate Courbet";[41] master and imitator were the two "Marquis de Sade of painting."[42] The violence of this final phrase was not necessarily a guide to the critics' overall tone: though Courbet was still condescended to in 1865, his school was an

28. James McNeill
Whistler, *La Princesse du
pays de la porcelaine*,
1864.

established part of the French scene, and even its enemies wished to dis-
criminate and recognize talent where it occurred. They tried to do so in
Manet's case.

Manet was a skilful technician, they quite often conceded. His draughts-
manship had character and originality, his colour was supple and mordant,
he had "tempérament," "facultés," "une main d'artiste."[43] His painting was
understood to be deliberately bold and experimental, and regularly attained
to "a very great truth of tone";[44] it had "the charm of naïveté," it had touch,
vigour, and "hardiesse,"[45] it derived (a bit slavishly) from Goya,[46] and even
at its worst "one made out passages which were straightforwardly well
done."[47]

Yet on the whole the critics in 1865 could not be so charitable as this.

29. Antoine Vollon, *Un Intérieur de cuisine*, 1865.

There was something about *Olympia* which eluded their normal frame of reference, and writers were almost fond of admitting they had no words for what they saw. *Olympia* was "informe," "inconcevable," "inqualifiable," "indéchiffrable"; the picture "ne s'explique pas."[48] "The least handsome of women has bones, muscles, skin, form, and some kind of colour,"[49] whereas Olympia had none; she was "neither true nor living nor beautiful."[50] The negatives multiplied: "she does not have a human form,"[51] and therefore "I can say nothing about her in truth, and do not know if the dictionary of French aesthetics contains expressions to characterize her."[52] "Not that I dream of examining her, describing her. God preserve me from so doing!"[53] *"Que signifie cette peinture,"* finally, "and why does one find these canvases in the galleries of the Palais de l'Industrie?"[54]

Of course these phrases are partly mechanical. A good salon review was

30. Cham, *Manet, La Naissance du petit ébéniste.* Wood engraving in *Le Charivari,* 14 May 1865.

MANET.

La Naissance du petit ébéniste.

M. Manet a pris la chose trop à la lettre :
Que c'était comme un touquet de fleurs !
Les lettres de faire-part sont au nom de la mère Michel
et de son chat.

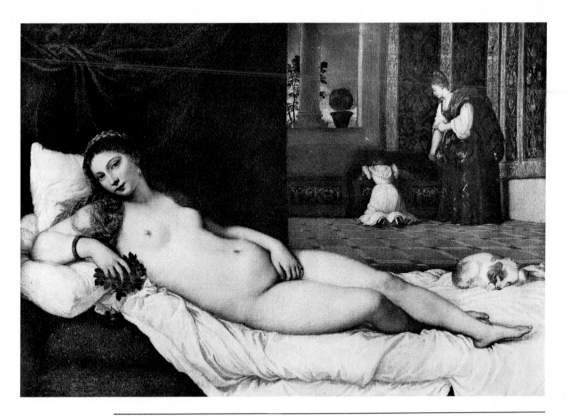

31. Titian, *The Venus of Urbino*, 1538.

incomplete without its quota of monstrosities, and one or two works each
year were consigned to the space outside Art altogether. They were to be
compared with the latest popular song or Hottentot Venus, and described
as mere sign painting or "images d'Epinal."[55] All of these stock figures were
tried out on *Olympia* in 1865; and yet in this case the critics' sneering claim
not to be able to see or describe *Olympia*—not to have the least sense of
its formal logic—does seem to be close to the truth. There are ways, after
all, in which *Olympia* was at pains to disclose its relationship to the great
tradition of European art, and by and large the critics seem genuinely not
to have noticed that it did so.

For instance, *Olympia* derived—and stated its derivation—from Titian's
Venus of Urbino.[56] The pose of the nude is essentially the same, and the
nude's accessories seem to be chosen as the modern forms of their Re-
naissance prototypes: orchid in place of roses, cat for dog, Negress and
flowers instead of servants bringing dresses from a distant *cassone*. The
nineteenth century believed that Titian's Venus was a courtesan. This was
probably too secular a reading, but the sense of the picture's sensuality it

stemmed from—the unchasteness of its chastity, the openness of its promise of undress and attentiveness—does not seem much mistaken. Promise, in Titian's case, may have been the operative word: if the picture was painted to commemorate a wedding, it was most likely that of Guidobaldo II della Rovere, who was married in 1534 to a ten-year-old girl, Giulia Varano.[57] That the body represented in the picture is older and more mature, and that the signs arranged round it seem to denote for the most part fidelity and the domestic virtues, may well have carried in the circumstances a quite pointed meaning. In any case, the picture's domesticity is of a special kind: the woman on the bed is Venus as well as wife, and the Urbino records were surely right to name her, bluntly, "la nuda."[58]

For the nineteenth century this painting *was* the nude. Like many another student, Manet had done an oil copy of it in the Uffizi when he was in his twenties, as a normal part of learning the alphabet of art. Salon criticism was supposed in turn to be largely about that alphabet and how well young painters were using it: the writing of a *Salon* was organized around the critic's ability to recognize quotations from older art and say whether they were apposite or not. But in the case of *Olympia*'s relation to the *Venus of Urbino*, for all that the critics were capable of producing the key word *courtisane,* the usual connections did not follow. In the mass of commentary in 1865, only two critics talked at all about Manet's sources, and they did so in a thoroughly outlandish way. "This Olympia," wrote one Amédée Cantaloube in *Le Grand Journal,*

a sort of female gorilla, a grotesque in India rubber outlined in black, apes on a bed, in a state of complete nudity, the horizontal attitude of Titian's *Venus:* the right arm rests on the body in the same fashion, except for the hand, which is flexed in a sort of shameless contraction.[59]

This should be compared with some lines by Pierrot in a fly-by-night publication called *Les Tablettes de Pierrot:*

. . . a woman on a bed, or, rather, some form or other, blown up like a grotesque in India rubber; a sort of monkey making fun of the pose and the movement of the arm in Titian's *Venus,* with one hand shamelessly flexed.[60]

Perhaps the other seventy-odd writers said nothing about Titian as a way of registering their contempt for what Manet had done to him; but I am inclined to think that they simply did not see that Manet had done anything. We might compare their silence in 1865 with what they had had to say two years earlier about Manet's *Déjeuner sur l'herbe.* That painting was similarly held to be bizarre and immoral, and it had been shown in the extraordinary Salon des Refusés—to that extent, officially beyond the pale of Art. Critics certainly came to laugh at its mistakes and incoherences,

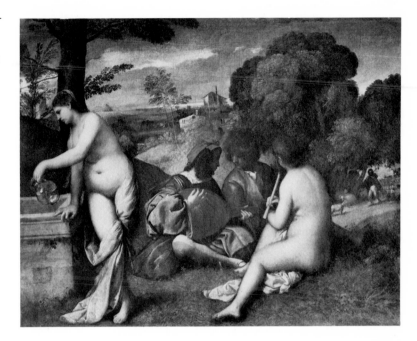

32. Titian (in the nineteenth century commonly attributed to Giorgione), *La Fête champêtre*, c. 1510–11.

and yet the very way to do so best was to point out what Manet's picture derived from—and how incompetently. The writers whose *Salons* dealt with *Le Déjeuner sur l'herbe* were quick to connect it to the painting in the Louvre then thought to be by Giorgione, the so-called *Fête champêtre*; and one of them even claimed to detect that Manet had quoted—a peculiar, literal repetition it is—from a print after Raphael of river gods and attendant nymphs.[61]

But in 1865 none of this took place. If the revisions of the *Venus* could be seen at all, they could not be said; and if on one or two occasions they were spoken of, it was in Cantaloube and Pierrot's terms. Their violent fantasies of what Manet had done to Titian explain the other critics' silence, I think, for if the old arrangement of the nude was present at all in Manet's picture, it seemed there as a sign of everything the actual, latter-day *Olympia* was not. The past was travestied in *Olympia*: it was subjected to a kind of degenerate simian imitation, in which the nude was stripped of its last feminine qualities, its fleshiness, its very humanity, and left as "une forme quelconque"—a rubber-covered gorilla flexing its hand above its crotch.

I shall take Pierrot and Cantaloube's descriptions as licence to say—quite crudely in the end—that the meanings Manet contrived in terms of Titian in 1865 amounted to nothing for most of his viewers. The *Venus of Urbino* was painted out or painted over, and seemed to the public no part of the image Manet had produced. It is as if the work of negation in

Olympia—and some such work was surely intended, some kind of dissonant modernization of the nude, some pitting of Baudelaire against Titian—were finally done, but somewhat too well. The new Dona Olympia was too much the opposite of Titian's for the opposition to signify much, and the critics were able to overlook those features the two pictures had in common.

What the writers saw instead was some kind of indeterminacy in the image: a body on a bed, evidently sexed and sexual, but whose appearance was hard to make out in any steady way, and harder still to write about. Of course, the fact of Olympia's sexuality did appear in the critics' writing, but mostly in displaced form: they talked—not wholly facetiously, it seems—of violence done to the body, of its physical uncleanliness, and of a general air of death and decomposition. It was often quite clear—and presumably meant to be—that in talking of the one set of qualities they wished to indicate the other. Victor de Jankovitz, for example, managed the transition from fig leaf to putrefaction in fifteen words:

> The author represents for us under the name of Olympia a young girl lying on a bed, having as her only garment a knot of ribbon in her hair, and her hand for fig leaf. The expression of her face is that of a being prematurely aged and vicious; her body, of a putrefying colour, recalls the horror of the morgue.[62]

A critic called Ego, writing in *Le Monde Illustré*, was equally abrupt:

> The *auguste jeune fille* is a courtesan, with dirty hands and wrinkled feet; she is lying down, wearing one Turkish slipper and with a red cockade [*sic*] in her hair; her body has the livid tint of a cadaver displayed in the morgue; her outlines are drawn in charcoal and her greenish, bloodshot eyes appear to be provoking the public, protected all the while by a hideous Negress.
> No, never has anything so . . . strange been hung on the walls of an art exhibition.[63]

Olympia was unwashed, that was the commonest opinion. "Ce corps est sale," "cerné de noir," "avec du charbon tout autour."[64] "The tone of its flesh is dirty, the modelling nonexistent. Shadows are indicated by stripes of blacking of various widths."[65] Surely that was the steam of a bath in the background—from the look of things not a moment too soon! And why do the Realists, asked Louis de Laincel, "choose unclean women as their models and, having done so, reproduce even the filth which clings to their contours?"[66] The cat was a possible culprit: perhaps it had "left its mark on the contours of this *belle personne*, after having rolled on a coalheap"; perhaps those were its pawprints on the sheet; and so on.[67] Olympia was a coal lady "whose modest outlines had never been outraged by water, that banal liquid" (see p. 145).[68] She was a skeleton, said Lorentz in his *Revue galopante au salon*,

dressed in a tight-fitting tunic made of plaster, all surrounded with black like the armature of a stained glass window . . . and who to the horror of so much stupidity and ignorance now adds the disappearance of a finger . . . which cries out for examination by the public health inspectors![69]

Some of this sarcasm has to do with Manet's way of modelling—those brief, matter-of-fact lines of shading which trace out the edges of Olympia's hand and breast, her near shoulder, her ankle, and her heel. But the writers seize on these visual facts and immediately exceed them: the conceit of uncleanliness constantly leads to others more fantastic. Olympia was dressed in rubber, said Cantaloube. She was "exposed quite naked on a bed," so Victor Fournel told his readers, "like a corpse on the counters at the morgue, this Olympia from the Rue Mouffetard, dead of yellow fever and already arrived at an advanced state of decomposition."[70] There was more than ordinary ugliness here: there was decrepitude and outright bodily decay. It was no wonder that "the crowd presses up to the putrefied *Olympia* as if it were at the morgue."[71] Olympia, wrote Félix Deriège,

is lying on her bed, having borrowed from art no ornament but a rose which she has put in her towlike hair. This redhead is of a perfect ugliness. Her face is

33. Bertall, *Manette, ou La Femme de l'ébéniste, par Manet.* Wood engraving in *Le Journal Amusant,* 27 May 1865.

PROMENADE AU SALON DE 1865, — par BERTALL (suite)

MANETTE, ou LA FEMME DE *L'ÉBÉNISTE*, par MANET. 28158
Que c'est comme un bouquet de fleurs.
(Air connu.)

Ce tableau de M. Manet est le bouquet de l'Exposition. — M. Courbet est distancé de toute la longueur du célèbre chat noir. — Le moment choisi par le grand coloriste est celui où cette dame va prendre un bain qui nous semble impérieusement réclamé.

stupid, her skin cadaverous. She does not have a human form; Monsieur Manet
has so pulled her out of joint that she could not possibly move her arms or legs.
By her side one sees a Negress who brings in a bouquet and at her feet a cat who
wakes and has a good stretch, a cat with hair on end, out of a witches' sabbath
by Callot. White, black, red, and yellow make a frightful confusion on this canvas;
the woman, the Negress, the bouquet, the cat, all this hubbub of disparate colours
and impossible forms, seize one's attention and leave one stupefied.

> Quand, lasse de songer, Olympia s'éveille,
> Le printemps entre au bras du doux messager noir:
> C'est l'esclave, à la nuit amoureuse pareille,
> Qui vient fleurir le jour délicieux à voir.

Thus says the stanza appended in the catalogue to the mention of *Olympia*.
The verses are worthy of the painting.[72]

The catalogue of insults is now finished. The reader is entitled to be
impatient with them and find them untrustworthy, for no doubt they are
part of a journalistic game whose rules are obvious and in which hyperbole
always wins. Yet I intend to play the Dupin with them, and treat them
as evidence in which the real appearance of *Olympia* can be made out, in
however distorted a form. Certainly the critics' descriptions belong to a
shifty, knowing, hypocritical game of make-believe: make-believe anger,
make-believe morality, counterfeit concern for art. But what other kind
of evidence could we expect to have, and what better kind for the questions
raised by *Olympia*—questions of modernity and sex? When these are the
subject, even abuse can be depended on for information: it will show the
traces of actual desire and anxiety, sometimes with comic distinctness.
Consider the case of Lorentz and his disappearing finger, for example; or
Olympia's left hand's appearing to Ernest Chesneau, no less, "in the form
of a toad"; or a critic called Merson entitling *Olympia* "l'enseigne de la
Femme à barbe"!

Confronted with classic parapraxes like these, it is tempting to move
straightaway into the Freudian mode: Is that really a finger which has
disappeared? Where precisely is the lady's beard located? "Est-ce un chat,
décidément?" The mode is certainly appropriate to the material in hand,
and I do not intend to avoid it; but I think it should figure alongside other
kinds of questioning, more literal and for the most part more plodding.
To put the point most guardedly: though there is such a thing as normal
critical discourse in the mid-nineteenth century, and within it a flourishing
discourse of scandal, this is not it. There is something else appearing in
discourse here, and leaving behind the usual signs of its passage: repetitions
and redundancies, falterings, false and real silences, misrecognitions, illogic,

unintentional comedy (especially when the subject is sex). Or, to put it another way, we certainly have a normal critical discourse, even about *Olympia*—we have it in plenty—but there is nothing much to say about it, except that it has nothing to say about *her*. Normality in 1865 is largely a matter of making embarrassed noises off.

The case is clearest, naturally, when we come to the acknowledged experts in the field: connoisseurs like Gautier or Théophile Thoré, Paul Mantz, Gonzague Privat, Maxime Du Camp, and the sympathetic Ernest Chesneau. Some of these writers can be seen in 1865 *preparing* to criticize *Olympia*—going through the motions of making the picture an object of criticism. This was usually done by erecting a frame of generalization strong enough, so the critic hoped, to hold even this eccentricity. Paragraphs of well-informed and mostly empty prose were put together, in which it was clear that the critic had heard the studio gossip about Manet—his tonal aims, his Realist connections, his technical facility. Chesneau and Gautier were rather good at this, and their preliminary page or so was at least informative; but when they came at last to *Olympia*—they did so with obvious reluctance—they declined at once to the level of Pierrot and De-riège.[73] They saw no sources and found no terms; they failed to sustain attention to the particulars of form and content, much less their relation; the language of appreciation—the language of art—stood as futile preliminary to the language of description. So that all those coy figures of refraining—the promises not to speak, the wish not to analyze "par courtoisie"[74]—turned out to be accurate and serious after all.[75]

There was one exception to this rule, Jean Ravenel, to whom I shall return at the end of the chapter. He too was an expert, hiding behind a pseudonym: Alfred Sensier, friend and biographer of the painter Millet. Sensier, we shall see, broke the codes of *Olympia*, and applied to the picture the usual apparatus of art criticism: he detected sources and connotations, he moved between meaning and style, he was capable of saying that some things in the picture were well painted and others less so. He did the job of criticism, up to a point; but he was one, and there were seventy others who did not.

These were good critics, with a clear sense of the scope of their writing, and in particular a confidence, usually, about the move between seeing and interpretation. They savoured the painter's manual skills, and were sometimes long-winded about them, because they believed it was touch and handling—the ways the painter made his matter evident but showed it becoming an image—that best offered them entry into the picture's fictive world. It was not that they wished simply to look *through* the picture's surface: on the contrary, their writing often kept the surface present almost

too vividly. But it was valued as the place where the imagination could properly do its work, where the viewer was offered a rich, exaggerated play with normal identities, and reminded how much the most ordinary world was altered by being represented.

In a sense *Olympia* offered much the same thing. My argument will be that it altered and played with identities the culture wished to keep still, pre-eminently those of the nude and the prostitute, and that that was largely why it proved so unpopular. But the case should be inflected in the following way. It is the *means* of alteration which are crucial in matters of art in the nineteenth century; and even these identities, disputed and feared as they were, could have been put into a painted surface in such a way that change would have been allowed or at least comprehensible. If that did not happen in *Olympia*'s case, it was because the identities were in the surface, or on it, in such a brutal, odd, unmediated fashion. The surface contained a nude, a Negress, a cat, and some flowers; they were even done skilfully, but the skill was like a parody of itself, and of all the normal ways in which pigment, texture, and tone declare a likeness and let it be qualified. This is perhaps what critics meant, a few years later— when they were able to produce a few words—by calling Manet's handling "curt" or "acrid" or "abbreviated." There is a dreadful mere adequacy to the way things belong in paint when Manet is painting at his best.

We are used to thinking adequacy of this kind—the efficient production of a sign for something, so unequivocally that the mind is hardly engaged in the reconstruction—the mark of bad painting. But in Manet's case it seems to me his most complex and distinctive achievement—and an imaginative act in itself, however much it is meant to disqualify ours. For that reason a response to *Olympia* ought to recapitulate, at least partly, the first critics' sense of exclusion and defeat. A phrase from Baudelaire is useful here: talking of Ingres's painting and the feeling of malaise, ennui, and fear it produced in him, the poet wrote of "a population of automatons, who trouble our senses by their too visible and palpable extraneity" (*une population automatique et qui troublerait nos sens par sa trop visible et palpable extranéité*).[76] It is the best description of Manet's illusionism I know.

Olympia was a prostitute, and that fact alone presented the viewer with difficulties in 1865. Yet even here the case is not simple: there were contexts in this same culture in which the difficulties could be relished as necessary and significant, and they were certainly ones that *art* could make palatable. To start with a casually chosen example, consider the showing of Degas's *Femmes devant un café, le soir*, a pastel-on-monotype included in the third Impressionist exhibition, in 1877 (Plate IX). The critics that year were

certainly aware that the women in question were prostitutes, sitting at a table on the sidewalk of the Boulevard Montmartre, swapping stories and picking up trade information. It was the kind of scene that cropped up quite often in worried surveys of the social question at this time, such as this, from 1869:

There are even some of these *Panuches* who sit at the tables in the windows in the wintertime, or in summer on the verandahs of the luxurious cafés. Laughing and provocative, they gather in certain cafés on the boulevards of Paris which become bazaars of prostitution. The police, overindulgent as they are, turn a blind eye to these exhibitions and find reason to tolerate them. . . .[77]

In the decade of *ordre moral*—when public standards were ostentatiously prim, in expiation of the *fête imperiale* and the several dooms it had brought in its wake—one might have expected Degas's picture to be unpopular. It was not exactly liked, most often, but it was negotiated by the critics with considerable ease; they all saw the point of it, they placed it as part of Degas's exhibit, and the scolding they administered was really rather mild. Bernadille, for example, has this to say in *Le Français*:

Monsieur Degas lacks neither fantasy nor wit nor observation in his watercolours [*sic*]. He has gathered at the tables of an estaminet, or in the cafés-concerts and the corps de ballet, types of a cynical and quasi-bestial truthfulness, bearing all the vices of civilization written in large letters on their triple layers of makeup. But his wit has a heavy hand and a crude expression.[78]

This is close to being the most favourable note—only Caillebotte is better treated—in a long and scathing account of the Impressionists' show. Compare Alexandre Pohey in *Le Petit Parisien*:

Monsieur Degas seems to have issued a challenge to the philistines, that is to say to the classics. *Les Femmes devant un café, le soir* are of a terrifying realism. These painted, blighted creatures, sweating vice, who recount to one another the doings and gestures of the day, you have seen them right enough, you know them, and you will come across them again in a little while on the boulevard. And those hideous singers, braying away with their mouths wide open, are they true enough for you! And that dancer who floats by so gracefully, throwing her last smile to the audience? And the café-concert singer? It is nature studied on the spot, and a movement which is exact, living; transfixing in spite of its crudity.[79]

Degas's pastels appeared to appreciate the dark side of Paris, and this obliged the critics in 1877 to raise a verbal hand or two in horror. "The studies in the boulevard cafés are no less comic and curious, though cruel—passably so." "Passably" was the word: two sentences later and the same critic, Jacques, in an opposition paper called *L'Homme Libre*, was calling the pastel "an incomparable page in the book of contemporary anecdote."[80] And that is the characteristic note: these critics evidently approved of the

satirical edge to Degas's depiction of Paris, and did not seem to find his subjects too rebarbative. Part of their clemency had to do with the pastel's small size and its odd, modest medium, part with its lending itself to an anecdotal reading, and part with the fact that its women were fully clothed. No doubt the critics were tolerant, in other words, because they were able to trivialize Degas's achievement, but that in itself is interesting. It shows how easily prostitutes could appear in painting and be praised; as we shall see, they could even appear in the nude.

Prostitution is a sensitive subject for bourgeois society because sexuality and money are mixed up in it.[81] There are obstacles in the way of representing either, and when the two intersect there is an uneasy feeling that something in the nature of capitalism is at stake, or at least not properly hidden. Reasoning on the subject therefore tends to become overheated, like arguments about transubstantiation; and the issues in question are similar, if secularized. It is specifically a matter of bodies turning into what they are usually not, in this case money. The sociologist Georg Simmel, for example, believed that in prostitution both women and money were degraded, and the latter abasement was hardly less serious than the former. "Money loses its dignity," he wrote, and can only regain it if the price of the sexual act is increased beyond reason, till the sheer glitter of gold obscures the woman's tarnished reputation.[82] Thus the great courtesan redeems money and sex simultaneously, allowing them to put in an appearance arm in arm in the best society. This line of argument was the approximate opposite of that mounted by Simmel's contemporary Karl Kraus, for whom prostitution had a kind of glory, and certainly a symmetry: in it sex was given a genuine value, the only one left, and money was at last *desired* in the way it deserved.[83] But for both writers prostitution was some kind of unlikely plenitude: it was the site of absolute degradation and dominance, the place where the body became at last an exchange value, a perfect and complete commodity, and thus took on the power of such things in a world where they were all-powerful. The prostitute, or so the imaginary story ran, rode roughshod over the client: she offered money's body to him, she named the price.

No doubt these arguments were far-fetched and cynical. They certainly removed the prostitute from the world in which she made her living— the world of the pimp and policeman, of drunkenness, poverty, pregnancy, and the client's straightforward bargaining power. But that, of course, was the arguments' purpose. The prostitute is a *category*: one that authority tries to keep in being on the edge of social space, as a kind of barrier against nature—against the body's constant threat to reappear in civilized society and assert its claims. Balzac put the matter succinctly in his *Splen-*

deurs et misères des courtisanes, when he had a character say to one of his heroines, "You are, in the files of the police, a number, apart from all social beings" (*un chiffre en dehors des êtres sociaux*).[84]

The category "prostitute" is necessary, and thus must be allowed its representations. It must take its place in the various pictures of the social, the sexual, and the modern which bourgeois society puts in circulation. There is a sense in which it could even be said to anchor those representations: it is the limiting case of all three, and the point where they are mapped most neatly onto one another. It represents the danger or the price of modernity; it says things about capital which are shocking perhaps, but glamorous when stated in this form; and by showing sexuality succumbing to the social *in the wrong way* (if completely), it might seem to aid our understanding of the right ones.

That the courtesan was thought to be a main representative of modernity in the 1860s is hardly in need of demonstration: every second book of gossip or sociology has the same story to tell. The ordinariness of the equation is suggested by the passion with which it was sometimes refuted: for instance, in a report by the *facteurs d'instruments de musique* made to the emperor in 1867. The instrument makers were especially alarmed by Haussmann's argument—his excuse for the exodus of industry from the city—that "Paris, to speak properly, has no inhabitants, it is only a floating or, better still, a nomadic population."[85] They replied to the charge as follows:

> This is the moment to point out that here the functionary has followed the example of certain journalists who, speaking of a Paris of idlers and interlopers, have dared to describe it as *tout Paris*.
>
> We have several times put these senseless phrases in their place, phrases which would lead someone who did not know our great city well to believe it composed of nothing but dandies and *cocottes*.
>
> We frankly avow that this Paris of the turf and equivocal gallantry inspires in us only disgust. We are not afraid to say it: it is one of the shames of our time.[86]

So spoke the decent voice of the trades, but of course the instrument makers' indignation changed nothing. It went without saying that modernity *was* made of dandies and *cocottes*, especially the latter. "He talks to us of the *modern* he wishes to do from nature"—the Goncourt brothers are describing the young printmaker Félicien Rops—"of the sinister, almost macabre aspect he found in the house of a whore named Clara Blum, at daybreak after a night of sex and gambling: a picture he wishes to do, and for which he has made forty-five studies of *filles*."[87]

34. Chaffour, cover illustration for "Autre Temps, Autre Mode," c. 1865. Lithograph.

The literature of the 1860s is characterized, in fact, by a fear that the equivalence of Paris and prostitution might be too complete. "We are on our way to universal prostitution" was Dumas's catchphrase in 1867.[88] "Courtesans exist in all times and places. . . . But has there ever been an epoch in which they made the noise and held the place they have usurped in the last few years? They figured in novels, appeared on stage, reigned in the Bois, at the races, at the theatre, everywhere crowds gathered": thus Paul de Saint-Victor, looking back on the empire from 1872.[89] Experts at the time said much the same thing as journalists. They feared an invasion of vice, and in their minds it was associated with the belief that prostitution had slipped out of police control. The streets and stages were full of women who not only sold their bodies but did so *without registering*. It was the "deregulation of vice" that was the matter, and Paris was threatened most mortally by the *insoumise*. Hence the peculiar urgency of Charles Lecour in 1870:

Uncontrolled prostitutes, that is to say nonregistered, form the majority of the personnel of prostitution in Paris. They are everywhere, in the cafés-concerts, the theatres, the balls. One meets them in public establishments, railway stations, and even railway carriages. They are there on all the promenades, in front of most of the cafés. Late into the night they circulate in great numbers on all the finest boulevards, to the great scandal of the public, which takes them for registered prostitutes breaking the rules, and thus is astonished at the inaction of the police in their regard.[90]

Or this, from the *Annales d'hygiène* in 1871:

Clandestine prostitution has completely changed its outward signs; it advertises itself and becomes arrogant: just as things in the old days were kept hidden, nowadays they are put on show.

The *fille insoumise* no longer has another profession; she lives solely on the product of the street to which she has descended, on the same sidewalk alongside the *fille publique*, wearing the same kind of costume.[91]

These images are no doubt overdrawn. For the learned doctors they were a way of arguing for one more campaign against syphilis and gonorrhea, and a general revival of the *police des moeurs*. For the journalists they were figures of decadence in a society which liked to believe in its own dissolution—liked it too well in the end. The rhetoric continued unabated through the 1870s. Experts debated numbers, and Maxime Du Camp excelled, with an estimate of 120,000 prostitutes in Paris alone.[92] The fear of vice invading everything was spliced with wider fears of insurrection and general social mixing. Communard and prostitute often seemed to mean much the same thing to these writers: "Shareholding and sleeping partnerships have spread as far as love itself,"[93] said one, and "we find in the same bed, each given his day and accepting it without jealousy, the son of a good family, the draper's assistant, and the tenth-rate actor" (*le fils de famille, le calicot, le cabotin*).[94]

None of these anxieties were new. At the root of Parent-Duchâtelet's classic description of the prostitute had been the fear that if she were not analyzed, counted, and controlled she would circulate in the social body, spreading disease and confusion. They "come back into the world . . . they surround us. . . . They penetrate our houses, our interiors":[95] that was the danger with courtesans and had always been so. But in the later 1860s these fears were voiced with a new kind of urgency. There was a feeling abroad that the whole effort at counting and quarantining had come to nothing.

If we are to understand the new pessimism, we should first try to establish how prostitution was meant to be organized under the law. Being a prostitute was not in fact a common-law crime, but a network of city

ordinances and police regulations had grown up supposedly to deal with each step of the prostitute's trade, and keep it as wholesome as possible. (If Degas's prostitutes, for example, had been sitting in their café around 1900, they would have been breaking 351 separate prohibitions on their entering such premises;[96] and the situation in 1877 was hardly less complicated.) A prostitute was obliged to register with the police and receive a card. She was subjected as a result to regular checks for venereal disease, and sent to the care of the sisters of Saint Lazarus if she were found to have it. A *fille inscrite* was allowed to operate in two main ways. She could earn her living as a *fille publique*, an accredited member of a brothel recognized by the police and monotonously raided; or she could earn the uncommon status of *fille en carte* and begin a career as *isolée*—walking the streets, taking care not to fall foul of the unwritten rules surrounding *racolage*, her life a labyrinth of registrations, reports for duty, inspections, and proprieties.

This structure was never much more than a set of excuses for haphazard repression. There was always on the edge of it an informal war and collusion between the police and that great mass of women who did not collect their cards. Prostitution was many-faceted and widespread: nobody believed that it could be wholly confined to the brothel, with the doctor arriving each month with his speculum and *chaise*; but the system could be said to work if its specifications were not too grossly exceeded by what people saw on the streets; women might slip through the net, but the net existed, and its mesh at least divided them into classes—they were *filles publiques* or *isolées*, they were *insoumises* or part of *la prostitution populaire clandestine*, and so on. The system was a means of knowing the prostitute, and keeping her "dans les cartons de la police, un chiffre en dehors des êtres sociaux."[97]

When there was talk of invasion in the 1860s it was a matter first of visibility on the streets. As usual, Haussmannization was given a large part of the blame, and to some extent deservedly. The baron's demolitions had laid waste some famous streets of brothels near the Louvre and on the Ile de la Cité; the general rise in rents had obliged the owners of some brothels to move them out to the periphery, and many more to convert their establishments into *hôtels garnis* at the disposal of the individual streetwalker.[98] The city had changed shape, and the usual places in which the prostitute sought her client—places where men danced, drank, took dinner, or were entertained—had multiplied and become more conspicuous. Behind these matters of fact there were other changes taking place, more pervasive and harder to grasp at the time. The basic conditions which had determined the *demand* for prostitution in the first half of the century were coming

to an end: no longer was the ordinary prostitute most often catering to the physical need—the simple sexual deprivation—of a worker recruited from the countryside, living in the city as a kind of stranger and suffering from a shortage of women of his own age and class. That immigrant proletariat was being made part of Haussmann's city, in the manner already described. What it wanted from sex for money was changing: here, as elsewhere, it began to take its cue from the behaviour of the bourgeoisie.[99]

The bourgeoisie believed in Desire. The papers and streets were supposed to be full of it, and its force was imagined as working and changing the whole social body—breaking down the old distinctions between urbanity, sexual tolerance, *galanterie*, adultery, debauchery, and prostitution proper. These things appeared to be becoming aspects of one another, and men and women moved among the various states with ostentatious ease. In the 1860s there began to be visible as a consequence a new kind of demand from the prostitute's client, one which eventually altered the whole trade— a demand for intimacy, for the illusion of seduction. That doubtless went hand in hand with other theatricals, of pain and degradation, dominance and submission, Sacher-Masoch and de Sade. It made the prostitute's job more dangerous; and Edmond de Goncourt's description in *La Fille Elisa* can stand—a translation would sabotage its stabbing, perfunctory syntax— as the best description of the new regime:

D'ordinaire, à Paris, c'est la montée au hasard, par une ivresse, d'un escalier baîllant dans la nuit, le passage furieux et sans retour d'un prurit à travers la mauvaise maison, le contact colère, comme dans un viol, de deux corps qui ne se retrouveront jamais. L'inconnu, entré dans la chambre de la fille, pour la première et la dernière fois, n'a pas souci de ce que, sur le corps qui se livre, son érotisme répand de grossier et méprisant, de ce qui se fait jour dans le délire de la cervelle d'un vieux civilisé, de ce qui s'échappe de féroce de certains amours d'hommes.[100]

Surely Goncourt did not exaggerate the grimness and risk very much; but to his verdict should be added (it is the final irony of prostitution in the bourgeois era) that what fuelled the anger now was disappointment. For this, after all, was what money could buy; behind the apparatus of desire—on the other side of a great image, that of the courtesan and her cognates—was merely this abrupt, bathetic transaction. Someone must pay for it, and it could hardly be the drunken old man—he had paid enough already.

The fear of invasion—to return to that cliché—thus consisted of several different fears. It was partly a dislike of Haussmann's city and the general ambiguity it brought in its wake. There was a feeling that clandestines were everywhere and the policeman's mathematics more pure than applied. The boundaries between moral laxity and prostitution seemed to be dis-

solving, and this was held to be the more dangerous because it was not just sexuality that strayed over into the public realm, but money—money in fleshly form.

Of course there were ways in which the empire took pride in making money visible. That was its special glamour as an age, and there could be something almost comforting in the comparison—it was often made—between prostitution and high finance. "Les hommes boursicotent, les femmes traficotent":[101] analogies of this kind could be made quite lightly. The metaphor was not unsettling so long as its terms were made part of the same spectacle—the scheming men and unscrupulous women stepping out in a dance of experts and strangers, with money calling the tune. If prostitution could be represented thus, it posed no special threat to society's self-esteem; rather the contrary, in fact. But if it escaped from the spectacle or overwhelmed it—and that seemed to be the commentators' fear—it might still prove, even as an image, an embarrassment. For it could easily be taken to show money inflecting everything now, even those corners of life the culture wished to have private and "personal." The fear of invasion amounted to this: that money was somehow remaking the world completely, that it might indeed—as Parent-Duchâtelet had feared—"come back into the world . . . penetrate our houses, our interiors." Such an image of capital could still not quite be stomached.

Like any other society, the empire needed a representation of sex—representation here meant in its two main senses. The empire had to give sexuality a certain form, and wished to make it the property of a chosen few: women who would be given power over what they possessed, but also *impersonality*, a quite special existence lived out on the edge of the human world. These were the women called *courtisanes*. And they were part of the normal order of things: they were a necessary term in the myth of the "social," one which defined, by opposition, the more difficult category *femme honnête*. "Prostitution," wrote the *Westminster Review* in 1868, "is as inseparable from our present marriage customs as the shadow from the substance. They are the two sides of the same shield."[102] Of course the English writer wished to be understood in practical terms: he had in mind the need for guarantees of female chastity, and outlets for young men who had not yet come into money. But the truth of the argument exceeds his common sense: it can be said to apply at the level of epistemology. *Courtisane* and *femme honnête* are classifications dependent on each other for what clarity they have, in areas of conduct and perception where most things are in doubt. They are sides of the same shield, even if it is necessary for them not to perceive the fact.

Consider, for example, Parent-Duchâtelet's dream (it haunted the dis-

COLOR PLATES

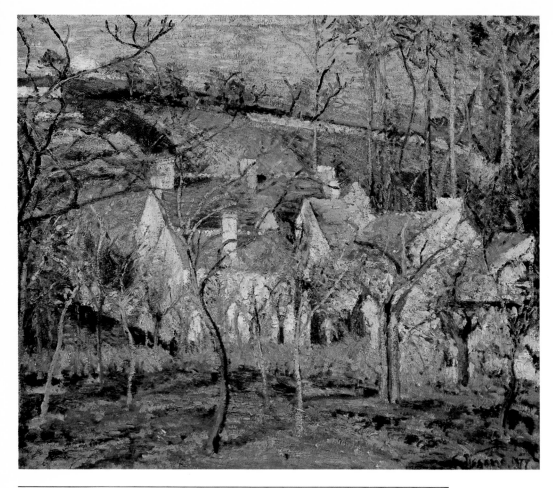

I Camille Pissarro, *Coin de village, effet d'hiver*, 1877.

II Camille Pissarro, *Coin de village, effet d'hiver* (detail).

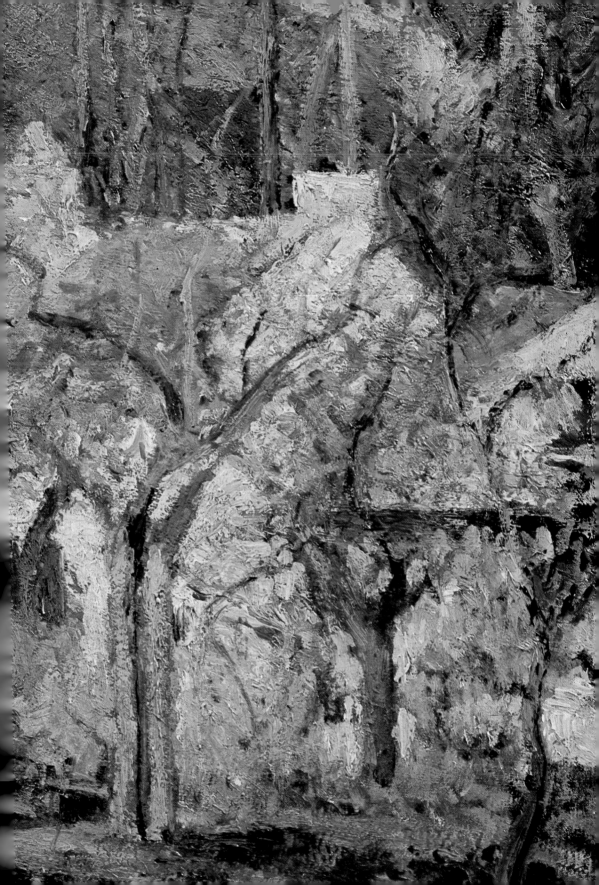

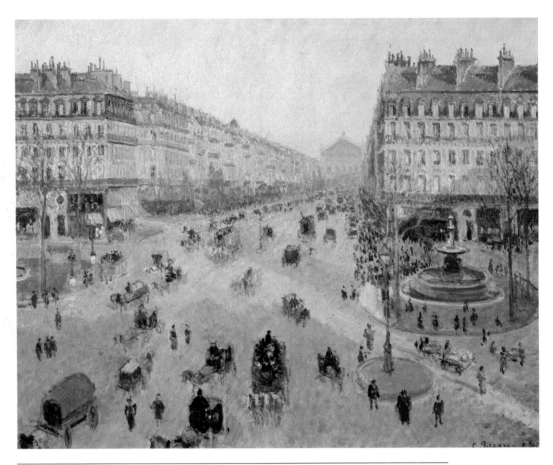

III Camille Pissarro, *Avenue de l'Opéra, soleil, matin d'hiver*, 1898.

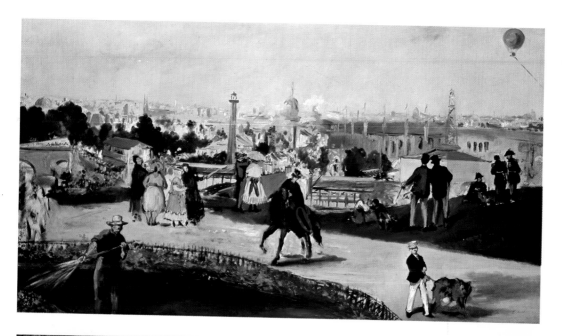

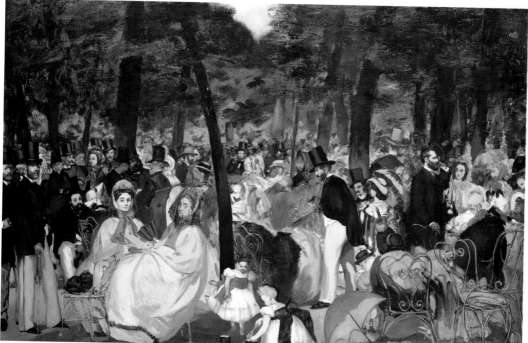

IV Edouard Manet, *L'Exposition Universelle de 1867*, 1867.
V Edouard Manet, *La Musique aux Tuileries*, 1862.

OVERLEAF VI Edouard Manet, *Olympia*, 1863.

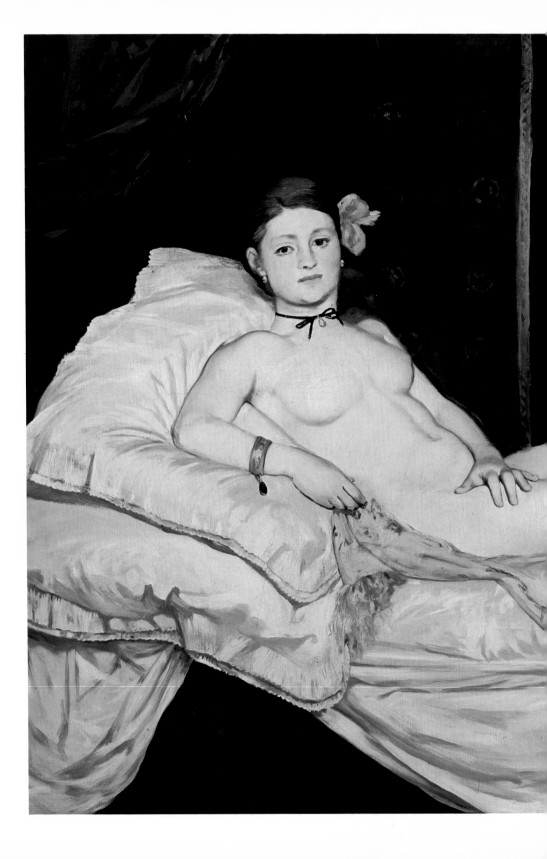

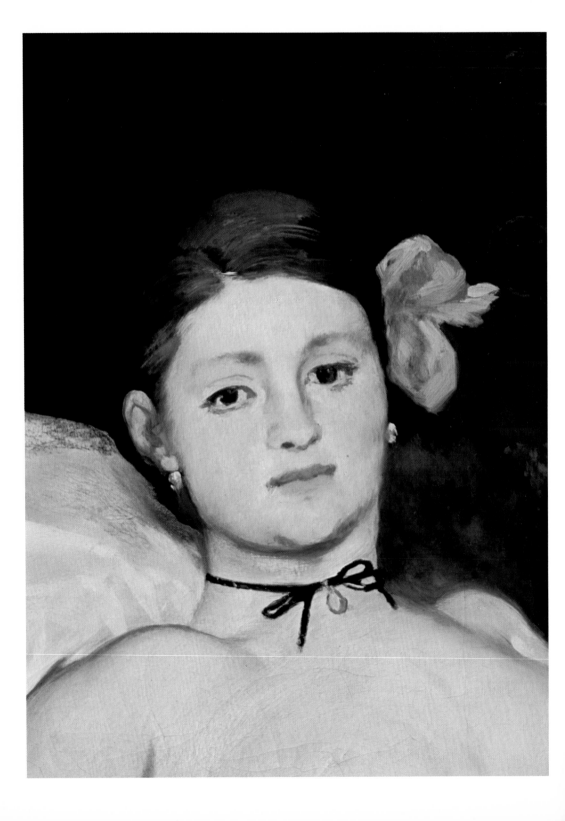

VIII Edouard Manet, *Olympia* (detail).

VII Edouard Manet, *Olympia* (detail).

IX Edgar Degas, *Les Femmes devant un café, le soir*, 1877. Pastel on monotype.

X Jean-Auguste-
Dominique Ingres, *Vénus
Anadyomène*, 1848.

XI Edouard Manet, *Argenteuil, les canotiers,* 1874.

XII Edouard Manet, *Argenteuil, les canotiers* (detail).

XIII Georges Seurat, *Une Baignade à Asnières*, 1883–84.

XIV Edouard Manet, *Claude Monet et sa femme dans son bateau-atelier*, 1874.

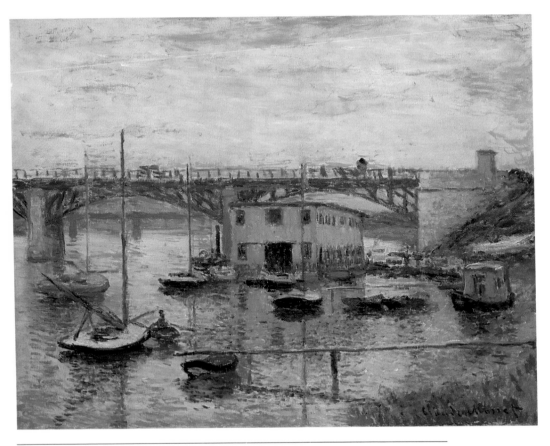

XV Claude Monet, *Le Pont d'Argenteuil, temps gris,* c. 1874.

XVI Claude Monet, *Le Train dans la neige à Argenteuil,* 1875.

XVII Claude Monet, *Le Pont du chemin de fer à Argenteuil,* 1873.

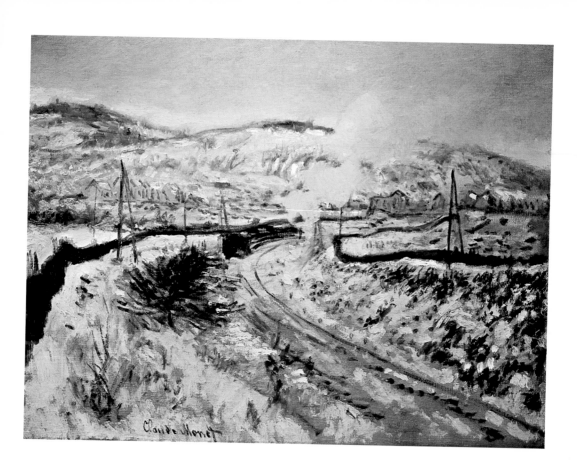

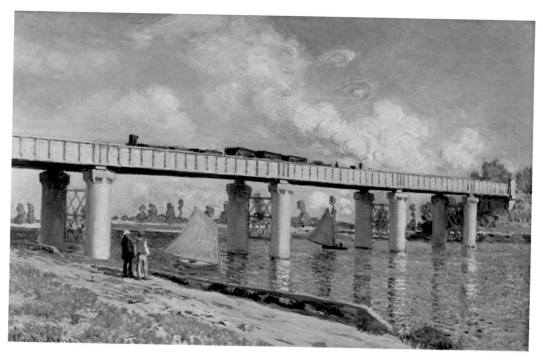

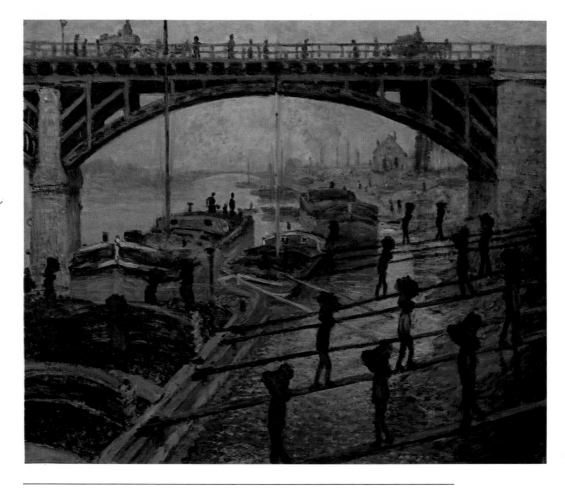

XVIII Claude Monet, *Les Déchargeurs de charbon*, 1875.

XIX Claude Monet, *Les Déchargeurs de charbon* (detail).

XX Claude Monet, *Boulevard Saint-Denis, Argenteuil*, 1875.

XXI Claude Monet, *Vue d'Argenteuil, neige*, 1875.

XXII Edgar Degas, *Au Café-concert, le chanson du chien*, c. 1875–77.

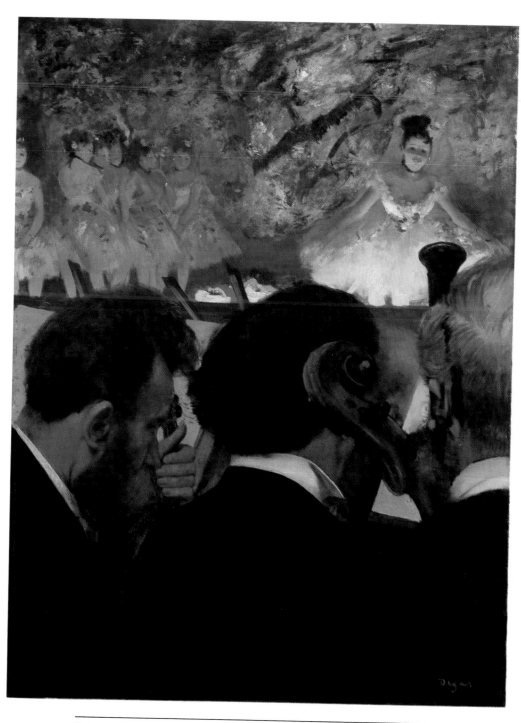

XXIII Edgar Degas, *Les Musiciens à l'orchestre*, 1872.

XXIV Edouard Manet,
Un Bar aux Folies-Bergère,
1882.

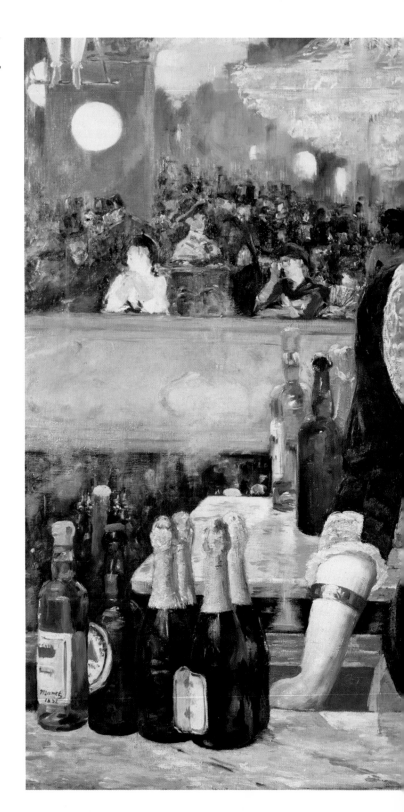

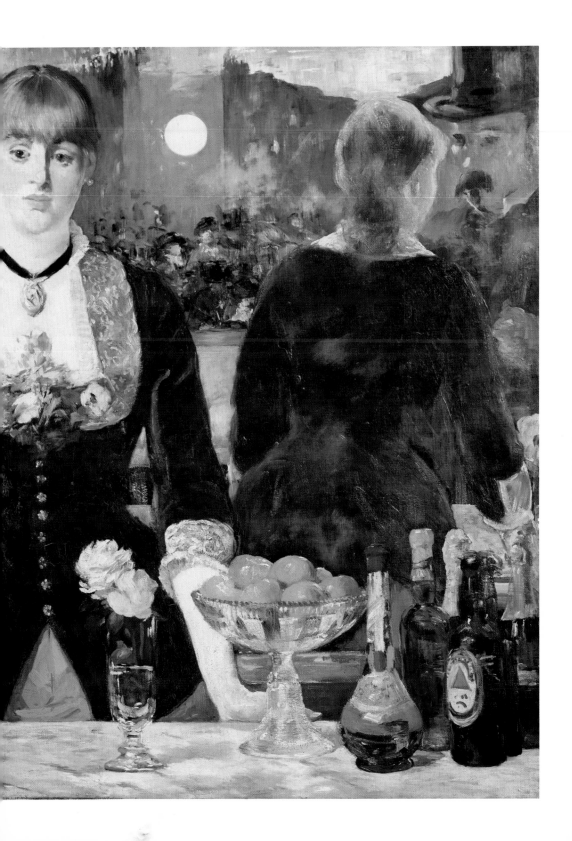

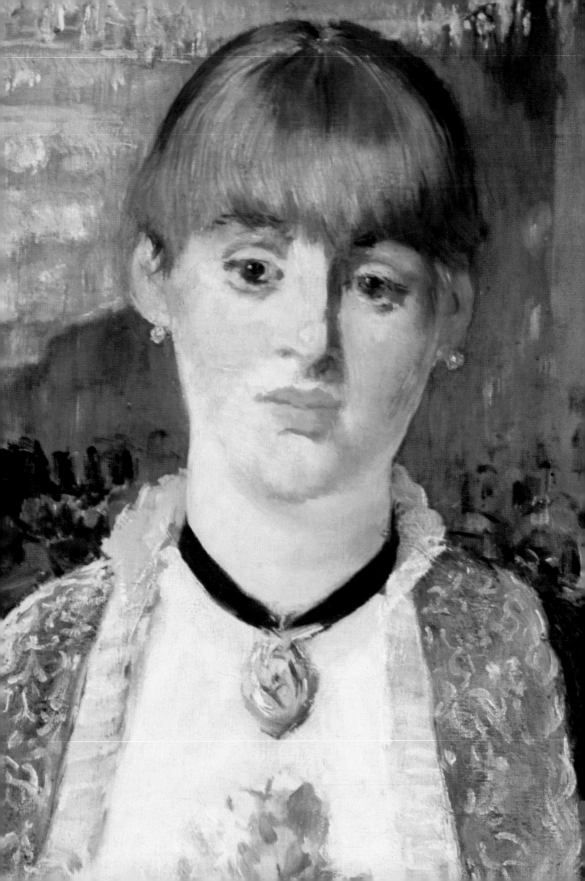

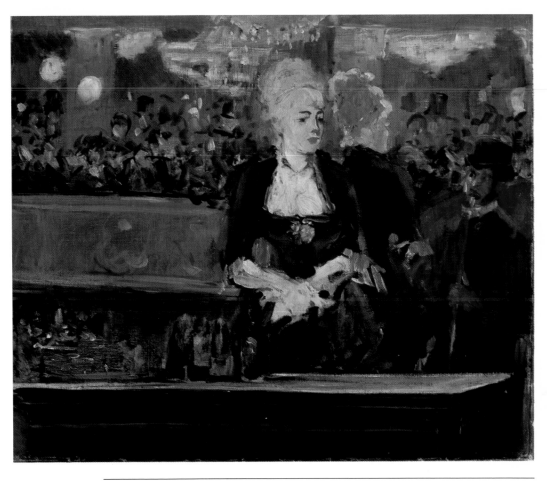

XXVI Edouard Manet, *Un Bar aux Folies-Bergère*, c. 1882.

XXV Edouard Manet, *Un Bar aux Folies-Bergère* (detail).

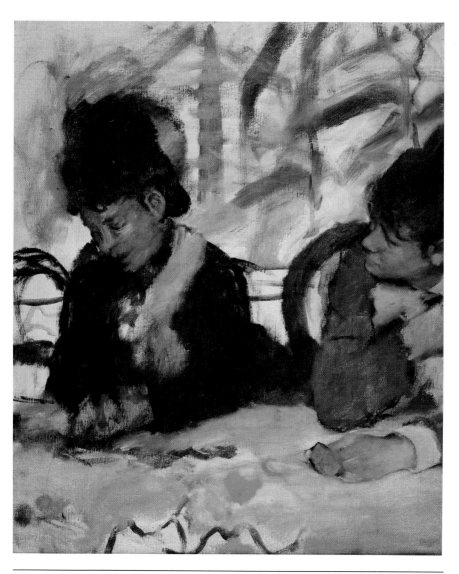

XXVII Edgar Degas, *Au café*, c. 1877–80.

XXVIII Edgar Degas, *Portrait de Michel-Lévy*, c. 1873.

OVERLEAF XXIX Georges Seurat, *Un Dimanche après-midi à l'île de La Grande Jatte*, 1884–86.

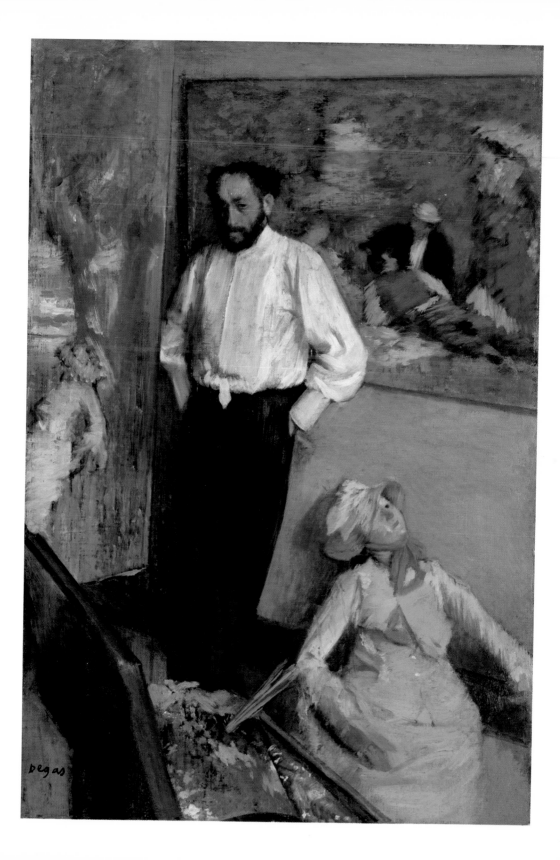

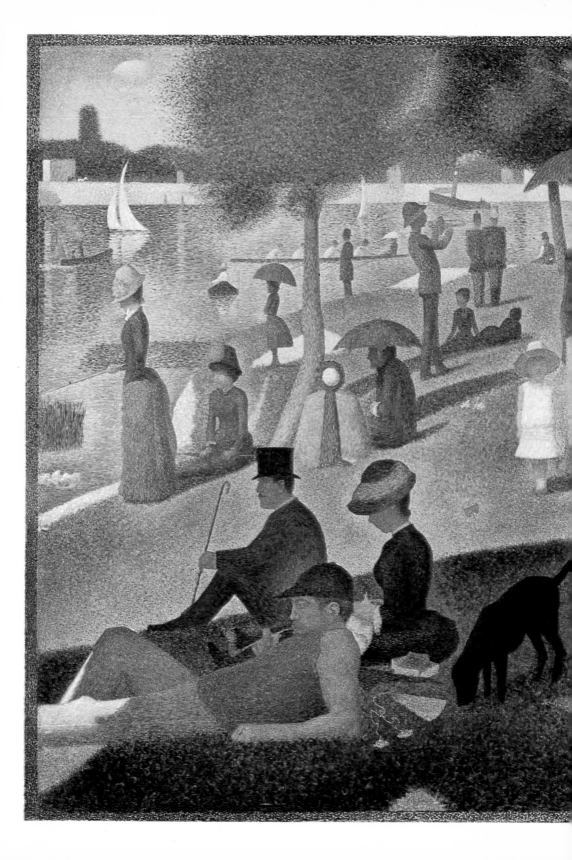

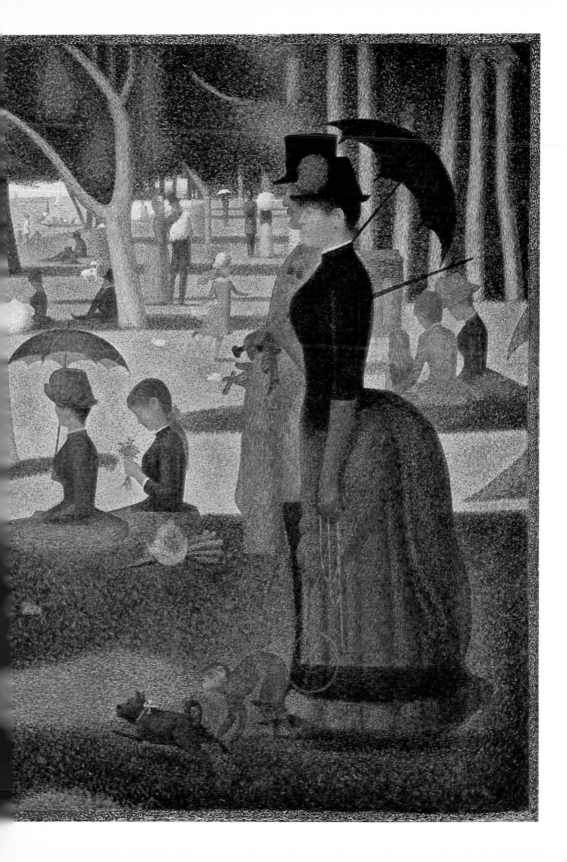

XXX Georges Seurat, *Un Dimanche après-midi à l'île de La Grande Jatte* (detail).

course of the experts who followed):

We will have arrived at the limit of perfection, and of the possible, in this regard, if we arrange it so that men, and in particular those who are looking for [prostitutes], can distinguish them from honest women; but that those women, and especially their daughters, cannot make this distinction, or at least can do so only with difficulty.[103]

We might ask of this imaginary scheme of things: first, why is it desirable, and second, whom is it desirable for? The answers are clear from the text itself. The women in the case know more or less nothing about what is going on; and doubtless Parent-Duchâtelet would have said that even the streetwalker, beneath her cynicism, was ignorant of the essential distinction—between herself and *honnêteté*. Women must know nothing in order for men to know: it is striking that in Parent-Duchâtelet's best of all possible worlds it is not only the client who can tell the difference, but any man: all men possess the categories, only some men will wish to possess what they contain.

The clearest statement of the general logic here is made by Huysmans in his novel *Marthe*. Towards the end of the story, the abominable hero, Léo, forgives his prostitute lover in a letter announcing his return to polite society. He offers her pardon because she has done a certain indispensable work: "Women like her," Léo sums up, "have this much good about them, that they make us love those they do not resemble; they serve as *repoussoir* to respectability."[104]

This was the essential task of the *courtisane*, or the *joueuse*, the *lionne*, the *impure*, the *amazone*, the *fille de marbre*, the *mangeuse d'hommes*, the *demi-mondaine*, or the *horizontale*—her names were legion, but they all meant much the same thing. The *courtisane* was a category, that is my argument: one which depended not just on a distinction made between *courtisane* and *femme honnête*—though this was the dominant theme of the myth—but also on one between *courtisane* and prostitute proper. The category *courtisane* was what could be *represented* of prostitution, and for this to take place at all, she had to be extracted from the swarm of mere sexual commodities that could be seen making use of the streets. These humbler tradespeople were shuffled off stage, and the world of sex was divided in two: on the one hand, the dark interior of the *maison close*, where the body escaped outright from the social order, and on the other the glittering, half-public palaces of the *grandes cocottes* on the Champs-Elysées. Money and sex were thus allowed to meet in two places: either apart from imagery altogether, in the private realm, in the brothel's illicit state of nature; or

in the open space of the spectacle, the space of representation itself, where both could appear as images pure and simple.

Of course it was possible to doubt these ideological distinctions, especially that between *courtisane* and *fille publique*. Jules de Goncourt, for example, was sceptical, coming back from an evening at La Barucci's in 1863:

That makes several great *courtisanes* I have had the chance of knowing. In my opinion none of them escapes from the class of prostitutes. They offer you nothing but a woman of the brothel. Whether they emerge from it or not, it seems to me that they smell of it for ever, and by their gestures, their words, their amiability, they constantly return you to it. None of them, this far, has seemed to me of a race superior to the woman of the streets. I believe that there are no *courtisanes* any longer, and all that remain are *filles*.[105]

But this kind of cynicism was only the obverse of the myth; for the most part in the 1860s the distinctions Goncourt begs leave to doubt were maintained quite successfully, and the *courtisane*'s qualities rehearsed at length—in the press, on the stage, in songs and photographs and the stream of books and pamphlets on Parisian *moeurs*.

The *courtisane* was supposed to be beautiful. Therefore her price was high and she had a choice of clients, to some degree. Her business was dominance and make-believe; she seemed the necessary and concentrated form of Woman, of Desire, of Modernity (the capital letters came thick and fast). It was part of her charm to be spurious, enigmatic, unclassifiable: a sphinx without a riddle, and a woman whose claim to classlessness was quite easily seen to be *false*.

The myth of the *courtisane* may strike us now as tedious and dispiriting, and the list of her qualities will not bear much elaboration. But there has to be a word or two about dominance and falsity, the key items in the bill of fare. They both derived, no doubt, from the *courtisane*'s role as representative of Desire: Desire ruled and Desire deluded, and consequently so did she. She was "the captain of industry of youth and love,"[106] she was "the true, the only 'Classe Dirigeante.' "[107] Naturally these claims were not meant to be taken seriously, and it was part of the myth that the *courtisane*'s attempt to be one of the ruling class should eventually come to nothing. Here, for example, is Dr. Jeannel:

Most often they try, in their pompous and crumpled costumes, to follow the latest fashions for balls and soirees! . . .

Their language, as gross as that of the lees of the people, and which they season quite naturally with obscenities, thicken with jargon and patois, or enrich with argot; their worn-out, raucous voices with their ignoble timbre; . . . their *tutoiements* and their swearwords, their falsely lascivious glances, the nicknames they give themselves—all of this makes a hideous contrast with the appearance and manners of the *grand monde*, which they so pretentiously and clumsily counterfeit.[108]

This verdict is rather too harsh to be typical: it is, after all, an expert in public hygiene speaking, with an interest in appearing above mythology. Those with no such interest were less sure that the illusion was unsuccessful:

> . . . clothes, jargon, pursuits, pleasures, cosmetics, everything brings together the *demi-monde* and the *monde entier*; everything allows us to confuse things which should not even be aware of one another's existence. . . . The nobleman's wife from the Faubourg Saint-Germain passes, on the staircase at Worth's, the elegant female from the Quartier Bréda.[109]

These writers were sure that the *courtisane*'s great game was to play at being an honest woman; and she played very skilfully, though not so well as to deceive her clients; that would have spoilt the whole thing. Her purpose was to pretend to be a woman of no identity and many: her admirers knew perfectly well that she had come from the *faubourgs* or the Parisian lower depths, and she even took care that her speech should indicate that freedom; for what she had to offer her guests—the Goncourts were really no exception here—was the fact of her own falsity.[110] It was her most lavish production: "Bored chatelaine, misunderstood bourgeoise, failed actress, corrupted peasant girl, she is all of these. . . . She is the perpetually undeciphered enigma, intriguing and terrifying man."[111]

Bourgeois, peasant and *petite faubourienne*—the *courtisane* was the person who moved most easily between roles in the nineteenth century, trying on the seemingly fixed distinctions of class society and discarding them at will, declaring them false like the rest of her poses. And falsity was what made her modern—in Rops's terms or Ravenel's, or even Flaubert's in retrospect.

Looking back on the empire in September 1870, Flaubert penned the inevitable epitaph for the decade. "Everything was false," he wrote, "false army, false politics, false literature, false credit, and even false *courtisanes*."[112] This was perhaps as close as the novelist ever came to stating programmatically what he took to be modernity's distinctive features; and it seems that the category is finally secured for him when social practice is soaked right through with duplicity, when nothing is spared from the rule of illusion. In such a society, prostitutes are purveyors of essential goods.

The most cursory survey of the salons in the same period will show how often the *courtisane* was allowed to appear among the portraits and still lifes. She was what could be represented of prostitution, and though the explicitness of visual art made for certain difficulties here, they were regularly circumvented. Year after year the *courtisane* looked down from the salon walls; usually she did so in some kind of antique or allegorical disguise, but there were notable exceptions to even this rule. In any case,

the critics were fond of disbelieving the painters' claim to show them prostitution in ideal form: one had only to attempt a *courtisane* picture to be added immediately to the list of those who set out for Athens each morning and ended in the Rue de Bréda.

In the Salon of 1861, for example, there was a painting by Félix-Joseph Barrias called *La Conjuration des courtisanes* which, from the critics' description, seems to have been taken from the history of Venice. There were two pictures by Gérôme, one of Phryne naked before the Areopagites, and the other of Socrates admiring the great *courtisane* Aspasia. Critics were scornful of the Parisiennes in both of them, trying to look like Greeks.[113] In the same year, Auguste Glaize showed a large picture, nearly nine feet long, entitled *La Pourvoyeuse misère*. On a road outside a gaslit city—too modern to be Babylon or Sodom, it was suspected[114]—a carriage full of naked and half-naked women came across Poverty in the form of a ragged and misshapen old woman. The carriage rolled on. The painter spelt out his moral in the Salon livret:

How many young girls, grown tired of work, throw themselves into all the vices that debauchery brings in its wake, in order to escape from this spectre which seems always to pursue them?[115]

35. Jean-Léon Gérôme, *Phryné devant l'Aréopage*, 1861.

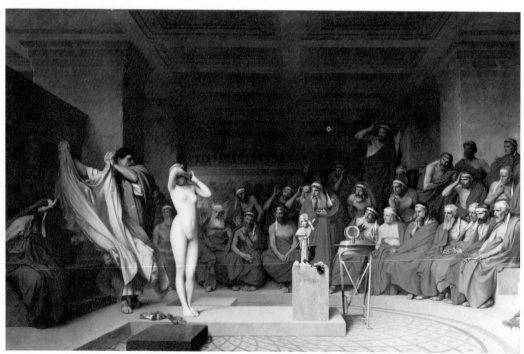

36. Auguste-Barthélemy Glaize, *La Pourvoyeuse misère*, 1860.

Maxime Du Camp was an expert on the subject. In his *Salon de 1861* he launched into the following explanation:

This picture should have been called the wise and foolish virgins. It is the allegorical figuration of what we see every day on our sidewalks and in our theatres, the growing invasion of women of dubious virtue who are today a new element of our society in transition and who, in the always active and intelligent hands of civilization, are perhaps no more than the instruments of equality, destined to make our inheritance prove illusory or at least to put it in forced circulation. When I look at this uninterrupted movement of *lorettes* (let us call them by their name), wave after wave of them, I've often wondered if the lower classes of our society were not carrying on, without being conscious of the fact, the struggle begun at the end of the last century, and whether, in producing these beautiful women whose mission seems to be to ruin and cretinize the haute bourgeoisie and the last remnants of the nobility, they were not continuing quite peacefully the work of the most violent clubs of 1793. Marat today would not ask for the heads of two hundred thousand aristocrats; he would decree the emission of two hundred thousand new kept women, and the result would be the same.[116]

It should be clear from this example—remember that Du Camp kept silent four years later in the face of *Olympia*—that critics knew quite well that prostitution and class struggle were connected, and that this and other dangers were part of the subject's appeal. Tony Zac sent a *Compagnes de Sappho* to the 1868 Salon which was inspired by Baudelaire's *Femmes damnées*, and known to be so.[117] Charles Marchal showed two pictures in the same salon of women in contemporary dress, one entitled *Phryné* and the other *Pénélope*.[118] The following year Emile de Beaumont had a painting hung called *Pourquoi pas?* in which an up-to-date young woman sat at her

dressing table amid a crowd of monstrous and suggestive old men. Gautier explained:

It is a madhouse for millionaires. The *courtisane* looks on at them without fear, without disgust, with that supreme indifference to beauty or ugliness which characterizes these creatures, and from her lips, with a puff of cigarette smoke, escape these words, which sum up what she is thinking: Why not?[119]

Pictures of this kind were almost commonplace, and certainly saleable. In 1864 the art dealer Paul Durand-Ruel paid Thomas Couture no less than 25,000 francs for rights to a picture under way, already called *La Courtisane moderne*.[120] When it was finished—many years later—its debt to Glaize's *Pourvoyeuse misère* was clear; only now the half-naked *courtisane* was dragged in her chariot along a weed-choked road far from the city, past the reproving gaze of a herm. Under her whip were Harlequin and Silenus, and behind them one young man wearing a poet's laurel wreath and another carrying a sword.[121] False army and false literature, no doubt, both dragged along by pleasure and make-believe, and subject to the *courtisane*'s chastisement.

37. Charles Marchal, *Phryné*. Wood engraving after oil painting in *L'Artiste*, 1 June 1868.

38. Thomas Couture, *La Courtisane moderne* (known as *The Thorny Path*), 1873.

These pictures of prostitutes are lunatic and fascinating in their own right, and yet misleading. For this was not the normal way in which the *courtisane* appeared in the salon: she was present for the most part only indirectly, as a kind of inflection or interference in pictures done with a different purpose. She was discovered, and to some extent permitted, in almost *any* depiction of the body or Desire in this decade. She seemed to be the necessary, if regrettable, form of nakedness itself. And not just of nakedness: everywhere that flesh was visible and feminine, the *courtisane* materialized. Consider, for example, the young critic Camille Lemonnier writing on Henri Regnault's *Salomé* in the Salon of 1870:

Her cheeks, white as those of a *fille d'amour*, are daubed with rouge, and pucker at the corner of the mouth into a proud, triumphant smile. . . . Her flesh has a tired and pampered look, a fat, unhealthy moistness, the livid colour that pleasures imprint on the skin of *courtisanes*. . . . I shall not quibble with Monsieur Regnault over the accuracy of his clothes and accessories. I am not looking for history here, I am looking for Woman. . . . I find his figure to be *a* Salome, it does not matter to me if she is not *the* Salome. It is enough if the artist has given us the *fille d'amour* in her crumpled finery, and done so picturesquely and with truth.[122]

39. Henri Regnault, *Salomé*, 1869.

The odd thing here is the self-evidence of Lemonnier's similes, for himself and presumably for his readers: the way it seemed to go without saying that Salome was a courtesan (which, strictly speaking, she was not); the confidence that Regnault's subject was woman in general, which meant *courtisane* in particular; the sight—which may strike us still as the right one—of the prostitute beneath the fancy dress.

The *courtisane* was not an easy subject for visual art. If she were left as an unrecognized inflection of the nude, she might produce representations worse than herself: Paul Baudry's nudes or Alexandre Cabanel's were "less than *courtisanes*," Maxime Du Camp once complained.[123] In any case, she was a dangerous fiction, a woman with a whip, impersonal and vicious, prone to Sappho's deviation,[124] apt to cretinize the bourgeoisie. But whatever the risks, it seemed she had to be represented; and so she was each year, that "chiffre en dehors des êtres sociaux," chased from the happy state of Venice; that ruler of youth, that misleader of millionaires, that Salome who "smells of rut and butchery, fierce in her indifference and lascivious without love."[125]

It is clear that critics in 1865 suspected Olympia of being less than a *courtisane*, and Manet of making her so deliberately. The category *cour-*

tisane, in other words, no longer quite covered or displaced those of *insoumise* and *petite faubourienne*, and the whole untidy place those words suggested of the prostitute in class society.

Yet this cannot be the whole story; or, rather, it cannot explain why the critics reacted as they did in 1865—why their prose was so vehement and strange, and why they found it so difficult to say *how* class figured in *Olympia*, even if they seemed sure that it did so. Class, after all, was regularly one of the *courtisane*'s best performances, and critics like Du Camp could play with the idea of social danger in such cases without seeming unduly nonplussed. Olympia could have been given a place in class and still have hardly disturbed the critics' sensibilities. She could have been pitied or half admired, or consigned to the nether world of pleasure which Alfred Delvau refers to at the end of his 1867 *Plaisirs de Paris*:

It is important here to draw a great demarcation line on the map of *galanterie*. The innumerable fallen women who wander in this great desert of men we call Paris can be divided into two classes. On one side are the poor *misérables*, of whom Victor Hugo talks in his novel of that name, living from day to day and wandering the streets haphazardly, in search of the human animal that Diogenes tried to find, and counting on his generosity to face the expense of their rent, food, and clothes.

There are special books, books of statistics, which will recount the atrocious lives of these daughters of sadness, as Monsieur Michelet calls them. Such turpitudes should have no place in a book devoted to Parisian pleasures. There are sores one must hide and tend in secret. . . .[126]

Hugo . . . Michelet . . . no doubt there were ways in 1865 to represent even the prostitution of the *faubourgs*. But such representations would not necessarily have challenged the myth of the *courtisane*; as Delvau's description suggests very well, they normally did no more than provide a glimpse of the dark and pitiable other side of her power. *Olympia*, on the contrary, tried to describe that power more completely; it tried to unfix the category *courtisane*, by contriving a different kind of relation between a prostitute's class and her nudity. The transcription of class in Manet's picture—this was its odd and *indescribable* force—was nothing now but an aspect of its subject's nakedness.

The challenge to the myth in this was twofold. What the myth essentially did, I have been arguing, was offer the empire a perfect figure of its own pretended social playfulness, of the perfect and fallacious power of money. "Les hommes boursicotent, les femmes traficotent"—and class, in the game, was merely another kind of masking. The *courtisane* put on the mask occasionally, and was appreciated for her falsity in this as in all other things. To break such a circuit, it would not have been enough to show a prostitute

possessed of the outward signs of class—costume and makeup, slippers, flowers, bracelets, servants, tokens of vulgarity or distinction—since these were all believed to be extrinsic to her real power. Her power was her body, which only money could buy.

But if class could be shown to *belong* to that body; if it could be seen to remake the basic categories of nudity and nakedness; if it became a matter of the body's whole address and arrangement, something read *on* the body, in the body, in ways the spectator could not focus discriminately— then the circuit would be broken, and the category *courtisane* replaced by others less absolute and comforting. The body and money would not be unmediated terms any longer, intersecting in the abstract, out there in the hinterland of images; they would take their place as determinate facts in a particular class formation.

Of course, it is not very likely that a picture on its own could do any

40. OPPOSITE Contemporary photograph of state purchases from the 1865 Salon, including (top left) Louis Lamothe's *L'Origine du dessin* and (top right) Louis-Frédéric Schutzenberger's *Europe enlevée par Jupiter*.
41. Contemporary photograph of state purchases from the 1865 Salon, including (top left) François Lemud's *La Chute d'Adam*, (top centre) Firmin Girard's *Le Sommeil de Vénus*, (top right) Félix-Henri Giacomotti's *L'Enlèvement d'Amymoné*, and (bottom centre) Joseph-Victor Ranvier's *L'Enfance de Bacchus*.

such thing. Ideologies are not magically dismantled in single works of art; and if paintings try too hard to anticipate social process, they run the risk of ending up speaking to nobody, neither those inside the world of ideology nor those existing at its edges. It remains to be seen how successful *Olympia* was in redescribing the nude, and whether the price of success was too high.

It so happens that in 1865 the state employed a photographer to record the works it had bought from the salon before they went off to the provinces. Two of the photos that survive group together paintings which contain the female nude. In one there is *Europe enlevée par Jupiter* by Louis-Frédéric Schutzenberger, a pupil of Charles Gleyre, an established salon medallist; and next to it *L'Origine du dessin* by Degas's teacher, Louis Lamothe:

42. Félix-Henry Giacomotti, *L'Enlèvement d'Amymoné*, 1865.

43. Paul Baudry, *La Perle et la vague*, 1863.

"Dibutades, a young Greek woman, traces on the wall the profile of her lover, drawn there by a shadow." In the other photograph there is *Le Sommeil de Vénus* by Firmin Girard, another pupil of Gleyre; an eight-foot *Enlèvement d'Amymoné* by Félix-Henri Giacomotti, winner of the Prix de Rome in 1854; *La Chute d'Adam* by François Lemud; and *L'Enfance de Bacchus* by Joseph-Victor Ranvier.

These pictures make a context for *Olympia*. It is almost too easy to imagine Manet's painting in the midst of them, and consider the differences—between *Olympia* and Schutzenberger, say—too obvious and comic to need much explanation. For what the photos show us is the official nude, the kind derided even at the time as academic, empty, timid, prurient, and bourgeois. Substitute bull for rock, and need we do more than repeat Castagnary's questions, asked two years earlier of Baudry's *Perle et la vague?*—

And how much better this beautiful lady, she with the looks of a Parisian *modiste*, would look upon a sofa! After living so well in her luxury apartment on the Chaussée-d'Antin, she can't feel quite comfortable on this rock, near all those painful pebbles and sharp-pointed shells.

But a thought occurs: what is it she's doing here all alone, rolling her enamel eyes and flexing her dainty hands? Is she lying in wait for a millionaire, on his travels to faraway places? Perhaps this isn't the Venus of the boudoir after all, but the Venus of the seaside resort?[127]

To put the questions another way: Is it any wonder that Cantaloube could hardly discover Titian in *Olympia*, and was disgusted when he did, if this was how the past normally appeared in the nude—as Titian does

in Schutzenberger's picture, or Raphael in Giacomotti's? And if this was the past, then how could the present manifest itself in painting except as some kind of ludicrous disjunction, an unintended text to be read in Europa's profile and hairdo, or Amymone's fierce eyebrows and mouth?

The general run of critics in the 1860s would have put these questions in a somewhat different form, but by and large they would have recognized their force. Critics agreed that the nude as a genre was in a precarious and confused state. The full extent of its disarray can be suggested best by mentioning straightaway some additions to the handful of pictures from the 1865 Salon; for *Olympia*'s competitors are less bizarre than many others of the decade's favourite nudes. There is Cabanel's *Nymphe enlevée par un faune*, for example, which was mightily celebrated in the Salon of 1861, or the same painter's best-selling *Naissance de Vénus*. There is Bouguereau's

44. Alexandre Cabanel, *Nymphe enlevée par un faune*, 1860.

45. Alexandre Cabanel, *La Naissance de Vénus,* 1863.

1863 *Bacchante,* fallen down in drunken glee and playing amorously with a goat; there is Puvis's deadly, unfortunate *Autumn,* and Jules-Joseph Lefebvre's *Nymphe et Bacchus,* sent from Rome to the Salon of 1866 and snapped up immediately for the Musée du Luxembourg. And if we include the 1870s, there are images of outright and imperative lust to add to the canon, like Bouguereau's *Nymphes et satyre* of 1873, in which the nymphs take their revenge on an all-too-human satyr, or Edouard Blanchard's impotent and perverse *Bouffon.*

The confusion of the genre centered, or so the critics said, on matters of propriety and desire, and the fact that there seemed so little agreement about either. Most writers and artists knew that the nude's appeal, in part at least, was straightforwardly erotic. There was nothing necessarily wrong in that, they insisted; it was part of the strength of their beloved "pagan ideal" that it offered a space in which woman's body could be consumed without too much (male) prevarication. Desire was never quite absent from the nude, and the genre provided various figures in which it could be represented: as an animal demand arriving in a half-man, half-goat form; or as Eros, that infatuated guide who stood for man's desire and woman's desirability. But the main business of the nude was to make a distinction between these figures and nakedness itself: the body was attended and to

46. William Bouguereau,
Une Bacchante, 1863.

47. Jules-Joseph Lefebvre,
Nymphe et Bacchus, 1866.

48. William Bouguereau, *Nymphes et satyre*, 1873.

49. Edouard Blanchard, *Le Bouffon*, 1878.

some extent threatened by its sexual identity, but in the end the body triumphed. To make the language less metaphorical: the painter's task was to construct or negotiate a relation between the body as particular and excessive fact—that flesh, that contour, those marks of modern woman—and the body as a sign, formal and generalized, meant for a token of composure and fulfilment. Desire appeared in the nude, but it was shown displaced, personified, no longer an attribute of woman's unclothed form.

I might make the point clearer by applying these absolute standards to a picture by Ingres, the *Vénus Anadyomène*, completed a generation earlier, in 1848 (Plate X). It is an appropriate painting to take as exemplary, since so many of the artists and writers of the 1860s looked back to it as a recent classic of the nude, and sometimes paid homage to it directly.[128] No critic worth his salt would have wished to deny that Ingres's Venus was sexually enticing, and intended to be. He might even have admired Ingres's ability to make a certain kind of sexual content legible in an unembarrassed way. Not that he necessarily would have wished, or been able, to translate the passage at the picture's bottom right—adoring *putto*, penis, dolphin, foam, red eye, fishtail, snout—into the analytic terms which are established, more or less, for the twentieth-century reader. But the picture's subject *was* Venus, and the *putti* are there to enact her power, offering her a mirror and us an arrow. The key word here, for the critic, would have been "enactment." The unavoidable sexual force of this nakedness is transposed into various actions and attributes, and made over into a rich and con-

ventional language. What is left behind is a body, addressed to the viewer directly and candidly, but grandly generalized in form, arranged in a complex and visible rhyming, purged of particulars, offered as a free but respectful version of the right models, the ones that articulate nature best.

The painting of the nude in the 1860s could be characterized by its inability to do the things Ingres does here. In the pictures I have presented already, sexual force and nakedness are most often not disentangled. When they are, and the active proponents of desire are included, there seems to be a massive uncertainty about how much reality to grant them: satyrs, fauns, and cupids regularly take on too much of the look of goats, male models, and three-year-old children. The naked body itself, as the critics

50. Eugène-Emmanuel Amaury-Duval, *La Naissance de Vénus*, 1862.

in the 1860s never tired of saying, is left curiously hybrid, marked by modernity in an incoherent way. If it is chaste, and it sometimes is, it is rigid and inanimate with its own decorum; and if it engages with sexuality, it does so in ways which verge on violence or burlesque.

Something is wrong here: a genre is disintegrating. Perhaps in a general way Castagnary was right to blame the bourgeoisie for the state of the nude: no doubt a culture pays a price for exaggerated concern for the proprieties, especially if such a concern sits ill with its appetite for sexual entertainment. But it does not necessarily pay it in terms of art. It would be hard to argue that Titian's Ferrara or Correggio's Mantua were notably healthier in sexual terms than Bouguereau's Paris. The nude is a matter not of sexual health but of artistic conventions, and it is these that were foundering in the 1860s. If there was a specifically bourgeois unhappiness, it centered on how to represent sexuality, not how to organize or suppress it. (Though the one unhappiness had effects. . . .)

One might expect these problems—especially the way they seemed to invite a reading in terms of some general cultural doom—to produce a lot of bad criticism. One might especially predict, at the end of a genre, a squad of Cassandras inflexible for truth and purity; and, sure enough, they existed. In the face of Cabanel's *Vénus* and Baudry's *Perle*, Maxime Du Camp put paid to the salon nude in general. "Art," he wrote in 1863, "should have no more sex than mathematics."[129] The mark of the nude in art was chastity and abstraction: "The naked body is the abstract being, and thus it must preoccupy and tempt the artist above all; but to clothe the nude in immodesty, to give the facial features all those expressions which are not spoken of, that is to dishonour the nude and do something disreputable."[130] The nude "ceases to be honest when it is treated so as intentionally to exaggerate certain forms at the expense of others,"[131] when its poses are "provoking," its attitudes "violent," and its whole language contorted and unnatural.

The vocabulary is tortuous—trying to speak of sex and yet not to speak of it—but the message is clear. Desire is no part of the nude: the nude is human form in general, abstracted from life, contact, attraction, even gender. Ingres is called in by Du Camp to attest to all these things.[132]

Now, insofar as critics in the 1860s attempted a general theory of the nude, they found themselves drifting in Du Camp's direction. Often they did so in spite of an effort—a quite spirited one—not to be absolute and moralistic. Here, for example, is Camille Lemonnier in 1870:

. . . The nude is not the same as the *undressed*, and nothing is less nude than a woman emerging from a pair of drawers or one who has just taken off her chemise. The nude has modesty only if it is not a transitory state. It hides nothing

because there is nothing to hide. The moment it hides something it becomes prurient, for in reality it shows it all the better. In order to stay virgin the nude in art must be impersonal and must not particularize; art has no need of a beauty spot upon the neck or a mole on the hindquarters. It hides nothing and shows nothing: it makes itself seen as a whole. . . .

The nude has something of the purity of little children who play naked together without minding at all. The *undressed*, on the contrary, always reminds me of the woman who shows herself off for forty sous and specializes in "artistic poses."[133]

But compare Lemonnier's statement of general rules and purposes with his description, in the same *Salon*, of a lost picture by Alphonse Lecadre:

The breast is well realized: one sees its lassitude, the marks of embraces upon it, the traces of kisses, and the breasts hang down, pulled out of shape by pleasure. There is a real solidity to the girl's form, and the grain of her flesh, stamped out in powerful impasto, is like a solid mass of close-woven fabric under the touch.[134]

And compare Lemonnier with Edouard Hache, describing a picture by Ferdinand Humbert in the 1869 Salon, of a North African odalisque sprawling naked on a bed:

The pose is bizarre, I grant you; the head horrible, certainly; and let us agree that the body is hardly seductive, if you insist. But what admirable drawing! With what richness of colour the painter has rendered the shifting tones of the flesh! And the modelling, the fineness of the belly, the delicacy of the arms, the soft folds that hollow the breasts! How palpably the nude's flesh sinks into those fine red cushions! It really is the woman of the Orient, in all her softness and bestiality.[135]

The examples could be multiplied. What they suggest is hardly surprising: the general rules simply did not apply when the critic was faced with particular nudities. The appeal of the nude was both simpler and more complex than theory, in an anxious time, could possibly allow. It included, as Cantaloube put it of Cabanel's *Nymphe*, "the idea of voluptuous beauty."[136] And even the insistence on *pudeur* would not make sense completely if the image did not include elements or traces of its opposite. In Jourdan's *Secrets de l'amour*, for example, from 1866, a naked young woman was surprised by Love in a wood. This is Félix Jahyer's description of the scene that ensued:

The child is artful and insistent: as he tells his dangerous secret his little hand is placed on the adolescent's breast, and she in turn, in a movement of exquisite grace, puts her own hand in the same place, which proves she has to defend herself against some kind of sensation. The child's delicious profile is put boldly against the delicate face of his confidante, in whom modesty and pleasure are joined in an adorable combat.[137]

We end in bathos, but it is there we are told the obvious truth. Of course

the burden of the nude was conflict, adorable or otherwise, between pro-
priety and sexual pleasure. The genre existed to reconcile those opposites,
and when the nude was working normally as a form of knowledge, both
would be recognized in criticism and spelt out in paint. In the 1860s that
did not happen: the nude, for the most part, was conceived to be the strict
antithesis of sex; because sex had no part in the matter, it kept appearing
directly in the flesh, unintended, as something which spoilt what was meant
to be a pure formality.

I have argued once or twice already against the critics' readiness to see in
all this a test of the empire's general sexual health. Théophile Thoré had
his own reasons for making that kind of premature equation—he had fled
from the empire in 1851—and dealing with the salon nude in 1865 he saw
no reason to doubt that its form answered immediately to the tastes of a
new ruling class:

Who is it encourages mythological and mystical art, Oedipuses and Venuses,
madonnas and saints in ecstasy? Those in whose interests it is that art means
nothing and fails to connect with modern aspirations. Who encourages these
nymphs and scenes of courtship à la Pompadour? The Jockey Club and the
Boulevard Italien. To whom are these pictures sold? To *courtisanes* and stock-
exchange *nouveaux riches*, to the dissipated members of a particular aristocracy.[138]

Thoré's questions and answers may be crude, but that does not neces-
sarily mean they are mistaken. Clearly the break-up of the nude is at some
level a social matter. The nude is a term of art and art criticism; but I
have quoted enough from the writers of the 1860s to make it clear that
art criticism and sexual discourse of a more general kind intersect at this
point, the one providing the other with crucial representations. Or so the
culture hopes: the nude is one important form—and there are very few—
in which sexuality can be put on show in the nineteenth century. It is the
place in which the body is revealed, given its attributes, brought into order,
and made out to be unproblematic. It is the frankness of the bourgeoisie—
here, after all, is what Woman looks like; she can be known in her
nakedness without too much danger. That is because her body is separate
from her sex. Her sex, one might say, is a matter of *male* desire: those
various fauns, bulls, falling coins, enfolding clouds, tritons, goats, and *putti*
which surround her. There they all are, for the male viewer to read and
accept as figures of his own feelings; and there *she* is, somehow set apart
from her own sexuality, her nakedness not yet possessed by the creatures
who whisper, stare, or hold up mirrors.

It was exactly the problem of the nude in the 1860s that this separation

proved so hard to obtain. Sex was supposedly expelled outright from Woman's body, only to reappear within it as a set of uncontrolled inflections—those rolling eyes and orgasmic turns of the hip that the critics spent their time finding decent ways to denounce. The nude became embarrassing; and what *Olympia* did, I shall argue, is insist on that embarrassment and give it visual form. It is as if Manet's picture drew the logical conclusions from the chaos of Bouguereau and Cabanel. The nude in its degenerating state was right about sexuality: sexual identity *was* nowhere but in the body; and it was not there as a structure or a set of attributes, but had to be figured as interference and excess, a tissue of oddities and inconclusiveness.

Of course the picture still contained, in a clichéd, almost comic fashion, the signs of separate male desire: there was the hissing tom cat and the offering of flowers from Monsieur Arthur. But these were read at the time, and surely correctly, as a kind of travesty of the old language of the nude; and Desire itself, in a form which carried any conviction, was the property now—the deliberate production—of the female subject herself. It was there in her gaze, her address to the viewer, her consciousness of being looked at for sexual reasons and paid accordingly—no doubt a good deal more than forty sous.

A nude, to repeat, is a picture for men to look at, in which Woman is constructed as an object of somebody else's desire. Nothing I go on to say about *Olympia* is meant to suggest that Manet's painting escapes that wider determination, or even escaped it once upon a time, in the 1865 Salon. It was meant as a nude and finally taken as one; the texts I have collected should not be read as so many indices of defeat in that project, but, rather, for signs of difficulty surmounted. The critics were obliged to take a metaphorical detour, produce their own hesitations, play with the picture's recalcitrance, before they declared it a nude of some kind—comic perhaps, or obscene, or incompletely painted. Nonetheless, the difficulties *counted* in 1865: the anger and uncertainty were not simply ersatz. The anger needs explaining, therefore; even if, in the critics' writing, it is already presented in retrospect, as a kind of fiction.

I have argued the gist of the matter already. Olympia is depicted as nude and *courtisane*, but also as naked and *insoumise*; the one identity is the form of the other, but the two are put together in such a way as to make each contingent and unfinished. The case is particularly clear when it comes to the picture's obvious main subject: Olympia's beauty, her sexual power, and how that relates to her body's being female. It is sometimes

said—it was said already in 1865—that Olympia is not female at all, or only partly so. She is masculine or "masculinized"; she is "boyish," aggressive, or androgynous. None of these words strikes me as the right one, but they all indicate quite well why the viewer is uncertain. It is because he cannot easily make Olympia a Woman that he wants to make her a man; she has to be something less or more or otherwise aberrant. This seems to me wrongheaded: surely Olympia's sexual identity is not in doubt; it is how it belongs to her that is the problem.

The achievement of Olympia, I should say, is that it gives its female subject a particular sexuality as opposed to a general one. And that particularity derives, I think, not from there being *an order* to the body on the bed but from there being too many, and none of them established as the dominant one. The signs of sex are present in plenty, but they fail, as it were, to add up. Sex is not something evident and all of a piece in Olympia; that a woman has a sex at all—and certainly Olympia has one—does not make her immediately *one thing*, for a man to appropriate visually; her sex is a construction of some kind, or perhaps the inconsistency of several.*

To show this in detail, I shall first of all point to the way the body is addressed to the viewer in Olympia, and then go on to talk of the body's "incorrectness," as a thing drawn and painted; from there I shall move to the particular marks of sex upon it, and how they are handled; and, finally, to the way the body is inscribed in paint.

A nude could hardly be said to do its work as a painting at all if it did not find a way to address the spectator and give him access to the body on display. He had to be offered a place outside the picture, and a way in; and be assured somehow that his way was the right one, leading to the knowledge he required. This was sometimes done simply by looking: by having the woman's eyes and face, and her whole body, address themselves to the viewer, in the fashion of Ingres's *Vénus Anadyomène* or Titian's

* The books sometimes say that Olympia's depiction of a prostitute is "realistic," and that that, quite simply, was why it offended in 1865. But the word "realistic" is as usual puzzling here—for instance, as it might apply to the picture's representation of sexuality. Insofar as it disposes of ordinary signs of that quality—the cat, the Negress, the orchid, the claustrophobic room—they are far from being "realistic" in any obvious sense of the word. Are they even self-evidently "contemporary"? (Several critics were certain in 1865 that the flowers were being brought in last month's newspaper; but the paint itself is grandly noncommittal on this subject, as far as I can see. The "contemporary" reference was *made* by the viewer out of something deliberately guarded and generalized.) Even if we wish to say that reality *is* figured here, it still leaves us with the question why it was offensive, if its figures are so hard to pin down.

Venus of Urbino. That candour, that dreamy offering of self, that looking which was not quite looking: those were the nude's most characteristic forms of address. But the outward gaze was not essential; the spectator could be offered instead a pair of eyes within the picture space—the look of Cupid or the jester's desperate stare, the familiarity of a servant or a lover. In any case, the woman's body had to be arranged in precise and definite relation to the viewer's eye. It had to be placed at a distance, near enough for seeing, far enough for propriety. It had to be put at a determinate height, neither so high that the woman became inaccessible and merely grand, nor so low that she turned into matter for scrutiny of a clinical or prurient kind.

These were fragile achievements, and open to burlesque or refutation. But that was not what took place in *Olympia*, for all the critics' occasional certainty that her look was a provocation and her body laid out for inspection at the morgue. By and large the critics could not dismiss the picture in this way, because they could not so easily specify their own exclusion from it.

They were offered an outward gaze: a pair of jet-black pupils, a slight asymmetry of the lids, a mouth with a curiously smudged and broken corner, features half adhering to the plain oval of the face (Plate VII). A look was thus constructed which seemed direct and reserved, in a way which was close to the classic face of the nude. It was close, but so is parody. This is not a look which is generalized or abstract or evidently "feminine." It appears to be blatant and particular, but it is also unreadable, perhaps deliberately so. It is candid but guarded, poised between address and resistance—so precisely, so deliberately, that it comes to be read as a production of the depicted person herself; there is an inevitable conflation of the qualities of precision and contrivance in the way the image is painted and those qualities as belonging to the fictive subject; it is *her* look, her action upon us, her composition of herself.

It is not just looking, that is the point: it is not the simple, embodied gaze of the nude. Aggression is not the word for it; that quality is displaced to the cat and given comic form. Compliance is inaccurate; that is the Negress's character, and what makes her inert and formulaic, a mere painted sign for Woman in one of her states. Olympia, on the other hand, looks out at the viewer in a way which obliges him to imagine a whole fabric of sociality in which this look might make sense and include him— a fabric of offers, places, payments, particular powers, and status which is still open to negotiation. If all of that could be held in the mind, the viewer might have access to Olympia; but clearly it would no longer be access to a nude.

Yet in a rough-and-ready way the viewer puts an end to this stalemate, at least temporarily, and tries to see Olympia's body as one thing. We have noticed already the signs of the critics' disappointment even here. The body was *not* one thing; it was pulled out of shape, its knees dislocated and arms broken; it was cadaverous and decomposing; falling apart or held together by an abstract, rigid armature of lead or plaster or India rubber; it was simply incorrect. These are the signs of panic and incomprehension in the critics, but they have some basis in the way Olympia's body is actually drawn. One aspect of that drawing is emphatically linear: it is the side seized on by some writers in 1865 and described in such phrases as "circled in black," "drawn in charcoal," and "stripes of blacking." These were ways of objecting to Manet's disregard of good modelling and the abruptness of his lights and darks. But this use of shadow—these lines of darkness put round heel or breast or hand—is also part of Manet's drawing, in the limited sense I want that word to have here. Olympia's whole body is matter of smooth hard edges and deliberate intersections; the lines of her shoulders are a good example, singular and sharp; or the way the far nipple breaks the bounding line of the arm with a neatness nothing short of ostentation; or the flat, declarative edge of the thigh and the kneecap, or the hand staked out on its grey surroundings. This kind of drawing is presumably what was meant by the journalist Gille when he talked of *Olympia*'s being full of "jarring lines which made one's eyes ache."[139] But it was just as common in 1865, and just as appropriate, for the critics to accuse the picture of *lacking* definition. It was "unfinished," after all, and drawing "does not exist" in it;[140] it was described as "impossible" or evasive or "informe."[141] One critic called it disarticulated, another inarticulate, and both were right.[142] The latter was responding to a second kind of graphic mode in the picture, which we might describe as painterly— meaning by that a grand and free suppression of demarcations, a use of paint to indicate the indefiniteness of parts.

One aspect of this is again the picture's suppression of halftones: it lies behind the lack of detail in Olympia's right breast, and the faded bead of her nipple; it is what makes the transition from breast to rib cage to stomach to thigh so indistinct, so hard to follow. But the body contains quite other kinds of ambiguity, harder and sharper and more directly tied to *line*: the direction of Olympia's forearm, for example, as it crosses her belly—perhaps touching it, perhaps not—is just as much a matter of high visual uncertainty.

There is a lack of articulation here. On its own it is not too disconcerting, and in a sense it tallies well with the conventions of the nude, where the body is offered—if the trick is done—as just this kind of infinite territory,

uncorseted and full, on which the spectator is free to impose his imaginary definitions. But the odd thing in Olympia's case is the way this uncertainty is bounded, or interrupted, by the hard edges and the cursive grey. The body is in part *tied down* by drawing, held in place quite harshly—by the hand, the black bootlace round the neck, the lines of charcoal shadow. The way this kind of drawing qualifies or relates to the other is not clear; it does not qualify the other because it does not relate; the two systems coexist; they describe aspects of the body, and point to aspects of that body's sexuality, but they do not bring them together into a single economy of form.

It is as if the painter welcomes disparity and makes a system of it; as if the picture proposes inconsistencies, of a curiously unrelieved kind—left without excuse or mediation—as the best sort of truth when the subject is nakedness.

This leads to the way the picture treats the particular marks of sex upon the body. The nude has to indicate somehow the false facts of sexual life, and pre-eminently that woman lacks a phallus. This is the issue that lies behind Lemonnier's talk of showing and not showing what woman is. The nude, he says, "hides nothing because there is nothing to hide." That is no doubt what most male viewers wish to believe, but it regularly turns out that that *nothing* is what has to be hidden, and indicated by other conventions. The *Vénus Anadyomène* shows us one of them, the most perfect: the illusion of simple absence and equally simple completeness, the fiction of a lack which is no lack and does not therefore need to be concealed or shown. Another is the hand placed over the genitals in Titian's *Venus* or Giorgione's: the hand seemingly coinciding with the body, enacting the lack of the phallus and disguising it. In that sense—in that particular and atrocious detail—Olympia was certainly scandalous (Plate VIII). Her hand enraged and exalted the critics as nothing else did, because it failed to enact the lack of the phallus (which is not to say it quite signified the opposite). When the critics said it was shameless, flexed, in a state of contraction, dirty, and shaped like a toad, they toyed with various meanings, none of them obscure. The genitals are *in* the hand, toadlike; and the hand is tensed, hard-edged and definite; not an absence, not a thing which yields or includes and need not be noticed. "When a little boy first catches sight of a girl's genital region, he begins by showing irresolution and lack of interest; he sees nothing or disavows what he has seen, he softens it down or looks about for expedients for bringing it into line with his expectations."[143] Freud's account of origins is not necessarily to be taken as the whole truth, but it states quite well the ordinary form of male inattention in art. And Olympia's hand demands to be looked at; it cannot be disavowed or

brought in line with anyone's expectations—anyone, that is, brought up on Ingres or Titian.

The hand is Olympia's whole body, disobeying the rules of the nude. We might even say that it stands too strongly for that disobedience, for, after all, the body on the bed is not simply scandalous; the hand is a detail, and the critics were wrong to focus upon it, as they sometimes did, as if there were nothing else there to be seen.

Its effect is qualified, for instance, by the picture's employment of a second sign—a strong one—for much the same thing: the body's hair and hairlessness. Hair, so the textbooks say, is a secondary sexual characteristic. In the nude, however, it is a prime signifier of sex: plenty of it in the right places is delightful and feminine; pubic hair, need it be said, may hide the lack of the phallus but is somehow too close to *being* that lack, which is why it cannot be shown; and hair is disallowed for some reason in all manner of other places, armpit (usually), nipple, stomach, legs—the list is still current. The right kind of hair more than makes up for the wrong kind, however, in pictures like Cabanel's *Vénus*: the painter is encouraged to provide a miserable profusion of tresses, overtaking the body and weighing it down, acting in this case as a second (equally spermatorrhoeaic) foam. This kind of hirsuteness is a strong sign and a safe one, for hair let down is decent and excessive at the same time; it is allowed disorder, simple luxuriance, slight wantonness; and none of these qualities need be alarming, since hair on the head can be combed out and pinned up again in due course.

How nearly Olympia obeys the rules—to the point, we might think, of uneasy parody again. She has no pubic hair, of course; that would have been unthinkable; there is honestly nothing beneath her open hand but shadow; and yet the painting lays on a whole series of substitutes for what it is forced to omit. The armpit carries a trace of hair (this was permitted in any case: even Giacomotti did it). The line which runs from Olympia's navel to her ribs is seemingly marked by something—it may be a shadow, but that would be odd on a body which is missing so many others. And there is an equivalent, a metaphor, in the frothing yellow fringe which hangs down the fold between pillow and sheet: it is the one great accent in all that cool surface of different off-whites.

These are all displacements of one kind or another: they put hair on the body, but do so with discretion; and on the head, above the choker, there is an odd, fastidious inversion of much the same terms. Olympia's face is framed, mostly, by the brown of a Japanese screen, and the neutrality of that background (what is shown is the back of the screen, the unpictured part) is one of the things that make the address and conciseness of the face

the sharper. But the blankness is illusory: to the right of Olympia's head is a shock of red-brown hair, just sufficiently different from the screen's dull colour to be visible with effort. Once it is seen, it changes the whole disposition of the woman's head and shoulders: the flat, cut-out face is suddenly surrounded and rounded by the falling hair; the flower converts from a plain silhouette into an object which rests in the hair beneath; the head is softened, the hair is unpinned; this body has abundance after all, it has a familiar sex. And yet my first qualifying phrase is essential here: once it is seen, this happens, but in 1865 it was not seen, or not seen to do the things I have just described. (The caricaturists were in that sense right to leave it out altogether from their versions of *Olympia*; it is the absence of hair which is this nude's distinctive, comic feature.)

The hair may be noticed eventually, and maybe it was meant as a test of looking and a small reward. But I doubt if even now it can be kept in vision very easily and made part of the face it belongs to. Face and hair are incompatible, precisely so; and in that they are a better pair of signs for what is done to the body in *Olympia* than the singular scandal of the hand.

There are *two* faces, one produced by the hardness of the face's edge and the closed look of its mouth and eyes; the other less clearly demarcated, opening out into hair let down. Neither face is ever quite suppressed by the other, nor can they be made into aspects of the same image, the same imaginary whole. The difficulty is visual, partly: a matter of brown against brown. But it is more basic than that, and more pervasive: the face and hair cannot be made into one thing because they fail to obey the usual set of equations for sexual consistency—equations which tell us what bodies are like and how the world is divided, into male and female, hairy and smooth, resistant and yielding, closed and open, phallus and lack, aggressive and vulnerable, repressed and libidinous. These are equations the nude ought to prove or provide.

Olympia's rules could be stated as follows. The signifiers of sex are there in plenty, on the body and its companions, but they are drawn up in contradictory order; one that is unfinished, or, rather, more than one; orders interfering with one another, signs which indicate quite different places for Olympia in the taxonomy of woman—and none of which she occupies.*

* A text by Georges Bataille is sometimes enlisted in the argument that *Olympia* "has no subject" (is purely pictorial, visual, or whatever). In *Manet: Etude biographique et critique*, Bataille takes issue with Valéry, who described Olympia as a "public power and presence of a miserable arcanum of Society," "the Impure *par excellence*, she whose position obliges a candid ignorance of any kind of shame. Bestial vestal, given over to absolute nudity, she makes one think of all the remnants of primitive barbarism and ritual animality which lurk beneath the routine of prostitution in great cities." Bataille comments (pp. 66–67): "It is possible (though questionable) that in a sense this was initially the *text* of *Olympia*,

Olympia, finally, is *painted* in a disconcerting way. The painter seems to have put his stress deliberately on the physical substance of his materials, and the way they only half obey his efforts to make them stand for things in the world. It is this which was subsequently held to be the essence of *Olympia*, and the basis of its claim to be modern in artistic terms. Critics came to admire the picture's peculiar transitions—or the lack of them—from passages of open, complex brushwork to areas where line and colour had been quite brutally simplified. The picture, they said, was overt about its means and their limitations; it admitted and relished the marquetry of paint; it spelt out the disparities involved in making an image of anything, not only the nude. One sign of that, for example, is the way the tangible hand at the centre of things is played against its painted neighbours, one holding the shawl and the other the flowers. These two hands are shadows of the one which hides Olympia's genitals: they appear as a double antithesis to that hand's efficient illusionism, its hard, convincing light and shade. One of them, the maid's hand inside the newspaper, is plain black, a clipped and abstract silhouette; and the other, as the critics said, is incomplete; perhaps it does not literally lack a finger, but it barely does its work of holding the cashmere shawl, and seems purposely left without substance, an approximate instance of hand, a sketched-in schema. We might compare the pillow which props up Olympia's shoulders, all puckers and shadows and softness, with the shoulders themselves, as sharp as a knife; or the flowers with the newspaper, or the shawl with the cartoon cat.

To call these disparities "flatness" or "flattening" does not seem to me quite right. The passages I have pointed to insist on something more complex than a physical state, or at any rate the state of a medium. They put in question how the world might appear in a picture if its constituents were conceived—it seems they may be—as nothing but material; and how paint might appear as part of that world, the ultimate dry sign of it. To call the picture "modern" is perhaps more sensible, if we mean by that

but this text is a separate matter from the woman … the text is *effaced* by the picture. *And what the picture signifies is not the text, but the effacement.* It is to the extent that Manet did not wish to say what Valéry said—to the extent that, on the contrary, he has suppressed (pulverized) that meaning—that this woman is there; in her provoking exactitude, she is *nothing*; her nudity (in this, it is true, corresponding to that of the body itself) is the silence which issues from her as from a drowned and empty ship: what she is, is the 'sacred horror' of her own presence—of a presence as simple as absence. Her hard realism, which for the Salon visitors was the ugliness of a 'gorilla,' consists for us in the painter's determination to reduce *what he saw* to the mute simplicity, the open-mouthed simplicity, of *what he saw*."

This is a stranger argument than it seems. What Bataille objects to in Valéry is the poet's attempt to situate *Olympia* in an older, established, pseudo-sacred text of prostitution—a text of ritual, mystery, pollution, animality. *Olympia* is the obliteration of that text, and the putting of another in its place—the text of literalness, the real silence of the

word desperate, ironic, and grim beneath the fiction of technique. But however we describe it, this manner of putting on paint should surely be seen as part of a complex attempt at meaning, whose elements I have tried to outline. For instance, the facticity of paint in Olympia is not something given or discovered or simply "seen." It is a kind of fiction; it is part of making this particular fictive world, this body. Olympia, that has been my argument, *is not an enigma*, not a *courtisane*; and her final, factual existence on the bed is the key to that of paint. We could put it another way: in order that the painted surface appear as it does in *Olympia*, the self-evidence of seeing—seeing the world, seeing Woman—had to be dismantled, and a circuit of signs put in its place. The places where that was likely to be done in the 1860s were few and special: a *courtisane*'s nakedness was one of them, for the reasons I have proposed.

These are remarks about Manet's practice, not his own theory of it; and they are not meant as an argument that Manet did not look hard at his model Victorine Meurend.

It is best to end with the one critic who managed criticism of *Olympia* in 1865. Jean Ravenel, writing in *L'Epoque* on 7 June, described Manet's two pictures in the following terms:

MONSIEUR MANET—*Olympia*—The scapegoat of the salon, the victim of Parisian Lynch law. Each passer-by takes a stone and throws it at her face. *Olympia* is a very crazy piece of Spanish madness, which is a thousand times better than the platitude and inertia of so many canvases on show in the exhibition.

Armed insurrection in the camp of the bourgeois: it is a glass of iced water which each visitor gets full in the face when he sees the BEAUTIFUL *courtisane* in full bloom.

Painting of the school of Baudelaire, freely executed by a pupil of Goya; the vicious strangeness of the little *faubourienne*, a woman of the night from Paul

body, the fact of *being nothing*—another sacred horror, that of presence so unmediated that it has no sign. Clearly Bataille sees this as reducing *Olympia* to *what a man sees*, but vision for Bataille is always wrapped up in some such complex act *against* meaning ("it is the hard resolution with which Manet *destroyed* that was scandalous": as before, Bataille's italics); seeing is making the world into nothing.

These are themes which figure endlessly in Bataille's fiction and philosophical prose: presence as absence, the body as essentially inanimate, death as its purest and most *desirable* state, representation as colluding in this putting to death. Bataille's untranslatable last words on Olympia—"Aux yeux mêmes de Manet la fabrication s'effaçait. L'*Olympia* tout entière se distingue mal d'un crime ou d'un spectacle de la mort.... Tout en elle glisse à l'*indifférence* de la beauté" (p. 74)—should therefore be read in at least two ways: as a reproduction of the cadaver fantasies of the critics in 1865, and as final, overt recuperation of *Olympia* into the terms of Bataille's own eroticism. Whatever else one might wish to say of this criticism, it has little to do with the simpler narratives of modernist art history.

Niquet's, from the mysteries of Paris and the nightmares of Edgar Poe. Her look has the sourness of someone prematurely aged, her face the disturbing perfume of a *fleur du mal*; her body fatigued, corrupted, but painted under a single, transparent light, with the shadows light and fine, the bed and pillows put down in a velvet, modulated grey. Negress and flowers insufficient in execution, but with a real harmony to them, the shoulder and arm solidly established in a clean and pure light.—The cat arching its back makes the visitor laugh and relax; it is what saves M. Manet from a popular execution.

> De sa fourrure noire et brune
> Sort un parfum si doux, qu'un soir
> J'en fus embaumé pour l'avoir
> Caressé une fois . . . rien qu'une.
>
> C'est l'esprit familier du lieu;
> Il juge, il préside, il inspire
> Toutes choses dans son empire;
> Peut-être est-il fée, est-il dieu?

Monsieur Manet, instead of Monsieur Astruc's verses, would perhaps have done well to take as epigraph the quatrain devoted to Goya by the most *advanced* painter of our epoch:

> GOYA—*Cauchemar plein de choses inconnues*
> *De foetus qu'on fait cuire au milieu des sabbats,*
> *De vieilles au miroir et d'enfants toutes nues*
> *Pour tenter les démons ajustant bien leurs bas.*

Perhaps this *olla podrida de toutes les Castilles* is not flattering for Monsieur Manet, but all the same it is something. One does not make an *Olympia* simply by wanting to.—The *Christ* would call for a certain technical analysis which we do not have time to give.—To summarize, it is hideous, but all the same it is something. A painter is in evidence, and the strange group is bathed in light.[144]

This is an extraordinary piece of writing. It is the only salon entry in 1865 to say anything much—or anything reasonable—about form and content in *Olympia*, and the way one might possibly inflect the other. It seems to accept or produce a measure of complexity in its object, and the points of reference it proposes for Manet's picture are not only well chosen but really explored in the text. This does not mean that Ravenel approves of *Olympia*, or thinks its allusions coherent. Rather the contrary, in fact: the more points of reference he proposes, the more certain he seems that they are ill-assorted, and the better prepared is his final, crushing verdict on the whole thing.

And yet the text provides material for other verdicts; that is its strength. Let us take, for example, the way it deals with Manet's relation to Goya and Baudelaire.[145] The two names appear together first as generalities,

masters whose lessons Manet is believed to have by heart. But they are immediately connected, across a simple but puzzling semicolon, to the further terms *petite faubourienne*, Paul Niquet, Eugène Sue, and Edgar Allan Poe. These are all terms a reader might have derived quite easily from *Les Fleurs du mal* in the 1860s, or at least from certain aspects of it that still seemed paramount then—the Satanic and fantastic, say, or the plainer city poetry of "Le Vin des chiffonniers" and "Le Crépuscule du soir." They are important to *Olympia*, and yet of course there are other, quite contrary, qualities to Baudelaire's verse which seem just as apposite: qualities of discretion and formality (all the more potent because they invite the reader to see through them), purity of diction, stateliness of rhythm, and general decorum. These qualities appear directly in Ravenel's text in the shape of the eight lines quoted, not quite accurately, from Baudelaire's "Le Chat"; but even here the actual entrance of Baudelaire is prepared for in two ways, both of them distracting. First, immediately before, Ravenel has the cat come on as a comic figure, which matches oddly with the two intense verses which follow. Second, in a more general way, this new aspect of *Olympia*—the aspect which is not out of Sue or Poe or Paul Niquet—has already appeared in the text, and quite elaborately, when Ravenel describes Olympia's form. The body is one thing, in other words, the way it is painted another. The body may be fatigued and tainted, but it is put down in a unified and transparent light, and the paint calls forth a stream of adjectives—pure, fine, frank, harmonious, solid, *moelleux*—which change our sense of what could have been meant in the first place by the references to Goya and Spanish madness.

This ambivalence is perfected in the final stroke, the compounding of Baudelaire and Goya in the quatrain quoted from "Les Phares." It is again, as in the glancing reference to Poe, the Baudelaire of nightmare who is invoked. This is the wildest stanza from "Les Phares," and supposedly we are meant to take it as an index of *Olympia*'s wildness. For Manet's creation is *not* Olympia, so the text concludes—by which is meant, I take it, not the Renaissance courtesan, not the "auguste jeune fille." She is an "*olla podrida* de toutes les Castilles," a character out of *Los Caprichos*, something brewed up on a witches' sabbath.

But is this the way *Olympia* derives from Goya? Is it even the way the quotation from "Les Phares" suggests? The figures Baudelaire brings on in his last two lines seem to be a compressed description of several plates in *Los Caprichos*, most obviously of Plate 31, *She Prays for Her*. And the link between it and *Olympia* is striking. Yet once we accept the possible source, and focus on the last two lines of the quatrain as opposed to the more vivid and strident first two, the valency of Baudelaire and Goya is

51. Francisco Goya, *Ruega por ella*, 1797–98. Etching and aquatint.

altered once again. These plates in *Los Caprichos* are after all among the sparest and most restrained of the series; they do not fall into either of its main modes—the satirical, burlesque depiction of the social scene or the narrative of outright fantasy. They belong to the former category, but lack its flavour of exasperated masque; and the lines from Baudelaire have something of their ceremonious, generalizing air. The word "demon," by the time we encounter it, is hardly enough to pull back the procession of figures—naked children, old women in front of a glass—from the realm of allegory or something like it.

That last proviso is the important one: it points to the special character of these few plates and the ground of Baudelaire's enthusiasm for them. Plate 31 of *Los Caprichos* may be something *like* allegory, but it is evidently not allegory pure and simple. There is a measure of grand simplification in it, even of decorum; but an equal portion of the grotesque or everyday or simply outrageous (that vessel on the floor, what is it?). And does that not read like a description of Olympia in turn? She is likewise not quite creature of fantasy and not quite social fact; neither metaphor nor violation of one, neither real nor allegorical. She is balanced between incompatible

modes; and no doubt it was this Manet learnt from Goya, as opposed to undiluted Spanish wildness.

This leads us finally to two aspects of Ravenel's text which are hardly less perplexing: where it appeared, and by whom it was written. It appeared in a paper of the Left opposition called *L'Epoque*, one associated closely with the republicanism, even socialism, of Jules Vallès. Ravenel, we know already, was a pseudonym, and behind it was hidden a civil servant, Alfred Sensier. He was a critic whose main allegiance was to the painter Jean-François Millet; he was already Millet's friend in 1865, and later in life he became his biographer. His *Salon* spelt out his commitments, to the painting of nature and *plein air* and *sens rustique*: it began with an epigraph from Rabelais, went on to enlist Euripides in praise of Corot, and started its discussion of landscape painting with Hesiod and Virgil.[146] Millet was absent from the Salon of 1865 and Sensier bemoaned the fact; he contented himself with a long panegyric of Millet's *Daphnis et Chloe s'amusant à donner la becquée à des petites merles qu'ils viennent de dénicher*, a decorative panel just completed for a house in Colmar.[147]

In no sense is Sensier's entry on *Olympia* a betrayal of these, his basic and ordinary aesthetic beliefs. The entry, one should realize, *is not important* in Sensier's *Salon*. It comes at the end of the eleventh long article in the series of twelve he did for *L'Epoque*, and it figures there as part of the alphabetical listing of pictures left out of account so far—items that had not found a place in the extended narrative of the main text. Insofar as the entry produces an author's voice at all—and it does so only incompletely, I feel—it is doubtless meant to be ironic, only half impressed by Manet's peculiar tour de force. The tone had been set already in Sensier's second article, on 4 May, when he dealt with Manet as follows:

> Monsieur Manet, a nude Olympia lying on a bed, and near her a Negress presenting some flowers; picture capable of exciting sedition if its neighbour, a Christ, by the same author, did not disarm the furious with a Homeric laugh. These two canvases are the two victims of the salon; nothing can convey the spectators' initial astonishment, then their anger or fear. These two excellent jokes do not merit this excess of rage; they are a trifle daring in their poses—Olympia especially!—but too visibly the natural offspring of Goya for anyone to be disturbed by their misdeeds.[148]

It is as if in the later entry Sensier tried to reproduce this tone and failed, and in doing so happened upon some kind of knowledge.

This is not meant to detract from the commentary Sensier in fact produced. It is a brilliant piece of criticism; but its success seems bound up, first, with the author's anonymity, his detachment from his normal aesthetic stance;[149] and second, with the way the offhand, compressed, notelike form of the

alphabetical listing allowed the text to leap from aspect to aspect, reference to reference, in a movement which did not need to be construed as judgement. There is a quality of inadvertence to Ravenel's writing; and by now it should not seem inappropriate that the only real criticism of *Olympia* in 1865 was done in these circumstances—by a critic leaving off his artistic self, and coming upon the picture in the most perfunctory of critical settings.

Or almost the most perfunctory, one should say: there was, after all, the page in the paper allotted to caricature. On one or two occasions, that mode allowed *Olympia*'s story to be told more or less in full. Bertall, for example, could offer the reader of *L'Illustration* his own solution to the absent phallus: he put the black cat, with its tail erect, in place of the hand which covered the genitals. He put a chamber pot under the bed, a pipe under the pillow, called Olympia a coal lady from Batignolles and added to her bouquet a *commandement*—an order from the bailiffs to pay up or prepare for the consequences. Aside from Ravenel, no critic scanned the picture to better purpose, or found a more economic way to denote its main effects.

It had once been possible for painters to show prostitution in a straightforward light, with actual coinage changing hands in an atmosphere of lechery, alcohol, and good cheer. Johannes Vermeer's *Procuress* is the best example. No doubt Vermeer's viewers were meant to take the figures in this scene as signs of the vanity of earthly things, but they were ordinary signs, easily read, and meant to be laughed at as well. Comedy has disappeared from *Olympia*'s world, unless we agree with Ravenel about the cat, and with it has gone the rest of Vermeer's openness. Money cannot be shown as part of prostitution now, nor can the client, and least of all a definite and matter-of-fact relation between the buyer and seller of sex. The picture is about the absence of such things.

We might sum it up by saying that in *Olympia* prostitution has become more extravagant and threatening; and that seems to have been an accurate reflection of the state of the trade in the later nineteenth century. Relations between prostitute and client involved, among other things, matters of social class; they often meant a transgression of normal class divisions—a curious exposure of the self to someone inferior, someone lamentable. That doubtless lent spice to the transaction, but only if it were made part of a set of sexual theatricals which became more cumbersome as the years went on. For prostitution to work in this society, the disproportion Simmel talked of between commodity and price had to be fought for and maintained in the sexual exchange itself. The client wished to be assured he

La queue du chat, ou la charbonnière des Batignolles.
Chacun admire cette belle charbonnière, dont l'eau, liquide banal, n'a jamais offensé les pudiques contours. Disons-le hardiment, la charbonnière, le bouquet dans du papier, M. Manet, et son chat, sont les lions de l'exposition de 1865. Un bravo senti pour M. Zacharie Astruc.

52. Bertall, *La Queue du chat, ou La Charbonnière des Batignolles*. Wood engraving in *L'Illustration*, 3 June 1865.

53. Johannes Vermeer, *The Procuress*, 1656.

had access to some mystery there, probably of Woman; hence the prostitute was obliged to make herself desirable—to run through the identities in which desire was first encountered by the child. It was a game in which the woman most often collaborated and to an extent was trapped; but there were other forces—market forces, essentially—which threatened to dislodge her from belief in the parts she played. She could be returned quite abruptly to the simple assessment of herself as seller of her own labour power, someone who put physical complaisance on the market and could never be sure what it would fetch. In this sense she belonged to the proletariat as undramatically as Vermeer's loose women.

I have given my reasons for believing that the ultimate cause of the critics' difficulty with Olympia in 1865 was the degree to which she did not take part in the game of prostitution, and the extent to which she indicated the place of that game in class. She came from the lower depths. The images of sickness, death, depravity, and dirt all carried that connotation, but they stayed as passing figures of speech precisely because the critics could not identify what in the picture told them where Olympia belonged.

Reduced to its most simple form, this chapter's argument amounts to saying that the sign of class in *Olympia* was nakedness. That may still seem a cryptic formula, so I shall redefine its terms for the last time. Class is a name, I take it, for that complex and determinate place we are given in the social body; it is the name for everything which signifies that a certain history lives us, lends us our individuality. By nakedness I mean those signs—that broken, interminable circuit—which say that we are nowhere but in a body, constructed by it, by the way it incorporates the signs of other people. (Nudity, on the contrary, is a set of signs for the belief that the body *is ours*, a great generality which we make our own, or leave in art in the abstract.)

It follows that nakedness is a strong sign of class, a dangerous instance of it. And thus the critics' reaction in 1865 becomes more comprehensible. They were perplexed by the fact that Olympia's class was nowhere but in her body: the cat, the Negress, the orchid, the bunch of flowers, the slippers, the pearl earrings, the choker, the screen, the shawl—they were all lures, they all meant nothing, or nothing in particular. The naked body did without them in the end and did its own narrating. If it could have been seen what signs were used in the process—if they could have been kept apart from the body's whole effect—they might still have been made the critics' property. They would have been turned into objects of play, metaphor, irony, and finally tolerance. Art criticism might have begun.

The ENVIRONS
OF PARIS

L'avenir est aux limonadiers.

—*Honoré de Balzac*[1]

The Argument That the environs of Paris from the 1860s on were recognized to be a special territory in which some aspects of modernity might be detected, at least by those who could stomach the company of the petite bourgeoisie. To use the word "suburban" to describe these stamping grounds—to apply it to resorts like Asnières or Chatou, Bougival, Bois-Colombes, or, pre-eminently, Argenteuil—was on the whole misleading, and remains so. It makes such places out to be the subordinates of some city, whereas in fact they were areas in which the opposite of the urban was being constructed, a way of living and working which in time would come to dominate the late capitalist world, providing as it did the appropriate forms of sociability for the new age. Where industry and recreation were casually established next to each other, in a landscape which assumed only as much form as the juxtaposition of production and distraction (factories and regattas) allowed, there modernity seemed vivid, and painters believed they might invent a new set of descriptions for it.

This chapter mostly looks for such descriptions, which occasionally do surface in modernist painting at this time. There are pictures by Manet and Seurat, for example, in which the environs of Paris are recognized to be a specific form of life: not the countryside, not the city, not a degenerated form of either. But the chapter also tries to explain why such descriptions were rare and for the most part metaphorical, the metaphors being those of dislocation and uncertainty, and the sense of the scene being suggested best by a kind of composition—perfected here—in which everything was left looking edgy, ill-fitting, or otherwise unfinished. These metaphors did not in the event turn out to be a way of storing knowledge: there was to be no sustained or cogent representation of suburbia in the twentieth century. Perhaps that had to do with the peculiar intractability—the foreignness of an unexotic kind—of the classes of people who came to occupy the new terrain. They were the petite bourgeoisie, but also the proletariat;

and though each despised the other, they both existed, and still exist, at an equal distance from the realm of Art. Painting turned instead to other primitives, whose culture it could patronize more safely.

———————————◆ ● ◆———————————

When painters went out to the countryside round Paris in the 1870s—in search of a landscape, say, or a modern *fête champêtre*—they would have known they were choosing, or accepting, a place it was easy (almost conventional) to find a bit absurd. The tone had been set as early as 1862 by the Goncourts in their journal, describing a day spent by the river at Bougival:

> We went to the country with Saint-Victor, like shop assistants. And we said to each other, as we went to look for a train, that really humanity—and all honour to it—is a great Don Quixote at heart. . . .
> We took a walk along the Seine at Bougival. In the long grass on the island people were reading aloud from *Le Figaro*. On the water, boaters in red jerseys sang songs by Nadaud. Saint-Victor came across an acquaintance of his among the willows: it was some stockjobber or other. Finally we found a corner where there was no landscape painter sitting at his easel and no slice of melon left behind. . . .[2]

The terms that seem to me crucial in the Goncourts' entry are the first and last—the shop assistants and the landscape painter. It is they that dictate the Goncourts' peculiar tone—the comprehensive, slightly hectic irony that has to be applied, apparently, to every item of the scene. For how else could one deal—this is the text's essential burden—with the people now laying claim to landscape, painted or not; with their wish or pretence to be "by themselves," and with oneself as sharing that wish; or with those others who dispensed with the illusion of solitude and simply regarded the riverbank as backdrop for the songs they always sang, the same newspapers, the same slices of melon? And the great river itself, after these people were done with it!

The manner and imagery of this passage were much reproduced in the next twenty years or so, and frequently to great effect. It very often seemed that describing this landscape at all, in any detail, depended on finding it false—though false by what standard was never made clear. There was precious little clarity, we shall discover, in any of the writers' opinions in this area. They were in a cleft stick about the countryside, and trying for irony at their own indecision. They were part of the crowd at Bougival and Asnières, and almost willing to admit as much. In a sense they relished their fellow Parisians, or at least were ill-equipped to do without them;

but they could not help wishing, at the same time, that the crowd would behave differently, put away *Le Figaro* and pick up the leftovers from the *Déjeuner sur l'herbe*.

Sometimes the sequence of their emotions was quite explicit in the text. Here, for example, is a writer called "Y" in *La Vie Parisienne*, beginning an essay entitled "Un Dimanche d'été":

I had been in the countryside for a week, and I was bored, tired of the silence, when at last the village bells announced the morning of the seventh day, the day of rest and rejoicing. And soon a shudder went through the woods, and the hills echoed with the sound of the day's first pun.

—The Parisians are coming! I cried out in delight. Nature will leave off its role of mute and mysterious nymph, and become a barmaid to whom commercial travellers somewhat brutally pay court.

Hour by hour the invasion mounted, taking possession of the countryside as of a vast *guinguette*, a café-concert even larger than those on the Champs-Elysées.

These people came to handle the hillsides as if they were breasts, to look up the skirts of the forests, and disarrange the river's costume.

The breeze began to murmur jokes and catcalls. The smell of fried fish and fricassee of rabbit rose in the air along the riverbanks and wafted across the fields. A concert of popping corks began, of knives clinking against glasses, and dirty songs; and it went on till nightfall, getting louder all the time. . . .

When I had seen the countryside given over to those who alone understand and know how to enjoy it, when I had had my fill of the spectacle, I took the train and went back to Paris. . . .[3]

If any one thing was to blame for this state of affairs, it was the railway on which "Y" made his final escape. The lines laid down since 1850, especially those to the west of the city, had quite abruptly rendered the countryside available to Paris, as part of a weekend or even a work day. These facts became common knowledge in the 1860s and soon affected the critics' sense of how landscape painting was to be construed. The novelist Robert Caze, for example, writing a *Salon* in 1885 and turning to a picture by Jacques-Emile Blanche—it seems to have had a lady sitting on a lawn as its central feature—was in no doubt as to what modern landscape amounted to:

Oh! the poor little Parisienne, bewildered and bewildering in the midst of this imitation nature—the nature of Sèvres and Ville d'Avray. We should be grateful to Monsieur Blanche for having seen so well the odious turf of these villas *extra muros*, these lawns brought in from England on the Dover or Southampton boat, arriving each morning on the fish train. And look at the landscape in which this pasty-faced model tries to take her ease! I dare say there's a globe of silvered glass round the corner, and a little fountain pissing its monotonous song into a basin with three goldfish in it! And here is the bourgeois—the proprietor!—bringing

54. Gustave Doré, *Les Plaisirs champêtres du parc du Vésinet.* Engraving from Labédollière's *Histoire des environs du Nouveau Paris,* 1861.

in a bunch of flowers bought on the asphalt at the Madeleine after the stock exchange closed . . . bringing them back to his home *in the country.* Doubtless it is excellent to give us the sensation, or, rather, the smell, of Asnières and Bois-Colombes, without obliging us to take the tramway. If I were one for economies, I would buy Monsieur Blanche's *Pivoines* and be saved the trouble of visiting this landscape of boating parties and the humorous public of Sundays, these fields full of pianos and hunting horns, of factory chimneys and the perfume of manure.[4]

It was the railway that had made this landscape. It carried the bourgeois back from the Madeleine at five, it ushered in the shop assistants and commercial travellers, the blue songs and the globes of silvered glass. It stood intrusive guard over the pleasures of Gustave Doré's picnickers in the *Parc du Vésinet,* and was pointed out by one bourgeois to another in a cartoon by Trock:

—Really, living in Paris, on the Place de l'Europe, had become unbearable! . . .
 Nothing but the noise of the Western Railway all day . . .
—And here, how do you entertain yourselves?
—We watch the trains go by.

55. Trock, "Habiter Paris, place de l'Europe." Wood engraving in *La Caricature*, vol. 1 (1882).

— Habiter Paris, place de l'Europe, ça n'était plus tenable!... Pas d'autre vue que le va et vient du chemin de fer de l'Ouest...
— Et ici, quelles distractions avez-vous?
— Nous regardons passer les trains.

Well might the "witty and benevolent" Monsieur Coindard, secretary of the same Western Railway, declare with satisfaction: "Les lignes de banlieue, c'est notre boulevard intérieur."[5] For he more than anyone stood to gain from the fact that Paris's outlines were changing; the city henceforward would have more than one thoroughfare, more than one scale, and no firm bounding lines between its various edges and interiors.

It was partly this last uncertainty that so provoked the critics of the Parisian countryside, and had them lay on the irony with a trowel. The environs of Paris, they said, were neither town nor country any more. Worse than that, these places failed to offer a visible—or even a symbolic—transition between one form of social existence and another, as the land outside the *barrière* had done for Hugo's philosophic stroller. At Sèvres or Le Vésinet, for example, there was nothing to be seen but countryside; it

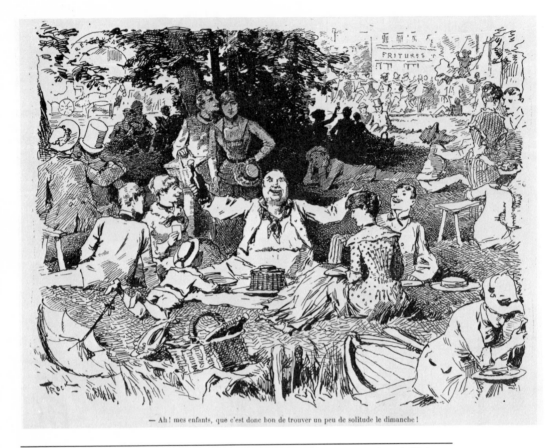

— Ah! mes enfants, que c'est donc bon de trouver un peu de solitude le dimanche!

56. Trock, *Ces Bons Parisiens.* Wood engraving in *La Caricature,* vol. 1 (1882).

might be thick with the signs of Paris at the end of the line—with restaurants, watermelons, smoke from factory chimneys—but Paris itself had still not arrived. These were landscapes arranged for urban use, but part of their utility was the fiction, flimsy as it was, that city and citizens were far away.

The ironic commentator wished to make it clear that he for one was not deceived. There was no nature, he believed, where there were Parisians. The very sky over Bougival was pale and unhealthy, "the colour of a Parisienne's skin."[6] The dust at Chatou was compounded with rice powder,[7] and "wherever there was a wretched square of grass with half a dozen rachitic trees, there the proprietor made haste to establish a ball or a café-restaurant."[8]

No doubt the illusion was often perfunctory, but by and large it worked. The stockjobbers and landscape painters were in no doubt they had left the city behind. As they sat on the grass by the river, in another cartoon

by Trock, their father opened his arms and said: "Ah! my children, how good it is to find a little solitude on Sundays!" For this was the way they wanted nature to be; this was the way it essentially *was*—a kind of demi-Paris whose trees were like those on the boulevards, and whose restaurants resembled the best in the Rue Montmartre.[9] Should not a village be equipped, to count as a village at all, with "sellers of *coco* and amusements, games of macaroon, shooting galleries, swings, and a motley crowd of people, swarming and rowdy, all using Parisian argot, and studded with *modistes*, drapers' assistants, students, and reporters"?[10]

It was possible, of course, for the illusion to be too threadbare and simply misfire. Monsieur Bartavel, for example, the amiable hero of an *opéra-bouffe* from 1875 entitled *Les Environs de Paris*, did not enjoy his trip to the suburbs. His top hat was crushed in a winepress at Argenteuil, he lost his companions, he was not impressed by the sights at Robinson and Montmorency. This is his verdict in the play's last act:

BARTAVEL—Yes, my friend . . . apart from that everything has really been . . . disagreeable! . . . And behold before you a man who is completely disillusioned with the Environs of Paris!

JOSEPH—Why is that? . . .

BARTAVEL, *standing up*—Why is that? . . . Because I had a picture of the place which bore not the slightest resemblance to what I saw. When I set off I said to myself: And there, I shall have some air, some sun and greenery! . . . Oh, yes, greenery! Instead of cornflowers and poppies, great prairies covered with old clothes and detachable collars . . . laundresses everywhere and not a single shepherdess . . . factories instead of cottages . . . too much sun . . . no shade . . . and to cap it all, great red brick chimneys giving out black smoke which poisons the lungs and makes you cough! . . . Coach drivers who jeer at you, restaurateurs who take you for all they can get . . . winepresses that flatten your hat . . . vinegrowers who spill white wine all over you . . . forests where you lose your daughter . . . hotels where you mislay your son-in-law! . . . And that, my dear Joseph . . . that is the faithful description of what are customarily called . . . the Environs of Paris! . . .[11]

There is a quality in these texts which may strike us now as little short of desperate. The writers are so anxious to outflank all the attitudes towards landscape they are describing, and they never explain what other attitudes they take to be less silly. *They* are all bourgeois, whereas *my* irony is not: that seems to be the writers' message, essentially, and the main reassurance they mean to offer their readers. Bartavel's disillusion may be safely comic, but his inventory of faults and blemishes would not inspire much disagreement in any of the writers quoted so far. For was it not true that the

landscape consisted of rachitic trees and factory chimneys—or consisted too much of them? And which was more absurd, the good bourgeois who gave his blessing to the signs of industry in nature, or his partner who claimed not to notice them? "Come a little farther this way," says another Parisian, in *Le Nain Jaune*, showing off his weekend villa to a guest:

You'll see a most delightful view. . . . Isn't it charming? . . . And you can make out part of the panorama from my house. . . . How do you find it?

—I don't see anything very extraordinary . . . apart from those great chimneys and their black smoke, which for me rather spoil the landscape. . . .

—For me it's an added charm. . . . My dear fellow! It is industry which comes to add its note. . . . But here we are at the house. . . . Watch out for the puddle. . . . It never dries out, even in the height of summer. . . .[12]

There was clearly some discord in the landscape, something which prevented nature from being seen in the proper way. It had to do with a fact as large as bourgeois society itself: not just the signs of its industry, but *other* bourgeois, too many of them, pretending not to be industrious. These were the people Bernadille described in an 1878 article entitled "Le Dimanche à Paris":

On that day a whole new population takes possession of Paris, of its spectacles, its cafés, its promenades, its public gardens, its boulevards, its Palais-Royal, its railway stations, its *banlieue*. During the week, you could no doubt have seen them, mixed in with the ordinary public, but as it were effaced by it. Now they show themselves off in their pure state; they flood through the streets, they spread over Paris and overflow. The great city belongs to them all day long.

Where do they come from? From behind the counters of humble shops and offices, from businesses and government departments. This is not precisely a "popular" public in the full force of that word, for the people of *L'Assommoir* celebrate Monday in preference to Sunday; it is a public of petits bourgeois, of small tradesmen, mixed up with real workers.[13]

Once a week, in other words, there was an excess of bourgeoisie in the spaces Haussmann had provided: it was this that upset the commentators and elicited their scorn. The excess was comprised of shop assistants and commercial travellers, readers of *Le Figaro*, clerks in detachable collars, the spawn of banks and bureaucracies—the new men.

These people's access to the public realm was a phenomenon of the 1870s, and much remarked on at the time. Politicians were fond of regarding them as a force to be reckoned with, and never tired of harking back to the radical leader Léon Gambetta's great verdict on the new republic—that it owed its existence to a great mass of men who had previously been excluded from the state, and would henceforth have to draw its strength directly from the "nouvelles couches sociales."[14] Those last

three words were usefully vague, but what they pointed to essentially was a shift of power *within* the wider middle class. The regime of landowners and *notables*—those men whose influence at a local level had survived all previous changes in the form of government—was finally coming to an end; and in its place was a congeries of shopkeepers and small builders, schoolteachers and civil servants, "the party of pharmacists and vets."[15] Somewhere at the edge of that party—wanting a place in it, not sure of how to insist on one—was the odd new animal, the petit bourgeois.

The texts I have been quoting are ironical at the petit bourgeois's expense. What was held to be the most comical thing about him was his unpreparedness for the leisure he now enjoyed; he was a workaday creature, after all, who naturally clung to the society of his fellows and had need of fried food and regattas. He was naïve and tasteless; easily elated and easily duped; and he too mourned his own enfranchisement—there was always a time before trippers and tourists, when the spot was unspoilt and there wasn't a soul on the beach.

But it seems to me that more is at stake in the writers' irony than this. What they seem to find laughable in the "nouvelles couches sociales" is their *claim* to pleasure, the degree to which they asserted a right at all to solitude, to nature, to spontaneity. Various descriptions were offered of the absurdities that resulted, but these hardly account for the writers' acrid tone: they seem to be reasons, on the contrary, for finding the subject harmless and the claims quixotic. But the subject was not treated lightly; or, rather, the lightness was repeatedly tinged with a kind of hysterical loftiness. No doubt these people did not get what they asked for, and had only the faintest notion of what it would have been like to have had it. Yet the claim was enough; the claim was the threat, because it was their way of claiming to be part of the bourgeoisie.

There was a struggle being waged in these decades for the right to bourgeois identity. It was fought out quite largely in the forms the new city had brought to perfection: the squares, the streets, and the spectacles. The crowds on the riverbank on Sunday afternoon, all moving about in identical dresses, all eager to be seen, were engaged in a grand redefinition of what counted as middle-class. And the redefinition was resisted: Gambetta, after all, was out of step with the general run of his class in the 1870s, and well aware that his slogans would be found provoking. One means of resistance was irony, and the ironists' message amounted to this: that the claim to pleasure was nothing if not an attempt to have access to Nature; that these people knew nothing but Paris, and took Paris with them wherever they went; that that was the key to their vulgarity—and because they were vulgar, they could never be bourgeois.

To call someone vulgar is to say he insists on a status which is not yet proved or well understood by him, not yet possessed as a matter of form. It is a damaging charge, made by one bourgeois against another. To have access to Nature be the test of class is to shift the argument to usefully irrefutable ground: the bourgeoisie's Nature is not unlike the aristocracy's Blood: what the false bourgeois has is false nature, nature *en toc, la nature des environs de Paris*; and beyond or behind it there must be a real one, which remains in the hands of the real bourgeoisie.

> *Cohue hebdomadaire à travers les banlieues!*
> *Parisiens! cherchant des fleurs sur les pavés!*
> *Ils se figurent être à des milliers de lieues . . .*
> *Parce qu'il est dimanche, et qu'ils se sont lavés.*[16]

The reader could rest assured: the flowers in this landscape would wilt before evening, and the crowd would return to its counters and offices.

57. Jean-François Raffaëlli, *Promeneurs du dimanche.* From *Les Types de Paris,* 1889.

58. Georges Seurat, *Personnage assis, étude pour Une Baignade à Asnières* (known as *Banks of the Seine at Suresnes*), 1883.

One of the great subjects of Impressionist painting was the landscape I have just been describing, and therefore it does not seem unreasonable to ask how far the painters' attitudes towards it resembled those of the journalists and poets. In particular we might want to know how they dealt with the signs that this landscape belonged to Paris—the traces of industry "adding its note" and the presence in nature of the "nouvelles couches sociales." There are certainly pictures where these are the characters round which the landscape is organized, and where the painter appears concerned to establish some kind of comic connection between them. Sometimes the comedy seems to me essentially the same as Trock's or Bartavel's, and at others it strikes a muted, almost respectful note, which is not quite ironical, at any rate not supercilious or unkind.

Compare, for example, Raffaëlli's depiction of middle-class pleasure in his *Promeneurs du dimanche* with that of Seurat in the study for his *Baignade à Asnières*. There is no mistaking the coexistence of landscape, figure, and factory in both, or the fact that each one of the terms puts its neighbours in doubt. But the one picture surely invites its viewers to recognize the easy contradiction and laugh (not too maliciously; this is Bartavel's comedy, not Robert Caze's); while the other seems still to be feeling for a way to characterize the same situation—as if the painter were not sure that it had taken on a character at all as yet. (It matters here that Raffaëlli's individuals

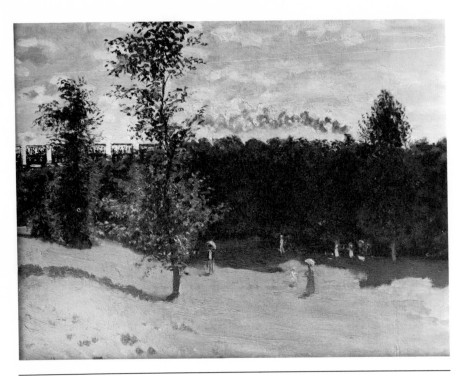

59. Claude Monet, *Le Train dans la campagne*, c. 1870.

are so much more securely established *as* middle-class than Seurat's. There is a difference in kind between the solitary, slightly overdone respectability of Seurat's figure—his bowler hat immoveable against the sun—and that of Raffaëlli's patriarch.) Compare, in the same manner, Doré's *Plaisirs champêtres* (p. 150) with those portrayed in Monet's *Train dans la campagne* from 1870.

At this point an unsympathetic reader—one finding the victory of Seurat and Monet over Doré and Raffaëlli a trifle easy—might respond in the following way. Very well, she might say, I'm prepared to accept that the irony here is easy and condescending, but surely irony of any kind is preferable in such cases to outright complaisance? And is not Monet's picture merely accepting—of more or less anything, if seen in a good light? Do not such images put us back with the happy landscape painter at Bougival, sitting at his easel next to the melon segments? The objector might bring on hereabouts some depictions of Bougival by Monet or Sisley or Pissarro as circumstantial evidence. Isn't there a point, she might continue, at which we *know* that what we are dealing with is straightforward bad faith? Wouldn't we agree that some such phrase applies to Jean-Charles Cazin's *La Marne*, for example—to its saccharine version of modern life?

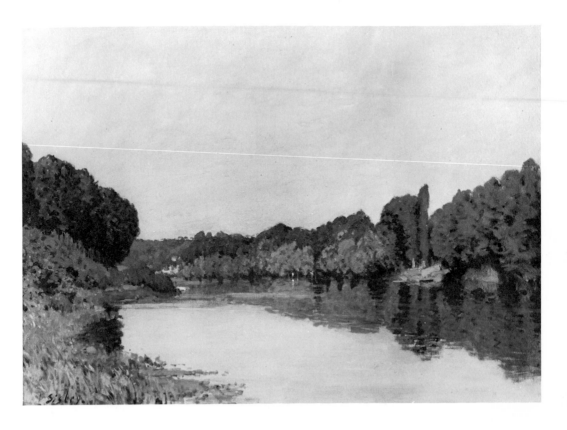

60. Alfred Sisley, *La Seine à Bougival*, 1873.

61. Jean-Charles Cazin, *La Marne*, 1882.

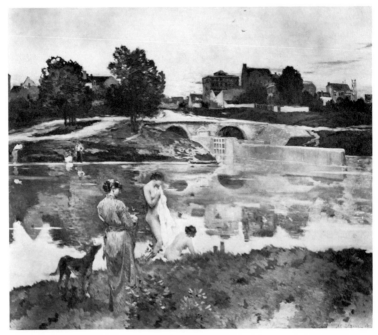

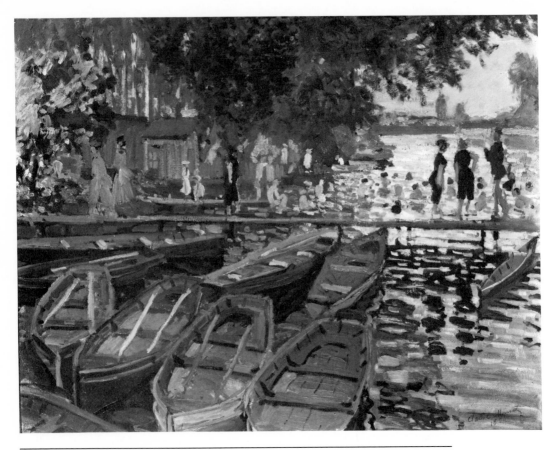

62. Claude Monet, *La Grenouillère*, 1869.

And what is the difference, in terms of meaning, between Cazin's countryside and Monet's?

The unsympathetic reader at least asks the right questions. It is presumably one thing to avoid irony and another to attain to blankness, and often in modernist painting it is not clear which description is the appropriate one. But let us put the same questions in a less aggressive form. Let us ask, for example, how Monet's depiction of the river bathing place called La Grenouillère might possibly stand in relation to an image of the same place taken from the weekly magazines—like the one I show by Jules Pelcoq (accepting straightaway that there is no question here of imitation or influence of a direct kind)? To what extent does Monet's oil painting borrow its vitality from the illustration, or is its purpose somehow to contradict such a quality, or at least its generalizing force? The painting's composure, and the cool way it savours certain (rather simple) formal rhythms, in the pattern of boats or the punctuation of figures on the straight

pontoon—are these meant, so to speak, as refutations of Pelcoq, as so many signs of the painter's way with things as opposed to the illustrator's? Does painting get done in spite of illustration—is that the proposal? Get done in spite of modernity, even, or because modernity does not amount to much? But then, why go to La Grenouillère in the first place? In search of the insignificant—is that it?

During the summer of 1875 Berthe Morisot did a number of paintings on the plain of Gennevilliers, a few miles east of Argenteuil. One of them, entitled *Un Percher de blanchisseuses*, she chose to show the next year in the second Impressionist exhibition.[17] Is it in order for us to read her depiction of landscape with, say, Bartavel's monologue in mind? They are all there, the motifs of his disappointment: the laundresses instead of shepherdesses, the new villa, the horizon of chimneys and smoke. But are these the motifs that matter here? Does it affect our reading of the idyll to know that the very fields at Gennevilliers were irrigated with water from the great collector sewer, and that the local press resounded with rumours of bad-smelling eggplants and poisoned soil?[18]

Consider Jean Ajalbert's description—he is the poet whose lines on the weekend crowd in the *banlieue* I just quoted—in a poem entitled "Gennevilliers." It was part of a collection called *Sur le vif* published in 1886, with the subtitle *Vers impressionistes*:

> Le soleil s'est lassé d'éclairer ce ciel, gris
> De la fumée opaque aux faîtes des fabriques,
> Qui bornent l'horizon du côté de Paris.

63. Jules Pelcoq, *A la Grenouillère.* Wood engraving in *Le Journal Amusant,* no. 991 (1873).

Un Eden où bêtes et gens se meuvent dans une douce confraternité; échange cordial de puces (de la part des individus de la race canine).

64. Berthe Morisot, *Les Blanchisseuses, plaine de Gennevilliers* (known as *Un Percher de blanchisseuses*), 1875.

Vers Argenteuil, pays des moulins minuscules,
S'étagent des carrés de maigres échalas
Condamnés, sous le poids d'éternels crépuscules,
A fournir les marchés d'acides chasselas.

Les récoltes ont là d'impossibles genèses;
Les paysans sont plutôt des égoutiers,
Arrachant, par l'engrais, des légumes obèses
D'un sol à qui la Lune a caché ses quartiers,
Et pour qui le soleil n'a pas eu de lumière.

Sur les maisons, des toits de tuiles "vermillon" . . .

C'est la campagne, mais sans chaume et sans chaumière,
Sans la moindre alouette ou le moindre grillon. . . .[19]

How much should it matter to us, this description? Or should we, rather, put our trust in the good humour of Morisot's husband, writing to her in 1882:

I have come from the plain of Gennevilliers, which I went across on my way from Epinay. Everything is in blossom there and has the smell of spring. The plain looked pretty in every direction.[20]

The *Percher de blanchisseuses* does not seem quite so straightforwardly *delighted* with the landscape as this. The view it presents is not exactly "pretty in every direction," but it is not grim and lugubrious either. Morisot's peasants—they do occasionally appear in her pictures, standing in

65. Berthe Morisot, *Dans les blés,* 1875.

front of the waving grain—are not like Ajalbert's "égoutiers." The sun evidently persists in illuminating the crude tiles on the weekend *lotissements*; the crudity and even the encroaching grey are given a place in the landscape and even some kind of weight; modernity is not overlooked, but the painter does not seem to find it in the least melancholy, or believe it should change her bright, bucolic handling of the things in front of her—those scraps of linen on the fence, that crisscross of lines and figures against the grass.

And where—final question—are the lumpish boys supposed to be bathing in Seurat's *Baignade à Asnières* (Plate XIII)? In what kind of landscape, in what kind of water? Opposite the mouth of the same *grand égout collecteur*, in fact; and this at a time—in the hot summers of the 1880s—when

more than 120,000 cubic meters of solids have accumulated at the collector's mouth; several hundred square meters are covered with a bizarre vegetation, which gives off a disgusting smell. In the current heatwave, the town of Clichy [it is there in the background of Seurat's picture, its line of factories blocking the river] possesses a veritable Pontine Marshes of its own.[21]

Pictures are being whisked in and out of the reader's field of vision, and questions multiplied, mainly because I do not have any very clear answers to most of them. Perhaps it would help if we focussed on one picture, not

noticeably less cryptic than the rest, Manet's *Argenteuil, les canotiers*, from 1874 (Plate XI); for here, I believe, the main elements of the matter are assembled: the middle class and its pleasures, the countryside organized to attend to them, and the answering presence of industry. This is the picture, it seems to me, in which the most literal effort was made to put such things in order and insist they belonged together.

It is important that the picture is big. It is a picture for the salon: a dominating image, four feet wide and nearly five feet high, whose message was meant to carry across a crowded room. And the first impression, as so often with Manet, is of a great, flat clarity of form—clearness of edge, and plain abbreviation of surface within those edges. Of course the viewer soon sees that these qualities coexist with others: with an extraordinary, calculated fat richness of touch, a thick weave of individual brushstrokes, dab after dab in the woman's dress or the flowers she holds, in the distant boats or the great blue surface of water. The eye gets involved in the details: it makes out the fingers half lost in the flowers, or the stuff of the folded parasol on either side of the yachtsman's arm. But detail plays against plainness; an exuberant tissue of touches, worked over and into one another, mixed and remixed, hard-edged and soft-edged, and all of them quite safely *contained* in the end, made part of an order that is simplified and flat.

The examples are obvious. The man, for instance, is seemingly turned towards his inscrutable companion, no doubt in admiration; his body is swivelled in space, half leaning back from the picture's surface. And that obliqueness is half offered to the viewer and half refused: the tunic and torso are kept in touch with the surface, flattened out—by the curious line of light which runs from the neckline diagonally across the open chest; by the narrow, flat rainbow curve of lines on the man's far shoulder; by the ruck of brushmarks where the tunic puckers; and by the shadowy flatness of the man's forearm, lined up as it is against the picture surface and touched with a couple of unattached, absolute dabs of colour where the light outlines a knuckle and finger on the fist.

The picture offers these irresolutions to us: the flattened body; the mast which never quite manages to be modelled; the dense, opaque blue of the water and the floating, tilted, improbable woman's hat (Plate XII). The hat, I suppose, is the strongest sign of flatness in the picture. It is a black straw oval, hardly seeming to belong to the head underneath it. It is a simple surface; and onto the surface is spread that wild twist of tulle, piped onto the oval like cream on a cake, smeared on like a great flourishing brushmark, blown up to impossible size. It is a great metaphor, that tulle; and it is, yes, a metaphor of paint and painting. One of the things that the

66. Edouard Manet, *Les Bords de la Seine à Argenteuil*, 1874.

ornament does is put in doubt the picture's already fragile space; for it laps like a wave against the far white wall, the one across the river in front of the houses.

These are the things which are always said about Manet's painting; in his lifetime querulously, and later by critics and historians who were certain that here—in the oddities and flourishes—lay the point of the picture and the key to its classic appeal. They were not wholly wrong, it seems to me; but it has to be said—I shall say it again and again later, meaning it metaphorically—that Manet *found* flatness more than invented it; he saw it around him in the world he knew. I mean that literally here. If we look at one of the other pictures Manet did in Argenteuil, we can see, from the back, the unlikely construction of the black straw hat. For hats themselves were two-dimensional in 1874; they were tilted forward and tied up behind, real pieces of fashionable machinery. (That fact makes sense, incidentally, of a tiny fleck of black which can be seen, in *Argenteuil, les canotiers*, at the upper edge of the woman's ear: it must be the tip of the hidden bow, the clue to the whole outlandish construction.)

Nevertheless the later enthusiasts were right to single out the things they did. The more we look at the picture the more we come to dwell on its peculiarities, and see it as flaunting the facts of its own discrepancy.

Signs, things, shapes, and modes of handling do not fit together here. Paint does not make continuities or engineer transitions for the eye; it enforces distinctions and disparities, changing completely across an edge, insisting on the stiffness of a pose or the bluntness of blue against yellow. This is the picture's overall language—this awkwardness of intersection, this dissonance of colour. But once again the viewer is afforded a few special instances of the general lack of fit. For example, the hank of rope which hangs over the orange side of the boat towards the right. No doubt we decipher the flecked rope and the fluffy tassel without too much difficulty, and proceed to examine the more elusive trail of paint which starts down from the gunwale, bends, and seems to peter out into the orange—peter out for no good reason. And in due course the eye makes sense of the situation: we begin to see the wandering line as a shadow, and realize eventually that the orange surface is not—as it is first assumed to be— simply flat. It is curved, it is concave; and the curve explains the peculiar shadow and is explained by it—or, rather, is half explained and half explaining: the broken triangle of brushstrokes is not mended quite so easily, and never entirely proves the illusion it plays with. It stays painted, it stays on the edge of a likeness.

And what are we supposed to make, finally, of the visual rhyme which Manet puts at the picture's centre? In between the figures, outlined against the sky, is a distant factory chimney. Beneath it a reflection spreads out across the water, grey and white at first, opening slowly into the ripples of the river, then reappearing farther down, dispersed a bit more and touched with yellow, before the water surface finally breaks up. Now in fact these marks are *not* a reflection. They are a line-up of false equivalents—two pieces of rope hanging down from the end of a furled-up sail, and four tiny yellow flowers straggling free from a band on the woman's hat brim. They are a kind of joke—the word comes awkwardly, but I cannot think of a better one—about false equivalence; about things appearing to connect and then being seen not to; about illusion, about the difference between illusion and untruth. These are the picture's main concerns, of course; and in general it is far from playful in its treatment of them.

It has the look of an icon, this picture, does it not?—an altarpiece with two great meek figures presented to us, dominant, the one half turning to the other, yielding, indicating, paying some kind of homage. And both of them closed in an arbour of boats, sitting on a plain horizontal throne, hemmed in by a patient system of straight lines—masts and chimneys, riverbank and far white wall. Yet it is no icon: it is too casual, too uncomposed, too untidy. The river is full of the signs of *canotage*: rigging

and bits of boats and rolled-up canvas, the whole thing patchy and pro-
visional. It is the lack of order which must have been striking in 1875, for
here was a subject which lent itself normally to simple rhythms and sharp
effects: sails bending in unison, rigging arranged in casual geometries,
reflections laid out as counterpoint to the world above. Manet's regatta
was not like this: there was no single sail unfurled, and the whole of a
boat was never shown. *Canotage* was a litter of ropes and masts and
pennants, its casualness confirmed by the invading slab of blue which so
perplexed the critics. The blue was the foil for this patchwork, this debris;
it was the consistency of nature, they might have said, as opposed to the
random signs of manufacture; it was what survived of landscape.

So what can we say of the objects and persons at Argenteuil? How are
people depicted here, how do they present themselves, what kind of in-

67. Claude Monet, *Canotiers à Argenteuil*, c. 1874.

dividuals are they? It would be nice to be as sure of the answer as the English critic in 1876 who called Manet's subject "these vulgar figures," this "couple of very ordinary-looking lovers sitting on the gunwale of a boat."[22] Or as certain as Maurice Chaumelin, writing a year earlier in *Le Bien Public*:

Under the pretext of representing nature and society just as they present themselves, the realists dispense with balance in their pictures of both. But let that pass. There are at least, in this nature and this society, aspects which are more agreeable than others, and types which are more attractive. Monsieur Manet is deliberately out to choose the flattest sites, the grossest types. He shows us a butcher's boy, with ruddy arms and pug nose, out boating on a river of indigo, and turning with the air of an amorous marine towards a trollop seated by his side, decked out in horrible finery, and looking horribly sullen.[23]

We may prefer, however, the admission of uncertainty in Baron Shop's entry on the picture in *Le Petit National*:

His *Canotiers d'Argenteuil* are two, one of them a lady. They are shown full face, sitting on a bench together, with the air of being tolerably bored, as far as the wilful impasto on the faces allows one to judge.[24]

"L'air passablement ennuyé autant que permettent d'en juger les empâtements volontaires des figures"—at least this critic seems aware of the problem. The previous writers, one cannot help feeling, were wishing expressions and simplicities where the paint allowed them none. They were wanting the signs, the largely absent signs, of social inferiority: they would have their butcher's boy and brave "donzelle," they would have vulgarity and grosssness; anything rather than the actual disguise they were offered, the deadpan, the uncertainty.

The people in the picture are *posing*, perhaps we could put it that way—posing not as artists' models do, but as people might for a photograph, as they might have done later in just such a place. Their faces go blank, their bodies turn awkward, they forget how to look happy or even serious. The woman's face, especially, is worked and reworked to the point of effacement; it is scarred and shadowed and abbreviated, hairless and doll-like, animate but opaque. The eyes look out levelly from underneath the hat brim, the mouth just opens, the earrings and necktie are neat as a pin. The woman resists the critics' descriptions: she is not quite vulgar, not quite "ennuyé," not quite even sullen.

This is a picture of pleasure, remember, of people taking their ease. We need a word to express their lack of assurance in doing so; or at least the curious, complex *qualification* of pleasure as these people seem to have it. Veblen talks of individuals—he has in mind considerably wealthier women than the one we are looking at—"performing" leisure, or "rendering" it.[25]

68. Hadol, *Le Salon comique*. Wood engraving in *L'Eclipse*, 30 May 1875.

The verbs are useful but a bit too strident. "Joylessness" would almost do—it has the advantage of defining the matter in negative terms—but in practice the word has lost its limitations, and has too pejorative a ring. The best phrase, I believe, occurs in Norbert Elias's writings: he talks of the places allowed for excitement in our society—he thinks they are rather few—and points to "the cover of restraints" which spreads, more and more evenly, over action and affect in modern times.[26] The "cover of restraints" in the place of pleasure—that seems to me the great subject of Manet's art. But it should be said at once, by way of proviso, that in Manet's art the restraints are visible: they are not yet embedded in behavior; they still have the look of something made up or put on. Of course there is *fashion* already, and that is the strongest sign of the order to come; but it is important that fashions are still assumed a bit awkwardly and seem not to belong to their wearers. (Is that what Chaumelin meant by calling the woman "horriblement fagotée"?)

The part of the picture that has so far been left out of discussion is the landscape in the background. On the other side of the river is a town or a village—anyway, some kind of built-up area—in which the viewer can quite easily make out a mansarded villa, trees and houses, a white wall, and some factory chimneys—two of them idle, one producing smoke. These details were noticed in 1875. The cartoonist in *L'Eclipse*, Hadol, imagined the man's (now phallic) hat floating in the Seine beside its flowery partner, in front of a building labelled "Fabrique d'Indigo." He added the caption,

"The Seine at the Sewer of Saint-Denis." And thus the blue of the river was explained—by the great chemical-dye factories a few miles upstream from Argenteuil, pouring their indigo waste into the water.[27]

It is a pedestrian joke, of course, but its materials seem to me the right ones. The cartoonist's mistake, if I can put it this way, is to picture the landscape as literally *made* by industry, and therefore have the factories to

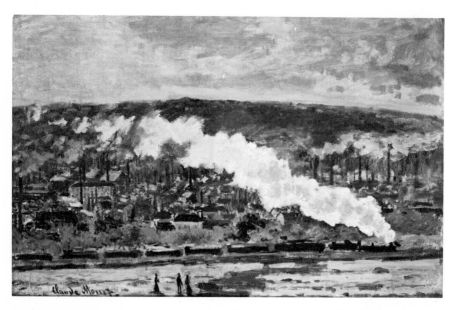

69. Claude Monet, *Le Convoi du chemin de fer,* 1872.

70. Armand Guillaumin, *Soleil couchant à Ivry,* 1873.

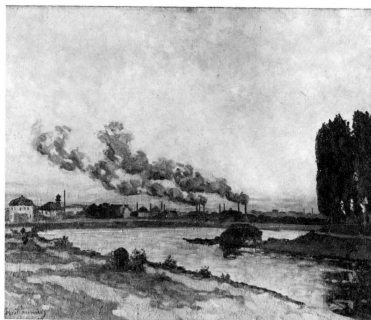

68. Hadol, *Le Salon comique*. Wood engraving in *L'Eclipse*, 30 May 1875.

The verbs are useful but a bit too strident. "Joylessness" would almost do—it has the advantage of defining the matter in negative terms—but in practice the word has lost its limitations, and has too pejorative a ring. The best phrase, I believe, occurs in Norbert Elias's writings: he talks of the places allowed for excitement in our society—he thinks they are rather few—and points to "the cover of restraints" which spreads, more and more evenly, over action and affect in modern times.[26] The "cover of restraints" in the place of pleasure—that seems to me the great subject of Manet's art. But it should be said at once, by way of proviso, that in Manet's art the restraints are visible: they are not yet embedded in behavior; they still have the look of something made up or put on. Of course there is *fashion* already, and that is the strongest sign of the order to come; but it is important that fashions are still assumed a bit awkwardly and seem not to belong to their wearers. (Is that what Chaumelin meant by calling the woman "horriblement fagotée"?)

The part of the picture that has so far been left out of discussion is the landscape in the background. On the other side of the river is a town or a village—anyway, some kind of built-up area—in which the viewer can quite easily make out a mansarded villa, trees and houses, a white wall, and some factory chimneys—two of them idle, one producing smoke. These details were noticed in 1875. The cartoonist in *L'Eclipse*, Hadol, imagined the man's (now phallic) hat floating in the Seine beside its flowery partner, in front of a building labelled "Fabrique d'Indigo." He added the caption,

"The Seine at the Sewer of Saint-Denis." And thus the blue of the river was explained—by the great chemical-dye factories a few miles upstream from Argenteuil, pouring their indigo waste into the water.[27]

It is a pedestrian joke, of course, but its materials seem to me the right ones. The cartoonist's mistake, if I can put it this way, is to picture the landscape as literally *made* by industry, and therefore have the factories to

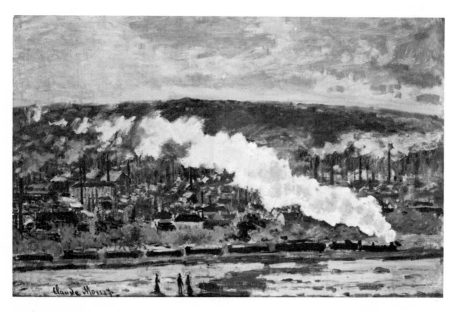

69. Claude Monet, *Le Convoi du chemin de fer,* 1872.

70. Armand Guillaumin, *Soleil couchant à Ivry,* 1873.

71. Camille Pissarro, *L'Usine, Saint-Ouen l'Aumône*, 1873.

blame for everything—the water, the people, the shape of the hats. That might prove to be true in the long run, but the point about Argenteuil and its neighbours was that the long run seemed such a long way off. This was not a terrain where industry was master, even picturesquely so. It was not like the hillside at Déville-lès-Rouen, for example, which Monet had painted a few years before: a forest of chimneys belching smoke, and the railway running past them like a river in spate—industry as landscape, certainly, with three small strollers in the foreground twirling parasols and taking in the sights. Nor was it the forge at Ivry, as Guillaumin showed it in 1873, blocking the river, backlit and melodramatic; nor the quiet enclosure of Monet's *Ruisseau de Robec*; nor the blunt shape of the starch works at Saint-Ouen, in the oil by Pissarro done in 1873.

The presence of industry at Argenteuil is different from this. It lays

82 – Argenteuil (S.-et-O.) – Le Pont du Chemin de Fer

72. Anonymous, *Argenteuil—Le Pont du chemin de fer*, c. 1895–1900. Photograph.

claim to the landscape in rather the same way as the two people in the foreground—a bit erratically, a bit naïvely, acre by acre, without much of a flourish. And this seems to me the ultimate point of the picture's formal language. It fits its figures and landscape together, it makes out relations between them—between shoulders and water, chimney and halyard, straw hat and white wall—but the edges and links are mostly implausible, and surely meant to be so. The forms are like cut-outs against the bright blue ground; the outlines of everything are too sharp and simple.

This has to do, I think, with many things: with the look of objects close up in sunlight, with the fact that a picture is actually flat, and with the received wisdom in 1875 about such places as Argenteuil. It is not that Manet reproduced that wisdom in any simple form. His picture does not strike me as comic in the way of "Y" or Robert Caze; and irony is seemingly what he was working to avoid, above all in the woman's face. The best description is a limited one: the figures and landscape do not quite belong together yet; they are incomplete, they have the look of contingency. This does not mean they are shown as fugitive and impalpable, in the way of a sketch. On the contrary, the picture is massively *finished*; it is orderly and flawless, and the word "restrained" applies to it as much as the word "contingent." But whatever it is, it is not "natural": it is not offered the viewer as something already made and self-evident, there to be looked at and not questioned (this is true of landscape and figures alike). What Manet was painting was the look of a new form of life—a placid form, a modest

73 — Argenteuil (S.-et-O.) - Bords de la Seine

B. F., PARIS

73. Anonymous, *Argenteuil—Bords de la Seine*, c. 1895–1900. Photograph.

form, but one with a claim to pleasure. The careful self-consciousness of the woman, her guarded attention to us, the levelness of her gaze: these are the best metaphors of that moment. It is Olympia's gaze again, but lacking the fierce engagement with the viewer or the edge of insecurity. This woman looks out circumspectly from a place that belongs to people like her. How good it is, in these places, to find a little solitude on Sundays! How good, how modern, how right and proper.

Argenteuil in the 1870s was modernizing fast.[28] It was still surrounded by vineyards, and one or two windmills looked down on it from the slopes of Orgemont and Sannois. The *petit bleu d'Argenteuil*—it had been the theme of many a joke at Manet's expense in 1875—was still just drinkable; and whatever the quality of the wine, people came out from Paris to watch the peasants get drunk at *vendange*.[29] The town was "famous for its plethoric asparagus"[30] and its figs: its agriculture was geared to the Parisian market, as it had been since the eighteenth century.[31]

In the 1870s Argenteuil grew: it had 8,000 people at the beginning of the decade and close to 12,000 in 1882.[32] Part of that increase was straightforwardly suburban: the town was a fifteen-minute ride from the Gare de l'Ouest, and many a stockjobber and commercial traveller decided that it was just the place for a house and garden. To the west of Argenteuil grew up what the locals called "la nouvelle cité," and to the east "la colonie

parisienne."[33] Yet the majority of newcomers in the 1870s were most probably not bourgeois and no longer strictly Parisian: they were people who came in search of work to a town that was quietly making itself over to industry. Already in the 1860s it had boasted factories and plaster works. Five hundred men had made their living in the gypsum quarries;[34] three hundred or so had worked for Monsieur Joly in his iron foundry next to the railway bridge. They built the Palace of Industry for the Exposition Universelle of 1867, and the great iron canopies for Les Halles; they tried their hand at bicycles for a year or two, and of course they forged the parts for the new railway bridge itself when it was rebuilt in 1872.[35] The town had a saw mill and several distilleries, a tannery, a gas works, an establishment which made mineral water, another producing cardboard boxes. There was lacemaking, fine crystal, and clocks. Bezons, to the south, had a rubber factory (by 1869 the waste from the plant had killed off the local fish).[36] In the 1870s more industry arrived: a new chemical works in 1872 and an albumin refinery two years later; another distillery, a second foundry with jobs for 170 men, and a third in 1876.

This list of premises and dates is all very well as far as it goes, but it does not rule on most of the decisive questions. It does not permit us to say how much these new activities marked the landscape or transformed it, or whether the factories somehow stood in the interstices of the town, left out of sight between the vineyards and the river. Certainly the landscape had long since lost its claim on the attention of the traveller in search of

74. Alfred Sisley, *Le Pont de péage à Argenteuil*, 1872.

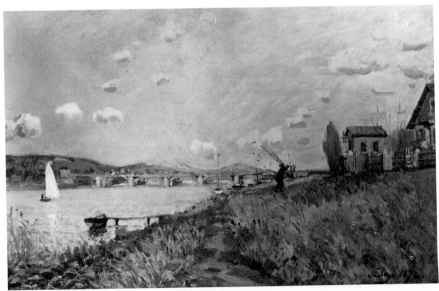

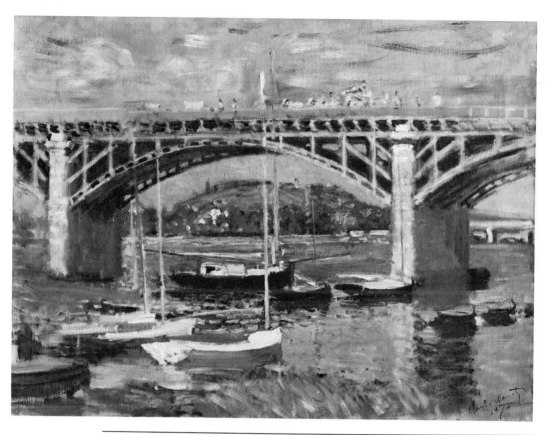

75. Claude Monet, *Le Pont de péage, Argenteuil*, 1874.

the picturesque, and Louis Barron, on the Argenteuil road in the 1880s, "made haste to flee the monotonous spectacle of the quarries, marking the hillsides with yellow, and the plaster works which keep a whole population of poor workers tied to the region, and the vines, and the interminable squares of vegetables bordering the road."[37] But Barron's verdict does not really speak to the town and its immediate hinterland, and it is that area which concerns us most. What we need to know about Argenteuil is how large the twenty factories loomed, and whether the piles of coal and plaster on the towpath actually *showed*—whether they made the town look "industrial." (The force of that word is anyway not clear when applied to a place, as opposed to a way of working.)

The best evidence we have is Impressionist painting, but it too is ambiguous. Are we to trust the perspective it offers, for example, in Manet's *Bateau-atelier* (Plate XIV)—the river looking south and west, the atmosphere heavy with Ajalbert's twilight, the fields walled in with new buildings? Or should we prefer the hills upstream, in Sisley's hands or Renoir's,

76. Auguste Anastasi, *Environs de Paris—Port des clippers dans le bassin d'Argenteuil*, 1858. Wood engraving.

77. T. Weber, *Environs de Paris—Argenteuil*, 1869. Wood engraving.

without a sign of industry to interfere? Is it sleight of hand when Monet looks north through the toll bridge to the Côte de Sannois, and has one pillar of the bridge block out the Joly ironworks to the right—sleight of hand or felicitous arrangement? Might not the composition speak quite well, in fact, to the modest place of such things in the landscape, to the way they hardly interrupted vision?

One thing undoubtedly did mark the town, and that was the invasion of the pleasure seekers. The effects of that process on the riverside were

unmistakeable: they are there, innocently charted, in the engravings of the place published at the time in all the illustrated magazines. Argenteuil changes—from an open riverbank where clippers are drawn up casually for an afternoon, making use of a few slipways and a natural harbour; to a town still nestling deep in trees—the year is 1869—and a towpath still grassy and overgrown, but the river already thick with boats; to a bank which is crowded with shipyards, spectators, offices with boats-for-hire; to a suitable place for a steamboat race, or the launching of a new yacht, or the national rowing championships. Argenteuil was putting in its bid to be the capital of Parisian recreation—with what determination can be judged from this entry in *Le Petit-Journal* from May 1877, announcing the programme for Trinity Sunday:

> *Argenteuil* (Gare Saint-Lazare)—Continuation of festivities. At 2:30, bicycle races organized by the Union Velocipédique with music provided by the municipality; costumes *de rigueur*.—At 9:00, grand torchlight procession with music and the fire brigade.[38]

It is by far the most flamboyant of the twenty-two local entertainments listed that weekend.

No wonder that by 1884 the town has taken its place in the ironic discourse which the reader now knows well. This is Louis Blairet, for example, in *L'Opinion*, describing Argenteuil in his series "Autour de Paris":

> Come Sunday, there is an invasion of the Gare Saint-Lazare, lady fruit-sellers from the Rue Saint-Denis, cabinetmakers from the Rue de Cléry, girls who make chocolate in the Rue de Vivienne—there is not one of them who does not descend on the banks of the Seine, beneath the Moulin d'Orgemont or in the Auberge des Canotiers. And wherever there trots a Parisienne, a Parisien is sure to follow.

78. Anonymous, *Course de canots à vapeur à Argenteuil*, 1874. Wood engraving.

. . . There is singing, shouting, dancing, running about, falling down, and going astray. It all begins with *entrecôtes au cresson* and ends with aching limbs. The banks of the Seine are full of mysteries that day, mysteries of the private and pastoral life.

Here we serve lobster salad on the grass, messieurs![39]

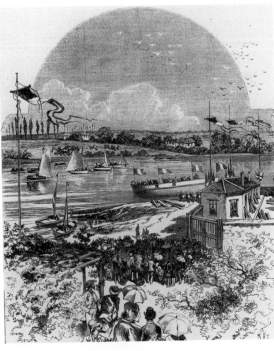

79. Ferdinandus, *Lancement d'un navire à Argenteuil*, 1877. Wood engraving.

80. M. Grenier, *Course du championnat de France dans le bassin d'Argenteuil*, 1886. Wood engraving.

The terms are the normal ones: grocers' wives and cabinetmakers have once again put paid to the genuine *fête champêtre* and established a counterfeit in its place. Argenteuil is part of the environs of Paris and can therefore be condescended to.

The other main picture Manet did at Argenteuil in 1874 was a portrait of his younger colleague Claude Monet at work in his houseboat studio (Plate XIV). The scene is presented from roughly the same vantage point as that of *Argenteuil, les canotiers*, though now the horizon is opened wide enough to give a glimpse of the Gennevilliers shore. The chimneys are all smoking fiercely, and the house with the mansard is no more than a smudge. To the left there is much the same debris of masts and furled sails as in *Les Canotiers*, though one of the yachts is sailing now, or at least has its mainsail hoisted.

Monet, at any rate, is turned away from the evidence of industry: he seems to be looking towards the right, past a further crop of boats and rigging, whose forms are blocked out on the canvas on his easel. His manner of working is something Manet clearly admired and wanted his viewers to know about; he showed them Monet's way of painting in the way he put on paint himself: it is looser and lighter than in *Les Canotiers*, with the edges of most things no longer so sharply outlined. The bow of the houseboat, for example, is splashed with a hatchwork of blue and grey strokes, and the water has lost its absolute colour—it is grey, yellow, white, and green, mixed up with reflections and seeping into every solid it touches. The picture is surely concerned to associate these qualities with others the critics thought Monet deficient in: steadiness, for instance, patience, concentration, relentless detachment. The patience may strike us as belonging to the self-effacing wife as much as to her husband, but the relentlessness is all Monet's own. It is there in the profile he offers the viewer, sharp against a plain blue ground; and in the way his brush is held, tight in the fingers like a pen, ready for rapid and sure notation.

What Monet is insistent on is *landscape*; and Manet's depiction of him might be read as a kind of reflection on what it meant to keep hold of that category in a place like Argenteuil. It meant contriving to notice some things that loomed large in one's field of vision and to overlook others just as prominent; a picture depended on choosing and maintaining a certain point of view, doing so often with fastidious and, in its way, cynical care. No doubt painting landscape had always involved some such process of reading out and reading in; but what the painter excluded had rarely been there so emphatically, so much wrapped up with the matter in hand. Landscape is in doubt in Manet's picture: the sheer range of shapes and

incidents which cry out for representation puts the whole business of landscape in question, and Monet has seemingly turned away from the untidiness, preferring to focus on what the scene still offers of pleasure or nature in undiluted form. Manet, by contrast, still looks to the south and west, as if resolved to show that the Bezons reach could be faced by painting—even painting of Monet's kind. There was a way to put down such matters in oils and have them be part of landscape quite strictly conceived. They would have to be sketched in lightly, almost carelessly, without much attention being paid to differences and identities, to the weight and substance of objects. The whole thing would necessarily be done with a great show of painterly wit, a flaunting of facility, as if daring the world to resist one's notation of it; and if the tour de force was successful, the play of paint would absorb the factories and weekend villas with scarcely a ripple. Surface would replace substance; paint would *perform* the consistency of landscape, in spite of everything a particular landscape might put in its way; there was nothing that could not be made part of a picture— of a picture's fragile unity—if the painter confined himself to appearances

81. Claude Monet, *Les Bateaux rouges, Argenteuil,* 1875.

82. Claude Monet, *Le Voilier au Petit Gennevilliers*, 1874.

and put aside questions of meaning or use.

It may even be that one does Monet an injustice by having him disagree with that last verdict. If we look again at the picture on his easel and take notice of the tree at left, and the masts and water in roughly the right places, we may end by believing that Monet too is out to paint the view behind him—the one downriver, towards the smoke. Are we given enough on the slanting canvas to reconstruct a picture something like *Les Bateaux rouges, Argenteuil* or *Au Petit Gennevilliers*? (No particular surviving Monet seems quite to fit the vague clues on offer, but there are four or five which show the same slice of riverbank rendered from more or less the same spot.[40]) Pictures like the one I have chosen are in their way more absolute with industry than Manet could ever quite be. They look towards the industrial shore and do not seem for a moment to find the litter over there at odds with the water and masts in the middle ground; they have no high horizon with chimneys separate and clear; such things are incidental to the landscape, and if the painting stands to benefit, they can simply be left

out. (That happens quite often and is done very matter-of-factly.) In any case, suppression is not usually necessary. The signs of industry can be included, in a picture like *Le Voilier au Petit Gennevilliers*, but in such a way that they hardly register as different from the signs of nature or recreation. A chimney is not so different from a tree or a mast; the shape and consistency of a trail of smoke can be taken up in other, stronger traces—the edge of a reflection or the body of a cloud. The factory is a minor note, and the smoke serves to provoke various analogies—between smoke and paint, smoke and cloud, cloud and water—all of them guaranteeing the scene's coherence.

The chimneys, in other words, are made part of landscape as Monet imagined it. And landscape, for Monet as for many other painters in the later nineteenth century, was the one genre left. They seemed to believe—the belief was not often stated explicitly, but the drift of practice is unmistakeable—that nature possessed consistency now, in a way that nothing else did. It had a presence and a unity which agreed profoundly (this was the crucial point) with the act of painting. The flat unison of a picture like Monet's was *like* landscape, like the look of sky and water *en plein air*; and these were the things on which painting could thrive. No other subject proved to match so well with the actual material of oil and canvas; no other offered painting the right kind of resistance, the kind which had the medium seem more real the harder it was pressed in the service of an illusion.

This was a powerful belief and in some ways a merited one. The achievements of the previous generation, and above all the work of Courbet and the Barbizon school, could be taken to confirm it; though they also suggested—in Millet's art the suggestion was particularly strong—that the genre of landscape would have to be rephrased and extended if it were to go on providing matter for major art. The genre came down to the new group of painters in a necessarily complex form, with a special and in many ways perplexing history; and that history was not a dead past. It was supposedly part of the genre's appeal to practitioners that it seemed to offer them a wealth of examples which were still effective, still useable in detail. Landscape painters had access to a tradition, they believed; they were confident that there was almost as much still to be learnt from Hobbema and Ruysdael, say, as from Daubigny and Jongkind; they might even go further and say that learning from the latter pair *was* learning from the former, and that a painter looked closely at Ruysdael precisely in order to understand better what Daubigny was doing.

The vividness of the tradition was exacting as well as helpful. The painter of landscape was notoriously engrossed in the natural world as it

83. Jean-François Millet, *Pâturage sur la montagne, en Auvergne*, 1867–69.

simply was, as it stood over there in front of his easel; and yet nature was nothing for painters if not encountered in other people's painting, and it existed there in not at all simple form. Nature had substance for Monet and his friends as a term in a tradition; they learnt it as part of their practice, by using and adapting what the Dutch had done, or Constable and Corot. The term in the hands of these older masters was specially protean: there *was* no nature, in the great tradition of landscape painting, except as part of a movement, an equivocation, in which Man and Nature (bravely capitalized) were seen to depend on each other for their sense. Landscape put together the man-made and the natural, the wild and the cultivated, the elements and man's attempts to defy them. Certainly it celebrated the limits of the human world, and often affirmed that people lived in a landscape that was not put there simply for their convenience— or not securely. There was the sea, the marshland, storms, waterfalls, wilderness, dark woods, ruins. But the wilderness could be charted, marshes drained, land pulled from the sea and found fertile; waterfalls could turn wheels and ruins be restored and venerated.

These are the obvious examples, and no doubt they seem to come a little

pat; but that is largely because they are the repeated conceits of the genre, by now a bit stale in the telling. Whether one looks at the painters of Rome and its *campagna*, or the Dutch, or the English in the eighteenth century, or Auvers and Barbizon, it is always the difficult, provisional relation of man to nature—the extent to which man makes the landscape or is made by it—that is the main motif. It is the stuff of landscape painting, this progress from barren waste to broken column to rude cot to decent farm to thriving village to nestling town with determinate edge; or from commons to enclosure and rapids to sluice. The modern artists of the 1870s inherited this idiom: they shared the older painters' assumption that nature could hardly be seen in the first place—or construed as an order apart from the human—unless as something mapped and tended, interfered with and not infrequently replaced by man. And how was man present in his landscape? What kind of mark did he make upon it, what kind of boundaries; how had his artifacts made peace with their surroundings, or had they made peace at all? (It was not necessarily the case that they should: a city wall and a windmill were equally part of a well-ordered province.) What forms of *visibility* were provided as part of this overall process of control and understanding? How was the countryside kept at a distance, brought into view, produced as a single human thing, a prospect or a panorama? Upon the answers to questions like these depended the artist's sense of a scene's amounting to landscape at all, and therefore being paintable.

These were practical matters, in other words, not just theoretical ones; from them derived the exercise of landscape as an art and the possession of its basic terms and skills. In the 1870s the questions recurred with a vengeance; they were not essentially different from the previous ones, but there was a feeling abroad that the answers this time might not prove particularly encouraging. Was there a way now for landscape to admit the new signs of man in the countryside—the chimneys, the villas, the apparatus of pleasure?* Could the factory be added to the series which went from wilderness to working river? (And if not, why not?) Was the city with determinate edge to be joined, in painting, by the city without one? How much of inconsistency and waste could the genre include and still keep its categories intact? So landscape was to be *modern*; but if it was—if the

* The most interesting verbal evidence that questions of inclusion and exclusion—and questions of overall *attitude* towards landscape—were consciously raised at the time by painters of the group comes from Georges Rivière, the friend of Renoir and critical champion of the Impressionists in 1877. In his *Renoir et ses amis*, p. 182, he discusses Renoir's sunny view of Bougival, Saint-Cloud, and Argenteuil, and adds: "This landscape which so delighted Renoir, other painters saw it in less cheerful colours. They noted only *terrains vagues* strewn with rubbish, scabby grass trodden by inhabitants in rags, miserable

signs of modernity were agreed on and itemized—would the landscape not be robbed of what the painters valued most in it? Would it not lose its singular beauty, its coherence, the way it seemed to offer itself as an unbroken surface which paint could render well? For Monet and his colleagues, landscape was the guarantee of *painting* above all; it was the thing that justified their insistence on matter and making, on the artisanal facts of the art. Perhaps that guarantee would not hold, least of all in places like Argenteuil. But painting in a sense had nowhere else to go. It was here that the terms of the landscape tradition still seemed to present themselves with some kind of vividness. The roll call of edges and stages of civilization could still be taken at Argenteuil, as once it had been outside Rome or Haarlem. Without such a roll call, landscape painting was a poor thing.

Monet moved to Argenteuil just before Christmas 1871 and lived in the town for the next six years. Friends came to stay and paint—Sisley in 1872, Renoir on several occasions. Caillebotte's family had a summer place across the river at Petit Gennevilliers, and Manet lodged there while painting *Argenteuil, les canotiers.* Landscape painters came and went, but mostly the town and the river were Monet's property, and he charted them in picture after picture—over 150 by the time he left.

I do not intend to sum up the character of 150 canvases in a page or two, still less to endow them with an overall "attitude" to the landscapes they show. Their attitudes—and the very word had better be used sparingly, with the emphasis on the physical side of the underlying metaphor—are many; and from year to year Monet seems to have sought out quite different things in his surroundings, to have been seized with a sudden enthusiasm for a motif and given it up equally suddenly, made use of snowstorms or floods, painted reedy backwaters because at last he had a boat equipped to get him there, and so on. Yet something can be said about these pictures' specificity as landscapes: we can point to the ways they diverge from the genre's normal range of motifs. I believe that the paintings provide evidence that Monet was thoroughly alive, at least in his first three years at Argenteuil, to the kind of problem I outlined previously. In picture after picture—some of them frankly experimental and botched—he seems to be testing ways to extend landscape painting's range of reference and still have it

hovels and tumbledown cottages, a grey sky punctuated by tall factory chimneys belching thick black smoke. It is exactly the same place, but seen by men of different temperaments and interpreted in both cases with equal sincerity. I am thinking, in writing this, of Raffaëlli, who exhibited with the Impressionists.

"—In his pictures, Renoir said to me one day, looking at a picture by Raffaëlli, everything is poor, even the grass!"

serve his fierce, necessarily narrow conception of what painting was and ought to be.

About one of the new items in the landscape he never appears to have had much doubt. The boats on the river were there to be painted, even if, as happened on the Gennevilliers shore, they blocked out half the horizon and brought with them an accompaniment of floating offices, boatyards, boathouses, pontoons, and villas all bidding for their few yards of river frontage. The crush did not matter, or it did not seem offensive. The sails and masts were a useful middle ground; they added a touch of geometry, not too insistent, which the painter could edit or soften as he saw fit. Monet himself was part of the boating world; in one or two paintings from 1874 he found room for his own houseboat studio, tied up to a slipway next to the bureau where yachts could be rented[41] (Plate XV). The studio was part of the general litter, its outline more ungainly than most of its neighbours.

There was an industry of pleasure taking its place in the landscape, making the river available to people who wished to go as far as Bezons, take a closer look at the false Louis XIII villa—the one with the mansard roof—and be back in time for the train. This industry could certainly be made part of landscape painting; Monet is often at his strongest when he spells out the encroachment of pleasure on the countryside, but insists, in the way he handles it, that the scene has lost none of its unity and charm. Pleasure of this kind is natural, these pictures seem to imply: it gives access to nature, whatever the ironists say. No doubt there was something abrupt and superficial about the boaters' encounter with the Bezons shore, but speed and superficiality were not qualities necessarily to be despised in one's dealings with nature. Did not Monet's own painting, in the 1870s, experiment with ways to make such qualities part of its repertoire? Were not pictures required to be more casual and lighthearted now, less encumbered with grand forms and correct ideas? Did not Monet's painting make believe—the fiction was as crucial as it was peculiar—that its maker proceeded at breakneck speed and could hardly tell a hawk from a handsaw, let alone a chimney from a mast?[42] Perhaps it was true that Argenteuil was a factory, with nature produced as its best commodity; but Monet was seemingly prepared to accept the fact, and take his place among the amorous marines.

Argenteuil, we have seen, had factories of the normal kind, more of them each year. The question therefore arose whether this industry would interfere with the other, and to that Monet's answer was less unequivocal. In due course he seems to have decided that it would and did, and that was presumably part of the reason for his moving from Argenteuil in 1878

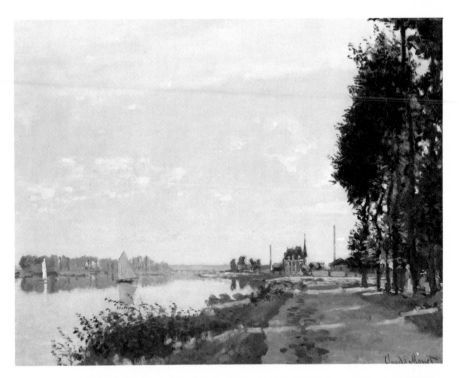

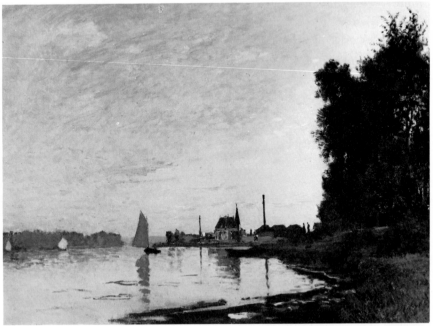

84. Claude Monet, *La Promenade d'Argenteuil*, 1872.
85. Claude Monet, *Argenteuil, fin de l'après-midi*, 1872.

and setting up house in an unspoilt spot. (Though it is a notorious fact that four trains a day passed along the railway line that cut off the artist's garden at Giverny from his precious lily ponds.) But again, in the first three years at Argenteuil his painting often seemed to dispute the very terms of the antithesis. What did it take, after all, to *spoil* a landscape? If one looked downriver on the Argenteuil side, did not the factory chimneys chime in with the villas and tree trunks, and was not the saw-toothed outline of the factory taken up in the mansard roofs and sails? Industry could surely be made part of the idyll if the painter tried hard enough; it could be precisely and firmly stated, but nonetheless balanced with landscape's other elements. We have seen Monet do it already in *Le Voilier au Petit Gennevilliers*; and in the four pictures he painted in 1872 on the promenade at Argenteuil he seems to be plotting the various means to put leisure and industry together.[43] Smoke drifts gently into a clouded sky in one; the blue roof of the villa is framed by trees in another, with the right-hand chimney half masked by leaves, and with smoke pouring from it like a pennant; people stroll on the footpath in black and grey, their shapes picked out against the water, played off against the white of the yachts. The chimneys catch the evening sun in another, and the shadows of trees establish distance on the promenade. In the largest picture of the four, the painter goes down to the water's edge and has the chimneys dark against the sky, with a sail put next to them in silhouette, and all three forms throwing long, clear reflections across the water; from this vantage point the whole shape of the factory is visible and plainly stated. Industry is

86. Claude Monet, *Le Pont de Bougival*, 1870.

87. Claude Monet, *Le Pont de péage à Argenteuil*, 1874.

masked or distanced or immobilized; it is part of the general well-being. (These pictures from 1872 take up a format Monet first devised two years earlier, in his great *Pont de Bougival*: they imitate that painting's composition and also its basic tone. The landscape of the later nineteenth century is to be celebrated above all for its orderliness and domesticity: it is all decent gas lamps and solid pedestrians, paved streets and convenient *terrasses de restaurant*. There is not a discarded melon in sight.)

There are other pictures of a similar kind from the first three years: chimneys appearing at the end of a path between the vineyards, aligned with Argenteuil's church steeple; chimneys in among reeds or almost lost in mist; smoke pouring from the funnel of a dredger or a barge, making freehand looped reflections in the water; floodwater or snow overtaking the promenade; flowers in the foreground of much the same scene, with the factories just above them in the distance, a vague grey against a pale yellow, smoke from the chimneys scrawled in lightly.[44]

There is a rule to these paintings, and it might be stated roughly as follows: Industry can be recognized and represented, but not labour; the factories have to be kept still, as if that were the guarantee of their belonging to the landscape—a strange guarantee in an art which pretended to relish the fugitive and ephemeral above all else. Industry must not mean *work*; as long as that fictitious distinction was in evidence, a painting could include as much of the nineteenth century as it liked. The railway, for instance, was an ideal subject because its artifacts could so easily be imagined as

88. Claude Monet, *Argenteuil, la berge en fleurs*, 1877.

self-propelled or self-sufficient. The train went discreetly through the snow, in a landscape as wild as Monet ever found in the area (Plate XVI); the station yard was full of machines and empty of people; the railway bridge was a fine, civic, obligatory sight, looking its best for the visitors [45] (Plate XVII). (Train passing over, smoke becoming cloud; boat passing under, sail just entering the shade. If only modernity were always like this!)

Once, and only once, this general rule was apparently disobeyed. Some time in 1875 Monet painted a picture usually called *Les Déchargeurs de charbon* (Plate XVIII). At first glance it seems a close enough pendant to his other pictures of the bridge at Argenteuil, the ones with yachts and slipways and floating offices. Here instead is a line of barges drawn up by the riverbank, the nearest filled with coal, and a few dim figures inside it filling their baskets with the stuff or balancing the new load on the back of their necks. Out from the barges runs a pattern of planks with more men arranged along them in regular order, walking warily with their baskets full or coming back with the baskets upturned and empty, worn as hats. It seems to be the factual, repetitive rhythm of work that the painter is trying for: the scaffold of wavering lines and the rigid figures taking their small steps (Plate XIX). In the indistinct background are more boats, a built-up riverside, and another range of chimneys in full spate.

But this is not a picture of Argenteuil. It is a scene by another bridge entirely, at Asnières, two or three miles down the railway line towards Paris. The rule is therefore followed after all: it seems that labour must always be absent from Argenteuil, and it is as if this single unlikely picture—Monet himself called it *une note à part*—were done to confirm that fantasy and make it safe.[46] Labour would be imagined once, and the full range of qualities belonging to it be articulated—physical effort, caution, constraint, stiffness, monotony, even gloom. But it would be imagined somewhere else, as part of a landscape all its own. The qualities just listed are the strict opposites of those belonging to Argenteuil (or later to Giverny, and by implication to painting in general). Instead of effort there had to be an easy lucidity; openness, spontaneity, the taking of risks and a willingness to improvise; above all there was not to be gloom. These were the characteristics of art itself and especially of landscape; they expressed the way that the one category informed the other now, and was its substance if the painter performed well. Such a picture of art necessarily depended on a strict system of exclusions.

It would be wrong to leave the impression, however, that Monet was systematic at Argenteuil. There is no single dominant sequence in the pictures he painted in the 1870s; there are many series, some echoing the others' strategies and some not; and there are single pictures, seemingly left behind from abandoned campaigns, pointing in all kinds of directions. It was true that labour could not be represented: the rule applied to agriculture as much as to industry, and the fields at Argenteuil are either empty or occupied by people with parasols.[47] But suburbia occasionally could be. There is a painting from 1873 which apparently represents the hinterland on the Gennevilliers side of the river, not far from where *les canotiers* must have been sitting; and it could almost be taken, compositionally speaking, as companion piece to van Gogh's painting of the Plaine Saint-Denis thirteen years later (p. 25).[48] The foreground of Monet's picture is the same dishevelled waste of half-tilled, half-abandoned land, all frost and inconsequential furrows; and to the right, in the middle ground, are a few suitably rachitic trees concealing a villa, three storeys high, complete with a roof of vermilion tiles. Farther back is another house, looking much the same as its neighbour, and then another and another; and so on down the riverbank towards Bezons. Bezons's chimneys are registered, lightly, with a couple of easy, unmistakeable strokes; but what the eye is mainly directed to is the *terrain vague* in the foreground, and the pungent red and yellow of the villas taking irregular possession of the plain.

This landscape cannot fairly be described as suburban, for there is too much space still remaining between the weekend retreats; but it can hardly

89. Claude Monet, *Gelée blanche au Petit Gennevilliers*, 1873.

be called countryside, in Monet's terms. It is too empty to deserve the
name; too ragged and indiscriminate, lacking in incident and demarcation
apart from that provided by the houses (which does not amount to much);
too formless, too perfunctory and bleak. These negatives add up, it seems
to me, to a specific kind of composition, one appropriate to the thing in
hand: they are Monet's way of giving form to the elusiveness of Argenteuil's
surroundings, their slow dissolution into something else. What had to be
registered was the imperceptibility of the change; there had to be a sense
of its almost not happening, and the factories and villas perhaps not posing
a threat; the earth ought to be shown degenerating gradually in a fine
light, and the viewer feel that the process was accidental, almost modest,
a bit of a waste but not necessarily more than that. The tone and imagery
are reminiscent of van Gogh, but also of Ajalbert, with both picture and
poem describing the landscape in an elliptical, half-cheerful deadpan. (Ajal-
bert was indebted to Jules Laforgue, and adapted for his purposes the
younger poet's flatness of diction, his pretence of losing a train of thought

between images, his dying fall, his apologetic dots at the end of a line.[49] Monet's picture secures its meaning through analogous devices: the looming redundancy of the earth in the painting's bottom third, the peculiar elusiveness of its horizon line, the tracks and furrows which lead off so boldly nowhere in particular, the general uncertainty of scale and lack of relation between its main parts. Is the picture's immediate frosty foreground somehow raised higher than the ground to the right? How far away is the solitary left-hand tree, and where does it stand with respect to the houses? And so on . . .)

And then, finally, there was the inside of Argenteuil. During the years Monet lived there, the town was constantly changing shape, not just at the edges but internally as well. Wide new roads were built and old ones resurfaced, drains were laid, saplings planted à la Haussmann, land given over to *lotissements*, cafés opened, and remaining spaces fenced off in readiness for the developers. The process was most likely unspectacular and must have seemed rather a nuisance; Monet held back from painting the town until the first months of 1875, and what seems to have made the place paintable then—and discouraged him from going farther afield from his house—was a covering of snow. The weather gave Argenteuil the unity it lacked, taking the edges off most things. The signs of construction in *Effet d'hiver à Argenteuil*—those haphazard piles of stones in the foreground—are naturalized, as it were, by the fall of snow. The new streets

90. Claude Monet, *Neige à Argenteuil*, 1875.

are similarly disguised, their surfaces enlivened by the erratic traces of cartwheels and a pattern of fresh-trod, improvised paths.

There were fifteen paintings done in early 1875,[50] and in spite of the snow the impression they end up giving of the town is of a place essentially lacking form, a territory of tracks, odd corners, abrupt coexistence of new streets and old waste land. Argenteuil was full of spaces where the town gave way to a stream, a marsh, and a few trees, and even its built-up areas often had the look of an overgrown village, all loose ends and lean-tos. The town was proud of its rural appearance and wanted it preserved; but it wished to be modern and have amenities, and it laid out new boulevards leading to the railway station.

There is a pair of pictures by Monet from 1875 which I take to be contrary views of much the same spot, across from Monet's house in the Boulevard Saint-Denis (Plates XX and XXI).[51] (The house was hard by the railway station—convenient for an afternoon trip to the dealer's.) In one, the painter is looking across the boulevard from a small path which leads to the station yard; an embankment goes up to the railway at the left, with some kind of shed at the top of the slope in an unprepossessing clump of bushes; snow is falling, a watery sun is struggling through the clouds, and people are pushing their way to the station, holding umbrellas. The house in the background to the right, with the steep roof and the two green balconies, is the one where Monet lived. It was as brand-new as the boulevard; Monet had moved in the previous October. The other painting is of the same scene, essentially, as it must have looked from one of those balconies or through the painter's studio window. It is certainly the view from Monet's new house: the boulevard, the path, the figures with umbrellas are the same, and the wicker fences and the railway shed. Beyond them is a little square in front of the station with regulation plane trees; the station itself, a factory or two, a smokestack, and the Côte de Sannois.

What we see is the artist's immediate world: his street, the way he went to Paris, his glimpse of open country. Is it any wonder that he chose to paint it only once? It stood too well for everything painting was supposed to ignore: the litter of fences and factories, the town seeping like a stain into the surrounding fields, the incoherence of everyday life. A painter in the nineteenth century very often believed he was faced with a choice because of such things, and here it appears with horrible vividness. Outside the window are the suburbs, and people determined to catch their train in spite of the weather. Inside the house is the world of landscape, preserved after all from the ironists' chatter. The house would have a garden, with high hedges and borders and permanent profusion. The painter would make his own landscape there, in a place he could fill with intimate things,

91. Claude Monet, *Le Banc*, 1873.

hoops, hats, coffee, children, wives, maids. It would be an interior, a fiction, a *hortus conclusus*. There would be people in it, brought on to emphasize its artificiality: his wife, Camille, stiff-jointed on a garden bench, complete with smug proprietor; Camille holding the parasol, the maid holding the hoop and small boy; Camille putting up her hair among the dahlias, with the child like a broken toy on the grass; a great dim emptiness circulating round the table always laid for lunch; and, finally, the garden brought into the house—a watery, vegetable, uterine stillness, all polished floors and potted plants, with wife and child looking out of the orifice towards the daylight.[52] The painter is sitting on his balcony again, looking the other way.

This last series of pictures points forward to the work Monet did in the 1890s and later. The people gradually fall away, the garden grows larger, the studio is put out on a promontory next to the lily pond and the paintings are filled with weeds, water, flowers, and reflections of clouds. This chapter has tried to suggest the circumstances of such a choice, and I want to end by listing again the things in the outside world that proved inimical to landscape, and eventually to art.

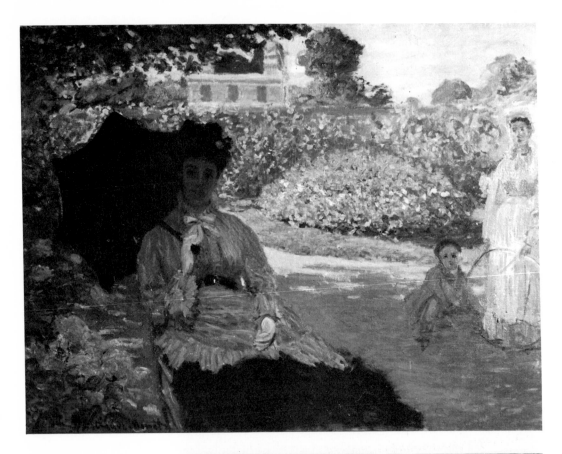

92. Claude Monet,
*Camille au jardin, avec
Jean et sa bonne,* 1873.

93. Claude Monet, *Le
Déjeuner,* 1873.

94. Claude Monet, *Un Coin d'appartement*, 1875.

The countryside was being made part of the city; that was the first notorious claim. Several different things were meant by the formula. There was a sort of nature being built into the city's actual fabric: parks and squares and suchlike, homeopathic doses of air and greenery which were sure to do someone good. Yet no one pretended that this was a substitute for real fields and woods, and, after all, the genuine article could be had any time for the price of a round-trip ticket. It was the age of the "outing." The word itself, said the *Saturday Review* in 1861, "may not be found in Richardson or Webster or, indeed, anywhere within the pale of lexicon orthodoxy, but we are prepared to justify the use of it notwithstanding."[53] Of course they were: the word and the activity were suddenly indispensable.

Perhaps it is, strictly speaking, wrong to talk of the countryside's being *included* in Paris. For literally it was not: it was a kind of foil or frame for the city, and it took a little time to get out to it. There would have been no point to Argenteuil and Bougival if they had ceased altogether to be exotic. Parisians were looking for somewhere to act naturally, to relax and be spontaneous; people took pleasure in Argenteuil; they did what they wanted there, they left the city behind. That was the sense in which

95. Roland Debreaux, *Les Vendanges à Argenteuil*, 1875.

96. Paul Renouard, *Les Régates d'automne à Argenteuil.* Wood engraving by M. Moller, 1879.

the environs belonged to Paris, or at least to its map of urbanity. The city had need of it, and certainly its citizens believed they had. They wanted the difference between town and country spelt out as part of their lives. Cities ought to have an ending, an outside, an elsewhere one could reach, as if in doing so one gave the city back a lost identity. Paris was a set of constraints and formalities, and thus the opposite of nature; from a distance it all seemed clear—what the city had to offer and why one had to get away from it; the exile was momentary and the crowds came home at evening re-created.

My tone has slipped too close to Ajalbert's. Irony at the expense of the new re-creation myth is prone to explode in the user's face, for the truth is that it proved entirely possible to imagine Argenteuil was the countryside. It was all the countryside one needed; nature was made up essentially of *vendanges* and regattas, and art lent support to the felicitous equation. If we put side by side two typical images from the 1870s, Roland Debreaux's *Vendanges à Argenteuil* of 1875 and Paul Renouard's *Régates d'automne* (also at Argenteuil) of 1879, we have the elements of the myth displayed and can appreciate its resilience. Such pictures in their innocence are foils to Impressionist painting; they help one understand why Manet's *Argenteuil* was unpopular, and perhaps why Monet's was not.

In this limited sense Manet may be said to belong to the ironists' camp. His picture is a kind of proof that what they have to say is potentially serious and ought to be included in a representation of the new class. Let me try to strip their case of its facetiousness and state it for the last time.

97. Alfred Grévin, *Aux champs.* Wood engraving in *Le Journal Amusant,* 7 August 1875.

They do not believe that the city has limits any more, and in particular they doubt it ends at Argenteuil and Asnières. The countryside provided there is false (if a true one still exists—and some of them are sceptical— it will be inaccessible to outings). The signs of its falsity are, first, the little Parisians themselves and their irredeemably urban manners and, second, the presence of industry in the landscape. It is especially this last that indicates what is bound to happen next: the factories will come out across the Plaine de Gennevilliers from Clichy, and Argenteuil will have no more *vendanges* and regattas.

What one objects to in the ironists is not their diagnosis but their tone;

and even here one's protest is not moral—not a request to the writers to be serious for once—but, rather, a suspicion that the tone reinstates the distinctions it claims to put in question. At one level the writers seem to be saying that town and country are hopelessly confused, and that this has to do with a blurring at the edges of the bourgeoisie. But the way that they say it enables them to insinuate, on no very good grounds, that somewhere the confusion stops and a real countryside remains, perhaps even a real bourgeoisie. They are constantly making fun of both concepts, and as constantly dependent on them for their comedy.

"Y," you will remember, admitted being bored with nature, but that was because he had actually had it: he had been in his village a full six days and could afford to escape to Paris on the seventh. Paris too belonged to him; he was a bourgeois, not a commercial traveller; he was one of "les riches," in a caricature by Alfred Grévin from 1875, where a peasant wife attempts to moderate her man's *ressentiment de classe*. "The rich!" she says, as the ladies and gentlemen walk past the potato field: "You'd never know it to look at them, but they work as hard as we do, my poor Baptiste—doing nothing, that's their job." They still existed, these fabulous creatures, and were not to be confused with their inferiors.

No doubt this landscape and its inhabitants would be difficult to portray in any other way than ironically, and the caricature is quite good about the reasons why. (It needs only a factory chimney or two—over Baptiste's left shoulder, perhaps—to satisfy the keenest wish for a comprehensive statement on the matter.) And yet serious depictions of it do exist: Manet's *Argenteuil, les canotiers* for one, and Seurat's *Une Baignade à Asnières* (Plate XIII). Describing the landscape, these pictures suggest, depends on the painter's not avoiding the contact of industry and nature, and trying to show how the one term inflects the other. But that in turn depends on describing how people behave in these new circumstances. A painting which did so would not lack comedy: it would inevitably have to do with the absurdities involved in performing idleness or not being used to it; but the painting would pre-eminently give form—at the risk of appearing a trifle stiff, a trifle wooden—to the dialectic within distraction: the play of ease and unease, restraint and spontaneity, pleasure and ennui, nature and artifice, fashion and recreation. It would try to make these moments articulate, and conceive them as part of the wider business of laying claim to bourgeoisie.

In Seurat's *Baignade*, for example, there are plenty of things to suggest that the idyll is awkward as well as dignified: the sheer unlikely neatness of the bathers' clothes, to start with, the boots and bowlers and concentric straw hats; the dim profile of the central boy (the "lout," as my mother insisted on calling him); the careful outlines of figures and grass; the doll's-

house trees, the smokestacks and gasworks, the frantic rower going off frame. We would not need to know the unpleasant facts about the great collector sewer to realize that this was an unfashionable place to swim. The figures appear to be floating freely, self-absorbed and separate, each perfect in its artless way, sharp-edged and individual. They would not be here except for the landscape, by which is meant the factories as well as the river, the sewer as well as the grass. So the landscape has to be painted in a way which agrees with the figures: it has to be awkward and hieratic like them, but also lifelike and composed. The piles of clothes are put against the glittering water, smoke against sunlight, bland against pungent colours, the lout on the bank alongside the ephebe in the water shouting to the other shore.

I believe that Seurat's most important source for *Une Baignade à Asnières* was Poussin's *Moïse sauvé des eaux*, in the Louvre. It seems to lie behind some of the picture's details—the flat-bottomed boat on its way across the river, the backdrop of architecture, the tree put in place of the pyramid—and to be echoed in its overall format. Presumably the source was meant to be somehow appropriate as well as queer, as if the painter was arguing that there was order and calm at Asnières, and even the faint possibility a miracle might happen. There might be a Moses in the bullrushes yet, about to lead his people back from exile in the *banlieue!*

This chapter and the next are essentially studies in the emergence of the lower-middle class. That phenomenon seems to me one of the main circumstances of modernist art, though the connection between one thing and the other is by no means direct. Modernist art is characterized, indeed, by its desire to take its distance from the petite bourgeoisie and the world of entertainments it ushered in, but artists were paradoxically fascinated by those entertainments and made them the new art's central subject for a considerable time. It has sometimes seemed an intractable problem, this. Not so much that leisure and pleasure were chosen to be painted in the first place—their visual appeal is sufficiently obvious—but that they survived as the new art's favourite theme and underwent such a potent series of transformations: in the work of Seurat and his anarchizing followers; in the art of Toulouse-Lautrec and the Nabis; in Matisse's depictions of *Luxe, calme et volupté* or *Bonheur de vivre*, in the pictures of the other Fauves; within Cubism, even, in the images of *Aficionados* and *The Cardiff Team*; in the long procession of harlequins and picnickers, music halls and *jours de fête*, undressed natives and Englishmen in Moscow.

Historians talk about the rise of leisure in the later nineteenth century,

98. Nicolas Poussin, *Moïse sauvé des eaux*, 1638.

by which they mean mainly its crystallization out from the rhythms and caesuras of work.[54] Something had certainly happened; leisure had become a mass phenomenon, a separately capitalized sector of social life in which great profits were to be had. Recreation took on increasingly spectacular forms: the park, the resort, the day at the river or the races, the café-concert, the football league, the Tour de France, and finally the Olympic Games. These various subcultures of leisure make more sense, I think, if they are put in relation to the history I sketched in chapter one. From at least the start of the 1860s there was felt to be some kind of threat to the moral economy of bourgeois society—the fine fabric of Parisian neighbourhood trades and manufacture, the face-to-face, small-scale, master-and-man society of the metropolis in the earlier part of the century. Haussmannization was resisted as the visible form of that threat; it was held responsible for the dark deeds of the Pereire brothers and the owners of department stores.

The subcultures of leisure and their representations are part of Haussmannization understood in this light, part of a process of spectacular reorganization of the city which was in turn a reworking of the whole field of commodity production. Their role in the process was by no means

trivial. It was not just that they were one main form in which everyday life was colonized in the later nineteenth century—given over to experts, addicts, entrepreneurs, consumers—but that there was such active disagreement over who had the right to plant the flag in the new territory. The colonies were claimed by various uneasy fractions of the middle class; by those who wished to reaffirm a status which had previously been made in the world of work, but seemed no longer to be available there; and by those who believed they had a right to the same status, even if their conditions of employment still seemed menial in many ways. The world of leisure was thus a great symbolic field in which the battle for bourgeois identity was fought; the essential warring claims were to forms of freedom, accomplishment, naturalness, and individuality which were believed to be the keys to bourgeoisie; actions both rearguard and offensive were mounted, disinformation was much in evidence.

Leisure was a performance, Veblen said, and the thing performed was class; though what is interesting about the acting in the 1870s, say, is its relative incompetence, as in *Argenteuil, les canotiers*.

I think this implication of leisure in class struggle goes some way to explain the series of transformations undergone by the subject in painting from 1860 to 1914. In particular it seems to me to shed light on the painters' changes of mind about how leisure should be depicted: the way, for example, styles of spontaneity are repeatedly displaced by styles of analysis—grandly individualistic modes of handling, that is, abandoned in favour of ones claiming to be anonymous, scientific and even collective. The classic instance is Neo-Impressionism: I do not believe that its vehemence (or its appeal to Pissarro) can be understood unless it is seen as deriving from an altered view of leisure, and of art as part of that leisure—which in turn derived from a new set of class allegiances. But just as interesting is the speed with which the Fauvist style—which had appeared for a moment to open nature again to the free play of fantasy—collapsed into its Cubist opposite. By the time of Fauvism, one could say, the myth of recreation could be stated only in overtly mythical terms: the dream of freedom and self-consciousness, of crepuscular boating and *Bonheur de vivre*, is adjourned to the golden age.

The reader should be warned, finally, that the notion of the "nouvelles couches sociales" being involved in any great revision of class society—any wholesale change in social structure—is controversial. Gambetta, for one, repudiated it. "I said *nouvelles couches* not *classes*," he said somewhat ruefully in a speech at Auxerre in 1874; "that last is a bad word I never use."[55]

\mathscr{A} BAR AT THE
FOLIES-BERGÈRE

A Mabille, entre deux figures
Un jeune homm' qui s'disait Baron,
M'offre un hôtel et deux voitures
Pour y fair' briller mon bon ton.
En baissant les yeux je m'approche,
Mais en voilà bien du nouveau,
J'vois des ciseaux sortant d'sa poche. . . .
L'Baron n'était qu'un calicot. . . .

—*Café-concert song, 1867.*[1]

The Argument That the adjective "popular," applied to persons, manners, or entertainment in the later nineteenth century, came to mean too many, too indefinite things. The word's elusiveness derived from its being used for ideological purposes, to suggest kinds of identity and contact between the classes— ways they belonged together and had interests in common—which did not exist in their everyday life or organized social practice, but seemed to in the spectacle. There was a sense in which the "nouvelles couches sociales" were nothing in our period, or very little, without the place allotted to them in "popular culture"—which is not to say that they lacked a determinate economic position, only that it was not yet clear, to them or anyone, what it was. Popular culture provided the petit-bourgeois aficionado with two forms of illusory "class": an identity with those below him, or at least with certain images of their life; and a difference from them which hinged on his skill—his privileged place—as consumer of those same images. Painting was mostly a complaisant spectator of this spectacle, perfecting the petit bourgeois's view of things and leaving behind the best picture we have of what it amounted to. But there are certain canvases which suggest the unease and duplicity involved in this attaining to a new class; something of the kind is claimed in this chapter for Manet's last painting, *Un Bar aux Folies-Bergère* (Plate XXIV).[2]

99. Pierre-Georges
Jeanniot, *Jupillon et
Germinie au café-concert.*
Etching for Edmond and
Jules de Goncourt's
Germinie Lacerteux, 1886.

One of the things very often said at the time about Haussmannization was
that it had ushered in an amount of make-believe and uncertainty in
modern life, especially in matters of social class. It is not entirely clear that
the charge was true, and that Paris was any fuller than usual of people
pretending to be better or worse off than their incomes allowed. But the
business of their doing so was visible and glittering in a new way.

Writers believed that the favourite premises for such behaviour were
the glorified beer halls which came to be known as cafés-concerts or cafés-
chantants. A guide to Paris was not complete without a brief description
of these institutions, and advice to the traveller to see them and savour
their vulgarity. All the best novels had a scene at the Ambassadeurs or the
Eldorado in which the seal was set on a character's ruin; and painters,
following suit, were fond of doing studies of the leading performers or
the crowd at the tables taking their lukewarm *consommations.* The cafés-
concerts were thought to be trivial but representative. To call them "in-
stitutions" at all, as I have done, is to adopt the commentators' tone, which
was a bit sententious and a lot condescending: it was out to let the reader
know that this particular Parisian had resisted the Eldorado's charm but

had done his duty and looked at the audience—even at the stage—in order to find out what it was that appealed to whom in such places. It seemed important to know, since all Paris was there with the writer, and he could not detect anyone else resisting.

The Goncourts, we have seen in chapter one, were the pioneers of this kind of account. They had ventured into the Eldorado rather early, in 1860, four or five years before it was customary for the grands bourgeois to do so; and they had taken their evening as a comprehensive sign that things were changing for the worse. To see women and children out at night on their own, or, just as bad, escorted by a proud papa: this struck them as sufficient evidence that one form of life was ending and another being born. The interior was dying, they said, and life henceforth would be lived in public, over the tables at the Jockey Club or on top of the Butte de Chaillot. They did not want that to happen, and the disdain they felt for the Eldorado was intense, almost naïve—or as near to naïveté as these writers were capable of. Their feelings did not soften with time. They went back to the same café in 1865, accompanied now by a good sprinkling of their *semblables*, and wrote the following lines in their journal:

At the Eldorado . . . A big circular room with two tiers of boxes, all gilt and painted with false marble; dazzling chandeliers; a café inside the room, black with men's hats; bonnets of women from the *barrière*; children in military képis; hats belonging to prostitutes in company with shop assistants, pink ribbons on the women in the boxes; the breath of all this crowd visible, a cloud of dust and tobacco smoke.

Towards the back a theatre stage with footlights; and on it a comic in evening dress. He sang disconnected things, interspersed with chortling and farmyard noises, the sounds of animals in heat, epileptic gesticulations—a Saint Vitus's dance of idiocy. The audience went wild with enthusiasm. . . . I may be wrong, but it seems to me we are heading for a revolution. There is a rottenness and stupidity in the public, a laughter so unwholesome that it will take a great upheaval, the spilling of blood, to clear the air and make even comedy sanitary.[3]

As with the Goncourts' joyless afternoon at Bougival three years before, what is striking in the entries on the café-concert is the way they anticipate so much of later, lesser commentary; the way they seem to have happened upon a serviceable *attitude* towards the odd things they portray. "At present we live a great deal out of doors, we are all more less in flight from the interior and the hearth. . . ."[4] "To live at home, to think at home, to eat and drink at home, to love at home, to suffer at home, to die at home, we find this boring and inconvenient. We need publicity, daylight, the street, the cabaret, the café, the restaurant. . . . We like to *pose*, to make a spectacle of ourselves, to have a public, a *gallery*, witnesses to our life."[5] "No one

here is at home, alas! The Parisian does not have a home any more. Everyone behaves as if he lived in a cheap hotel. So much so that the interior no longer has any intimacy or comfort, and each of us is disposed to think it disgusting and live out of doors as much as possible."[6]

Even the Goncourts' admixture of fear and hatred, and their transparent delight in both, were not unusual when the subject was the café-concert. The sense of blood and revolution in the background was not normally so explicit, let alone so gloating; but the stress itself was commonplace when journalists turned to Paris by Night. The Eldorado would not have been so appealing if it had not provoked some such *frisson*; its fans and defenders, of whom there were many in 1865, were often inclined to agree with the Goncourts and admit that what they relished in the ambience *was* idiocy and its attendant risks. Degas's brother René is typical of the mild form of this enthusiasm: writing home to his parents in New Orleans in 1872, he slips straightaway into the prescribed form of words: "After dinner I go with Edgar to the Champs-Elysées, from there to the café-chantant to hear idiotic songs, like the song of the *compagnon maçon* and other absurd nonsense."[7]

"Idiots" . . . "bêtises" . . . "absurdes": the insults are casual and not meant to be wounding. Nonetheless they are insults, and their persistence in other descriptions—their positive urgency on occasions when one would not have expected such a note to be sounded—ought to strike us as odd and in need of explanation. If, for example, the serious Parisian had turned to his *Larousse du dix-neuvième siècle* for guidance on the new phenomenon, he would have found under "café-chantant" a long entry which depended for its tone, and most of its detail, on a citation *in extenso* from Louis Veuillot's *Odeurs de Paris*. The worthy Larousse confessed to detesting Veuillot's (Catholic) opinions in general, but in this case had "nothing to add; the photograph is accurate and exaggerates nothing."[8] The "photograph"—it is of the Alcazar, and the singer described is the most famous of all, Thérésa, seen at the height of her powers—reads as follows:

Through the smoke we saw two or three empty seats which we reached not without difficulty. What an atmosphere! What a smell of tobacco, spirits, beer, and gas all mixed together! It was my first time in this place, the first time I had seen women in a café with smoking permitted. All around us were not just women, but *Ladies*.

Twenty years ago, you could have sought in vain for such a spectacle in all of Paris. Visibly, these ladies had dragged their defeated husbands here; the vexed and embarrassed air of those unfortunates made that all too clear. But the ladies themselves seemed hardly out of their element. . . . The presence of these "well-bred" women gave the audience a quite particularly slovenly appearance—gave it a kind of social slovenliness!

There was still half an hour to go, and all the places were taken. . . . A baritone came on, to a round of applause. He had a fine voice and the most funereal aspect imaginable. You would have guessed him to have been in bygone days a *représentant du peuple*, a member of the Montagne, a "thinker" who prided himself on his looks; Monsieur de Flotte, for example. [Larousse left out the last sentence, with its twenty-year-old sneers at the politics of 1848; but it is appropriate that the Alcazar should provoke such memories in Veuillot.] If this baritone were to figure in the troubles which await us, I for one would not be surprised. He sang:

> *Un nid, c'est un tendre mystère*
> *Un ciel que le printemps bénit.*
> *A l'homme, à l'oiseau sur terre,*
> *Dieu dit tout bas: Faites un nid!*

The crowd of pipesmokers, all far away from their own nests for the moment, and in no hurry to return, listened to the song with softened expressions; the "little women" could hardly restrain their tears; the well-bred ladies signalled their approval in a genteel fashion. . . . SHE was about to appear; a thunderous outbreak of applause announced her entry.

I did not find her so hideous as I had been told she was. She is rather a large girl, quite well built, without any charm besides her fame—which is charm of the first order, I admit. She has, I believe, some hair; her mouth appears to stretch right round her head; she has great fat lips like a Negro; shark's teeth. . . .

She knows how to sing. As for the song itself, it is indescribable, like its subject. You would need to be a Parisian to appreciate its qualities, a refined Frenchman to savour its profound and perfect ineptitude. It has nothing in common with any known language, or art, or truth. It is picked out of the gutter; but even the gutter has its own standards of taste, and one must find in the gutter the product which has the real flavour of the gutter. Parisians themselves are not without skill in seeking out such delicacies. . . .

The music has the same character as the words; they are both vulgar and corrupt caricatures, and moreover cheerless, like the sly face of the guttersnipe. The guttersnipe, the natural Parisian, does not cry, he blubs; he does not laugh, he cackles; he does not joke, he wisecracks; he does not dance, he does the *chahut*; he is not a lover but a libertine. [*Le voyou, le Parisien naturel, ne pleure pas, il pleurniche; il ne rit pas, il ricane; il ne plaisante pas, il blague; il ne danse pas, il chahute; il n'est pas amoureux, il est libertin.*] Art consists in assembling these ingredients in one song, and this the songwriters manage nine times of ten, with the singer's help. Success varies with the strength of the dose.

All of it smells of old pipes, gas leaks, fermenting liquor; and there is sadness at the bottom of it, that flat and eloquent sadness we call ennui. The physiognomy of the audience in general is a kind of troubled torpor. Nowadays these people come alive only as a result of a shock [*Ces gens-là ne vivent plus que de sécousses*]; and the chief reason for the success of certain "artists" is that the shock they give is the strongest. It passes quickly, and the habitué falls back into his torpor. The

spectator who is not a habitué makes haste to depart and breathe the pure air of the street.⁹

Veuillot in fact draws breath and stumbles on down to the next circle: the reader of *Les Odeurs de Paris* is treated to a further ten pages describing the Café Bataclan. Larousse, we may be thankful, breaks off at about this point (I have actually shortened his indefatigable citation by a good third), and one presumes that the seeker after encyclopaedic knowledge would have known by now what he was supposed to think.

For us, however, the text is obscure, and its length and magniloquence make it only the more elusive. How seriously are we meant to take it, and in particular its sense of impending social doom? It is a performance, no doubt, in the old grand manner, but its tropes are not merely decorative; they were certainly not seen as outlandish or unmotivated at the time (otherwise they would not have found their way into Larousse); and even Veuillot's gifts of prophecy were not noticeably inaccurate. There was a revolution round the corner, made by baritones or not. The minister of Public Instruction was quite clear in 1872 that "the orgy of songs produced during that epoch" (he means the Commune) was partly to blame for the Communards' depravity; he made it a reason for reimposing censorship on the café-concert in an effort to prevent such things from occurring again.¹⁰

All the same, the evidence so far is bound to strike the twentieth-century reader as something less than photographic. These writers seem to be making a scapegoat of the Eldorado, and probably for specious reasons— because it was visible, because it was fashionable, because it was easy to deride its repertoire and audience. The reader will have noticed that Veuillot and the Goncourts are not at all clear about who made up the normal crowd in the café-concert. Was it comprised of guttersnipes, and whores in cheap hats from the *barrières?* Or was the tone somehow set by respectable women who had dragged their husbands—sometimes even their children—this far down, at least for an evening? The crowd was some kind of *canaille,* for certain, but in it there figured some new recruits: those unhappy families, those ladies with ribbons, and those *putains* brought in on the arms of *commis de magasin.*

I propose to retreat from this uncertainty for a moment and try to establish some obvious things about the cafés-concerts.¹¹ They were cafés, not theatres. The law took the distinction very much to heart, and only reluctantly allowed the performances to consist of more than a singer and a stand-up comic. It took years for the state to agree to costumes and scenery, or to let the *poseuses* behind the singer move. This was partly the reason why places like the Alcazar laid on the scenic effects in the body

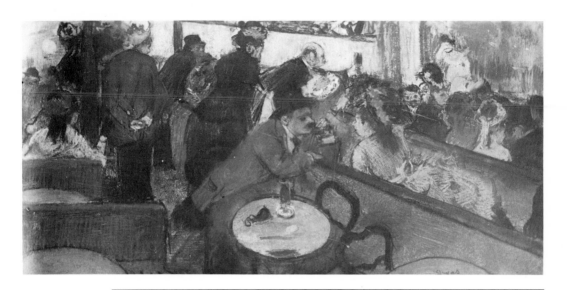

100. Edgar Degas, *Le Café concert*, 1882. Pastel.

of the hall: the tiers of boxes, the great candelabra, the sixteen colossal statues of women in the cupola, the ceiling painting of *Candide in Eldorado*, the two fountains, the mouldings by De Bay, the enormous mirror behind the bar:[12] they were there to distract the audience's attention from the strict, bare choreography on the other side of the footlights. Often there was little or no such pretence: a café-concert would declare itself to be a café plus a singer plus a stage. There are pictures by Manet and Degas that seem to indicate just such a lack of pretention, with beer and tables filling the foreground and the spectacle itself half glimpsed in a mirror, or largely left off to one side. Lighting was important in the better class of café-concert—gas at first, and then the famous glare of electricity. (The blankness of the new white light was one of the main effects in Manet's *Bar aux Folies-Bergère*; several critics in 1882 were not sure that Manet had captured its full intensity.) Lights and gilt and ladies on stage in stunning décolletage: the cafés-concerts were meant to be loud, vulgar, and above all modern: it was not for nothing that Haussmann's beloved architect Davioud tried his hand at designing the Ambassadeurs in the Champs-Elysées; or that Pissarro, passing judgement on the new Hôtel de Ville in 1891, should call it "that horrible café-concert" and evidently feel that nothing more need be said.[13]

The cafés-concerts were once again essentially Baron Haussmann's creation. They grew fat in the free market for eating and drinking which boomed on the boulevards in the 1860s. As the journalists never tired of saying, there seemed no end to the Parisian's appetite for public victuals;

customers appeared out of the night with every new establishment, and yet a café's survival depended on its fixing those customers' habits and persuading them to return.[14] Victor Fournel was on the whole admiring of the various bribes and stratagems adopted by the hard-pressed proprietors: the free billiards and resident freaks, the performing monkeys, the *feuilletons* sold with each franc's-worth of beer.[15] The cafés-concerts were one such stratagem, the most ordinary and successful. By the early 1870s there were at least 145 of them, probably many more.[16]

People naturally wondered at the time what made for success, and who it was that came back so regularly. Various answers were proposed to the second question, and I shall begin my own by listing some of them and pointing to the main themes and variations. Occasionally a commentator had no doubt about the audience in the Eldorado: it was simply the people of Paris, the "culotteurs de pipe," the "blouses blanches," the "très petits gens."[17] Murray's *Handbook for Visitors to Paris* had the following to say of the cafés-concerts in its 1872 edition—it had a duty that year to advise its readers where not to go, in a city so recently reclaimed for tourism:

There are two or three in the Champs-Elysées, where the spectators sit in the open air and listen to singing and music by performers outrageously overdressed and seated in a brilliantly lighted little theatre. No charge is made for admission, but the spectators are expected to take some refreshments, usually of an inferior quality. The company is not the most select, and the performance tends to the immoral. Respectable people keep aloof.[18]

The trouble was that Murray's verdict—the one contained in his last four words—was plainly wrong. Even in 1872 respectable people came down in droves to the Ambassadeurs; it was their presence there that most exasperated Veuillot and the Goncourts. Writers on the whole agreed with Veuillot, as opposed to Murray: the cafés-concerts were characterized by a mingling of the classes, or at least an agreement to listen to the same songs. Of course, agreement did not necessarily *mean* mingling, and often the writers interested themselves in the manner by which a degree of aloofness—or at any rate separation—was maintained even here. It was effected primarily by money: drinks were dearer at the best-placed tables, the Eldorado had private boxes, and the grander establishments took to charging an entrance fee. (The Folies-Bergère cost two francs for admission in 1882, but drinks in other places could anyway run as high as three francs, and the Eldorado had long ago insisted that its customers "replenish their glasses" at regular intervals.[19]) One way or another the *gandins* and their ladies were kept from contact with the poor—though a crowd which presumably qualified as poor was often noted, standing outside the ring

of lights and tables on the Champs-Elysées, hanging on the singer's every word. It was even picturesque, that presence:

> The most curious aspect of the picture for the *flâneur* who cares to observe is the audience outside, which gives itself the pleasure, free of charge, of seizing the new songs on the wing; they are Parisians, listening naïvely to the inept refrains they so much want to learn by heart. There is no fear of their interrupting the singers with one of those formidable dances which—following the present fashion—our young men about town like to organize with their lady companions. The naïve listener will have none of it; he grows angry; and the visitor from the provinces beats a retreat.[20]

Those *gamins* in the darkness, climbing the plane trees for a better view, were supposedly close to the great performers' hearts. In her ghosted *Mémoires* of 1865, Thérésa claimed to be singing with them in view; they were her sounding board, her own people, the audience that understood her best.[21]

Nobody made believe, in other words, that tensions and distinctions ceased to exist in the café-concert, but many were struck (and alarmed) by the sheer fact of contact—the cramming together of classes in one place and the general "social dishevellment."[22] "Three thousand people at least were stuffed inside"—this is Victor Fournel at the Alcazar in 1872—"bourgeois, small shopkeepers, a few workers in their Sunday best, entire families out for an outing, provincials, foreigners."[23] Given the right rhyme scheme, the list could be extended indefinitely:

> *Le Soir de ce jour mémorable*
> *Il se trouva, bien par hasard,*
> *Dans la salle de l'Alcazar*
> *Plus de monde que de coutume:*
> *Des employés, des gens de plume,*
> *Des étrangers de tous pays,*
> *Des grandes dames, des laïs,*
> *Des ouvriers, des militaires,*
> *Des princes, des apothicaires,*
> *Des étudiants, des avocats,*
> *Des médecins, des auvergnats. . . .*[24]

And no doubt the emperor himself in mufti.

The listing and naming very soon became formulaic, but the formulas were not necessarily this straightforward. In particular, the roll call of popular and bourgeois types—so eighteenth-century in flavour—was often supplanted by a stress on the audience containing all kinds (specific kinds) of petits bourgeois. These people were regularly held to be the key to the

café-concert's success. They held the institution together, it was claimed, and set its peculiar tone:

Passionate habitués of those establishments in which melody is sold by the pint or the glass, they belong in general to the special caste of *gandins* who are dandies only by night.

Their days are spent at some job or other, bureaucratic or commercial, and their evenings given over entirely to the platonic love they have sworn for Mlle. Pétronille. . . .

For the most part they are worthy fellows, but they have made the mistake, having as they do only the few hours after dinner to take the air and exercise necessary for their health and intelligence, of going instead to brutalize themselves in an atmosphere of tobacco smoke, breathing lungfuls of mephitic air in a narrow room crammed with hundreds of people.—And all this to listen to what, I ask you![25]

The Goncourts' shorthand for such people, we have seen, was the dismissive job description "commis de magasin." The term and its cognates are never far away when writers depict the audience at the café-concert. It crops up in Maurice Talmeyr, for example, when he points to the white ties and official faces at the Ambassadeurs, and then notices

alongside them, rubbing shoulders with them, a crowd of little people, shopkeepers, shop assistants, and manservants; and beside them, inevitably, cranks and criminals and thugs. There can be seen here, without any barriers between them, each quite at home with the other, the woman for sale and the society lady, the ex-convict and the magistrate, masters and servants, honest men and thieves.[26]

It is there in *Le Réveil* in 1886, when the crowd at the Alcazar is summed up as "a wholly Parisian public of toffs, prostitutes, petits bourgeois with their families, and shop assistants" (*de gommeux, de filles, de petits bourgeois en famille et de courtauds de boutiques*).[27]

The most effective code name for these unfortunates—it appears repeatedly from the 1860s on—was the simple metonymy *calicot*. They were what they sold, the metonymy said, for all their wish to be something better; the word came into widespread use around the time that shopworkers were forming a union and going on strike,[28] and its nearest equivalents in English are "draper's assistant" or "counter-jumper"—the latter perhaps to be preferred for its period flavour and less than affectionate snobbery. ("I don't want to see my daughter spinning round a public assembly room in the arms of any counter-jumper," as the dictionary quotes Miss Braddon in 1880.) The *calicots* were supposed in turn to haunt the Alcazar and the Eldorado; if any part of Paris belonged to them it was this one:

There are persons who come each evening to deposit their tribute of flowers at the feet of the open-air prima donna. They can be seen at the tables next to

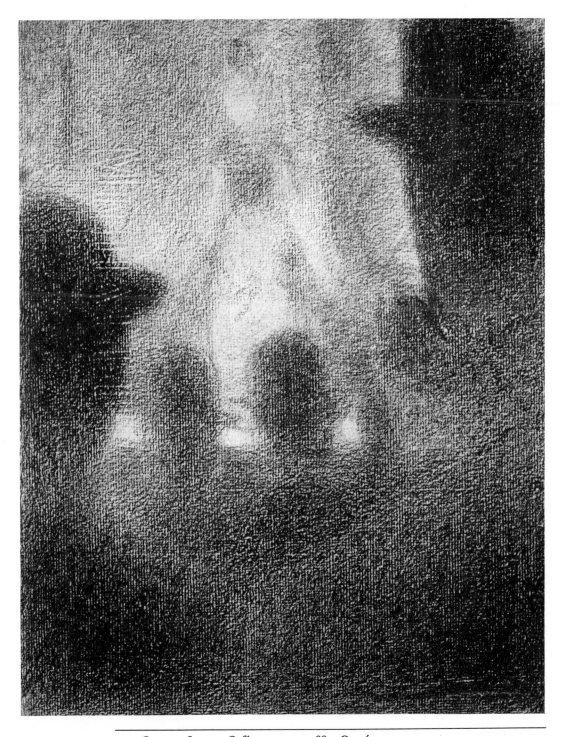

101. Georges Seurat, *Café concert*, c. 1887. Conté crayon.

the orchestra. These strictly optical devotees are generally *calicots* whose shops close early, notaries' clerks taking the day off, married men—who said they were going to the Club.[29]

Their pleasures were infinite, unsubtle, easily described:

> Ils passent tout leur temps à rire, à se pâmer,
> Ces bourgeois, calicots, et gommeux très peu dignes
> Qui hêlent la chanteuse et l'appellent par signes.
> On est heureux, on boit, on chante, on peut fumer,
> Et garder son chapeau pour ne pas s'enrhumer.[30]

Men with their hats on—a good sign of vulgarity, this—gulping mephitic air; torpid Parisians in search of shocks; children in képis, barons with scissors in their pockets; clerks, employees, little people, "commis-voyageurs en bordée."[31] The café-concert, wrote one Walter Francis Lonnergan in 1880, "is the Elysium of the emancipated *calicot*, or apprentice."[32]

The songs Thérésa sang, and the general run of the entertainments which the *calicot* enjoyed, were often described as "popular."[33] The best discussion of this word in a comparable context is the one provided by T. S. Eliot in his 1923 obituary of Marie Lloyd:

Marie Lloyd was the greatest music-hall artist of her time in England: she was also the most popular. And popularity in her case was not merely evidence of her accomplishment; it was something more than success. It is evidence of the extent to which she represented and expressed that part of the English nation which has perhaps the greatest vitality and interest.

Among all of that small number of music-hall performers, whose names are familiar to what is called the lower class, Marie Lloyd had far the strongest hold on popular affection. The attitude of audiences toward Marie Lloyd was different from their attitude toward any other of their favourites of that day, and this difference represents the difference in her art. . . . And the difference is this: that whereas other comedians amuse their audiences as much and sometimes more than Marie Lloyd, no other comedian succeeded so well in giving expression to the life of that audience, in raising it to a kind of art. It was, I think, this capacity for expressing the soul of the people that made Marie Lloyd unique, and that made her audiences, even when they joined in the chorus, not so much hilarious as happy. . . .

Marie Lloyd's art will, I hope, be discussed by more competent critics of the theatre than I. My own chief point is that I consider her superiority over other performers to be in a way a moral superiority: it was her understanding of the people and sympathy with them, and the people's recognition of the fact that she embodied the virtues which they genuinely most respected in private life, that raised her to the position she occupied at her death. And her death is itself a significant moment in English history. I have called her the expressive figure of

the lower classes. There is no such expressive figure for any other class. The middle classes have no such idol: the middle classes are morally corrupt. That is to say, their own life fails to find a Marie Lloyd to express it; nor have they any independent virtues which might give them as a conscious class any dignity.[34]

This is not exactly the kind of argument, particularly in its closing stages, that one associates with T. S. Eliot, though the piece was never dropped from the canon of his prose. It is tempting to ask how far the obituary might apply to Thérésa, who was in many ways Marie Lloyd's Parisian counterpart. The question is difficult to answer at all conclusively, however, because so much of the evidence is lacking, and so much that remains is spuriously vivid. The words on the page of Thérésa's sheet music, for example, or the notes of the simple tunes she put to them, seem concrete enough, but they do not come near the heart of her undoubted power. It would be hard to argue, after all, that the lyrics of Marie Lloyd's "One of the Ruins That Cromwell Knocked Abaht a Bit," or the melody of "My

102. Grob, photograph of Thérésa, 1864.

103. Claude Reutlinger, photograph of Thérésa, c. 1867.

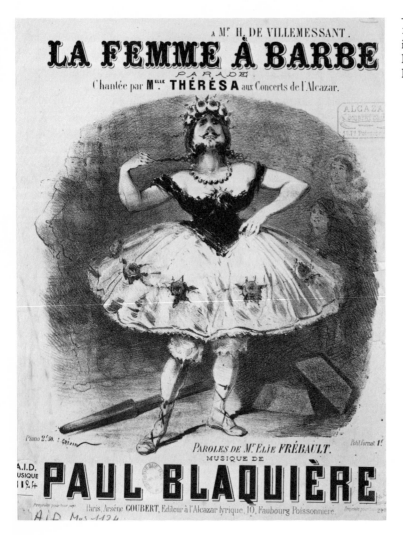

104. Alfred Grévin, cover illustration for "La Femme à barbe," c. 1864. Lithograph.

Old Man Said Follow the Van," establish at once what Eliot was on about. It was Marie Lloyd's *way* with the songs that impressed him—her ability to invest them with detail and pathos, her sense of how they might be made to carry the inflections of genuine stoicism in the one instance, or comic self-knowledge in the other. The claims being made for Thérésa's art are of a similar kind, and will involve us in a certain amount of guesswork and a great deal of reading between the lines.

When we attend, for example, to the lyrics of one of Thérésa's most famous songs, "A bas les pattes s'il vous plaît," and single out the following verses from the rest—

—*Que j'aime à voir votre poitrine blanche*
Dont la blancheur est rivale du lait:

105. Célestin Nanteuil, cover illustration for "Un Grand Clerc de notaire," c. 1864. Lithograph.

Son double flot qui se gonfle, s'épanche
Et cherche à fuir les remparts du corset. (bis)
 —Cet air m'est connu revenez dimanche
 Monsieur, à bas les pattes s'il vous plaît!

—De votre écuelle où votre soif s'étanche
Voyez la queue est brisée, on dirait.
Permettez moi de lui remettre un manche:
C'est mon métier je l'ai toujours bien fait. (bis)
 —Cet air m'est connu revenez dimanche
 Monsieur, à bas les pattes s'il vous plaît![35]

—we are looking essentially for the ways such modest material might have been used, by the right performer, to do something as grand as "giving expression to the life of a class." And we can sometimes intuit how it was done. There is a framework here in which the singer had room to introduce a wide range of plausible qualities: disabused tolerance, for example, sexual hardheadedness, lack of false modesty, simple high spirits, outright salaciousness. These were attitudes and attributes that supposedly belonged to the lower classes, or so the bourgeoisie believed. The performer's job was to make them come alive in the course of the song.

Even Veuillot conceded that Thérésa had a fine, powerful voice. "She acts out her song," he said, "as much as she sings it. She acts with her eyes, her arms, her shoulders, her haunches, unflinchingly."[36] Her act was visual, in other words, and when we try to imagine what it looked like, there are images we can call to our aid. Photographs survive of Thérésa in her heyday, and though the poses are stiff and discreet, enough can be seen of her thickset body and emphatic face to make it clear how she must have exploited them on stage. There are sometimes vignettes on the covers of café-concert sheet music—like the one by Célestin Nanteuil for a song from the early 1860s called "Un Grand Clerc de notaire"—which seem to translate the atmosphere of the lyrics inside quite successfully. Fig leaves were never larger or less concealing than in Nanteuil's lithograph, fathers more menacing, girls more dreamy and stolid, suitors less to be trusted. (The censor decided that the song itself had better be left out of the Alcazar's repertoire.[37])

What Nanteuil seems to have wished to evoke as characteristic of his song was its raucous good humour, its sentimentality, and the sheer physical presence of its objects, bursting from flowerpots and elbows of suits. These were Thérésa's qualities too; and they seem to have been what attracted Degas's attention as he sat with his brother on the Champs-Elysées. Some time towards the middle of the 1870s he did several studies of Thérésa: one in oil and pastel called *Le Chanson du chien* (Plate XXII), another in

106. Edgar Degas, *La Chanteuse au gant*, c. 1878. Pastel and distemper.

pastel and distemper called *La Chanteuse au gant*, and a series of pastels-on-monotype which most probably show Thérésa's lesser competitors. These pictures treat their common subject in very different ways. In one or two the singer is on her own, facing the audience, her features whitened by the glare of the footlights, her eyes hooded, her arm upraised to clinch a final note. In others the picture is crammed with significant detail, much of it familiar by now: top hats and *chapeaux de putains* in the foreground, dishevelled musicians, batteries of lights and foliage, fidgeting *poseuses*. But the heart of the matter is always Thérésa: the stab of her thumb back towards her body in between the lines of a chorus, the sweep of an arm to include the audience in a song, the piled-up hair, and the pugilist's face. These were her ways of dominating the distractions all round her and making them part of her act. She floated on top of the lights and profiles

107. Edgar Degas, *Le Café-concert des Ambassadeurs*, c. 1875–77. Pastel on monotype.

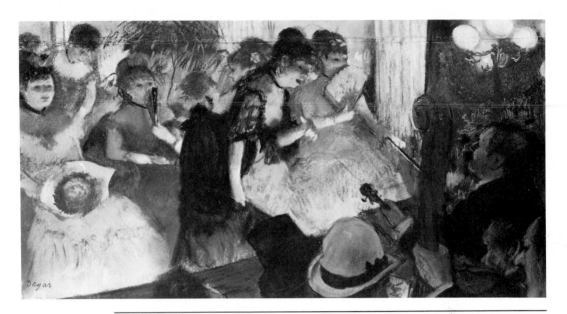

108. Edgar Degas, *Cabaret*, c. 1875–77. Pastel on monotype.

and flowery hats, and carved out a space for herself against them. The picture which finds the best form for this relationship, I think, is *Le Chanson du chien*—in some ways the least elaborate and crowded of the series. In it Thérésa is partly detached from her surroundings, her face half flattened against a pillar and a globe of electric light; but the distance established is clearly provisional, and the singer in a sense is placed quite graphically in the middle of things, face to face with her unkempt audience, almost down on its level. The crush of spectators is filled in around and behind the performer as a kind of backdrop, and Thérésa's obliging, sardonic address to her public—her pretending to be a good dog and beg for her supper—therefore makes straightforward comic sense. She is wrapped up in her preposterous song, her eyes almost closed, her body erect and still, her hands weightless; but the song makes no sense without its answering, excluded context—the trees, providing such excellent cover for women doing business in the shadows; the scurrying men in brown suits and bowler hats; the small moustachioed faces looking patiently towards the star.

The relation between art and its circumstances in this picture is a special one, and I think that Degas was aware of its strangeness. If we compare the picture of Thérésa with one of its principal prototypes in Degas's art, *Les Musiciens à l'orchestre* from 1872 (Plate XXIII), it soon becomes clear that *Le Chanson du chien* was built by reversing almost all of its predecessor's main terms. In the earlier picture art is also being made against an active

backdrop, a surface of thickly painted forms—perhaps trees and foliage—
and intense affective colour. A dancer at the right comes forward to the
footlights and drops a curtsey; she addresses the audience a little naïvely
and the viewers are allowed to see, looming formally in the picture's lower
half, the machinery which supports the illusion on stage—the attentive
musicians, their brisk haircuts and well-starched collars. The painter has
chosen a moment in between illusions, so to speak, in which the audience
lets off steam and the corps de ballet stands at ease. And certainly there
are moments when art is so confident of its effects—so sure of its basic
hold on an audience—that it can afford to dispense with continuity and
accept applause. Degas often painted such interim states; they allowed him
to focus on art as a kind of production, and they gave him space to show
off his own artistic means—his dazzling, casual checkerwork of back-
ground and foreground, all half-glimpsed shapes and strange connections;
the sharp touches of colour he used to establish a fingernail or differentiate
a row of faces; and above all the bold, unmotivated marks he allowed
himself on the distant scenery.

Thérésa, by contrast, had to be shown in the throes of her art and
absorbed by it; but it had to be suggested at the same time that that fact
no longer guaranteed the artist a hold on her audience. The audience was
there all round her, some of them looking towards the stage and others
intent on different business altogether. And in a sense the singer's art was
nothing without this public's inattentiveness. For they *were* the illusion,
those prostitutes and petits bourgeois in the shadows: they were the matter
to be made over into Art, and their very distance from any such thing—
but also their willingness to be enlisted by it—was part of the art form's
special character. The illusion depended, as Gustave Geffroy was to put it
later, on "the tacit complicity of the crowd, of these people so much
resembling each other, this gathering of the bored."[38] Complicity in such a
place could not be assumed or suspended at will, since boredom was always
waiting in the wings; it had to be won by shock and interpellation, with
the crowd being pulled in and out of the realm of art by the sheer force
of the singer's will.[39]

A great deal of the writing about Thérésa was concerned with that
force and the audience's submission to it. Degas himself urged a corre-
spondent to

go quick and hear Thérésa at the Alcazar. . . . She opens her great mouth and
out comes the most grossly, delicately, wittily tender voice imaginable. And feeling,
and taste, where could one find more? It is admirable.[40]

And Jules Vallès, writing his history of the decade leading up to the
Commune, was in no doubt about the politics of the case:

One day there came along a woman with virile voice and gestures, at a time when men all had their mouths tight shut and their arms amputated. She cried out: It is time we gave the people something in return for their money! And the people understood her and applauded, they made the fortune of the singer whose "Sapeur" sapped an empire by holding it up to laughter.[41]

Some of the clearest accounts of Thérésa are offered in retrospect or in the period of the singer's long decline, because in describing her failure the writers feel obliged to state explicitly what had previously made for success. This, for example, by an anonymous columnist in 1886:

Once upon a time I had plenty of admiration for Thérésa. It seemed as if, in that huge voice with its low-pitched notes, there vibrated the soul of the people. She stirred me and made me shiver; more than once she brought tears to my eyes. In the last two years I have gone to her comeback performances as if to visit an old friend, searching for that impression of the past which she cannot reawaken. Her fine diction, so strong and clear, is spoilt now by pretentiousness, pomp, and solemnity. No doubt she imagines she is now a social force, and that each word she drops will have repercussions in the world. She adopts without discernment songs which are inept, and tries to colour their empty words with a redundant sentimentality and a false picturesqueness. Instead of the brutal and sincere art which used to delight me, the singer displays a procedure which has grown uniform and a search for violent effects.[42]

The last two or three sentences in particular are a good definition, in negative, of Thérésa's original strengths.

I think these descriptions are worth reproducing; they often include some not quite standard detail or judgement (it was a matter of dispute, for example, whether Thérésa undermined the empire or was its faithful servant), and they suggest the peculiar weight of significance that soon accrued to her every gesture. And yet of course the claims they make for her performances are essentially modest in comparison with Eliot's for Marie Lloyd. What was the nature of Thérésa's popularity? To what extent did she ever "represent or express that part of the French nation which had perhaps greatest vitality and interest"? Was she a social force or not? No doubt answers are offered to these questions by Veuillot and Vallès, but the ones they give are too obviously the product of vague enthusiasm or contumely; they lack detail, they do not contain any very impressive discussion of particular cases.

The answer I shall offer is bound to be tentative and ought to be a bit sceptical. By 1865 Thérésa's actual effects were hard to distinguish from the machinery of stardom that surrounded her. She was packaged and cosseted, censored and ghosted, admired by Auber and Rossini, invited to sing for the empress at the Palais des Tuileries.[43] She was fast becoming a bore, in short, in the familiar modern manner; and the process provoked

109. Hippolyte Mailly, *Darcier et Thérésa*. Wood engraving in *Le Hanneton*, 1867.

an answering agnosticism even at the time. *Le Hanneton*, for example, had a cover in 1867 which showed the singer Darcier—the voice of 1848, the favourite of those who still pined for a previous, radical age of popular song—putting a firm hand over Thérésa's outsize mouth. And the socialist paper *La Rive Gauche* (it was published in Brussels to avoid imperial censorship) had this to say on the subject of Thérésa in 1865:

The other day she was the subject of a brawl on the Champs-Elysées between

the police and a crowd of idlers and dandies who had come to hear her sing. It appears that several officers were knocked about and had to draw their swords, but no blood was spilled.

What a great people, which knows how to fight for a brasserie singer but can do nothing to win back its liberty![44]

I for one find it easy to sympathize with *La Rive Gauche* and *Le Hanneton*; but all the same the lines they draw, in their exasperation, are a little too clear-cut. Had not Darcier, after all, possessed his quota of haut-bourgeois admirers? Did not Berlioz write a *feuilleton* in his praise?[45] And Darcier had written some of Thérésa's first songs. Could not a defender of the Alcazar have argued that the violence on the Champs-Elysées was better— from *La Rive Gauche*'s point of view—than no violence at all? For the spectacle of revolution does occasionally lead to revolution proper, and the word "revolutionary" was applied to Thérésa by all kinds of witnesses, many of them not having Vallès's axe to grind. The unctuous Gaston Jollivet, for example, penning his *Souvenirs de la vie de plaisir sous le Second Empire*, produced this memory of the singer in her heyday:

She launched her revolutionary challenge from the depths of her magnificent contralto, to the bosses and exploiters of the poor:

> *Nous sommes ici trois cent femelles,*
> *Et la danse (bis) va commencer.*[46]

This is no doubt trivial testimony, but its very lack of seriousness lends it a kind of weight. People believed that Thérésa posed some sort of threat to the propertied order, and certainly the empire appeared to agree with them. It policed her every line and phrase, and its officers made no secret of the fact that they considered the café-concert a public nuisance. Things had evidently gone too far for the new institution to be suppressed outright, but the censor could dream of an Alcazar where torpor was largely untroubled and the bored stayed bored. He drafted memos on how to achieve that desirable state, and he realized it would be a matter of very fine tuning.[47] Everything depended on his success in permitting a popular edge to the entertainment without having that quality be too emphatic or precise.

The kind of popularity that appealed to the censor, we might guess, is the one exemplified by Paulus's ballad "Le Baptême du petit ébéniste"— the same the cartoonists used in 1865 as mock-heroic point of reference for *Olympia*. In it a proud artisan father is overheard improvising a toast to his newborn son. He gathers about him his audience of carpenters and cabinetmakers, pays preliminary homage to the father of popular song, Pierre-Jean de Béranger, and launches into his favourite themes—the joys of matrimony and the wrongs once done to the great Napoleon:

 I: *Là-bas, là-bas, tout au bout de la terre*
 Là-bas, bien loin tout près du Luxembourg,
 Fut un vieillard, chansonnier populaire
 [*In a low voice to his neighbour*] Béranger
 O! celui-là, respectons-le toujours.
 Refrain: *Que j'aime à voir*
 autour de cette table
 Des scieurs de long,
 des Ebénisses,
 Des Entrepreneurs de bâtisses
 Que c'est comme un bouquet de fleurs [*in chorus*]
 II: [*addressing the baby*]
 Petit Léon, dans le sein de ta mère
 Tu n'as jamais connu l'adversité:
 Tu n'as pas vu le drapeau de tes pères
 Souillé de boue, couvert d'iniquité. . . .
 Refrain: *Que j'aime à voir, etc.*
 III: *Mais, sans vouloir parler de politique,*
 Dessur l'ancien versons tousse des pleurs;
 L'ennemi l'a plongé dedans une île
 Ous' qu'il est mort! ce grand législateur. . . .
 Refrain: *Que j'aime à voir, etc.*
 . . .
 V: *Laissons, laissons les débauchés vulgaires*
 Sercher l'amour dedans la volupté,
 Le vrai amour, ah! c'est celui d'un père,
 Qui met-z au jour un petit nouveau-né.
 Refrain: *Que j'aime à voir, etc.*
 VI: *Pourquoi donc pas nous occuper d'la mère*
 Qu'à l'heur' qu'il est z-est encore alité,
 Elle a bien plus souffer-re que le père
 Qui, lui, a u tout' la félicité.
 Refrain: *Que j'aime à voir, etc.*[48]

And on it goes. Moral, naïve, sentimental, patriotic . . . a dream world of hard work and high emotion.

By "popular" in such a case was meant a certain range of reference, a style of delivery, and a claim—mostly implicit, but flaunted on the right occasion—to be addressing one kind of audience and excluding several others (those "débauchés vulgaires," for instance). The songs that Thérésa and Paulus sang were supposed to draw on the concerns and experiences

of the Parisian working class, a fact they signified most effectively by their choice of language and by the way of singing Thérésa made famous: her use of the body to carry a phrase, her fierce low notes, her sudden shifts from stuttering patter to full vibrato, her manner of making the audience part of the song—making them join in, literally or figuratively, with a wave of her hand or an interpolated line of argot.

The café-concert *produced* the popular, and did so in a seemingly incongruous setting. The language of laundresses and *ébénistes* issued from the throats of overdressed contraltos surrounded by mouldings, mirrors, and chandeliers. The songs themselves were sometimes cynical about the whole performance:

> *Puis qu'il le faut, et pour vous plaire,*
> *Je parle argot comme un chiffonnier.*
> *J'ai pris la voix d'une écaillère,*
> *Et les allures d'un palfrenier;*
> *Je lev' la jamb' mieux que Clodoche*
> *J'chant' pas si just' qu' la Malibron.*
> *J'suis distingué tout comme Gavroche. . . .*
> *Eh! que qu'ça me fait! J'gagne cent mill'francs.*[49]

It may not seem to us a very powerful piece of metalanguage, this, but it was too much for the censor: in 1867 he refused permission for the song, "L'Etoile des concerts," to be performed at the Eldorado.

Perhaps the censor was right to be nervous. For the circuitry of popular art in capitalist society does appear to be delicate, and therefore to stand in need of fairly constant overhaul if it is not to produce undesirable effects. The situation in the Eldorado is typical of many that followed in the later heyday of the industry—from the vogue for flamenco in the 1890s to the first years of rock 'n' roll. On the face of things, it seems that those who control the means of symbolic production in these societies repeatedly have reason to exploit the values and images of the working class and allow them some form of representation. And this cannot simply be a matter of careful, sardonic hegemony over the masses—the provision of bread and circuses—since the bourgeoisie itself is an avid consumer of the representations in question. "That is to say, their own life fails to find a Marie Lloyd to express it; nor have they any independent virtues which might give them as a conscious class any dignity." To put Eliot's verdict in a more limited form: the middle class in the later nineteenth century, and even the early years of the twentieth, had not yet invented an *imagery* of its own fate, though in due course it would do so with deadly effectiveness: the world would be filled with soap operas, situation comedies, and other small dramas involving the magic power of commodities. But for the time

being it was obliged to feed on the values and idioms of those classes it wished to dominate; and doing so involved it in making the idioms part of a further system, in which the popular was expropriated from those who produced it—made over into a separate realm of images which were given back, duly refurbished, to the "people" thus safely defined.

From the start this process was far from trouble-free. The material called popular had to be continually renewed and recast, lest its working-class users find ways of giving it back its original consistency—making it assume, for example, the form called proletarian. In the 1860s the signs of that struggle for possession of the popular were particularly clear in the cafés-concerts. The government regarded them as dangerous, unruly places whose repertoire was prone to two main deviations—politics, which the censor believed he had under control, and obscenity, which he knew he did not.

The extraction of politics from popular song had preoccupied the empire all through the previous decade. Its scribes had drawn up their registers of forbidden ballads year by year: titles like "L'Aumône du pauvre" and "Du Pain pour tous" vying with the new "Crédo républicain," the various "Chants du prolétaire, des laboureurs, du travailleur," the cries for "Dieu sur terre" and "Christ au peuple," the stories of "Misère en Irlande."[50] It was excellent to see the lists get shorter and the reports of provincial recrudescence less frequent, but the censor in the 1860s could not rest easy. His spies reeled from the concert halls, their notebooks filled with disarranged clothing, broken cornets-à-pistons,[51] bad smells, and requests not to "fourrer vot-nez là-dedans." "Do you want to know the titles of a few of the songs which are sung in our cafés-concerts?" asked Marc-Constantin in 1872. "Just listen and judge for yourself:

> —*Où qu'il est que je lui retire ma casquette.*
> —*Je renfonce mon chapeau.*
> —*J'vous conseille pas d'fourrer vot-nez là-dedans.*
> —*Ça presse.—Balayez-moi ça.*
> —*Soufflez dessus.—Quel barbottage!*
> —*Faut avaler ça, Verpillon.*
> —*Ote donc tes pieds d'là, ça sent la trichine.*
> —*J'ai tapé dans le tas!*
> —*Asseyez-vous dessus!*
> —*Je t'enlève le ballon, etc., etc.*"[52]

Or Victor Fournel, insatiable as ever, describing the Café-Concert de la Pègre:

Nothing in particular to be said about the singers—apart from the fact that they had white gloves and black suits, the poor things—the public likes that— but what suits and what gloves they were!

I memorized the titles of the principal songs:

"Je n'comprends pas ça"—*"Je suis tout chose"*—*"Complet partout"*—*"La Vénus au battoir"*—*"Comment qu'ça s'fait?"*—*"La Calotte de velours"*—*"Je n'suis pas préparé."*

In that last song, as in several others, the tenor did not fail to interpolate a patriotic couplet of monstrous ineptitude [the year is 1872], delivered with ridiculous emphasis and received with thunderous applause. This way of coupling patriotism and obscenity struck me as the most ignoble profanation of them all. For does it need saying that all the songs whose titles I have just transcribed are nothing but a tissue of filthy allusions and *doubles-entendres*, thoroughly worthy of such a public![53]

It is hard to decide which is the more tedious, the titles themselves or the journalists' high moral tone.

One of the things these writers wish to insinuate is in fact confirmed by the other evidence we have: there seems to have been precious little wit or variety to the café-concert's depiction of sex. Yet however monotonous and niggling these songs may have been, even in Thérésa's hands, they remained a firm favourite with the audience at the Alcazar.[54] And the question remains, what could they possibly have *represented* to the *blouses blanches* and *calicots* who gathered there? The answer derives from the general logic of popular art which I outlined previously: like all the other imaginary attributes of working-class life, obscenity was partly a provided imagery and partly an insubordinate one. No doubt the songs on Marc-Constantin's list did reproduce the relations of the sexes in frozen, preposterous form. No doubt their humour was false-genteel or lavatorial: their subject was often apparently sex disallowed and uncontrollable, but they regularly ended by agreeing with the censor that there did not need to be a language to deal with such things. They were best confined to the margins of discourse, matters one didn't stick one's nose into, needs about which the audience was always pretending to be ignorant (*comment*, finally, *que ça se fait?*) but happily knew what there was to know before the singer started.

If this had been all there was to obscenity, the censor need not have worried so much about its social consequences. And in a sense he did not worry; he was almost convinced that obscenity was trivial, a sign of the mental and somatic inferiority by which the working class confirmed its station in life. But what an unfortunate sign it was! It could not be good for a class to *revel* in its own inferiority as the crowd at La Pègre seemed to do; it could not be safe to put such stress on the claims of pleasure and have the body represented each night as a mad categorical imperative— all innocence and cynicism, all itches and flushes and going-too-far. And

110. Edgar Degas, *Le Chanson des ciseaux*, c. 1877–78. Monotype.

did not the stripped-down impersonality of the formulas employed seem to lead the singer on, too often for the censor's liking, towards genuinely dangerous ground? The sign of that last escalation—it is there often enough in the evidence which survives—is violence of an unmitigated and seemingly unmotivated kind; one in which words have become means to eviscerate and abuse, to smear shit on the audience, to have it experience again the nameless fears of childhood. Of course that violence too has its simple phallic sources and sometimes reveals them. There is a chanteuse in a Degas monotype, her mouth wide open and a pair of formidable scissors in her hand, who makes that side of the business clear. Yet once violence takes hold of a set of representations in this way, it is no longer just a sexual matter; or, rather, it is the point at which sexuality is tied back to

other kinds of terror or denial: it is the mode most often and plausibly used to insist that all repressions are the same—sexual, political, religious, economic. That may in itself be an equivalence too easily made, but it is one which has certainly had political, religious, and economic effects.

The censor appears to have feared that it might do so again. Of course his files are not to be trusted if we are trying to arrive at the real extent of the problem, for what were his spies paid for if not to report that the minister's wishes were being flouted each night, that singers were putting back forbidden verses and provoking a glee that was clearly unsafe?[55] Yet other sources tell roughly the same story. Censorship was a brake on custom: if the proprietor of a café-concert wanted to keep a hold on his audience—an audience whose values and vocabulary were changing fast all through the 1860s—he simply could not afford to obey the ministry's regulations. No doubt the censor was resourceful: he multiplied his army of spies and his books of prohibited gestures. But the sheer pressure of the market defeated him; year after year he wrote his dispirited, hectoring reports to the minister, pointing out the insufficiency of the empire's police: how could it be that the Alcazar was entitled to publish a songbook in 1869 which contained all the words the censor had crossed out? Would it not help if the Paris authorities really investigated a man's moral character before granting him a licence to put a stage at the back of his bar? Might I be permitted respectfully to suggest . . . ? The minister seemed to have more important things on his mind.

The informer went into the smoke-filled café and found the audience singing

a resolutely antisocialist ditty of which I retained the following four lines:

> *Puisque tous les hommes sont frères,*
> *J'demand que les ceuss qu'a pas l'sou*
> *Recoiv't des rentes viagères*
> *De ceuss qui couch't dans l'acajou.*

The *blouses blanches* themselves seemed to laugh till their buttons popped, and I got up to leave with an agreeable taste in my mouth.[56]

Of course this is a journalist speaking, not a spy: a spy would not have risked quite this degree of sarcasm in his nightly report, and he would have made it clear that he stayed till the bitter end. Yet Vallès and Veuillot, Degas and Fournel, Nanteuil and Agent X from the Faubourg du Temple have all clearly been listening to the same songs; and they do not essentially disagree with one another about what they meant. The café-concert was the home of disorder: its audience lived for the moment when the band struck up "La Canaille" and the singer invited them to join in the chorus

of "J'en suis! J'en suis!"[57] A rabble they were, and Thérésa thrived on her ability to give form to the fact.

The reader may reasonably be wondering by now what has happened to the little clerks and respectable *commis de magasins*. It is true that journalists and spies are prone to take for granted that an audience laughing at songs like these must be basically working-class. But I seem to have followed them in assuming that when the subject is disorder, the class that concerns us—concerns the censor—is largely composed of labouring men; and then to have felt free to discard the innuendo, as the journalist often does, when it suited my purpose to stress how low the middle class had come in its entertainments.

Well, yes. There is a kind of shifting going on in my account, and in those of the commentators I am using, but it seems to me appropriate to the odd thing we are concerned with, and in any case unavoidable. It is a shifting induced by the café-concert itself, a set of uncertainties we might almost describe as the Eldorado's best production. To explain what I mean by that verdict I shall first set down again, in summary form, what I take to be the essence of the new entertainment, and then attempt to see it broadly as playing a part in the new relations between the classes. (The part it played was not altogether negligible: that will be my main point.)

Writers who bothered with the café-concert at all tended to agree that its appeal had to do with its popular character. The epithet was applied to the performance on stage but also to the audience—in particular, to the way the audience was included in the spectacle and accepted the identities provided for it there. The café-concert *produced* the popular, which is to say that it put on class as an entertainment. And part of its doing so, the critics thought, was that the customer should entertain himself with the same material, putting on class for the evening, playing at being a baron or a navvy. (The idea that there were places or persons where class was *inessential* seems to have been a great comfort in this society. We have seen it was one of the *courtisane*'s tasks to provide a similar reassurance.) There were unmistakeably two main types of travesty going on: first, the pretence of the bourgeois to be working-class; but second, mixed in with that general slumming, and making the mixture all the more weird, the pretence of a certain kind of worker to be bourgeois, or something quite like it—the *calicot* sitting at the table next to the *homme d'affaires*, taking care not to spill beer on his best suit or miss the words of Thérésa's latest song.

Calicot, I have said already, was a code word for a whole class of people secreted by capital at a particular stage: the new army of clerks, accoun-

tants, cashiers, brokers, petty bureaucrats, insurance agents, bank tellers, salesmen, and commercial travellers; to be joined before long by stenographers, telegraphists, primary-school teachers, and advertising men—the class which a later historian dubbed, perhaps not even ironically, "low white collar."[58] There was a "blank in the life of the lodger"—the phrase is from the prospectus of a Methodist social club in the 1890s[59]—and an industry developed to try to fill it. It began with the *feuilleton*, the chromolithograph, and the democratization of sport, and soon proceeded to a tropical diversity of forms: drugstores, news agents and tobacconists, football, museums, movies, cheap romantic fiction, lantern-slide lectures on popular science, records, bicycles, the funny pages, condensed books, sweepstakes, swimming pools, *Action Française*.

It has sometimes been argued that a connection exists between this industry of leisure and the emergence—or at least the self-consciousness— of the "nouvelles couches sociales."[60] I agree with the argument and would like to put it in stronger form: it seems to me that the two main histories dealt with in this book, the commercialization of leisure and the beginnings of suburbia, are both forms—perhaps pre-eminent ones—in which the "nouvelles couches sociales" were constructed as an entity apart from the proletariat. To phrase things more strictly: the rise of commercialized entertainments in Paris, catering to a mass public and dependent on large injections of capital, cannot be understood apart from the process described in chapter one—the end of the old patterns of urban neighbourhood and the birth of a city organized round separate unities of work, residence, and distraction.

In a sense there was never much mystery to that connection: observers in the 1860s saw quite well that Haussmann's city was nothing if not a pattern of residence plus a pattern of entertainments. But the less obvious thing to be said is this: both of these patterns were forms of class formation and class control. They were what constituted the new working class in white collars, but *as* a form of bourgeoisie—one that was often portrayed as subordinate and comic, but was nonetheless allowed its peculiar access to middle-class identity, and above all confirmed in its difference from the wider proletariat.

Of course, that difference was never cut and dried, and there exists in all contemporary descriptions of the class—whether seen singing in the Alcazar or as part of a crowd cheering General Boulanger—a speculative, anxious undertone, as if the writers were wondering how long the illusion could last. Often these people seemed too bourgeois to be true. They laid claim to a rigid and primitive version of class consciousness, in which the stress on what separated them from the workers struck the real bourgeoisie

as embarrassing: their probity was awful, their gentility insufferable, their snobbery outright comic: they made it too clear what being middle-class amounted to. And at the same time they were *unaccountable* in many ways, unfixed and inauthentic creatures, without so much as songs of their own or their own way of dressing, given to dangerous enthusiasms (particularly political ones) and ideas above or below their station—populism on the one hand and rank social-climbing on the other.

The very word "populism" is a late-nineteenth-century coinage, and it has built into it from the start the suggestion that producing the popular is a risky business. What begins as a process of control and containment is too often liable to end in mob rule. That is the case because the "popular" is not simply a commodity made from dead, obedient materials—here a phrase, there a value—waiting to be worked over and decently represented. It is something done with actual violence to resistant forms of life; and those forms survive in Thérésa's chorus and the audience she appeals to; they are always capable of recapturing the apparatus of production. In producing the popular, bourgeois society produces its opposite; and for the most part it manages to make that opposite into an image—one withdrawn or provided at opportune moments. Yet the image itself—the main sense of what is pictured—is inimical to everything the bourgeoisie most believes in, and its effects cannot be calculated as accurately as the class would wish. There is always a chance that a line or phrase will be used by the singer to enforce fleetingly the kind of attention—the kind of collective vehemence—that Veuillot and the censor fear.[61]

It is above all *collectivity* that the popular exists to prevent, and doing so means treading a dangerous line. If the entertainment does not provide a passable facsimile of that other mode of appropriating the world, it will fail altogether to engage its audience; but if it falls short of framing and arresting that facsimile—if it fails to make it a spectacle—then the other mode may take over the song and put it to unpredictable uses. The best effects of popular art are therefore won *against* the standardized melodies, the footling lyrics, the cynical production values, the farrago of violence and souped-up emotion. Those who possess the means of symbolic production in our societies have become expert in outflanking any strategy which seeks to obtain such effects consistently; but they cannot control the detail of performance, and cannot afford to exorcise the ghost of totality once and for all from the popular machine.

Yet none of this exactly addresses the problem we were supposed to be dealing with; in some ways, it seems to make matters worse. For if this

is the nature of popular entertainment—or even the characteristic risk associated with it—then why did it appeal so much to an audience of clerks and shop assistants? How did it fit with their striving to be middle-class? These people were widely believed to be extracting themselves from collectivity and becoming individuals; they wished to be respectable, opinionated and well dressed. Was their going to the Alcazar part of that determination or not?

These questions can only be answered, I think, by looking again at the *calicot*'s place in the late-nineteenth-century class system. It was not, to repeat, that he *had* no place, or even an accidental or peripheral one. As an economic fact he was here to stay, and as a political one he was used to having speeches aimed in his direction. But he found it was possible to be declared an economic and political fact by all and sundry, and still be allotted no stable place in the established system of social identities; and it was this that led to his peculiar, excessive insistence on class—on class as a matter of forms and proprieties. The *calicot* laid claim to membership in the bourgeoisie, but the way that he did so, we have seen, most often embarrassed or amused that class's spokesmen. And yet it could not be the case, he said, that he belonged anywhere else in the social order, especially not to the proletariat. His "way of life" prevented that; his tastes, beliefs, and aspirations; his cultural skills. He posited his class position—opened a distance between himself and his inferiors—in terms of preferred representations, in terms of sheer style.

That he was obliged to do so at all is evidence of some kind of *unintelligibility* in his relation to the means of production; and that so much of his stress was put on the difference between himself and those below him suggests that the difference was small. His presence in the Alcazar thus bears on the general dilemma of the "nouvelles couches sociales": it seems that if class identity has to be claimed largely at the level of cultural choices, then the claimants are bound to immerse themselves in those forms and values they wish not to be their own. It is as if the clerks and shop assistants are required to admit their cultural and material links to the working class even as they deny them: they define themselves by their difference from the popular *but also their possession of it*, their inwardness with its every turn of phrase. They are the connoisseurs of popular culture, its experts, its aestheticians; but that expertise is a way of establishing imaginary distance and control. It is the power of the petite bourgeoisie over the proletariat.

The argument so far can now be recapitulated:

The various forms of commercialized leisure which bulked so large in the late-nineteenth-century city were instruments of class formation, and

the class so constructed was the petite bourgeoisie. It was defined primarily by its relation to the working class, and by that relation being given spectacular form. Popular culture was produced for an audience of petit-bourgeois consumers; a fiction of working-class ways of being was put in place alongside a parody of middle-class style, the one thus being granted imaginary dominion over the other.

Both these fictions were unstable, and realized to be so: the popular was prone to divulge too much of the actual form of working-class collectivity, and the *calicot* to seem merely absurd. (If this happened too often, it was feared he might discover in the popular the grounds of his belonging after all to the proletariat; the appeal of Thérésa was therefore not safe. Remember that the 1860s was the time when Varlin predicted an end to the state of affairs "which up to now had made workers and shop assistants two different classes."[62])

The café-concert mitigated these instabilities by making a spectacle of them. It *generalized* the uncertainty of class, and had everyone's be a question of style. It may well have been that this nightly pretence and play-acting only served to confirm class identities for those who possessed them at all securely; but it was not clear whose class *was* secure in the late nineteenth century, at least in cultural terms. For a part of the public, at any rate, it seems most likely that the masquerade had a different effect: it confirmed their sense of class as pure contingency, a matter of endless shifting and exchange; for society was pictured in the café-concert as a series of petty transfiguration scenes, in which everyone suffered the popular sea-change, the "real" bourgeois as much as the false.

It is hard to say anything precise about the psychology deriving from this sort of night out. Observers agreed about the guardedness and anonymity of the crowd in the Alcazar, their troubled torpor, their air of vacancy, the infinite care they took with appearances, their seeming wish to give nothing away.[63] These are partly formulas of condescension, but they should not simply be dismissed on that ground. The sneering has something as its object—some noticeable new way of presenting the self in public.

This is the place to quote the most famous description of analogous states of mind, that given by Georg Simmel in his 1903 essay, "The Metropolis and Mental Life." It is a theoretical sketch, of course, quite lofty and general in a late-nineteenth-century way, and clearly it describes a limiting case of big-city anomie. Nonetheless, its imagery does seem to apply without too much forcing to the material presented so far:

There is perhaps no psychic phenomenon which is so unconditionally reserved to the city as the blasé outlook. . . .

The essence of the blasé attitude is an indifference toward the distinctions

between things. Not in the sense that they are not perceived, as in the case of mental dullness, but rather that the meaning and the value of the distinctions between things, and therewith of the things themselves, are experienced as meaningless. They appear to the blasé person in a homogeneous, flat and grey colour with no one of them worthy of being preferred to another. This psychic mood is the correct subjective reflection of a complete money economy to the extent that money takes the place of all the manifoldness of things and expresses all qualitative distinctions between them in the distinction of "how much". To the extent that money, with its colourlessness and its indifferent quality, can become a common denominator of all values it becomes the frightful leveller—it hollows out the core of things, their peculiarities, their specific values and their uniqueness and incomparability in a way which is beyond repair. They all float with the same specific gravity in the constantly moving stream of money. They all rest on the same level and are distinguished only by their amounts. . . . The nerves reveal their final possibility of adjusting themselves to the content and the form of metropolitan life by renouncing the response to them.[64]

In 1882 Manet sent two works to the salon, one a picture of a young Parisian woman called *Jeanne* and the other, larger and more elaborately finished, of *Un Bar aux Folies-Bergère*[65] (Plate XXIV). The latter had been described to the readers of *Le Réveil* one month before the salon opened, by Paul Alexis, a pupil of Zola:

Standing at her counter, a beautiful girl, truly alive, truly modern, truly "Folies-Bergère" in the expression on her made-up face, plies her small trade. She is seen again from the back, in the glass behind the counter—a glass which reproduces the whole room, with its candelabra, the busy, teeming crowd, and far away in the background a redness which is the red velvet of the boxes; a glass in the corner of which is also seen reflected the whiskered face of a client, an ardent admirer perhaps, who is in intimate conversation with the pretty salesgirl. Finally, in the foreground, on the counter, glitter all sorts of amusing and varied wares: liqueur decanters, bottles of champagne, mandarin oranges in a crystal bowl, flowers in a vase, etc., the whole thing rendered as Manet knows how to render still lifes.

Such will be, for me, the great attraction of the salon, the most exactly modern and the most typical of the works on show. Perhaps, and I do not believe my prediction will turn out to be wrong, Manet will even have a success with the public—as big a one as he had with *Le Bon Bock*.[66]

Alexis's preview set out the main terms in which *Un Bar* would be described by other critics a month or so later, but his prediction did not quite come true. It was only six months since a scandal had been whipped up in the press over Manet's being given the Legion of Honour through the good

offices of his friend Antonin Proust, and in any case the critics had not forgotten or forgiven the outlandish portrait of Pertuiset "assassinating his bedside rug in the desert"[67] which Manet had shown in the Salon of 1881. They were looking forward to further eccentricities, and *Un Bar aux Folies-Bergère* did not fail to provide them. Here is Jules Comte's description, in *L'Illustration*:

A young woman standing at the counter of a bar; in front of her the various decanters and bottles awaiting the customer; behind, a mirror in which the room is reflected, and in the foreground the figure of a habitué who is seen chatting with the same woman viewed from the back; that is the subject, which we shall take as it is offered, without discussion. But what strikes us first of all is that this famous mirror, indispensable to an understanding of all these reflections and perspectives, does not exist: did Monsieur Manet not know how to do it, or did he find an *impression* of it to be enough? We shall refrain from answering this question; but let us simply note this fact, that all of the picture takes place in a mirror, and there is no mirror. As to the incorrectness of the drawing, as to the absolute inadequacy of the form of the woman, who is, after all, the only person shown, as to the lack of correspondence between the reflected objects and their images, we shall not insist on these things: they are lacunae which are common to these Impressionist gentlemen, who have excellent reasons for treating drawing, modelling, and perspective with disdain. At least, we had always heard that Manet's great merit was to show men and things in their true colours, in the atmosphere which surrounds them; but look how this fine principle is applied here: the bar and the room are lit by two globes of electric light, that white, blinding light we all know; but Monsieur Manet has probably chosen a moment when the lamps were not working properly, for never have we seen light less dazzling; the two globes of polished glass have the look of lanterns glimpsed through a winter's fog.[68]

Jules Comte's criticisms were often repeated in 1882. The woman in Manet's picture was held to be badly drawn and insubstantial; the light was "indecisive,"[69] "bluish and murky";[70] the glass and reflection were hopelessly botched. Sometimes the critics were almost kind to this last imperfection, or at least untroubled by it—it was something in the picture that they could test out verbally and declare to be simply, factually *wrong*. "Manet's *Bar* almost makes one want to go there, one of these evenings, in order to understand the truth of the room's reflection in the mirror on the spot, in front of nature."[71] "The effect of the mirror difficult to understand; the woman's head rather agreeable."[72] "I agree that the effect of the reflection in the glass is not understandable at first sight. But what law in art decrees that effects should be seized and perceived straightaway? I spent three days in Amsterdam without seeing a thing in the *Night Watch*. You can surely grant Manet three minutes."[73]

ÉDOUARD MANET.

UNE MARCHANDE DE CONSOLATION AUX FOLIES-BERGÈRE. — (Son dos se reflète
dans une glace; mais, sans doute par suite d'une distraction du peintre, un
monsieur avec lequel elle cause et dont on voit l'image dans la glace, n'existe
pas dans le tableau. — Nous croyons devoir réparer cette omission.)

111. Stop, *Edouard Manet, Une Marchande de consolation aux Folies-Bergère.*
Wood engraving in *Le Journal Amusant,* 27 May 1882.

The mirror on its own did not seem to provoke any great uncertainty
in Manet's first public: it was either straightforwardly a failure or sketched
in boldly enough for the job it had to do.[74] The general critical tone was
set by the cartoonist Stop in *Le Journal Amusant,* who pretended to offer
Manet a helping hand with a minor problem. His caption read:

UNE MARCHANDE DE CONSOLATION AUX FOLIES-BERGÈRE.—(Her back is reflected in
a mirror; but, no doubt because the painter was distracted, a gentleman with
whom she is chatting and whose image one sees in the glass, does not exist in
the picture itself.—We thought we should repair the omission.)[75]

Not all the writing in 1882 was as genial as this, or as much in agreement
about what could be seen and how best it could be interpreted. In particular
the critics were strikingly lacking in unanimity when it came to saying

something about the pose and expression of the barmaid. Was she beautiful and animated, as Paul Alexis had asserted in passing, or pasty, listless, and inert? And what was it she was selling, after all? Giving answers to either of these questions did not produce any great turbulence in the critics' discourse—the barmaid was not Olympia—but the answers themselves make a strange, contradictory set.

The *Bar aux Folies-Bergère* is interesting and ingenious. The salesgirl is seen head-on, and there can be seen behind her, in the mirror she leans her back against, the whole room with its spectators, the crush and movement on the balconies, the blinding lights. The woman is firmly established, with a natural movement which is a little brutal. The foreground is taken up by still lifes, magisterially handled.[76]

Thus Charles Flor in *Le National de 1869*. Or alternatively this, from Caroline de Beaulieu:

. . . the chief [of the Impressionist school] has deigned to take up his pencil and draw the accessories of the *Bar aux Folies-Bergères* [sic]; and it is true that Monsieur Manet has painted with a remarkable sureness and truth of tone a number of decanters, arranged very well, and a bowl of mandarin oranges done very effectively; the salesgirl is so surprised at this fact that she is paralyzed in place by it. Next year Monsieur Manet's figures will no doubt possess movement and grace. . . .[77]

Compare the terms of Emile Bergerat's enthusiasm—

Here is something seen, sincere, new, something which shakes us out of our habits! Furthermore, the fine girl in the blue-black dress who stands at the counter is excellently drawn, modelled with a fine sense of local tone, frank in colouring, natural in pose and altogether full of character.[78]

—with those of Maurice Du Seigneur:

I shall not deny that Monsieur Manet has the truth of the matter; the young woman at the counter, with her hair combed down over her forehead, her bored look, the bottles of champagne, the flasks of multicoloured liqueurs, the pile of oranges, the bundles of barley sugar [sic], they are done from life. . . .[79]

Or Le Senne's defence in *Le Télégraphe*—

The salesgirl, her tight-fitting dress which shows off an anatomy which is mediocre and all the more Parisian for that, her low hairdo, the brightness of her gaze, the tension of her arms, all that is profoundly observed and happily rendered.[80]

—with Henri Houssaye's assault in *La Revue des Deux Mondes*:

It seems that this picture represents a *bar* at the Folies-Bergère; that this gaudy blue dress, surmounted by a cardboard head like those one used to see in milliners' shopwindows, represents a woman; that this mannequin of uncertain form whose face is slashed in with three brushstrokes represents a man; and that this stump

which holds a cane represents a hand. It seems also that those vacillating shadows which stir in the background, in front of the new façade of the Opéra, with balloons floating above them, represent, reflected in a mirror, the public of the Folies-Bergère, the stage on which gymnasts are performing, and the globes of electric light. . . . In all good faith, are we supposed to admire the flat and plastered face of the *bar-girl*, her body without modelling, her offensive colour? Should we admit that the painter has succeeded, by means of a little white dust spread over the young woman's back, in giving the illusion of a scene reflected in a mirror? Is this picture true? No. Is it beautiful? No. Is it attractive? No. But what is it, then?[81]

It is not just that these descriptions disagree with one another, but that each is produced so casually, as if the meanings and interpretations involved were self-evident. And one can understand the critics' unconscious way of thinking here: it is as if they assume that an image which seems in many ways so plain and straightforward in its arrangement, lining up its objects and persons so that they can be taken in completely at a glance, must also provide an equally uncomplicated set of expressions and exchanges. The critics begin with a visual reading and move quite confidently to an affective one; but that the cues for the latter are fragmentary or opaque is suggested at once by the way both "tête de carton," say, and "toute pleine de caractère" are offered as obvious verdicts on the same face.

The business of interpretation was greatly helped in 1882—or so the writers seemed to believe—by the viewers all knowing, as men of the world, what the woman was up to at her bar in the Folies-Bergère. "It is not possible to be more of a *fille* than this creature the artist has installed . . . behind the marble."[82] "A young person in charge of a bar—in French a *buffet*—puts on the most innocent expression so as to pretend she does not know that her twin sister is being chatted up behind her, by a man of property.—Hypocrisy! cries out Monsieur Joseph Prudhomme. You are found even here, in the very sanctuary of easy pleasures!"[83] The girl who sells, according to the always well informed Philippe Burty, "American and other drinks" is also, we have seen, "une marchande de consolation"; the image in the mirror is of a "monsieur with whom she flirts";[84] and so on. This possibility—the presence yet again of prostitution, thinly disguised—is something that the critics appear to delight in; it gives their reading added spice, and, looking back at Paul Alexis, one is inclined to believe that it is what makes the barmaid "living" and lends her made-up face whatever expression it has for him. Certainly in Alexis's case it is what makes the barmaid "modern": if what the woman is selling is herself, then she becomes at once a standard figure in the Naturalists' typology of modern life. She could be construed, therefore, as an elegant variant of

Zola's Nana or the writer's own Lucie Pellegrin—"the modern *fille*, prod-
uct of our advanced civilization, agent of the destruction of the upper
classes." Those words are Alexis's own, in fact, written the previous year
in praise of Zola's great novel of prostitution; and they surely determined
his attitude to Manet's picture in April 1882.[85]

The Folies-Bergère was a kind of café-concert. The guidebooks of the time
invariably listed it under that rubric, though they warned their readers
that it cost money to go in. The entry in Baedeker's 1878 survey of "cafés-
chantants" is representative:

> The Folies-Bergères [sic], Rue Richer 32, near the Boulevard Montmartre, a
> very popular resort, belongs to the same category. Visitors take seats where they
> please, or promenade in the galleries, while musical, dramatic, and conjuring
> performances are given on stage. Smoking is allowed. Admission 2 fr.[86]

The decor of the Folies was garish, and its entertainments more highfal-
uting than was usual in the Alcazar—the green shoes and yellow socks of
a trapeze artist signal that fact in *Un Bar*'s top left-hand corner—but the
tone of the audience was much the same. Or so Guy de Maupassant would
have us believe, propelling his hero Forestier along the Folies' galleries in
his novel *Bel-Ami*:

> . . . Duroy hardly bothered at all with the spectacle on stage, and, turning his
> head, he kept his eyes fixed on the great gallery behind him, full of men and
> prostitutes.
> Forestier said to him: Notice the orchestra stalls; nobody there but bourgeois
> with their wives and children, good stupid souls who come for the show. In the
> boxes, boulevard types, a few artists, a few women from the *demi-monde*; and,
> behind us, the most bizarre mixture in all of Paris. Who are these men? Look
> at them closely. They are of all types, of every profession and caste, but the scum
> predominates. Look at the clerks, the clerks from the banks, the stores, the
> ministries, look at the reporters, the pimps, the officers in mufti, the toffs in the
> evening dress, who have just eaten in some tavern and have slipped out of the
> Opéra on their way to the Boulevard des Italiens, and then again a whole world
> of dubious men who defy analysis altogether. And as for the women, there is
> only one kind: the kind that eats supper at the Américain, the forty-franc whore
> who lies in wait for the foreigner with a hundred francs to spend and tips off
> her friends when she is free.[87]

This is a piece of fiction, of course, and we should not take its description
too much to heart: the loathsome Forestier has to be provided, after all,
with appropriate surroundings, in his case those of dissolution and social
decay. But it is evidence enough for our purposes that Maupassant saw
the Folies-Bergère as the right place for his hero to relax in, and trotted

out the clichés with such gusto. He was not alone in so doing in 1885: the novelist-critic Robert Caze—the same who waxed sarcastic in the last chapter over Blanche's *Les Pivoines*—had a prostitute in a story from his *Paris vivant* come home from the Folies-Bergère in the small hours, remembering how

she plied her trade in the middle of a mob of German whores, croaking away with some Jews and some youngsters, *commis* from the wholesale houses on the Rue Hauteville. They bored her sick, that crowd. She doesn't like Germans. Really! things'll have to be bad before you'll catch her going back to the Folies.[88]

Without a doubt, by the time Manet painted it the Folies-Bergère had become a "permanent fair for prostitutes."[89] It was already firmly established as such by the middle of the 1870s, and its reputation survived various attempts to clean it up and "give less importance to its *promenoirs*."[90] The entry in the *Guide secret de l'étranger célibataire à Paris* for 1889 was succinct and unambiguous: "The Folies-Bergère, 32 Rue Richer: famous for its *promenoirs*, its garden, its constantly changing attractions, and its public of pretty women."[91]

Prostitution, electric light, general glitter, Jews, Germans, *crapule,* and *commis*: the images are ordinary enough, and choosing to paint the Folies-Bergère presumably meant that Manet did not wish to avoid them completely. At one level, Alexis's confidence was understandable: Manet's picture did seem "the most exactly modern and the most typical" of the works shown in the 1882 Salon. One has only to compare it in passing with some of its competitors for such a title for the point to be clear: with Alfred-Philippe Roll's enormous *Quatorze juillet*, for example, which lorded it over the Salon Carré, or with Ernest-Ange Duez's careful *Autour de la lampe*, or Henri Gervex's mural for the Mairie du Dix-Neuvième entitled *Les Bassins de La Villette*. Modern life for Manet, by contrast, is not greatly animated, not familial, and not proletarian. It lacks the composure of real private life, but equally the energy of a public one. On those occasions when the classes are encouraged to celebrate the same symbols, their unanimity rings hollow; and when one class is extracted from the mix and made into a symbol, it straightaway takes on a doleful solemnity—muscled stevedores replacing downtrodden peasants in the repertoire of official concern for the poor.

Manet's picture of modernity is limited in comparison with those of his rivals: he is less certain of relationship than Duez, less confident than Roll in showing how citizens interact and have emotions, and more opaque about class—its costume and physiognomy—than all the other three. I do

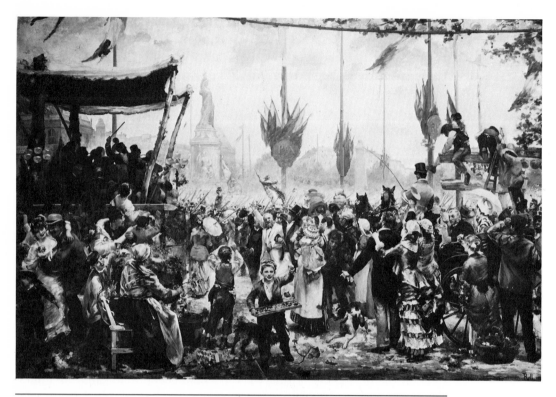

112. Alfred-Philippe Roll, *Le Quatorze juillet, 1880*, 1882.

113. Ernest-Ange Duez,
Autour de la lampe, 1882.

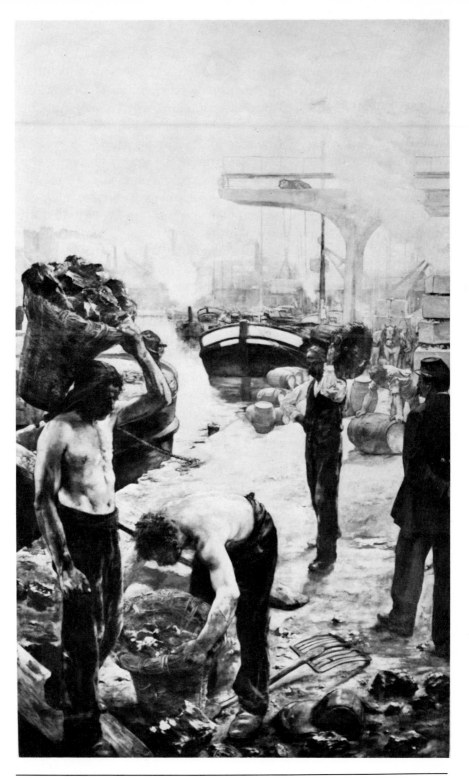

114. Henri Gervex, *Les Bassins de La Villette*, 1882.

not want simply to celebrate those limitations and say they are the truth of modernity; for modern life does include relationships of Duez's kind and even of Roll's, and it certainly includes a proletariat. Modern painting suffers, I think, from not having the means or perhaps the occasion to depict them. But the sense of limits in Manet's painting—the sense of distinctions made between those things in modernity which can be represented and those which cannot—seems to be the other face of a massive ambition to be definitive about *something*, and that not unimportant in the Paris of 1881. The picture is almost ostentatiously exact, well adjusted, grand, quiet, and complete. It stakes its claim to classic status; and its tentative, guarded quality seems quite compatible with that claim—indeed, seems to be part of it. I shall therefore cast my own description of the picture initially in negative terms, starting out from its lack of depth, its resistance to interpretation, its impossible mirror and incomprehensible barmaid. To that extent my description will start from those written in 1882, but alter their emphasis; what the critics then took to be oddities or incoherencies, or anyway features which on the whole prevented the picture from making sense, I shall take to be systematic, and supportive of a quite simple meaning for the actions and persons shown.

Un Bar is a painting of surfaces: that verdict applies not just to the things in the world it seizes on as paintable—the gold foil, the girl's makeup, and the shine on the oranges—but to its insistence that *painting* is a surface and should admit the fact. Where solids and volumes are suggested in the picture, as of course they have to be, the business of shading is got over in a few brilliant strokes—a patch of shadow to turn a wrist, black-and-white hatching on a bottle of champagne, abbreviated lines of white on the oranges and glass of flowers. The paint surface itself is mostly dry, with almost a scraped quality, a bit harsh, a bit brittle, on the edge of being flimsy. This has to do, among other things, with the amount of white paint worked dryly across the other colours—the powdery white of the chandeliers and crystal, the white of marble, lace, makeup, rose, and buttons, the smudges of white put everywhere to stand for dazzle and discoloration on the mirror. These marks draw attention to themselves; they make it clear that the picture surface is all one thing. So does Manet's way of drawing here—his arrangement of the edges of his main forms. The barmaid's waist and shoulders, her hands on the counter, the cut glass against her arm, the chandelier just touching her reflection's head: the picture depends on these sharp edges and intersections, in much the same way as *Olympia* had done; it is organized around juxtapositions on the flat.

Thus the inevitable platitude imposes itself, and need not be avoided—

the picture *is* flat, it confesses and savours its own literal two dimensions. It even arranges particular signs of this flatness, offering the viewer those two thick-painted, pasty circles of electric light, each placed conveniently against a distant wall; or the red triangle on the bottle of Bass at right, peeling away from its label onto the picture surface; or the neat parallelogram of the trapeze, just touching the picture's top left corner, its crossbar bisecting a third electric light already bisected by a pillar! These signs all point to the paradoxes of painting, and do so in a knowing way; but they have their effect precisely because they are incidents, and do not dictate the picture's overall idiom. *Un Bar* is a surface and yet it invites the viewer—with plenty of other effective signs—into a series of quite firmly established spaces.

Behind the girl is a mirror. One can make out the yellow moulding of its frame on either side of the barmaid's wrists, and take in the general haze and dazzle on the glass—the illusion being strongest towards the left, where white paint obscures the distant balcony, or over the heads of the crowd at the right. A mirror it palpably is: one has only to notice the edge of the marble counter reflected in it, or the back view of the bottle of pink liqueur, for the illusion to be inescapable. And is there not even the reflection of the central white rose in its wineglass, wedged in between the second barmaid and her client, hard against the picture's right-hand edge?

But as soon as the general grounds for such a reading have been established—and I take it that most viewers discover them fairly soon—the difficulties in sustaining it begin. If that *is* a mirror behind the barmaid, then what exactly is being reflected in it? If it is a mirror, then the second young woman, towards the right, must be the mirror image of the one who looks out towards us. She must be, and she cannot be. There are clearly things about her which are meant to suggest that she is the same person seen from the rear. And yet how could the barmaid's reflection be there, so far towards the right? Does it mean—it must mean—that the mirror's whole surface is somehow arranged at an angle to our vision, quite a sharp angle, in fact, going back from right to left? Again, that could almost be so; and yet one look at the plain straight edge of the mirror's gilt frame, and the line of the counter just above it in the glass, puts paid to the possibility; and this leaves aside the more general problem of how this slanting mirror would fit in with the picture's overall formal logic.

For that overall logic is strict and emphatic. Every main thing in the picture is presented frontally, face on to the viewer, layer after layer aligned to the lower edge, where the frame itself cuts the marble. And the mirror

is seemingly a main part of that arrangement: it is one more flat surface taking its place among the rest. Are we being invited, then, to insert into this orderly sequence of spaces *another* space altogether, a quite contrary diagonal? We surely cannot do it, by and large—or not in a way we can keep in being, and make part of a reasonably coherent picture; that tilted mirror will not stay in place, it keeps lining up again parallel to the bar and the balcony; the reflection at the right escapes from the person it belongs to.

This last is not simply a matter of inconsistent spaces, I think; it also derives from the painter's rather careful mismatching of the front and back views of his barmaid subject. Looking out at us, the woman is symmetrical, upright, immaculate, composed; looking in at him, the man in the mirror, she seems to lean forward a little too much, too close, while the unbroken oval of her head sprouts stray wisps of hair. She looks a bit plumper than she ought to; the pose she adopts is more stolid and deferential. And thus the critics' descriptions come back to mind: the "jolie vendeuse," the "marchande de consolation," "bien campée dans un mouvement naturel," exchanging clichés with her serious admirer. The critics have a point, of course: the girl in the mirror does seem to be part of some such facile narrative, or could easily be made so. But that cannot be said of the "real" barmaid, who stands at the centre, returning our gaze with such evenness, such seeming lack of emotion or even interest.

And then, of course—final uncertainty—there is the gentleman in the mirror, standing in the top right-hand corner, clutching a gold-knobbed cane, wearing a top hat, a wing collar, and a drooping moustache. Who is this unfortunate, precisely? Where is he? Where does he stand in relation to her, in relation to us?

I wrote just now "looking out at us . . . looking in at him"; but the problem the picture presents is that the barmaid must be doing both at once, that *we* must be where *he* is. But we cannot be; not, anyway, if we are to remain what that easy "we" implies, in the discourse of looking— the single viewer of the painting in question; ourselves, myself; the subject for whom the picture exists and makes sense, who stands and sees a determinate world. "We" are at the centre; he is squeezed out to the edge of things, cut off by the picture frame. His transaction with the barmaid cannot, surely, set the tone for ours.

I suppose most viewers believe that the tone will be set properly, if at all, by the expression on the barmaid's face (Plate XXV). And presumably those viewers do some work to make the face take on an expression that seems plausible given the circumstances, and compatible with the general air of deadpan. (I am leaving aside the inveterate modernist here, who no

doubt sees at once that the face is nothing but that of painting itself, the presence of the signifier, the absence of the signified, etc.) It is perfectly possible, in fact, to imagine the barmaid's face as belonging to a definite state of mind or set of feelings: that of patience perhaps, or boredom and tiredness, or self-containment. We might even have it be "inexpressive," in the sense of the word that implies there is something being deliberately kept back, or that some mistake has been made about how best to signal what one is feeling. But the problem is that all these descriptions fit so easily and so lightly, and none cancels out or dominates the rest; so that I think the viewer ends by accepting—or at least by recognizing—that no one relation with this face and pose and way of looking will ever quite seem the right one. In any case, we resist the suggestion that everything depends on the man with the cane and his ordering the next round. "We" are not looking from where he looks: we do not believe that all we are seeing is the professional impassivity of a barmaid or a prostitute. (It might be possible to dismiss this as a kind of sentimental wish for complexity on our part, were it not for the way the more general perplexities of the picture chime in with the viewer's sense of the face as ambiguous. Or, to put it another way: if this *is* the professional look of a prostitute, then surely the picture divests that look of any simplicity: it suggests that expressions have complex circumstances, and are best understood as constructions—rather fragile constructions—in their own right.)

What I have been describing up to now is a texture of uncertainties. Some of them may have struck the reader as a bit hectic and contrived, and some not; the point in following them thus far is to suggest how easily doubts about looking accumulate in front of *Un Bar aux Folies-Bergère*, doubts of various kinds, all reinforcing one another. What begins as a series of limited questions about relationships in space is likely to end as scepticism about relationship in general. Little by little we lose our imagined location, and because of that—as part of that—our first imaginary exchange of glances with the person in the picture is made to appear the peculiar thing it is. Here too, in the matter of persons and looks, we begin to struggle for a reading, become aware of contradictory cues, and feel obliged to include in the transaction the various things which may or may not be there in the mirror. And we cannot do it: the equation fails to add up. We cannot or will not take the place of the gentleman in the top hat, but there is no other place to occupy, it seems; we are left in a kind of suspended relation—to the barmaid, to ourselves as viewers, to the picture itself as a possible unity.

There seems little doubt that the structure which gives rise to these uncertainties was devised by the artist with conscious care.[92] We have an

oil sketch in which Manet put down his first general idea for *Un Bar* (Plate XXVI), and it serves to show how easily things might have been sorted out and put in order if that had been what Manet had wanted. He might have given us, as he did in the sketch, a readable, eye-catching relation between the barmaid and man in the mirror; the more or less blousy *dame de comptoir* dwarfing the eager buyer of drinks. He might have put the barmaid and her reflection together, back to back, with the mirror established between them. He could have pushed the counter back in space and marked out its edges and sides; he could have put the barmaid safely behind it, and taken away her peculiar symmetry and her absolute, outward stare. But of course he did not: he seems to have worked instead to discover and exacerbate inconsistencies in his subject, teasing out the anomalies, letting in the blanks, having them dictate the picture's order.

And so the further question occurs, as to *why* the mirror was treated in this peculiar way. What does the mirror do in Manet's painting? Why is it placed as it is? What is the viewer supposed to make of the distance opened up between the objects and their reflections, and the suggestion that one belongs to the other only incompletely? These are partly questions about Manet's possible working procedures, about how it happened that the glass and reflections took this form in the process of painting. And partly they feel for possible intentions: kinds of matching, most probably sensed by the painter only indirectly, between a formal arrangement of this type and the actual subject, the bar and the barmaid. Both questions are speculative, given the evidence we have, and the answers I offer are therefore meant to be tentative. But at least they proceed from what seems to me the plausible hypothesis (on which this book as a whole is based) that inconsistencies so carefully contrived must have been felt to be somehow appropriate to the social forms the painter had chosen to show.

A mirror is a surface on which a segment of the surrounding world appears, directly it seems, in two dimensions; as such it has often been taken as a good metaphor for painting. Is that perhaps the way it is meant in *Un Bar*? The great room, the lights, the crowd, the trapeze, the elusive atmosphere—the mirror fixes and flattens them all, before the painter begins. There is literally nothing behind the barmaid but glass, on which the world already takes place in miniature, much as it will on canvas. But in order for the mirror to have that connotation—for it to be read as a simple, factual surface calling to mind the plainness with which painting puts down the world of appearance—it would not do for the glass to be pictured at an angle. The mirror must repeat the picture's literal surface: it must be the same surface, only farther back. The thing it must *not* do is act on the matters of visual fact it shows; it must not *do* things to them.

There is a plain fact of vision somewhere, and an equally plain one of painting; the mirror is there to show that each can be true to the other: it guarantees the orderly unfolding of the real world to the eye, band after band—counter, frame, counter, balcony, pillars—until the picture stops.

The mirror must therefore be frontal and plain, and the things that appear in it be laid out in a measured rhythm. And yet it is clear that some of those things will not be allowed to appear too safely attached to the objects and persons whose likenesses they are. I think that this happens, to repeat my previous point, as a result of Manet's attitude towards the Folies-Bergère—towards modern life in Paris, if you like. It seems to me also that a degree of conflict exists between that attitude and the beliefs about painting and vision—the metaphysic of plainness and immediacy— just outlined. That Manet held both sets of beliefs is incontestable, and the tension between them was never more visible than in his last big painting.

It is a picture of a woman in a café-concert, selling drinks and oranges, and most probably for sale herself—or believed to be so by some of her customers. Those customers, we know, were a motley crew, "le plus drôle de mélange qui soit dans Paris,"[93] and therefore peculiarly hard to make out. The elements involved in making sense of the situation were as follows: that the entertainments provided were popular, the general decor pretentious and glittering, the women loose, and the men engaged in a quite serious game of class. The face that the barmaid presents to this spectacle is, we might think, the only one possible. It is the face of fashion, first of all, made up to agree with others quite like it, the hair just hiding the eyebrows and leaving the ears free, the cheeks pale with powder, the lips not overdone this season, the pearls the right size.[94] Fashion is a good and necessary disguise: it is hard to be sure of anything else about the barmaid, in particular what class she might belong to. She does not seem, as the critics hinted in their choice of language in 1882, to be firmly part of the bourgeoisie; and that fact is the key to her modernity, in Alexis's smug sense; it is part of her appeal. The face she wears is the face of the popular, as previously defined, but also of a fierce, imperfect resistance to any such ascription. It is a face whose character derives from its not being bourgeois, and having that fact almost be hidden. For if one could not be bourgeois— if that status was always pushed just a little further out of reach—then at least one could prevent oneself from being anything else: fashion and reserve would keep one's face from *any* identity, from identity in general. The look which results is a special one: public, outward, "blasé" in Simmel's sense, impassive, not bored, not tired, not disdainful, not quite focused on anything. Expression is its enemy, the mistake it concentrates on avoiding at all costs; for to express oneself would be to have one's class be legible.

Un Bar is surely concerned to picture that kind of effacement, but also the actual social circumstances in which it took place and which made it obligatory. The painting delights in flatness in general, wherever it occurs, and no doubt it aims to show us what a face looks like when it too becomes two-dimensional—when that is the way it presents itself to the world. But it offers at the same time a form of explanation for that state of affairs, a form built into the picture's visual structure. The explanation consists, if I can put it this way, in the "actual social circumstances" barely appearing to be any such thing—to be either actual or social—to us or the actors involved in them. A curious balance must thus be struck. The circumstances must all be *there* in the picture, but somehow not quite convincingly. They must be seen to apply to the barmaid, but at one remove, as if they came to her—to us—as things slightly insubstantial, not wholly real.

That is why they are placed in a mirror and only half attached to the figure in front of it. For if the barmaid were *in* the mirror—part of the glamour of lights and performances, directly addressed by the man with the cane—she would be given back the actual social circumstances which are precisely what she does not have. And equally, if the mirror were all paradox and instability, its angle turning the room around and opening it up, then the gap between the woman and her reflection would lack the peculiar tension it has. It is important that even the Folies-Bergère appears in the picture as almost real, almost orderly, only just interrupted by the glass. For there is a definite set of class relations here to which the barmaid belongs; it is only her way of belonging to them that is the problem. The world that Manet offers as "modern"—and the same is true of *Olympia* or *Argenteuil, les canotiers*—is not simply made up of edges and uncertainties. It is plain as well as paradoxical, fixed as well as shifting; it lacks an order, as opposed to proclaiming the end of order as the great new thing.

I do not think, in other words, that the barmaid is carried away into the odd spaces and displacements I have spent my time describing; she is not dispersed by them. Even the word "ambiguous" will not quite do if we are aiming to describe her place in the picture and her relation to the life in the mirror. To disagree with Alexis one last time, it does not seem to me that she is animated by her alienation; she is posed and composed and confined by it; it is felt as a kind of fierceness and flawlessness with which she seals herself against her surroundings. She is *detached*: that is the best description. She looks out steadily at something or somebody, the various things which constrain and determine her, and finds that they all float by "with the same specific gravity in the constantly moving stream of money." The customer evidently thinks she is one more such object

which money can buy, and in a sense it is part of her duties to maintain the illusion. Doing so is a full-time job.

Let me compare *Un Bar aux Folies-Bergère*, finally, with a painting by Degas done in the later 1870s of two women sitting at a café table, with some kind of foliage behind them: the women seemingly engaged in quizzical conversation, and one of them holding a flower in her fist (Plate XXVII). Degas seems to have believed for a while in the 1870s that modern life would offer the painter of sufficient skill a new set of characteristic physiognomies; he would be able to elaborate a repertoire of types, gestures, and expressions to stand for his century and give the viewer the feel of its life.[95] The project bore fruit for a time in pictures like this one, or portraits of friends, or the pastels shown in the 1877 Exhibition, or the parallel study of brokers and dealers outside the stock exchange. Nonetheless the project did not continue for long; in the 1880s Degas largely abandoned it in favour of studies of the ballet and the nude. There was to be no physiognomy of modern life, and surely the reasons for Degas's failure to design one have to do with his whole notion of the form in which modernity would show itself. The modern city, Degas thought, would produce "characters"; it would therefore be subject to sharp, ironical notation and equally fine physiognomical encoding. What this confidence amounted to—it was plainer still in the sketches and recipes of Degas's spokesman, Edmond Duranty—was a kind of nostalgia for times when identities had been stamped on a man's skin; and this at a moment when the mapping of the psyche around the polarities of "inside" and "outside" was being displaced by quite other topographies.

These were eventually to issue in a new kind of polarity—that of conscious and unconscious mind—which theorized (among other things) the great fact of character in bourgeois society: that the "inside" *cannot* be read from the "outside," and that the determinant facts of mind need have no visual effects, or may appear at most as interruptions in the flow of public signals. The previous pictorial concept of the psyche had depended on a notion of the self as something acted out, in familiar contexts and informing roles. This chapter has tried to describe the circumstances in which such acting out became rare.

For various reasons Manet seems to have been able to accept the implications of the new situation for painting more readily than Degas, but this is not to say that Degas's effort at modern physiognomy came to nothing. The nature of Degas's achievement in the 1870s is suggested well, I think, by *Au café*, and the artist's seeming admission of defeat in face of

115. Edgar Degas, *A la Bourse*, 1878–79.

his trivial slice of modernity. The picture of the women—talking? dreaming? gloomy? intent on something? exchanging confidences?—left, as it is, half finished, picked out mostly in livid *grisaille*, is a kind of study in the resistance of modern life to physiognomic reading. And so are many others of Degas's pictures at this time: what comes across most strongly is the muffled, secretive, fragmentary, almost catatonic quality of the sitters and their expressions. Behind them all—behind the woman in *L'Absinthe* or the puppets on the Place de la Concorde, behind the snarling brokers, pouting girls, slouching seducers, and barking singers—lies the final lack of animation in the *Portrait de Michel-Lévy* (Plate XXVIII).

There the modern artist stands, in a corner of his studio, surrounded by his props. The walls on either side of him are hung with freshly painted canvases—picnics and landscapes, ladies with parasols, glimpses of riverbank and greenery, absence of restaurants and regattas. The painter is in shirt sleeves, leaning against one of his *Déjeuner sur l'herbe*s. His outfit and pose are informal, but somehow uneasily *smart*; he wears a cryptic, acidulous expression, and at his feet is modern woman herself, the lady he chooses (or is able) to represent. She sits on the floor of the studio, a mannequin made up for the countryside, out of joint and overdressed, compliant and

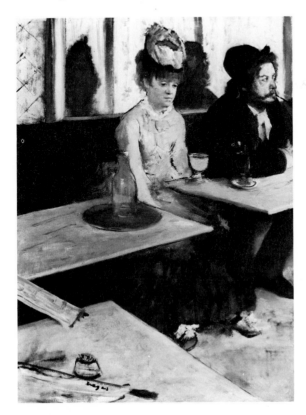

116. Edgar Degas,
L'Absinthe, 1876.

featureless, her minimum physiognomy seeking the studio sun. She is wedged into the same unsatisfactory space as the painter; they are both awkward and impenetrable, both lurking in the "cover of restraints."

What is visible in modern life, in other words, is not character but class. And yet of course the culture presented its own set of obstacles to the recognition of that fact, or to taking it seriously. In the case of the artists who concern us, the obstacle took the form of an ideology: the avant-garde appears to have been persuaded by the view that modernity was no longer characterized by a system of classification and control but, rather, by mixture, transgression, and ambiguity in the general conduct of life. It seems to me that this was to mistake the real and important margin of error in capitalist society for an overall loosening of class ties. (It is true that capitalism by its very nature does not affix and stabilize status in the way of feudalism, say; it does not require its identities to be absolute, so many forms of the Sacred on earth. It is part of the new order that a few should escape it.)

The perfect heroes and heroines of this myth of modernity were the petite bourgeoisie. They appeared in many ways to have no class to speak of, to be excluded from the bourgeoisie and the proletariat and yet to thrive on their lack of belonging. They were the *shifters* of class society, the connoisseurs of its edges and waste lands. And thus they became for a time the alter egos of the avant-garde—ironically treated, of course, laughed at and condescended to, but depended on for a point of insertion into modern life. I believe that sometimes in depicting them the painters discovered the limits and insufficiency of their own ideology, and in some sense described these people's belonging to the class system. That only happened occasionally. In any case, once the "nouvelles couches sociales" were no longer available as heroes of modern life—once they became a banal and established part of the bourgeoisie—description of that life, ideological or otherwise, largely ceased.

CONCLUSION

What I take to be the essential criticism of modernist painting was made at the time by the young writer Camille Lemonnier. In his "Notes on the Universal Exhibition" of 1878, he had this to say of Degas, Manet, Caillebotte, and Forain (I have been literal with his entry's staccato French):

> None of them appears to possess *the sense of the picture*. They make fragments; they confine themselves to certain specialities of observation; they have familiarized themselves with only certain corners of humanity, the most striking in their display of corruption. They have above all the sense of the immoral woman. From them one gets frightful gesticulations of *filles perdues*. They deliberately keep company with the demented. Let them beware: this too is a form of virtuosity. The lower depths in which they linger have excessive aspects to them which are easier to do and more accessible than the simple order of bourgeois life, so hard to express because it has no surprises.[1]

Lemonnier's first sentence probably strikes us now as excessive; which is to say that these artists and others have so altered our "sense of the picture" that we find it hard to imagine what other sense a good critic could have had. But the charges that follow still have their force. They amount to saying, as this book has done, that modernist painting accepted and reworked a myth of modernity in which the modern equalled the marginal. Shifting and uncertainty were thus taken to be the truth of city life and of perception, the one guaranteeing the other. I have spent my time trying to suggest the strengths and limitations of this belief, and have put more stress than is usual on the latter.

In particular I have argued, as Lemonnier did, that this painting did not find a way to picture class adequately; though adequately here should not be understood to mean simply or unequivocally. It was not able to devise an iconography of modern life, one capable of being sustained and developed by succeeding generations. That failure derives above all, I think, from its mistaken sense of what class was and how it showed itself, its belief that the founding categories of social experience could only appear— or could only be represented—as an absolute presence on the other side of codes and conventions, or as a glimpse, a flickering into visibility, itself part of the general rule of elusiveness. "Content . . . is a glimpse," a later

modernist painter said:[2] that was already the rule of *Olympia* or *Le Chanson du chien*.

These are not surprising conclusions, particularly if one believes, as I do, that the sense of class just outlined is basic to bourgeois ideology, and that a contrary imagery would have to be based on some form of identification with the interests and values of other classes in capitalist society. That Manet and his followers had no such identification is obvious. It is not enough to say that they were bourgeois artists; it needs stressing, rather, that their practice as painters—their claim to be modern—depended on their being bound more closely than ever before to the interests and economic habits of the bourgeoisie they belonged to. The period covered by this book has been described by Harrison and Cynthia White as that of "the rise of the dealer-critic system," and the main facts they adduce as evidence for such a claim will bear repeating.[3] By the end of the 1880s, Impressionist painters depended for their livelihood on the movements of the world art market, particularly the American part of it. Artists like Monet became adept, no doubt reluctantly, at playing off one sector of the market against another, and adjusted their practice to the new contractual situation. Market conditions encouraged the dealer to speculate in the long-term "creativity" of those artists he favoured; and artists in turn learnt to market that peculiar commodity with some skill—nursing and refining it in a steady sequence of shows, interviews, and promotional literature, trying to strike the right balance between innovation and product reliability, sniffing out the market's approximate wishes while maintaining (to the death) the protocols of individuality and artistic freedom.

These were the determining conditions of artistic production in the period: it was because art was produced in these circumstances to serve these interests that it could find no basis for representation besides the spectacular ones this book describes. If I have spent a great deal of my time rehearsing exceptions to the general rule, it has not been in order to suggest that the rule did not apply, or that the exceptions were more than partial. Nonetheless they are worth studying, first because it seems to me wrong to picture ideology as a seamless garment, and second because any present-day opposition to modernism had better recall how much modern painting was capable of representing, at least in its first decades. To repeat the obvious: belonging to a class and sharing its ideological set is never a matter of total acceptance or perfect fit; an ideology presents its limits and incoherencies for possible use, even to those inside the limits; and if certain bourgeois artists now wish to exceed the modernist frame of reference, this will involve them in discovering what remains of modernism might still be used to represent the point of view of the proletariat.

Therefore this book ends with Seurat's *Dimanche après-midi à l'île de La Grande Jatte* (Plate XXIX), and makes the following claims for it: that it attempts to find form for the appearance of class in capitalist society, especially the look of the "nouvelles couches sociales"; that the forms it discovers are in some sense more truthful than most others produced at the time; and that it suggests ways in which class might still be painted.

The island of La Grande Jatte, perched in the Seine between Asnières and Neuilly, was a favourite place for an outing from Paris in our period—it could be reached in minutes from the trains that stopped at Clichy or went on to Courbevoie. By 1885 even the guidebook could afford to be ironical about its pretence of nature:

The island of La Grande Jatte, without being a rustic Eden, affords the youth of Paris charms which regularly prove irresistible. On holidays and Sundays, a ball whose splendour rivals the luxury of the Elysée-Montmartre makes the island echo with interminable refrains; people take lunch on the worn-out grass, and swings, skittles, and games of toad-in-the-hole spring up in place of the absent trees.[4]

There were already pictures that presented La Grande Jatte in much the same way as the guidebook. In the Salon of 1878 a painter called Roger Jourdain showed two pictures, *Le Dimanche* and *Le Lundi*, and when they were reproduced in *L'Illustration* that June, the caption writer was clear about what they signified:

It is to the island of La Grande Jatte, between Neuilly and Asnières, that Monsieur Jourdain has gone to compare the promenaders of Sunday and Monday; we behold the first kind, numerous and all dressed up in their Sunday best, walking along the banks, while in the island's interior those favoured by fortune have found more shade and solitude. The graceful mahogany rowing-boat has been pulled up onto the grass; the cushions have been taken from it so that the ladies, who were afraid of dampness for their new dresses, could sit down; then the food was taken out, a great tablecloth was spread on the green grass, the inevitable pâté was cut open and the bottles uncorked. . . .

But dessert still has its surprises: here comes one of the oarsmen back from the boat, carrying two bottles of champagne in triumph; after all, one is still entitled to a thirst! . . .

The *employés* and *commis* have gone back to their offices and shops; today is the day of the worker. Yesterday's champagne has given way to the *petit vin d'Argenteuil*; people no longer stretch out recklessly on the grass, they gather around wretched tables, on tavern benches.

The youngsters of yesterday felt they had the right to enjoy themselves; the devotees of Monday are not carefree; the memory of the workshop haunts their spirits; the reproaches which await them cramp their open good humour; it will need several more litres before those troublesome phantoms go away.[5]

LE DIMANCHE
Tableau de M. Jourdain.

117. Roger Jourdain, *Le Dimanche*. Wood engraving after lost oil painting in *L'Illustration*, 15 June 1878.

What the caption is describing in its facetious and evasive way is the form of class struggle on the island. The celebration of *saint lundi* had once been a well-established custom with the working class, and at times it had had a definite anticlerical, antibourgeois edge.[6] By the 1870s the custom was becoming an anachronism, with almost a touch of the picturesque about it, and this is no doubt why Jourdain thought it suitable for the salon. Monday was a day for workers who could not afford a second-hand suit. "Sundays," says one to another in a tract of 1865, "I simply cannot do: I'd need three months' wages in advance to be up to it." His companion replies, "I see what holds you back; as one friend to another, let's be frank: it's the smock and the cap."[7] In other words, the poor preferred Monday from a sense of shame, since "there was no dressing up to do, and they did not wish to appear in public on Sundays in worker's costume."[8]

Jourdain is willing and able to articulate the difference between petit bourgeois and worker because it presents itself here, at least in fantasy, as a clean separation in which each class knows its place. They have different days, drinks, dress, and attitudes towards sitting on the grass; and though

LE LUNDI.
TABLEAU DE M. JOURDAIN.

118. Roger Jourdain, *Le Lundi*. Wood engraving after lost oil painting in *L'Illustration*, 15 June 1878.

both are a little absurd in their pleasures, it is clear that one is inferior to the other. There is no such certainty in Seurat's painting, and the critics who saw it first when it was shown in 1886 were often sensitive to precisely that fact.[9] They seemed aware that Seurat's subject in *La Grande Jatte* was double-edged: that he wished to show the nature of class distinction in a place given over to pleasure, but also the various things that made distinctions hard to grasp. It was important that his people looked alike, and yet were sharply discriminated from each other in detail.

Here, for example, is Seurat's friend Jules Christophe writing in *Le Journal des Artistes*:

Monsieur Georges Seurat, finally, with the temperament of a Calvinist martyr, who has planted, with the faith of a Jan Hus, fifty people, lifesize, on the bank of the Seine at La Grande Jatte, one Sunday in the year 1884, and tries to seize the diverse attitudes of age, sex, and social class: elegant men and elegant ladies, soldiers, nannies, bourgeois, workers. It is a brave effort.[10]

Seurat's subject, says Henry Fèvre in *La Revue de Demain*, is "the rigidity

of Parisian leisure, tired and stiff, where even recreation is a matter of striking poses (*la raideur de la badauderie parisienne, compassée et avachie, et dont la récréation même est poseuse*).[11] Compare the verdict of Jean Ajalbert again, addressing the Marseillais subscribers of *La Revue Moderne*:

Monsieur Seurat paints in little measured touches; they produce a uniformity which goes with his way of drawing. Using a simple line, he evokes the attitude, the theoretical dress of our age, the frocks which follow the curves of the body and hang straight down, the close-fitting tunics, the tight jackets, the drainpipe trousers. He leaves out the affectations, the accessories, and the frills, and gives us a schema—a very suggestive one.

Once the first impression of surprise is over, the exaggerated stiffness of these people softens; the dots of colour are less fatiguing and a shower of sunlight comes through the trees.

Those really are rowers, off in the distance, that row of white shirts and red caps all bent at the same angle, their pink reflections in the water, and all these people who hardly differ, all dressed in the same clothes, they really give the impression of the intense life that flows out, on Sundays in summer, from Paris to the outskirts of the city.[12]

"Parisiens! cherchant des fleurs sur les pavés!": Ajalbert's interest in the subject is clear. But here is the modest Alfred Paulet, with no axe to grind that we know of:

Monsieur Seurat's idea comes out clearly. The painter wished to show the tedious to-and-fro of the banal promenade of these people in their Sunday best, who take a walk, without pleasure, in the places one is supposed to walk on Sundays. The artist has given his people the automatic gesture of lead soldiers, each on its separate base. Maids, clerks, troopers move with the same slow, banal motion, all alike, which certainly conveys the character of the scene, but does so with too much insistence. Apart from giving only a general idea of things from a single point of view, this general idea is underlined in an exaggerated way. Observation here is no longer original and detailed, no longer penetrating: it is superficial and carried out according to a formula.[13]

Or this from the naturalist Paul Adam:

And even the stiffness of these people, their punched-out forms, help to give the sound of the modern, to recall our badly cut clothes, clinging tight to our bodies, the reserve of our gestures, the British *cant* we all imitate. We strike attitudes like people in a painting by Memling. Monsieur Seurat has seen that perfectly, understood it, felt it, and translated it with the pure drawing of the primitives.[14]

All of these critics are trying, it seems, to make sense of the balance held in Seurat's work between diversity of social detail and a "uniform and as it were abstract execution."[15] For some of them it is the schematism and stiffness which are decisive; but Ajalbert was right, I think, to see the

synthetic contour lines and little measured touches as not necessarily at odds with the final impression of intense life.[16] The life *is* intense for all its rigidity; and that is because each separate shape is so sharp and clear and yet boxed in by others, touching and intersecting them, as if the picture was hardly big enough to contain them. (It is a huge picture: ten feet long and nearly seven feet high.)

La Grande Jatte is a painting which teems with improbable distinctness of form: dogs and monkeys adopting perfect attitudes in the shade, parasols and trombones outlined against the light, puffs of cigar smoke compared to butterflies, hats bristling with brims and flowers, nurses seated like Egyptian scribes, the strings of a fan in arabesque upon the grass; waists pinched, bustles protruding, soldiers tin, rowers identical, and as final note the two points, of a skirt and an umbrella, appearing as pure, comic geometry at the picture's right-hand edge. The forms are distinct and so, on the whole, are the social types: worker with pipe, bourgeois with cigar; a woman equipped for the afternoon with two novels and a newspaper, a young girl with a nosegay of flowers; a proud father holding the baby while mother sees to its covers, an outlandish *cocotte* coming on with a monkey; solitary people, family parties, women out on their own without chaperons.

One of the questions we might want to ask of these people, since they are gathered together in groups and couples, is who precisely belongs with whom. Which of the strollers has nobody with him in the crowd, and which sits down with a friend? It is not always easy to be sure. The threesome in the foreground at the left, for example, consists of a worker, seemingly, sprawled full-length upon the grass, dressed in sleeveless shirt and jockey cap, smoking a long-stemmed pipe; beside him the lady with the novels and the fan; and beyond her a little *employé* done up to the nines, positively sweating with propriety, holding his stick and keeping his hat on (Plate XXX). It is hardly likely that the three are out for the day together (the latter two could just about belong to each other, but nothing in their placement suggests as much); yet here they all are, oc-cupying the same sliver of space and shade. And the point of the grouping—the point of the awkward angles and absolute profiles, the shadow bisecting the lady's breast, her feet appearing through the pipe smoke, a tree shooting up from the clerk's top hat—seems to me to suggest the queerness of the juxtaposition. Class is present here, unmistakeably, but the fact that workers and bourgeois share the same pleasures does not result in this case in an infinite shifting so much as an effort at reaching a *modus vivendi*, agreeing to ignore one another, marking out invisible boundaries and keeping oneself to oneself. The sign of that effort is the picture's comic way with form:

its rhymes and tangents and interruptions, its mad symmetry and template silhouettes.

The critics were right in 1886: there is an appearance of uniformity to *La Grande Jatte*, at least on the surface, but that very fact makes difference more salient when it happens; it makes us attend to the signs of "age, sex, and social class" in a special way, with a sharpened sense of their oddity and separateness. The comedy that results from this is *formal*: it is grand and restrained, and does not give rise to ironic point-making at the petit bourgeois's expense. The characters are not for the most part meant to be funny—let's leave aside the soldiers and the monkey—but the general pattern of constraint and distinction certainly is.[17]

We have only to turn back to Jourdain's *Dimanche* and *Lundi* for the point to be clear. Seurat's subject, by contrast, is the intermingling of classes, not their neat separation; it is the elaborate texture of controls and avoidances that the classes bring with them to the place of pleasure—the worker as much as the bourgeois, the prostitute as much as the tin soldier. The scene that results is enormous and orderly: one can understand Seurat saying that in it he wished the viewer to see a new version of Phidias's Panathenaic procession, with "the moderns moving about the same way, friezelike, stripped down to their essentials."[18] The picture is epic, that presumably is what Seurat meant: large in scale and positive in its overall attitude to the events it chooses; concerned to give them definitive form, and not afraid to repeat itself a bit in the process, or to relish the accidental intricacies thrown up by the hard, bright detail; certain, above all, that what was shown was somehow historical, a grand new ordering of the most important matters of the moment.*

One of those matters was certainly freedom, and these people are out

* Several of the critics in 1886 seemed aware that this was the measure of Seurat's ambition, whether or not they thought his picture a success. "At the same time," wrote Maurice Hermel in *La France Libre*, "he seeks the perfect synthesis of the suburban stroller. A man with a fishing rod, a simple *calicot* sitting on the grass are fixed in the hieratic attitude adopted by ibises on obelisks. People out walking in their Sunday best under the shady trees of La Grande Jatte take on the simplified and definitive aspect of a cortege of pharaohs. [En même temps il cherche la synthèse absolue du promeneur suburbain. Un pêcheur à la ligne, un simple calicot assis sur l'herbe se fixent dans l'attitude hiératique qu'affectent les ibis sur les obélisques. Des flâneurs endimanchés sous les ombrages de la Grande Jatte prennent l'allure simplifiée et définitive d'un cortège de pharaons.]" The image of *calicot* as pharaoh here seems apt. It points to the kind of historical weight that I believe Seurat intended his strange mixing of the banal and the hieratic to have. The new men—the men on the grass in the Grande Jatte—are as hungry for definitive form as once were the builders of pyramids; and Seurat is almost ready to grant them the same rigid immortality. Their stiffness may still prove their strength. They are the makers of history now, and painting can no longer quite afford to condescend to them.

to let one another know they possess it—in the form of new dresses and newspapers, the nerve to promenade with a monkey, the time to smoke a pipe, to go without a chaperon and have no dealings with their neighbours. No doubt these things *are* freedoms, and the price paid for them is high. ("Does the husband tax the Congo for the monkey's keep?" as Delmore Schwartz once had it.) But in a sense they have already stiffened, in Seurat's picture, into a subculture, and opened themselves to the guidebook's good humour. Pleasure is a provided margin here; if the modern is the marginal, finally, then the periphery is by now every bit as well policed as the centre— policed by fashion and respectability, by the wish not to stand out, not to take a chill or have things lead to any unpleasantness. It is meant to be marvellous, that delicate still life of spiked hat and furled pink parasol in the shadows, but also a trifle grotesque; the bodies and dresses are like replicas of themselves, not quite the real thing; the spots of light are decent and meticulous, keeping a safe distance from the things they are called on to portray; the decision to strip down to one's shirt sleeves is a momentous one, which most gentlemen do not take; even the weed on the river has floated discreetly into a parallelogram.

The limits of modernity are clear in this case. The painter has taken pains to spell them out unequivocally, and expose them to critical reading. I do not think that Lemonnier's judgement quite applies to *La Grande Jatte*.

As a kind of coda, I want to end with some paragraphs from the article by Stéphane Mallarmé on "The Impressionists and Edouard Manet." It is not that Mallarmé's vision is meant to epitomize the arguments of this book; on the contrary, his optimism about art and democracy seems to me largely misguided, for reasons which should by now be sufficiently clear. But I have wanted to suggest why such optimism was possible as well as wrong.

Therefore I expect the reader to be sympathetic, if a bit bemused, when Mallarmé shrugs off the history of art since the Renaissance as so many attempts "to decorate the ceilings of salons and palaces with a crowd of idealized types in magnificent foreshortening,"[19] and so clearly assumes that painting's relation to power will be different from now on. The optimism, to repeat, has not worn well, and the ironies attending Mallarmé's final prediction—that the new art might prove directly useful to the masses as they take over the state—do not need to be spelt out. Impressionism became very quickly the house style of the haute bourgeoisie, and there are ways in which its dissolution into the decor of Palm Springs and Park Avenue

is well deserved: it tells the truth of this painting's complaisance at modernity. But there are other aspects to Manet's art, and Mallarmé insists on them, not absurdly:

At a time when the romantic tradition of the first half of the century only lingers among a few surviving masters of that time, the transition from the old imaginative artist and dreamer to the energetic modern worker is found in Impressionism.

The participation of a hitherto ignored people in the political life of France is a social fact that will honour the whole of the close of the nineteenth century. A parallel is found in artistic matters, the way being prepared by an evolution which the public with rare prescience dubbed, from its first appearance, *Intransigeant*, which in political language means radical and democratic.

The noble visionaries of other times, whose works are the semblance of worldly things seen by unworldly eyes (not the actual representations of real objects) appear as kings and gods in the far dream-ages of mankind; recluses to whom was given the genius of a dominion over an ignorant multitude. But today the multitude demands to see with its own eyes; and if our latter-day art is less glorious, intense and rich, it is not without the compensation of truth, simplicity and childlike charm.

At that critical hour for the human race when nature desires to work for herself, she requires certain lovers of hers—new and impersonal men placed directly in communion with the sentiment of their time—to loose the restraint of education, to let hand and eye do what they will, and thus through them reveal herself.

For the mere pleasure of doing so? Certainly not, but to express herself, calm, naked, habitual, to those newcomers of tomorrow, of which each one will consent to be an unknown unit in the mighty numbers of a universal suffrage, and to place in their power a newer and more succinct means of observing her.[20]

NOTES

NOTES

Full publication details of all books cited are given in the bibliography. Articles are cited in full in the notes and not included in the bibliography. In certain cases (e.g., the Salon of 1865) a list of salon criticisms, including items not actually cited in the text, has been included in the notes.

I have given the French text of citations (1)

where the materials quoted were not easily available in later editions or secondary works, or (2) where it seemed important to the point I was making for the reader to have the French text on hand (e.g., the Goncourt journal entry in chapter one). The translations from the French, unless otherwise indicated, are by the author.

Introduction

1 Meyer Schapiro, "The Nature of Abstract Art," *Marxist Quarterly*, January-March 1937, p. 83; reprinted (with no indication of its first place of publication) in *Modern Art: 19th and 20th Centuries*, by Meyer Schapiro. The passage I quote was subjected to interesting criticism in Delmore Schwartz's "A Note on the Nature of Art," *Marxist Quarterly*, April-June 1937, pp. 306–7. This is the place to acknowledge my other obvious debt, to the bits and pieces of Walter Benjamin's *Arcades* project, especially the material in *Charles Baudelaire: A Lyric Poet in the Era of High Capitalism*.

2 In the text I have sometimes used the word "myth" in place of "ideology" where it seemed right to point to an actual body of stories and images (e.g., the discussion of the myth of modernity in chapter one).

3 See *Internationale Situationniste*, nos. 1–12, also reprinted in one volume; Guy Debord, *La Société du spectacle*; Raoul Vaneigem, *Traité de savoir-vivre à l'usage des jeunes générations*; and the unsigned *La Véritable Scission dans l'Internationale*. In translation: Christopher Gray, ed., *Leaving the 20th Century: The Incomplete Work of the Situationist International*; Guy Debord, *Society of the Spectacle*; Ken Knabb, ed., *Situationist International Anthology*; Raoul Vaneigem, *The Revolution of Everyday Life* (trans. of *Traité de savoir-vivre*).

4 Debord, *La Société du spectacle*, p. 24.

5 Stéphane Mallarmé, "The Impressionists and Edouard Manet," *Art Monthly Review*, 30 September 1876, p. 222. The Mallarmé text is known to us only in this translated form.

6 Clement Greenberg, "Modernist Painting," *Art and Literature* 4 (Spring 1965): 194.

7 Mallarmé, "Impressionists and Edouard Manet," p. 222.

8 See, e.g., Jules Christophe in *La Cravache*, June 16, 1888 (cited in *Post-Impressionism: From van Gogh to Gauguin*, by John Rewald, p. 130; translation slightly modified): "out of disgust for the coarse, completely external, and already old naturalistic formulae, symbolism was born, explorer of souls, of fragile nuances, of separate sensations, of fugitive and—sometimes—quite painful and intense impressions; an esoteric art, necessarily aristocratic, perhaps something of a bluff, if you wish, where one finds the semblance of a desire for mystification in revolt against universal foolishness, an art which derives from science and from dreams, evoker ... of all forms existing in the intelligence and outside of matter itself, a spiritual and Pyrrhonian art, nihilistic, religious and atheistic, even Wagnerian." The attitude was well enough established by 1886 to provoke a reply from Octave Mirbeau, "L'Art et la nature," *Le Gaulois*, 26 April 1886 (apropos of Odilon Redon).

9 Mallarmé, "Impressionists and Edouard Manet," p. 221.

10 "That one will be the *painter*, the true painter, who will know how to wrest from the life of the present its epic aspect, and make us see and understand, through colour and drawing, how great and poetic we are in our cravats and patent-leather boots" (Charles Baudelaire, "Salon de 1845," in *Oeuvres complètes*, p. 866). For the phrase from Rimbaud in quotation marks, see the epigraph to chapter one.

11 Gustave Vassey, "L'Exposition des impressionnalistes," *L'Evénement*, 6 May 1877: "Et dans la *Balançoire*, les effets de soleil sont combinés d'une façon si bizarre qu'ils produisent exactement l'effet de taches de graisse sur les habits des personnages." Bernadille, "Chronique Parisienne," *Le Français*, 13 April 1877: "Seulement, de grâce, qu'il ne peigne plus de *Balançoire* d'un violet criard qui ressemble à une gageure . . . ni surtout de *Jardins* apocalyptiques devant lesquels le spectateur, comme le dindon de la fable, voit bien quelque chose, mais ne distingue pas très bien." Bertall, *Paris-Journal*, 9 April 1877: "Je vous recommande sa balançoire, sublime de grotesque et d'audacieux aplomb. . . ."

12 Vassey, "L'Exposition des impressionnalistes."

13 Ernest Fillonneau, "Les Impressionnistes," *Le Moniteur des Arts*, 20 April 1877: "M. Pissarro devient complètement inintelligible. Il marie dans ses tableaux toutes les couleurs de l'arc-en-ciel; il est violent, dur, brutal. D'un effet qui pourrait être acceptable, il fait une gageure contre la vue et même contre la raison."

14 Marc de Montifaud, *L'Artiste*, 48th year, vol. 1, p. 337: "C'est à satiété que l'on répète que, pour juger les impressionnistes, il faut se mettre à distance. A cinquante pas, nous assure-t-on, les bras se renflent, les jambes nues sortent de la jupe, les yeux s'avivent, la peinture prend du corps, de la souplesse, du mouvement, chaque teinte s'affirme et chaque valeur rebondit à son plan. C'est ainsi que cela donne l'impression d'une chose vue moins accusée de forme que traduite par le sentiment. Un ou deux de la coterie réalisent à peine ce programme; et tous s'ingénient, la sueur au front, à étaler la couleur sur la toile, tout en cherchant la transparence, et, en mettant du vert dans leurs ombres, ils restent pâteux, sans fraîcheur et sans relief."

15 Léon de Lora, *Le Gaulois*, 10 April 1877: "On ne se figure pas les *impressions d'après nature* de M. Cesanne [*sic*]; je les ai prises pour des palettes non raclées. Mais les paysages de M. Pissarro ne se devinent pas plus et ne sont pas moins prodigieux. Vus de près, ils sont incompréhensibles et affreux; vus de loin, ils sont affreux et incompréhensibles. Ils font l'effet de rébus qui n'auraient pas de *mot*."

16 Alfred Sisley, letter to Adolphe Tavernier, no date, cited in *Alfred Sisley: Catalogue raisonné de l'oeuvre peint*, by F. Daulte, p. 23: "Car le soleil, s'il adoucit certaines parties du paysage, en exalte d'autres et ces effets de lumière qui se traduisent presque matériellement dans la nature doivent être rendus matériellement sur la toile." The issue for Pissarro seems to have been (as his later statements make clear) above all that the picture *as a totality* be made to register a likeness; but that in turn involved an action against any *particular* matching in the picture of aspect to aspect or detail to detail. What resulted was a quite specially unstable art practice, from which Pissarro made various attempts to escape, notably in the 1880s.

17 Zed, "Menus propos," *Le Télégraphe*, 6 April 1877: "Une forme blanche—ou noire—qui pourrait être un homme à moins que ce fût une femme, s'avançait (s'avançait-elle)? Le vieux matelot eut un frémissement—ou un éternuement—nous ne savons pas au juste; il s'écria: 'Allons-y!' et il se précipita dans une mer blanchâtre—ou noirâtre—nous ne savons pas au juste, qui pouvait bien être l'Océan."

18 Jules Claretie, "Salon de 1875," in *L'Art et les artistes français contemporains*, p. 337.

19 Jacques, "Exposition impressioniste," *L'Homme Libre*, 12 April 1877: "Elle démontre ceci, c'est que la peinture n'est point uniquement un art d'archéologue et qu'elle s'accommode, sans effort, de la 'modernité'."

20 Emile Bergerat, *Le Journal officiel de la République Française*, 17 April 1877: "Faut-il accorder, oui ou non, la naturalisation artistique au vêtement dont nous subissons tous l'uniformité noire et difforme? En d'autres termes, faut-il peindre le chapeau tuyau de poêle, le parapluie, la chemise à col cassé, le gilet et le pantalon?"

Chapter One: The View from Notre-Dame

1 "I am an ephemeral and not-too-discontented citizen of a metropolis believed modern because all trace of previous good taste has been evaded in the furnishings and exteriors of the houses as well as the plan of the city. . . . These millions of men who do not need to know one another live out their education, jobs, and old age so much alike that their lifespans need be several times less long than the unlikely figure found for the continental races." "Ville" in *Les Illuminations, 1872.* O. Bernard, ed., *Rimbaud: Selected Verse*, pp. 256–57. The poem was prob-

ably written in London and has that city as its ostensible subject.

2 H. Malet, *Le Baron Haussmann et la rénovation de Paris*, p. 323.

3 The Exhibition of 1878 was intended to symbolize France's recovery from the disasters of 1870–71; a national holiday was proclaimed in connection with it on 30 June. That Manet's depiction of it carries some kind of satirical edge was already argued by Edgar Wind (in lectures at Oxford; my thanks to Jon Whiteley for this information).

4 Victor Hugo, *Les Misérables*, 2:108. Van Gogh read *Les Misérables* in the 1870s and reread it in March 1883 (my thanks to Griselda Pollock for clarifying this).

5 Georges Seurat, letter to Signac, 16 June 1886 (cited in *Seurat: L'Oeuvre peint, biographie et catalogue critique*, by Henri Dorra and John Rewald): "Guillaumin entertains a mild hatred for me. I am doing a Rafaëlli, apparently (Je fais mon Raffaëlli à ce qu'il paraît)." Verdicts on Raffaëlli could be strikingly different. Compare the dedication of G. Coquiot's *Concerts d'été (Impressions de Paris)*, 1894—"To J.-F. Raffaëlli, to the genial painter of the *banlieues*, the powerful analyst of suffering in gloomy landscapes, the prolific caricaturist of the Paris Street," with Jules Christophe's passing characterization: "basically, no more than a superior Meissonier of the *banlieue*," in "Le Salon intime," *Le Journal des Artistes*, 20 June 1886, p. 206.

6 Emile Zola, *L'Assommoir*, pp. 267, 269.

7 Louis Lazare, *Les Quartiers de l'est de Paris et les communes suburbaines*, pp. 62–63, 142; cited in *Histoire de l'urbanisme à Paris*, by P. Lavedan, p. 482.

8 The story is told in Jeanne Gaillard, *Paris, La Ville: 1852–1870*, pp. 57–59. Elsewhere Gaillard stresses the resistance of big industry to Haussmann's wishes; the personal approach to Cail and Say should be seen in this light. (I am heavily indebted to Gaillard's work on Haussmannization throughout this chapter.)

9 Victor Hugo, *Notre-Dame de Paris, 1482*, pp. 157–58.

10 See Pierre Lavedan, *Histoire de l'urbanisme*, pp. 398–403.

11 Cited in *Du vieux Paris au Paris moderne: Haussmann et ses prédécesseurs*, by A. Morizet, p. 201. Balzac's novel was published posthumously in

1856; written mainly in 1847–48, it was never finished.

12 Edmond Texier, *Tableau de Paris*, 1:75; cited in *Haussmann: "Préfet de Paris,"* by G.-N. Lameyre.

13 L. Marie, *De la décentralisation des Halles*; cited in *Histoire de l'urbanisme*, by Lavedan, p. 403.

14 See H . Malet, *Le Baron Haussmann*, pp. 191–93. In his speech at the inauguration of the Boulevard Malesherbes, Haussmann revelled in the opportunity to make the correct Napoleonic-populist points: "One can understand that these persons, who have little acquaintance with the hard necessities of life meted out to others, should have been disagreeably surprised, in the case of the expropriations, to find themselves overtaken by the democratic rule of equality before the law; but that their complaints should have been echoed—passionately echoed—by those who claim to be liberals *par excellence*, this is a fact which is barely explained even by a systematic determination to contradict everything the Administration does" (ibid., p. 193).

15 See, for instance, Victor Fournel, *Paris nouveau et Paris futur*.

16 Edmond and Jules de Goncourt, *Mémoires de la vie littéraire*, 1:835: "Je vais le soir à l'Eldorado, un grand café-concert au boulevard de Strasbourg, une salle à colonnes d'un grand luxe de décor et de peintures, quelque chose d'assez semblable au Kroll de Berlin.

"Notre Paris, le Paris où nous sommes nés, le Paris des moeurs de 1830 à 1848, s'en va. Et il ne s'en va pas par le matériel, il s'en va par le moral. La vie sociale y fait une grande évolution, qui commence. Je vois des femmes, des enfants, des ménages, des familles dans ce café. L'intérieur s'en va. La vie retourne à devenir publique. Le cercle pour en haut, le café pour en bas, voilà où aboutissent la société et le peuple. Tout cela me fait l'effet d'être, dans cette patrie de mes goûts, comme un voyageur. Je suis étranger à ce qui vient, à ce qui est, comme à ces boulevards nouveaux, qui ne sentent plus le monde de Balzac, qui sentent Londres, quelque Babylone de l'avenir. Il est bête de venir ainsi dans un temps en construction: l'âme y a des malaises, comme un homme qui essuierait des plâtres."

17 Edmond and Jules de Goncourt, *Journal des Goncourts*, 1:345–46: "Mon Paris, le Paris où je

suis né, le Paris des moeurs de 1830 à 1848 s'en va. Il s'en va par le matériel, il s'en va par le moral. La vie sociale y fait une grande évolution qui commence. Je vois des femmes, des enfants, des ménages, des familles dans ce café. L'intérieur va mourir. La vie menace de devenir publique. Le cercle pour le haut, le café pour le bas, voilà où aboutiront la société et le peuple. . . . De là une impression de passer là dedans, ainsi qu'un voyageur. Je suis étranger à ce qui vient, à ce qui est, comme à ces boulevards nouveaux sans tournant, sans aventures de perspective, implacables de ligne droite, qui ne sentent plus le monde de Balzac, qui font penser à quelque Babylone américaine de l'avenir."

18 Edmond About, *L'Homme à l'oreille cassée*, p. 196; cited in *Histoire de l'urbanisme*, by Lavedan, p. 450.

19 Lazare first attacked Haussmann in *La Revue Municipale* in October 1861. Haussmann took Lazare to court for his article and had the magazine suppressed. See Lavedan, *Histoire de l'urbanisme*, p. 477.

20 See Lameyre, *Haussmann*, p. 139.

21 Number estimated by *Le Moniteur*, 18 August 1854; see A. Sutcliffe, *The Autumn of Central Paris: The Defeat of Town Planning 1850–1970*, pp. 137–38.

22 Lavedan, *Histoire de l'urbanisme*, p. 448.

23 See Morizet, *Du vieux Paris*, p. 280, and D. H. Pinkney, *Napoleon III and the Rebuilding of Paris*, pp. 4–5. The language of statistics was adopted early by Haussmann's defenders. See César Daly, "Etude générale sur les grands travaux de Paris," *La Revue Générale de l'Architecture et des Travaux Publics*, 1862, which regales its readers with percentage increase of *trottoirs*, proportion of *trottoirs* to total road surface, average distance between gaslights, increase in photometric units provided by the new type of gas lamp for the *banlieue*, etc., etc.

24 Théophile Gautier, "Mosaïque de ruines," in *Paris et les Parisiens au XIXᵉ siècle: Moeurs, arts et monuments*, p. 39: "leaving aside the dark tonality, one could take them for those tumbledown edifices, that uninhabitable architecture which Piranesi sketched in his etchings with such a restless touch. This destruction is not without beauty; the play of light and shade across the ruins, over the random blocks of fallen stone and wood, makes for picturesque effects. . . ."

25 Morizet, *Du vieux Paris*, p. 275.

26 Pinkney, *Napoleon III*, p. 70.

27 See Baron Haussmann, *Mémoires*, 3:164: electric light "will have after a certain time no supporters but oculists and opticians." See Pinkney, *Napoleon III*, p. 145, and Morizet, *Du vieux Paris*, pp. 281–82, on the battle over "tout-à-l'égout."

28 Morizet, *Du vieux Paris*, p. 286.

29 A fact relished by Walter Benjamin; see *Charles Baudelaire: A Lyric Poet in the Era of High Capitalism*, p. 129.

30 See the gloomy analysis of the effects of Haussmannization on public health in Sutcliffe, *Autumn of Central Paris*, p. 138. See also the discussion of Haussmannization and *la misère* in Gaillard, *Paris*, pp. 214–30.

31 This was the essential burden of Lazare's 1861 attack; it was taken up by the liberal republicans in the late 1860s. Public works and imperial patronage, they said, stood in the way of a decent free-enterprise economy. Gaillard's *Paris* (pp. 27–29) points out the pattern of interests and disappointments that underlay the republican rhetoric. For a still more hostile account of the liberal opposition to the imperial economy, see S. Elwitt, *The Making of the Third Republic: Class and Politics in France, 1868–1884*, pp. 21–28.

32 Pinkney's *Napoleon III* (pp. 25–26) argues most strongly for Napoleon's role as prime mover in the rebuilding.

33 There is a great deal of writing on this subject. The best discussions seem to me Gaillard's *Paris*, pp. 29–40 and the excellent conclusion, pp. 559–72; Pinkney's *Napoleon III*, pp. 35–38 (as sceptical a view as can reasonably be managed); Sutcliffe, *Autumn of Central Paris*, pp. 35–36; A. Vidler, "The Scenes of the Street: Transformations in Ideal and Reality 1750–1871," in *On Streets*, ed. S. Anderson, pp. 92–93.

34 Haussmann, *Mémoires*, 3:54.

35 Gaillard, *Paris*, p. 38.

36 Ibid., p. 38. There was considerable uncertainty about the appropriate name for the boulevard laid out on top of the canal. It was first decided that it should be called after Napoleon's mother, *la reine Hortense*. The emperor himself insisted that it be named after a worker, Richard Lenoir. See Georges Duveau, *La Vie ouvrière en*

France sous le Second Empire, p. 204. For a typical and early use of the strategic argument, consider Léon Faucher's official justification of the Rue de Rivoli extension in 1851 (cited in *Autumn of Central Paris*, by Sutcliffe, p. 35): "The interests of public order, not less than those of salubrity, demand that a wide swathe be cut as soon as possible across this district of barricades. . . . An intermediate line will be added to the great strategic lines of the boulevards."

37 C. Delon, *Notre Capitale Paris*, p. 372.

38 Fournel, *Paris nouveau*, p. 29: "Il faut bien le dire: ce qu'on a appelé les embellissements de Paris n'est au fond qu'un système général d'armement offensif et défensif contre l'émeute, une mise en garde contre les révolutions futures, qui se poursuit depuis douze ans avec une infatigable persévérance, sans que le Parisien candide ait l'air de s'en douter."

39 E. Pelletan, *La Nouvelle Babylone: Lettres d'un provincial en tournée à Paris*, p. 47: "Voilà pourquoi on a démoli Paris. On a voulu faire de Paris un camp retranché, et du Louvre un quadrilatère; avec cela et la garde impériale pour garnison, le principe d'autorité peut dormir. La population honnête ne verra plus d'hommes en tablier de lustrine, un pot de colle à la main, qui barbouillent la muraille d'un coup de pinceau et placardent gravement au coin de la rue l'affiche d'un nouveau gouvernement." Of course the general's explanation is meant to be partial and slightly lunatic, taken on its own; he is immediately followed in the book by equally emphatic spokesmen for the public-works-as-provision-for-the-working-class explanation and the need-for-a-decently-embellished-capital-city argument. Pelletan became a notable member of the republican opposition in the late 1860s.

40 Fournel, *Paris nouveau*, p. 231ff.

41 Lameyre, *Haussmann*, p. 324.

42 Good discussion of this second, "corrective," phase of Haussmannization can be found in Gaillard, *Paris*, pp. 48–49, 42. The "troisième réseau" of rebuilding, Gaillard argues, should not simply be seen as another installment in Haussmann's plan to build a "polycentric" city of separate districts; to some extent it tried to recentre the city and tie the *banlieue* back into Paris.

43 N. Sheppard, *Shut Up in Paris*, pp. 34–35.

44 Ibid., p. 116.

45 Victorien Sardou, *Maison neuve*, in *Théâtre complet de Victorien Sardou*, 9: 274–75; cited in *Haussmann*, by Lameyre, pp. 281–82.

46 The famous attack by Jules Ferry, *Les Comptes fantastiques d'Haussmann*, is the tip of the iceberg of such opposition criticisms in the late 1860s. The best discussions of the economics of Haussmannization are in Sutcliffe, *Autumn of Central Paris*, p. 37 ff. (good on the built-in financial contradictions in Haussmann's free-enterprise operation: Sutcliffe believes that even without the collapse of the empire in 1870 "the improvement programme would have broken down within a few years" [p. 42]); see also pp. 116–22; L. Girard, *La Politique des travaux publiques du Second Empire*, especially pp. 333–35; Gaillard, *Paris, passim*, especially pp. 67–84; L. Bergeron and M. Roncayolo, "De la ville pré-industrielle à la ville industrielle: Essai sur l'historiographie française," *Quaderni Storici*, September-December 1974, pp. 869–70 (good, brief discussion of the struggle to "valorize" the renovated older districts); J. Ceaux, "Rénovation urbaine et stratégie de classe: Rappel de quelques aspects de l'haussmannisation," *Espaces et Sociétés*, October 1974–January 1975 (a bit cut and dried); Morizet, *Du vieux Paris*, pp. 287–88 (on the alliance with the Crédit Foncier).

47 See Gaillard, *Paris*, pp. 138–39 and chap. 2 ("La Belle Époque de la propriété bâtie"), *passim*.

48 See F. Raison-Jourde, *La Colonie auvergnate de Paris au XIX^e siècle*, pp. 153, 312.

49 Daly, "Etude générale," p. 33; this is a prospect Daly seems to welcome. There is an immense literature on the same subject from a hostile point of view. A good round-up of such opinions is in Lameyre, *Haussmann*, pp. 278–87. It must be stressed how much of a *banality* the attack on anonymity and uniformity became, taking its place in the standard patter of guidebooks; see note 52 below.

50 Ferry, *Les Comptes fantastiques*: "C'est peine perdue de regretter l'ancien Paris, le Paris historique et penseur dont nous recueillons aujourd'hui les derniers soupirs . . . où il existait des groupes, des voisinages, des quartiers, des traditions."

51 Walter B. Jerrold, *Paris for the English*, p. 61.

52 Charles Yriarte, "Les Types parisiens—les clubs"

in *Paris-Guide* 2 (1867): 929: "La ligne droite a tué le pittoresque et l'imprévu. La rue de Rivoli est un symbole, une rue neuve, longue, large, froide, que parcourent des gens bien mis, gourmés et froids comme elle. . . . Plus de loques coloriées, plus de chansons extravagantes et de discours extraordinaires. Les dentistes en plein air, les musiciens ambulants, les chiffonniers philosophes, les bâtonnistes, les hercules du Nord, les vielleuses, les débitantes de serpents mal portants et les montreurs de phoques qui disaient 'papa' ont émigré. La rue n'existait qu'à Paris, et la rue agonise. . . ."

53 *Lamentations d'un Jérémie haussmannisé* (anon.); cited in *Du vieux Paris*, by Morizet, p. 290.

54 Sheppard, *Shut Up in Paris*, pp. 135–36.

55 There is no doubt that this was thought to be happening in the 1860s, and to be something Napoleon and Haussmann had intended. "The transformation of Paris having forcibly driven the working population of the centre out towards the city's extremities, the capital has been turned into two cities: one rich, one poor. The latter encircling the former. The class of the needy is like an immense cordon hemming in the class of the well-to-do . . ." (C. Corbon, *Le Secret du peuple de Paris*, p. 200). There is considerable disagreement still about whether the working class *was* expelled from the centre of Paris—or, rather, about how significant the exodus was. The traditional view is well stated in Duveau's *La Vie ouvrière* (pp. 206–9), and largely defended in Sutcliffe's *Autumn of Central Paris* (pp. 136–38, 322–27). For arguments against the traditional view, see Louis Chevalier, *Les Parisiens*, pp. 127–31; A. Cottereau, *De l'hygiène sociale à l'urbanisme: Etude des conditions politiques de la planification urbaine en région parisienne(1871–1940)*, pp. 67–86; Gaillard, *Paris*, especially p. 430 ff. ("Essor et crise de l'artisanat parisien"). See also note 61 below.

56 Sutcliffe, *Autumn of Central Paris*, p. 138.

57 Lameyre, *Haussmann*, p. 161.

58 Address at the banquet following the inauguration of the Boulevard Sébastopol, 5 April 1858; cited in *Le Baron Haussmann*, by Malet, p. 176. Malet notes the much-publicized official satisfaction at the enthusiasm of the *blouses bleues* in the crowd at the opening ceremony.

59 H. Graf von Moltke, *Moltke in seinen Briefen*, p. 100 ("Briefe aus Paris," 1856, no. 44); cited in *Haussmann*, by Lameyre, p. 149; the letter continues: "The workers thus find themselves pushed out towards the suburbs."

60 On the bourgeois fear of Belleville and the edge of Paris, see G. Jacquemet, "Belleville aux XIXᵉ et XXᵉ siècles," *Annales*, July-August 1975, p. 838, and Gaillard, *Paris*, p. 203: "The fear of the *faubourgs* has replaced the fear of the unhealthy *quartiers* of the city centre."

61 Everyone agrees that western Paris became a bourgeois stronghold; again there is disagreement over whether the city as a whole became segregated on class lines and broken up into separate units. The liberal indictment of the late 1860s is repeated, for instance, by R. Sennett, *The Fall of Public Man*, pp. 134–35, but scathingly attacked by A. Cottereau, *De l'hygiène sociale*, for whom the notion that Haussmannization produced a new level of social segregation is "un contre-sens total." Gaillard's overall verdict seems the most reasonable one: "From the great avenues [the Empire] required first of all the prevention of any coalition of the *quartiers*, any chance of disorder becoming contagious. The old pattern of circular boulevards had made the city a unity inside their rings; the avenues of the second and third networks separated *arrondissements* and *quartiers* from each other. They inscribed into the very fabric of Paris a decomposition of the urban ensemble [*Elles inscrivent sur le sol parisien une décomposition de l'ensemble urbain*] . . ." (*Paris*, pp. 39–40). An "osmosis" of the classes remained possible in the central districts, from which the workers refused to be parted, but "there developed, however, a segregation by *quartier* which was much more disturbing for the established order than the segregation by house . . . the constitution of homogeneous *quartiers* from which the bourgeoisie was absent, absent altogether or present in such small numbers that it was overwhelmed [*phagocytée*] or paralyzed by working-class elements" (ibid., p. 84). See the parallel verdict of J. Rougerie, *Paris libre 1871*, pp. 17–19: "The Commune of 1871 will be in large part the retaking of central Paris, the true Paris . . . by the exiles of the *quartiers extérieurs*, of Paris by its true Parisians, *the reconquest of the City by the City*" (p. 19).

Compare this diagnosis with Engels's classic verdict on Manchester in *The Condition of the Working Class in England*, p. 54: "The town itself is peculiarly built, so that a person may

live in it for years, and go in and out daily without coming into contact with a working-people's quarter or even with workers." What is at stake here—and what is being discussed in the literature on Haussmannization—is a *politics of invisibility*, itself an important (though double-edged) factor in social control. This politics of invisibility is part of the spectacle as I go on to define it.

62 On the debate over the siting of the Opéra, see Lavedan, *Histoire de l'urbanisme*, pp. 438–39: "The question was important and the answer given to it would in many respects determine the destiny of Paris. . . . The Empire's plan put the seal on the displacement of the city towards the northwest." One should obviously guard against claiming the drift to the west was wholly the baron's fault: it had been happening since the eighteenth century, and had been widely discussed since the 1840s. Halbwachs long ago argued that what Haussmann did was to follow—or provide for—patterns of internal migration which were already well established and had to be dealt with (see M. Halbwachs, *La Population et les tracés de voies à Paris depuis un siècle*). Again, this brand of demographic determinism has come under fire; among other things, Gaillard's work is a successful attempt to demolish it (see *Paris*, pp. 42–43).

63 Sheppard, *Shut Up in Paris*, p. 198.

64 Georges Duchêne, *L'Empire industriel*, pp. 102–3; cited in *La Vie ouvrière*, by Duveau, p. 206.

65 André Weill, *Qu'est-ce que le propriétaire d'une maison à Paris?*; cited in *Haussmann*, by Lameyre, pp. 158–59: "All these crinoline houses are plastered with makeup and wear pillbox hats on their heads. But their insides are, so to speak, fraudulent." There is a good speech by Genevoix on the subject: "But as for stucco which pretends to be marble! and cardboard looking like sculpture! and pearwood like ebony! Scratch it and it peels right off! Give it a knock and your fist goes through!" (Sardou, *Maison neuve*, p. 374.)

66 A good discussion of Haussmann's battle with Hittorff, his official chief architect, can be found in Lavedan, *Histoire de l'urbanisme*, pp. 448–63. Siegfried Giedion's classic treatment of Haussmannization in *Space, Time and Architecture*, pp. 650–79, centres on the way Haussmann's project exceeded the architectural frame altogether: "The architects were of singularly little help. They could not even adjust themselves to the scale of [Haussmann's] projects; on many occasions he had to send their work back and insist upon its enlargement. He remarks that the Second Empire was unfortunate in not producing a single artist equal to the problems of the *temps nouveaux*. Haussmann seems to have resigned himself to this fact" (p. 665).

67 See Haussmann, *Mémoires*, 3:493. The Place de la Concorde had of course been the site of the guillotine.

68 See the complaint of E. Pelletan in *La Nouvelle Babylone*, pp. 33–34.

69 Louis Chevalier, *Classes laborieuses et classes dangereuses à Paris pendant la première moitié du dix-neuvième siècle*, p. 376, on the persistence of criminality in certain Parisian neighbourhoods: "Unless there intervened some kind of total destruction, some act of divine or administrative wrath—Haussmann installing his offices on the very site of the Rue aux Fèves—nothing [would change these places]." The proprietor of the Lapin Blanc, which pretended to be the very tavern in Sue's *Mystères de Paris*, was expropriated in 1859, moved his business to the Rue des Amandiers, and never recovered his trade (see J. Hillairet, *L'Ile de la Cité*, pp. 68–69).

70 Morizet, *Du vieux Paris*, p. 214.

71 All of these are from contemporary descriptions, Victor Fournel being the master of the genre. See, for instance, his contribution to *Paris dans sa splendeur*, 2: 15–17; Pierre Véron, *Paris s'amuse*; Alfred Delvau, *Les Plaisirs de Paris: Guide pratique*; Yriarte, "Les Types parisiens"; C. Delon, *Notre Capitale Paris*; E. Fournier, *Enigmes des rues de Paris*; P.-L. Imbert, *A Travers Paris inconnu*. See also the list of street *métiers* in Eugène Atget's *La Vie à Paris, vers 1898–1900*.

72 Victor Fournel, *Ce qu'on voit dans les rues de Paris*, pp. 302–3: "Marchands d'encre, de marée, de pommes de terre au boisseau, de mottes à brûler, de mouron pour les petits oiseaux, ramoneurs, saltimbanques, charlatans, casseurs de pierres, joailliers en plein vent, étalagistes des boutiques à cinq sous, tout cela crie, chante, module ses apostrophés et scande ses invitations sonores sur les gammes les plus agaçantes."

73 See Rougerie, *Paris libre 1871*, pp. 9–14. In the discussion of the Parisian *quartier* economy that

follows, I am indebted to Rougerie's work, to Chevalier, to Gaillard's fine study (especially Part 3), to R. Gossez's "Les Ouvriers de Paris," in *Société d'Histoire de la Révolution de 1848,* 1967, and above all to conversations with Andrew Lincoln, whose study of Parisian capitalism ("Paris in the 1860's: Class, Valorisation and Workshop Politics," doctoral dissertation, Oxford University, forthcoming) promises to change a lot of established ideas. Some first fruits of Lincoln's research are "Le Syndicalisme patronal à Paris de 1815 à 1848: Une Etape de la formation d'une classe patronale," *Le Mouvement Social,* January-March 1981, and "Second Empire Paris: Valorisation and Workshop Politics," unpublished manuscript, 1982.

74 See Rougerie, *Paris libre 1871,* and Gaillard, *Paris,* pp. 430–36.

75 There is an excellent discussion of the "corporate idiom" of the trades in the period before 1848 in W. Sewell, *Work and Revolution in France: The Language of Labor from the Old Regime to 1848.* To what extent that idiom survived as an active one in the face of Second Empire capitalism—and to what extent it had ever been a *determinant* of working-class reaction to capitalist reorganization—are open questions.

76 Gaillard, *Paris,* p. 436: "The smaller the scale of the industry, the more dispersed the work-process, the more imperative becomes a territorial regrouping to make transactions easier."

77 See note 55 above. Gaillard, *Paris,* p. 431: "it appears that the *artisanat* consolidated its hold on the centre of the capital in spite of the demolitions, the shortage of housing and the unreasonable demands of the landlords." The "centre" here leaves aside the Cité and the new Rue de Rivoli area, which power did claim for its own to the exclusion of the native working class. "The Empire was more anxious to disengage the centre of the city and to *limit* the working-class *quartiers* than to transform them" (ibid., p. 35).

78 See H. Vanier, *La Mode et ses métiers 1830–70,* *passim.* In 1909 the artificial-flower industry in Paris employed 28,000 people, 25,000 of them women (M. H. Zylberberg-Hocquard, *Féminisme et syndicalisme en France,* pp. 32–33).

79 On the First International and the strike wave of the late 1860s, see Duveau, *La Vie ouvrière,* especially pp. 203 ff. (a vigorous argument in favour of this period as the key transition to large industry and a genuine proletariat); Rougerie, *Paris libre 1871,* pp. 20–24; R. Locke, *French Legitimists and the Politics of Moral Order in the Early Third Republic,* pp. 10–16 (on the period of 1868–71 as one process, characterized by the growing tempo of strikes and political agitation; on 24 June 1870, for example, strikes were taking place in Marseille, Rouen, Fourchambault, Vienne, Lyon, Givors, Saint-Etienne and Rive-de-Gier). Current work in France puts great stress on the pattern of working-class agitation, street demonstrations, etc., in the three years preceding the Commune.

80 See Lameyre, *Haussmann,* p. 147.

81 On the new framework for the workshop economy, see Gaillard, *Paris,* pp. 437–54. She calls in question the conventional picture of the surviving "traditional" trades: "Thus the dividing up and proliferation of small workshops derive essentially from that sharp awareness of competition and commercial threat which clearly emerges from the documents of the time" (p. 439). For parallel treatments of capitalist development *within* the framework of small-scale, seemingly "traditional" workshop organization, see G. Stedman Jones, *Outcast London,* chap. one, and R. Samuel, "The Workshop of the World: Steam Power and Hand Technology in Mid-Victorian Britain," *History Workshop Journal,* Spring 1977.

82 Morizet, *Du vieux Paris,* p. 279.

83 As enumerated by Duveau, *La Vie ouvrière,* p. 203.

84 The best discussion of Haussmannization and the *grands magasins* is again in Gaillard, *Paris,* pp. 525–58. See also Sennett, *Fall of Public Man,* pp. 141–46, and M. Miller's recent *The Bon Marché: Bourgeois Culture and the Department Store, 1869–1920.*

85 Sardou, *Maison neuve,* pp. 276–77.

86 See Gaillard, *Paris,* p. 529.

87 Ibid., p. 622, note 4.

88 In *Le Commerce,* 20 June 1869; cited in *Paris,* by Gaillard, p. 550; the story of the 1869 strike is well told on pp. 550–53.

89 An idea developed in Benjamin's *Baudelaire,* p. 54.

90 The number available at the Bon Marché (Gaillard, *Paris,* p. 539).

91 For the sources of the following discussion, see note 73 above. There is useful description of *marchandage* and its effects during the July Monarchy in C. Johnson's "The Revolution of 1830 in French Economic History," in *1830 in France*, ed. J. Merriman, pp. 162–63; and of "sweating," "finishing," etc., in semiskilled consumer-goods production in Stedman Jones's *Outcast London*.

92 On the decline of *saint lundi*, see M. Perrot, *Les Ouvriers en grève: France 1871–1890*, 2: 225–29.

93 Gaillard, *Paris*, p. 448: "More and more the entrepreneur of a job was a merchant who undertook to sell the workshop's product; as for the artisan properly so called, even if he possessed a license for his trade, even if he worked on raw materials which he himself owned, he behaved more and more like a labourer working to order." See also the following discussion (pp. 448–54), and the parallel conclusions as regards the Auvergnat braziers in Raison-Jourde's *La Colonie auvergnate*, p. 153.

94 Zola, *L'Assommoir*, pp. 387, 413–14.

95 The role of public works—railway building pre-eminently, but also city reconstruction—as a high-profit *motor* of capitalism in the mid-nineteenth century has been stressed by various writers, such as A. Plessis in *De la fête impériale au mur des fédérés: 1852–1871*, pp. 113–28.

96 Zola, *L'Assommoir*, p. 387 (again, part of Gervaise's response to Haussmannization).

97 The war scare and its temporary abatement are discussed in P. Sorlin's *Waldeck-Rousseau*, p. 112. For a different reading of the relation between Manet's picture and its public occasion, see P. Mainardi, "Edouard Manet's *View of the Universal Exposition of 1867*," *Arts Magazine*, January 1980.

98 See Malet, *Le Baron Haussmann*, pp. 248–49.

99 Cited ibid., p. 249.

100 James Thomson, "Spring," in *The Seasons* (lines 950–1, describing the view from Hagley); cited in *The Idea of Landscape and the Sense of Place: An Approach to the Poetry of John Clare*, by J. Barrell, p. 14.

101 Préault's sculpture was one of the more successful public commissions of the Bureau des Beaux-Arts in 1848, done originally in plaster for a Fête de la Concorde. See T. J. Clark, *The Absolute Bourgeois: Artists and Politics in France, 1848–51*, p. 61.

102 The best discussion of the picture is still in N. G. Sandblad, *Manet: Three Studies in Artistic Conception*, pp. 17–68. It is important for my account that the picture is full of particular portraits of friends and relations: Mme. Lejosne, wife of the commandant of the imperial guard (an old family friend); Mme. Loubens, wife of a distinguished headmaster; Jacques Offenbach; Lord Taylor; the society columnist Aurélien Scholl; Théophile Gautier; the monocled Albert de Balleroy; Baudelaire and Champfleury; Fantin-Latour and Manet's brother Eugène; Manet himself at the extreme left. One should recall that Manet came from an impeccable haut-bourgeois background (his father was *chef du personnel* at the Ministry of Justice) and even after notoriety struck was described as "one of the five or six men in present-day Paris society who still know how to make conversation with a woman" (Paul Alexis, "Manet," *La Revue Moderne et Naturaliste*, 1880, p. 289)!

103 See Giedion, *Space, Time, and Architecture*, p. 664, for enthusiastic discussion: the new parks "were made to be looked at, to be enjoyed for their wide vistas and the massing of their herbage; the new plants were a brilliant, spectacular stroke."

104 Emile Blavet's estimate in *Le Figaro*, cited in *Du vieux Paris*, by Morizet, p. 291.

105 Pelletan, *La Nouvelle Babylone*, p. 20: "Lorsqu'un homme a le spleen, n'importe dans quelle langue, c'est ici qu'il vient signer sa paix avec l'existence. . . . Les trains des chemins de fer versent sans cesse dans cette nouvelle Babylone des flots et des flots d'Anglais, de Russes, d'Allemands, de Norvégiens, de Suédois, de Danois, de Hollandais, de Serbes, de Bédouins, de Croates, de Moldaves." It is just too early, in 1862, for the list to include Americans.

106 Fournel, *Paris nouveau*, p. 116: "Rendons, du reste, cet hommage à l'artiste qu'il y a souvent très-bien imité la nature. C'est presque ressemblant. . . . On y rencontre des notaires posés en points d'exclamation, et des photographes qui prennent des vues. . . . Tout cela, en outre, est agrémenté de bateaux peints, de ponts coquets, de chalets, de kiosques, de cafés-restaurants, et autres objets que la nature ne produit pas."

107 Edmond and Jules de Goncourt, *Mémoires de la vie littéraire* 2:320.

108 Paul de Kock, in *Paris-Guide, par les principaux écrivains et artistes de la France*, cited in *Paris*, by Gaillard, p. 555: "The equator is the Boulevard Montmartre. . . . In the adjacent streets, silent and gloomy by eight in the evening, there lodges a crowd of export agents, buyers, *commissionaires en marchandises*, representatives from the wholesale houses or the big manufacturers [the men whose hold on the *quartier* economy I have just described]. Knock on any door at random, and it will be opened by a stockbroker."

109 Denis Poulot, *Le Sublime, ou Le Travailleur comme il est en 1870 et ce qu'il peut être* (Poulot spoke from direct working experience), cited in *La Vie ouvrière*, by Duveau, p. 492.

110 See, for instance, E. Texier and A. Kaempfen, *Paris, capitale du monde*: "When Paris was not yet the city of *nomads* [Haussmann's notorious phrase], it had *quartiers* which differed from one another and made up so many small cities within the greater one. . . . None of that these days, the same house everywhere. This house, reproduced here, there, further on, to the right, to the left, run off in an edition of forty thousand, gives each street the physiognomy of the street next door." See also Fournel, *Paris nouveau, passim*; e.g., p. 221: "Instead of all those cities, with their multiple and differentiated physiognomies, there will be only one city, new and white. . . ." And see Ferry, *Les Comptes fantastiques* (see note 50 above), Sardou, etc., etc.

111 My argument here connects with recent work stressing the extent to which the late-eighteenth- and early-nineteenth-century city was defined by patterns of symbolic *use* and appropriation. See, for instance, M. Ozouf, *La Fête révolutionnaire 1789–1799*, and, behind all such studies, the work of G. Soboul, *Les Sans-Culottes parisiens en l'an deux: Mouvement populaire et gouvernement révolutionnaire*, and Chevalier, *Classes laborieuses*.

112 Gaillard, *Paris*, pp. 245–53 and, from pp. 540–43: "By and large, then, the department stores did not get working-class customers. It was later, much later, that the department store would provide the model for an urban uniform to all classes of society. In the Second Empire that time was still to come" (p. 543).

113 Ibid., p. 267. Gaillard's whole discussion is basic to my conception of spectacle. "It seems to us that more profoundly, in the Second Empire, the powers-that-be took advantage of the diverse changes which Paris was undergoing in order *to effect a permanent change in the relation between the city and its inhabitants* [*modifier durablement le rapport des habitants avec la ville*], to change the very essence of the notion of urban citizenship: they strove to make Parisians *fit into* the city rather than create an active community" (pp. 231–32). The Commune was one attempt to resist that process and restore collectivity; so were the various efforts at "municipal" socialism. But both were failures. In the long run, "the Empire had a posthumous success . . . the urban collectivity, become passive, took its place over the years in a framework whose character has hardly changed since Haussmann" (p. 232). The verdict could come from Debord's *Société du spectacle*. See also pp. 528–31 in Gaillard on "la ville extravertie du Baron Haussmann."

114 See Gaillard, *Paris*, pp. 332 and 370, note 1; see also J. Rancière and P. Vauday, "L'Ouvrier, sa femme et les machines," *Les Révoltes Logiques*, no. 1 (the article is good on working-class resistance to the spectacle).

115 This is the crowning fact in Emile Zola's splenetic attack on Haussmann's suppression of working-class entertainments, "Causerie," *La Tribune*, 18 October 1868, in *Oeuvres complètes*, 13:193–97. The article reminds us that the bourgeois pleasures of Paris and its environs were founded on the elimination of the pleasure of the working class. "I know that M. Haussmann does not like *les fêtes populaires*. He has banned almost all those that took place in the old days in the recently annexed districts; he is pitiless in his campaign against hawkers and pedlars. In his dreams [as always], he must see Paris as a gigantic checkerboard, possessed of a geometrical symmetry" (p. 196).

116 In the Salon of 1880. The full title is given by Antonin Proust in his introduction to *Exposition Norbert Goeneutte*, p. 8. Proust stresses Goeneutte's links with Manet, and Manet's high opinion of him. The 1880 picture was one of several studies of working-class life by Goeneutte, including *L'Appel des balayeurs devant l'Opéra* (1877 Salon), and took its place alongside pictures of the normal Impressionist sites: *La Place de la Bourse, Le Parc Monceau, Le Pont de l'Europe, Gare Saint-Lazare, La Sortie du Moulin Rouge*, etc.

117 A point made by Kirk Varnedoe in lectures.

118 E. de Amicis, *Studies of Paris*, pp. 31–32; cited in *Paris, A Century of Change: 1878–1978*, by N. Evenson.

Chapter Two: Olympia's Choice

1 Henri Turot, *Le Prolétariat de l'amour*, 1904, from pp. 107–9: "Acceptons donc, si vous le voulez bien, la définition de M. Emile Richard, qui s'appuie sur le *Digeste* pour formuler sa pensée dans les termes que voici:

" 'Doit seulement être réputée prostituée toute femme qui, publiquement et sans amour, se livre au premier venu, moyennant une rémunération pécuniaire, formule à laquelle il convient d'ajouter: et n'a d'autres moyens d'existence que les relations passagères qu'elles entretient avec un plus ou moins grand nombre d'individus.'

"D'où il résulte—ce qui me parait être la vérité—que la prostitution implique d'abord la vénalité et ensuite l'absence de choix.

"Ah! je sais bien qu'à vouloir ainsi restreindre la portée du mot, nous arrivons à réserver toutes les indulgences pour les plus heureuses des femmes sans vertu, pour les privilégiées, pour les plus inexcusables, et que nous consacrons au contraire l'existence d'une sorte de *prolétariat de l'amour* sur qui peuvent impunément s'appesantir toutes les sévérités et toutes les tyrannies. . . .

"Et ce prolétariat est, tout comme l'autre, l'inéluctable conséquence du régime capitaliste."

2 C. Pichois, ed., *Lettres à Baudelaire*, pp. 232–33 (about 25 March 1865).

3 The literature on *Olympia* is vast. I owe most to the chapter in N. G. Sandblad, *Manet: Three Studies in Artistic Conception*; Theodore Reff, *Manet: Olympia*; E. Lipton, "Manet: A Radicalized Female Imagery," *Artforum*, March 1975; and B. Farwell, *Manet and the Nude: A Study in Iconography in the Second Empire*. A treatment (albeit sketchy) of the criticism will be found in A. Tabarant, *Manet et ses oeuvres*, pp. 106–10, and G. H. Hamilton, *Manet and His Critics*, pp. 65–80. I learnt a great deal from the article by M. Fried, "Manet's sources: Aspects of His Art 1859–1865," *Artforum*, March 1969, and the reply to it by Theodore Reff, "Manet's Sources: A Critical Evaluation," *Artforum*, September 1969. (Fried's study really has been "un-

justly neglected" in the Manet literature. Many of its most interesting arguments for my purposes are in the notes.) Some issues raised by the study of a picture through its critical reception were dealt with in my "Un Réalisme du corps: *Olympia* et ses critiques en 1865," *Histoire et Critique des Arts*, May 1978, and "Preliminaries to a Possible Treatment of *Olympia* in 1865," *Screen*, Spring 1980. The latter provoked a reply from P. Wollen, "Manet, Modernism and the Avant Garde," *Screen*, Summer 1980. We were both taken to task in C. Harrison, M. Baldwin, and M. Ramsden, "Manet's *Olympia* and Contradiction," *Block*, no. 5 (1981).

4 Pichois, *Lettres à Baudelaire*, pp. 233–34 (beginning of May 1865).

5 Charles Baudelaire, *Correspondance générale*, 5:96–97 (11 May 1865).

6 Jacques-Emile Blanche, *Manet*, pp. 36–37 (also reports Degas's *mot*).

7 D. Rouart, ed., *Correspondance de Berthe Morisot avec sa famille et ses amis*, p. 101 (letter to a friend, probably 1881).

8 In the following list of criticism and other items on the 1865 Salon, I have attempted to be as complete as possible, though there are omissions and loose ends. Entries which contain some mention of Manet or *Olympia* are marked *; the more significant discussions or descriptions **. Unless otherwise indicated, these items have the standard title "Salon de 1865" or minor variants. Page numbers are not given for newspaper *feuilletons*, invariably on pp. 1 and 2. All subsequent references to 1865 criticisms refer to this list.

Out of the 87 items known to me, 15 do not mention Manet or *Olympia*. Of the 72 that do, the kindest possible estimate would have to judge 43 as trivial, formulaic, or casual mentions; of the 29 which have something a little more substantial to say, 13 strike me as containing description or discussion of a vivid or cogent kind (this is not to say that there is nothing of interest in the rest, but it comes in utter fits and starts). Three of these 13 are caricatures-plus-captions, and of the 10 remaining there are 6 items (Cantaloube, Deriège, Geronte, Jankovitz, "Pierrot," and Postwer) where insight is *happened upon*, splenetically or ludicrously, in ways the writer is barely in control of. This leaves four pieces of criticism which

could be called deliberate and good—Chesneau, Gautier, Gonzague Privat, and Ravenel. None of the first three, as I argue in the text, is particularly detailed or acute about the form or content of *Olympia*; where they are good is in their preliminary and generalizing discussion of Manet. Ravenel is thus one out of 87.

I have attempted no systematic description of the politics or even the general aesthetic commitments of the journals in which the criticisms appear (this in spite of the arguments presented for doing so by Nicos Hadjinicolaou, "La Fortune critique et son sort," *Histoire et Critique des Arts*, November 1977). *Olympia* is a special case. There simply is no correlation that I can see between political and social ideology and ability or willingness to respond to the picture. For the one Ravenel writing in the radical opposition paper *L'Epoque*, there are the silences of other radical or socialist papers, such as *La Rive Gauche, Le Courrier du Dimanche,* and *L'Avenir National*. I cannot detect a significant ideological difference between the entry of Victor Fournel in the Legitimist *Gazette de France* and that of Félix Deriège in the leading Leftist republican paper, *Le Siècle*; or, for that matter, between the condescending hostility of the solid Bonapartist *Le Pays*, the solid republican *Journal des Débats*, the good Centre-Rightist *Le Constitutionnel*, and so on.

As for aesthetics, *Olympia* exceeded the available ideological frames of reference: hacks, caricaturists, and provincials like Victor de Jankovitz did better than experts and progressives like Edmond About, Charles Blanc, Maxime Du Camp, Paul Mantz, Marc de Montifaud, or even Théophile Thoré. The critic (C. S. d'Arpentigny) writing in the paper owned by Manet's dealer, Louis Martinet, was notably feeble. Especially tantalizing in this connection is the absence—or disappearance?—of a *Salon* by Castagnary. In *La Chronique des Arts* of 21 May 1865, he was announced as writing a *Salon* for *L'Europe*; neither of the papers I could find which possibly correspond to that title—*L'Europe Artiste* and a French-language paper published in Frankfurt—contains the piece. Did the salon present too many problems for a critic committed to Naturalism? (Also not located by me was the *Salon* by Jean Rousseau announced in *Le Figaro* as about to appear in a special number of the paper.)

*Anon., *L'Autographe au Salon de 1865*, 8 July, p. 87; *Edmond About, *Le Petit Journal*, 27 June; *A. Andréi, *La Comédie*, 4 June; *C. S. d'Arpentigny, *Le Courrier Artistique*, 21 May; *C. S. d'Arpentigny, *Le Monde Artiste*, 24 June (approving Privat's pages on Manet); *Francis Aubert, *Le Pays*, 15 May; *X. Aubryet, *Le Moniteur Universel du Soir*, 16 June (possible reference); *A. Audéoud, *La Revue Indépendante*, 1 July, p. 758; *Louis Auvray, *Exposition des Beaux-Arts: Salon de 1865*, Paris, p. 59 (originally in *La Revue Artistique et Littéraire* 9 [1865]); *C. Bataille, *L'Univers Illustré*, 10 May, p. 291, and 5 July, p. 423; *Rapinus Beaubleu, *Le Hanneton*, 11 June; **Bertall, *Le Journal Amusant*, 27 May (caricature); **Bertall, *L'Illustration*, 3 June, p. 341, and 17 June, p. 389 (caricatures); *A. Berthet and E. Simon, *Le Tintamarre*, 7 May; C. Blanc, *L'Avenir National*, 12 May, etc. (8 articles); *E. Blondet, "A l'Exposition," *Le Nain Jaune*, 27 May; *A. Bonnin, *La France*, 7 June; *J. Bonus, "Chronique," *Le Journal Illustré*, 7–14 May, p. 146 (obscure joke); F. Borgella, *La Critique Illustré*, 21 May, etc. (5 articles); *H. Briolle, "Faites attention à la peinture s.v.p.—Quatrains pour le salon," *Le Tintamarre*, 4 June; *A. de Bullemont, *Les Beaux-Arts*, June, p. 354; *H. de Callias, *La Gazette des Etrangers*, 24 May (internal evidence suggests that there is fuller discussion of Manet in the edition for 6 May, which I was unable to locate); **Amédée Cantaloube, *Le Grand Journal*, 21 May; *Amédée Cantaloube, *L'Illustrateur des Dames et des Demoiselles*, 18 June (passing reference, disguised); *P. Challemel-Lacour, *La Revue Moderne*, 1 July, p. 92; **Cham, *Le Charivari*, 14 May (caricature); *Cham, *Le Musée des Familles*, June, p. 288 (caricature); **Ernest Chesneau, "Les Excentriques," *Le Constitutionnel*, 16 May; *Jules Claretie, "Deux Heures au salon," reprinted in *Peintres et sculpteurs contemporains*, Paris, 1874, pp. 108–9 (originally printed in *L'Artiste*, 15 May); *Jules Claretie, "Echos de Paris," *Le Figaro*, 25 June; *C. Clément, *Le Journal des Débats*, 21 May; A. Cournet, *La Rive Gauche*, 14 May (critical of Courbet's Proudhon); **Félix Deriège, *Le Siècle*, 2 June; *C. Diguet, *Le Messager des Théâtres et des Arts*, 25 June; *M. Drak, *L'Europe Artiste, Journal Général*, 2 July; *Dubosc de Pesquidoux, *L'Union*, 24 May; *Maxime Du Camp, *La Revue des Deux Mondes*, 1 June, p. 678 (cryptic but unmistakeable reference); Alexandre Dumas, *La Mode de Paris*, 16 May and 1 June; *A. J.

Du Pays, *L'Illustration*, 17 June, p. 382 (and other mentions); *Ego, "Courrier de Paris," *Le Monde Illustré*, 13 May, p. 291; *H. Escoffier, *Le Journal Littéraire de la Semaine*, 29 May–4 June; *Ernest Fillonneau, *Le Moniteur des Arts*, 5 May, p. 2; *L. Gallet, *Salon de 1865: Peinture-Sculpture*, Paris, 1865, p. 36; **Théophile Gautier, *Le Moniteur Universel*, 24 June; *Théophile Gautier *fils, Le Monde Illustré*, May 6, p. 283; **Geronte, "Les Excentriques et les gro tesques," *La Gazette de France*, 30 June; *P. Gille, *L'Internationale*, 1 June; A. Hemmel, *La Revue Nationale et Etrangère*, 10 May and 10 June; *F. Jahyer, *Etude sur les Beaux-Arts, Salon de 1865*, Paris 1865, pp. 23–26 and 283; **Victor de Jankovitz, *Etude sur le Salon de 1865*, Besançon 1865, pp. 67–68; *Junior, "Courrier de Paris," *Le Monde Illustré*, 6 May, p. 275; E. de Labédollière, *Le Journal Politique de la Semaine*, 21 May, etc. (4 articles); *L. Lagrange, *Le Correspondant* 29 (1865):143; *Louis de Laincel, *L'Echo des Provinces*, 25 June, p . 3; *Louis de Laincel, *Promenade aux Champs-Elysées*, Paris 1865, pp. 13–14 (slight changes from previously published version); C. Lavergne, *Le Monde*, 24 May; *L. Leroy, *Le Charivari*, 5 May; *L. Leroy, "Un Critique d'art autorisé," *L'Universel, Journal Illustré*, 1 June, p. 139; *L. Leroy, *Le Journal Amusant*, 27 May; *M. de Lescure, *La Revue Contemporaine*, May-June, p. 535; *A.-J. Lorentz, *Dernier Jour de l'Exposition de 1865: Revue galopante au salon*, Paris 1865, pp. 12–13 (cryptic but unmistakeable attack); *Paul Mantz, *La Gazette des Beaux-Arts*, 1 July, p. 7; *O. Merson, *L'Opinion Nationale*, 29 May and 31 July; *M. de Montifaud, *L'Artiste*, 15 May, p. 224; C. de Mouy, *La Revue Française*, June, pp. 177–207; J. Nilis, *Revue d'Economie Chrétienne* 8:893–916; T. Pelloquet, *Le Nain Jaune*, May-June; **Pierrot, "Une Première Visite au Salon," *Les Tablettes de Pierrot—Histoire de la Semaine*, 14 May, pp. 10–11; *Pollux, "Mathurin au Salon," *Les Petites Nouvelles*, 8 and 18 May, p. 4; **C. Postwer, *La Fraternité Littéraire, Artistique et Industrielle*, 1 June; E. Poujade, *La Parisienne, Revue Mensuelle*, July, pp. 125–33; **Gonzague Privat, *Place aux jeunes! Causeries critiques sur le Salon de 1865*, Paris, 1865, pp. 63–66; **Jean Ravenel, *L'Epoque*, 7 June (also 4 May, 8 July); *C. Rolland, *L'Universel, Journal Illustré*, 8 June, p. 154; *E. R. Sainfoin, *La Mode Illustrée, Journal de la Famille*, 18 June, p. 198; *P. de Saint-Victor, *La Presse*, 28 May; *C. de Sault, *Le Temps*, 24 May; *M. de Thémines, *La Patrie*, 18 May, p. 3; *Thilda, *La Vie Parisienne*, 6 May, p. 239 (13 May, p. 257, has a caricature of the cat and flowers set into the salon, between columns); *Théophile Thoré (W. Bürger), *L'Indépendance Belge*, 13 and 19 June; P. Thouzery, *La Gazette des Familles*, 15 June, etc. (3 articles); G. Vattier, *Le Courrier du Dimanche*, 7 and 28 May, 4 and 25 June (a radical paper); A. de Viguerie, *Le Monde Chrétien Illustré*, May, pp. 341–43; *C. Wallut, *Musée des Familles*, June, p. 287; *J. Walter, *Messager des Théâtres et des Arts* (daily edition), 19 May; "Y", *L'Europe*, 8 May and 18 June; A. Z., *Jockey*, 16 May.

Where possible, I have used the notes to provide the full French text of the most interesting entries on *Olympia*; sometimes this has meant reserving to the notes the whole of an entry, citing only a part of it in the main text, or discussing and citing it in several different places in the text, according to the topic and vocabulary of particular sentences.

9 "When, weary of dreaming, Olympia wakes, Spring enters in the arms of a gentle black messenger; it is the slave, like the amorous night, who comes to make the day bloom, delicious to see: the august young girl in whom the fire burns." See J. Meier-Graefe, *Edouard Manet*, for complete poem, "La Fille des îles," and S. Flescher, *Zacharie Astruc: Critic, Artist and Japoniste*, chap. 2, for full discussion. The poem was dropped from the entry on *Olympia* in what appears to be a second edition of the salon *livret*, presumably at Manet's or poor Astruc's request!

10 Auvray: "Enfin, si, comme le dit la Presse théâtrale, M. Manet a voulu attirer l'attention par une excentricité, il y a réussi au-delà probablement de ses désirs, car jamais peinture n'a excité tant de rires, de moqueries, de huées que son *Olympia*. Le dimanche, surtout, la foule était si grande, qu'on ne pouvait en approcher, ni même circuler dans la salle M; tout le monde s'étonnait que le jury eût admis les deux toiles de M. Manet."

11 Audéoud: "l'unanimité de la réprobation et de la dédaigneuse pitié qu'a manifesté le public . . ."

12 Fillonneau: "l'épidémie de fou-rire . . ."

13 Jankovitz: "Le public, abasourdi d'une pareille exhibition, ne savait si c'était une plaisanterie

ou un défi porté à son adresse, et, pendant qu'on se pressait devant le tableau comme autour d'un dépendu, la risée publique et son grognement ont fait justice de l'oeuvre. Seuls, quelques rares connaisseurs aux notions superfines de l'art aventuraient quelques louanges modérées!"

14 Ravenel: see pp. 139–40 and note 144, below.

15 Bonnin: "C'est avec une couleur plus harmonieuse, mais sans la même facilité de pinceau [the comparison is with Jolyet's *Conscrits de la Bresse*], que M. Manet traite des toiles de genre historique d'une assez grande dimension. Son *Olympia* (no. 1428), étendue sur un lit, ayant pour tout costume un noeud de ruban rouge dans les cheveux; la négresse habillée de rose qui lui apporte un bouquet; le chat noir qui arrondit sa maigre échine et dont les pattes marquent des couleurs singulières la blancheur des draps, forment bien le tableau le plus bizarre qu'on puisse imaginer. Chaque jour il est entouré d'une foule de visiteurs, et, dans ce groupe sans cesse renouvelé, les réflexions et les observations à haute voix ne lui épargnent aucune vérité. Les uns se pâment d'aise et croient à une plaisanterie qu'ils veulent avoir l'air de comprendre; d'autres regardent sérieusement et montrent à leur voisin, un ton heureux ici, là une main malpropre, mais grassement peinte; enfin on a vu des refusés de cette année, et c'est la preuve décisive qu'il en existe, s'emporter de dépit et d'indignation devant cette peinture. Il est bien probable que tout le monde a un peu raison, et ces opinions si diverses sont autorisées par les incroyables irrégularités de la peinture de M. Manet. Il n'a exposé que des ébauches. Cependant nous ne partageons pas l'opinion, trop répandue, que cette négligence soit un parti pris, une sorte de défi ironique jeté au jury et au public. Le jury eût certainement distingué une charge d'atelier d'une oeuvre malheureuse, et il lui eût fermé la porte du palais des Champs-Elysées. D'un autre côté, un artiste ne peut traiter légèrement le public sans compromettre sa réputation, qui reste parfois à jamais atteinte; et M. Manet, qui paraît à chaque Exposition, poursuit certainement autre chose que la triste célébrité que l'on peut acquérir par ces procédés périlleux. Nous aimons mieux penser qu'il s'est trompé. Maintenant, quel est son but? Ses toiles sont trop inachevées pour qu'il soit possible de l'apercevoir."

16 Ego: "Les femmes qui passent se détournent, et les hommes ne s'arrêtent que pour protester dans tous les styles."

17 Audéoud; see note 11 above.

18 Aubert: "Grand buveur de chopes et d'absinthe, grand fumeur de pipes noires qui n'ont d'autre étui que sa poche, rabâcheur de trois ou quatre lieux communs, artistiques, littéraires ou politiques si vermoulus, qu'un écolier n'oserait s'en servir, jurant et sacrant à tout propos, ne parlant que l'argot des voleurs, républicain à coup sûr, socialiste probablement, communiste peut-être, mais sans savoir ce que c'est que l'une ou l'autre doctrine . . .

"Sa carrière? son passé? Ils n'ont de semblable que son présent, qui consiste à aller du garni à la brasserie, à imaginer des expédients pour ne payer ni l'un, ni l'autre, et, comme divertissement capital, à être insolent envers quelque honnête homme, ce qui s'appelle 'épater le bourgeois.' "

19 Drak: "Espérons que les rires moqueurs d'une foule qui n'était pas exclusivement composée de *bourgeois*, M. Manet, vous inspireront le désir d'une revanche où vous prouverez qu'il y a un artiste sous le mauvais plaisant."

20 Ravenel; see pp. 139–40 and note 144, below.

21 Jahyer, p. 283: "Qu'il me soit permis, à ce sujet, de remercier la commission d'avoir réalisé, pendant les quelques jours de la fermeture, le voeu que j'émettais au sujet de M. Manet. Actuellement, ses deux toiles sont si bien cachées au-dessus de deux portes dans l'un des salons du fond, qu'il faut des yeux de lynx pour les découvrir.

"A cette hauteur, l'*Auguste Olympia* fait l'effet d'une immense araignée au plafond. Il n'est plus même possible d'en rire; c'est devenu navrant pour tout le monde."

The removal is also mentioned by Geronte, and by Claretie in *Le Figaro*: "La réprobation publique l'avait chassée de cette place d'honneur. . . ." For the administration's similar treatment of Courbet's *Burial at Ornans* in the Salon of 1850–51, see T. J. Clark, *Image of the People: Gustave Courbet and the 1848 Revolution*, p. 134.

22 Baudelaire, *Oeuvres complètes*, pp. 1188–89.

23 See A.-J.-B. Parent-Duchâtelet, *De la prostitution dans la ville de Paris*, 1:134. Its usual French form, Olympe, is given as one of a list of thirty-five common *surnoms* for prostitutes of the *classe*

élevée. (Those of the *classe inférieure* preferred Belle-cuisse, Faux-cul, Mont-Saint-Jean, La Ruelle, Crucifix, Le Boeuf, etc.) B. Farwell, *Manet and the Nude*, p. 232, was the first to point out that Olympia was a well-known prostitutes' nickname.

24 Gautier: "*Olympia*, dont le titre réveille le souvenir de cette grande courtisane romaine dont raffola la Renaissance, ne s'explique à aucun point de vue, même en la prenant pour ce qu'elle est, un chétif modèle étendu sur un drap. Le ton des chairs est sale, le modelé nul. Les ombres s'indiquent par des raies de cirage plus ou moins larges. Que dire de la négresse qui apporte un bouquet dans un papier et du chat noir qui laisse l'empreinte de ses pattes crottées sur le lit? Nous excuserions encore la laideur, mais vraie, étudiée, relevée par quelque splendide effet de couleur. La femme la moins jolie a des os, des muscles, une peau, des formes et un coloris quelconque. Ici, il n'y a rien, nous sommes fâché de le dire, que la volonté d'attirer les regards à tout prix."

25 See L. Pastor, *The History of the Popes, from the Close of the Middle Ages*, 30:32–47. Delécluze's novel was first published in 1842.

26 As far as I can tell, these are the only connotations of the title to which the critics seem alert. There are other tempting possibilities: for instance, the automaton heroine, Olympia, of E. T. A. Hoffmann's story "L'Homme au sable," with which Astruc and Co. would surely have been familiar (see *Contes d'Hoffmann*, pp. 115 ff.). There is a similarly named cold *courtisane* heroine in Dumas's *La Dame aux camélias* (see Reff, *Manet: Olympia*, pp. 111–13).

27 Ego: "L'auguste jeune fille est une courtisane...." Leroy, *L'Universel*: "O chat de la courtisane Olympia...." Cantaloube, *Le Grand Journal*: "Il s'agit d'une Olympia chantée par M. Zacharie Astruc, et bien différente de la dame de beauté de la Renaissance."

28 Claretie, *L'Artiste*: "Qu'est-ce que cette odalisque au ventre jaune, ignoble modèle ramassé je ne sais où, et qui représente Olympia? Olympia? Quelle Olympia? Une courtisane sans doute."

29 Du Pays: "on a dit de Pradier qu'il partait le matin pour Athènes et arrivait le soir à la rue de Bréda. Aujourd'hui, un certain nombre d'artistes vont à la rue de Bréda directement."

This follows a discussion of Fantin-Latour's *Le Toast*, and various apoplectic asides about Manet in previous articles.

30 Challemel-Lacour, in a passage on the "grotesques" of painting: "Leur trait commun, un des symptômes les plus connus dans les Petites-Maisons, est la prétention d'être les seuls vrais amants de la Vérité; on l'adore sous les traits de quelque rousse du quartier Bréda, on se réunit autour d'elle en paletot, en robe de chambre, en chapeau tubuliforme, on lui offre des fleurs, on lui porte des toasts, on appelle le public à lui rendre hommage, et le public répond à cette leçon par une autre que ces artistes feraient bien de comprendre." Manet's painting and Fantin's are deliberately being conflated. See also p. 89.

31 Deriège: "l'on peut être également très-vrai, quand on sait peindre comme Goya, en représentant une *manola* de bas étage, couchée toute nue sur son lit, pendant qu'une négresse lui apporte un bouquet."

32 Postwer: "Quels vers! Quel tableau! Olympia s'éveille, lasse . . . de songer. La nuit a été mauvaise, c'est évident. Une insomnie, panachée de coliques, en a troublé la sérénité; son teint l'indique. Il y a deux '*messagers noirs*': un chat, qu'une circonstance malheureuse a applati entre deux tampons de chemins de fer; une négresse, qui n'a rien de *pareil à la nuit amoureuse*, si ce n'est un bouquet acheté chez la fleuriste du coin, et dont M. Arthur a fait les frais, ce qui m'en apprend très-long sur Olympia. Arthur est certainement dans l'antichambre, qui attend."

33 Geronte; see p. 97 and note 70 below.

34 Bertall, *Le Journal Amusant*.

35 Bertall, *L'Illustration*, 3 June.

36 For full text and translation, see pp. 139–40 and note 144 below.

37 Pierre Larousse, *Grand Dictionnaire universel du dix-neuvième siècle*, 3:11: "Ce cabaret, ouvert toute la nuit, était fréquenté par une clientèle tout particulière, des chiffonniers, des rodeurs, des ivrognes et des femmes dont l'age et le sexe n'eussent pu se reconnaître sous l'amas de haillons qui les couvraient. . . . Grâce à tout ceci, le cabaret de Paul Niquet était connu du monde entier, et lorsqu'un roman d'Eugène Sue eut mis les tapis francs à la mode, ce fut à qui irait

visiter celui-là, au risque de s'y trouver en bien mauvaise compagnie."

38 Described as such by Cantaloube in *Le Grand Journal*, in his general attack on the Realists that year. Geronte described him as "un Fra Angelico de pacotille." Lambron was regularly bracketed with Courbet and his followers. Geronte had previously, in an article of 2 June, praised Vollon's *Intérieur de cuisine* as worthy of Chardin, but could not resist a side swipe at Baudelaire in passing: "Il y a, dans cette cuisine, un certain mou de veau, pendu à un croc, qui vaut tout un poème. (Est-ce bien un mou de veau? Je consulterai M. Baudelaire.)"

39 Gallet: "un jeune réaliste qui promet beaucoup.—Ses deux marines: *L'Embouchure de la Seine à Honfleur* et *La Pointe de la Hève à marée basse*, portent l'empreinte d'une main forte, peu soucieuse du joli, très-préoccupée de la justesse de l'effet." Cf. Geronte: "Que dire, par exemple, de cette *Embouchure de la Seine à Honfleur* (no. 1524), où les flots sont figurés par des mottes de terre, les voiles des bateaux par des triangles de bois noir, et qu'on croirait dessinée par un enfant de douze ans sur la couverture de son catéchisme. . . ."

Among the many critics who discuss Manet in the context of a Realist school, the more interesting accounts are those by Louis Auvray (a bitter attack on the Realists' assault on traditional standards, and the art of Bouguereau in particular), Deriège, Geronte, Jankovitz, Mantz (for whom the Realism of 1850 survives only in Belgium!), and, in a typically bizarre way, Pierrot. One standard tactic was to extract Ribot from the group and declare him the only Realist worthy of the name; see, e.g., Gallet and Bonnin.

40 Ego: "Je ne cite pas le nom du prétendu réaliste, élève de Courbet, qui a déposé cette *Olympia* le long du mur officiel. . . ."

41 Jankovitz: "*Jésus insulté* par M. Manet, je veux dire dû à son pinceau, est un tableau au-dessous de toute critique. C'est du Raphaël corrigé par un Courbet de troisième qualité. . . ."

42 Gille: "Qu'on ne s'y trompe pas, MM. Courbet, Manet et autres font vraisemblablement ainsi, parce qu'ils ne peuvent faire autrement, et j'ai grand peur pour eux qu'ils ne soient que consciencieux en nous offrant ces monstruosités. Ce sont des esprits malades, comme qui dirait des sortes de marquis de Sade de la peinture,

dont le sens artistique est déplacé ou corrompu, et qui ont perdu le chemin lumineux du naturel et du beau; tous deux se heurtant dans l'ombre, y chercheront vainement l'inconnu et le nouveau, ils ne pourront y trouver que des fantômes difformes et hideux." The Baudelairean echoes in the last few phrases—especially the echoes of the close of *Le Voyage*—seem deliberate. Compare the terms of Ravenel's evocation of the same "source."

43 Anon., *L'Autographe au Salon*: "M. Manet a de rares qualités d'originalité et de caractère comme dessinateur, de souplesse et de mordant comme coloriste. On peut s'en apercevoir rien qu'à ces petits croquis qui semblent faits du bout d'une plume usée avec l'insouciance parfaite et la verve pittoresque de Goya." About uses the words "tempérament" and "facultés." Drak: "Une main d'artiste guidée par une cervelle bourrée de paradoxes jusqu'à l'indigestion."

44 Compare Fillonneau, "M. Manet expose aussi *Jésus insulté par les soldats*, où nous voudrions trouver autre chose à louer que des valeurs de tons, témoignages insuffisants d'une certaine recherche," with d'Arpentigny in Martinet's magazine: "M. Manet, entre autres, artiste d'une nature fine, distinguée, est remarquable dans ses oeuvres, par une vérité très-grande des tonalités, par une hardiesse, sans mesure il est vrai, mais qui cédera devant le besoin d'études plus sévères." Aubert, Chesneau, and Du Camp were also well aware of Manet's tonal aims.

45 Gonzague Privat, p. 66: "Eh bien! moi, je n'hésite pas à le dire: M. Manet a le tempérament d'un peintre, l'inspiration poétique, le charme de la naïveté, des tons, des finesses, et un côté vivant que peu d'artistes possèdent." Montifaud: "Nous savons reconnaître la touche de M. Manet au milieu des excentricités qu'il a voulu nous servir, comme son Christ insulté et sa composition d'Olympia, et cette touche dénote une vigueur qui, employée par un esprit plus sain, pourrait produire des oeuvres." Rapinus Beaubleu: "Un peintre de cette valeur devrait se méfier de son extrême facilité qui touche en quelque sorte à l'improvisation. Mais ce défaut prouve une ardeur, une vigueur, un tempérament peu communs à notre époque." (Fillonneau; see note 44 above.)

46 The Goya link is mentioned in *L'Autographe au Salon*; Cantaloube in *Le Grand Journal*— "Constatons, en effet, des tons dérobés aux Es-

pagnols, surtout à Goya, mais délayés dans je ne sais quelle mixture nauséabonde"—and more cryptically in *L'Illustrateur des Dames*: "Elle [the figure of Truth in Fantin's *Toast*] dirait à l'un, ne démonétisez ou ne barbouillez pas Goya avec vos hideux pastiches à la façon de Barbarie; à l'autre, ne décalquez pas au carreau l'une des estampes de l'album des cinquante femmes du Japon" (clearly Manet and Whistler are meant); Deriège (see note 31 above); Gautier, in discussing the Christ: "L'exécution rappelle, moins l'esprit, les plus folles ébauches de Goya, lorsqu'il s'amusait à peindre en jetant des baquets de couleurs contre sa toile"; and Ravenel (see pp. 139–40 and note 144 below).

47 Gautier *fils*: "Dans *Olympia* M. Manet semble avoir fait quelque concession au goût public et à travers le parti pris on discerne des morceaux qui ne demandent pas mieux que d'être bons."

48 Aubert: "Eh bien, comment se fait-il qu'il soit l'auteur de cette *Olympia*, que par courtoisie, par intérêt sympathique pour l'homme, je ne veux pas analyser, mais que je caractériserai en peu de mots en disant qu'elle n'est ni vraie, ni vivante, ni belle (belle, grand-Dieu!), qu'elle est informe, qu'elle a je ne sais quoi de lubrique, que ce corps est sale, que sais-je?" Cantaloube, *Le Grand Journal*: "Nous voulons, ici, parler de certaines ébauches informes ou grotesques qui causent un véritable scandale." Chesneau: "un parti pris de vulgarité inconcevable." Clément: "Quant aux deux toiles qu'a envoyées M. Manet, elles sont inqualifiables." Gille: "Cet indéchiffrable *rébus* . . ." Gautier; see note 24 above.

49 Gautier; see note 24 above.

50 Aubert; see note 48 above.

51 Deriège; see pp. 97–98 and note 72 below.

52 Dubosc de Pesquidoux: "Quant à l'*Odalisque* que M. Manet a exposée au-dessous de son *Christ*, et dans une pose si honnête, je n'en puis rien dire en vérité, et je ne sais pas si le dictionnaire de l'esthétique française offre des expressions pour la caractériser. . . . On ne peut point parler de tels tableaux, ni en donner l'idée."

53 Merson: "Auparavant, néanmoins, un mot des tableaux de M. Manet, initiateur fameux selon quelques gens. Non pas que je songe à les examiner, à les décrire. Dieu m'en préserve!"

54 Escoffier: "Que signifie cette peinture et pour-

quoi trouve-t-on ces tableaux dans les galeries du Palais de l'Industrie?"

55 Auvray: "Et voilà pourquoi Olympia est si bien placée. . . . 'Que c'est comme un bouquet de fleurs.'" Compare the captions of the Bertall cartoon in *Le Journal Amusant* and Cham's in *Le Charivari* (in all three cases the reference is to a famous café-concert song by Paulus, "Le Baptême du petit ébéniste," which is quoted and discussed in chapter four); Geronte: "cette Vénus hottentote"; Postwer: "Le tableau peut servir d'enseigne à une maison d'accouchement; l'auteur a une consolation toute trouvée"; Merson: "M. Manet, qui a peint l'enseigne de la *Femme à barbe*, est original," and, "Et aux personnes qui n'ont pas vu ces pièces mirifiques, il suffira d'affirmer que le *Juif errant*, tel qu'Epinal l'expédie à toutes les auberges du globe, est un pur chef-d'oeuvre auprès d'*Olympia* et de *Jésus insulté par les soldats*"; Cantaloube, *L'Illustrateur des Dames*: "Voilà donc ces artistes, comme bien d'autres entraînés par l'abus des improvisations et du métier, uniquement préoccupés d'attrouper le public selon le mode des enseignes de la foire" (his verdict on Manet, Fantin, and Lambron); Deriège, see note 72 below; Geronte (the pseudonym hides Victor Fournel, a special expert in such matters), see note 70 below, and a parallel phrase earlier in his article, "ces deux toiles foraines."

56 See Farwell, *Manet and the Nude*, p. 199 ff. for full discussion. See also Reff, *Manet: Olympia*, pp. 46–61.

57 See Theodore Reff, "The Meaning of Titian's Venus of Urbino," *Pantheon* XXI (1963): 362–63. C. Hope's more recent dismissal of the Guidobaldo connection (*Titian*, p. 82) seems based on an odd view of Titian's scrupulousness as regards the art market.

58 See H. Wethey, *The Paintings of Titian*, 3: 203.

59 Cantaloube: "Jamais, du reste, on n'a vu de ses yeux spectacle pareil et d'un effet plus cynique: cette Olympia, sorte de gorille femelle, de grotesque en caoutchouc cerné de noir, singe sur un lit, dans une complète nudité, l'attitude horizontale de la Vénus de Titien; le bras droit repose sur le corps de la même façon, sauf la main qui se crispe dans une sorte de contraction impudique. De l'autre côté du lit, une négresse, 'un doux messager noir,' lui apporte, à son réveil, le printemps sous le forme d'un bouquet de fleurs qui n'a guère l'air de flatter l'odorat.

On ne sait ce que vient de faire un pauvre chat maigre, d'une couleur de noir animal, car il gonfle piteusement son échine au pied de 'l'auguste jeune fille en qui la flamme brûle' (voir le livret)."

60 Pierrot: "L'autre peintre de ce groupe expose: 1. un Christ. O divin maître, tu n'a jamais été plus torturé; qu'on éloigne de toi ce calice! 2. une femme sur un lit, ou plutôt une forme quelconque gonflée comme un grotesque en caoutchouc; une sorte de guenon grimaçant la pose et le mouvement du bras de la Vénus du Titien, avec une main impudiquement crispée! Une négresse, un chat noir, tout maigre d'échine qu'il soit, n'en faisant pas moins le gros dos, complètent cette vision du sabbat." The nearest thing to another reference in 1865 is the title "la Vénus au chat" given the picture in passing by J. Claretie in *Le Figaro*. Pierrot and Cantaloube are surely one and the same writer.

61 The evidence for the critical reaction in 1863 is incomplete; but of the handful of references to Manet we know, one mentions the Giorgione connection directly—Zacharie Astruc in "Le Salon," *Le Feuilleton Quotidien*, 20 May 1863, p. 5 (cited in *Zacharie Astruc*, by Flescher, p. 121). Astruc's reference seems to be echoed, quite casually and not approvingly, in Thoré's attack on "ce contraste d'un animal [he means the reclining man] si antipathique au caractère d'un scène champêtre, avec cette baigneuse sans voiles," where the words "scène champêtre" are perhaps meant to remind the reader of the nineteenth-century title of Giorgione's picture (see Théophile Thoré, *Salons de W. Bürger, 1861 à 1868*, 1: 425.) The recognition of the Raphael source was added as a note to E. Chesneau's *L'Art et les artistes modernes en France et en Angleterre*, p. 190, which is a reprint of his "Salon" in *Le Constitutionnel* the previous year. Though Chesneau does not say so, one suspects he had been primed, perhaps by the artist.

The evidence is fragmentary and odd, as I say, but what we have of it suggests some kind of contrast between the critical language of 1863 and 1865 along the lines I have sketched.

62 Jankovitz: "L'auteur nous représente, sous le nom d'Olympia, une jeune fille couchée sur un lit, ayant pour tout vêtement un noeud de ruban dans les cheveux, et la main pour feuille de vigne. L'expression du visage est celle d'un

être prématuré et vicieux; le corps d'une couleur faisandée, rappelle l'horreur de la Morgue. Une hideuse négresse vêtue de rose tient à côté d'elle un bouquet d'une douteuse allégorie, tandis qu'un chat noir faisant le gros dos vient sur le drap imprimer avec ses pattes la trace non équivoque du lieu ou il a marché. . . .

"A côté d'erreurs de tous genres et d'audacieuses incorrections, on trouve dans ce tableau un défaut considérable, devenu frappant dans les oeuvres des réalistes. En effet, si la plupart de leurs tableaux affligent tant la nature et nos yeux, c'est que la partie harmonique qui tient aux rayonnements de la lumière et à l'atmosphère est pour ainsi dire complètement sacrifiée. A force d'éliminer le sentiment de l'âme, ou l'esprit de la chose, dans l'interprétation de la nature, les sensations des yeux ne leur donnent, comme aux Chinois, que la couleur locale nullement combinée avec l'air et le jour. On dirait du scepticisme physique."

The last sentences, for all their clumsiness, represent a real effort at criticism.

63 Ego: "L'auguste jeune fille est une courtisane, aux mains sales, aux pieds rugueux; elle est couchée, vêtue d'une babouche et d'une cocarde rouge; son corps a la teinte livide d'un cadavre exposé à la Morgue; ses lignes sont dessinées au charbon, et ses yeux éraillés et verdâtres ont l'air de provoquer le public sous la garantie d'une hideuse négresse.

"Non, jamais rien de plus . . . étrange n'a été appendu aux murs d'un salon artistique."

64 Aubert; see note 48 above. Cantaloube; see note 59 above. Lorentz; see pp. 96–97 and note 69 below. Pollux: "il a fait aussi une vilaine bonne femme avec une négresse; tout est dessiné avec du charbon tout autour et de la pommade au milieu."

65 Gautier; see note 24 above.

66 Laincel, *Promenade*: "Mais pourquoi s'obstinent-ils à ne reproduire les choses que sous le côté le plus laid? pourquoi, en fait de modèles, vont-ils, par exemple, choisir des femmes malpropres, et, après cela, reproduire jusqu'à la crasse qui enduit leurs contours? Olympia n'est pas la seule qui se trouve dans ce cas."

67 Laincel, *L'Echo des Provinces*: "Je me trompe peut-être par rapport à Olympia; il est possible que tout simplement le gros matou noir qui fait ronron à ses pieds ait déteint sur les contours de cette belle personne, après s'être roulé sur un tas de charbon." Bonnin; see note 15

above. Gautier; note 24 above. Jankovitz; note 62 above. Leroy, *L'Universel*; see note 145.

68 Bertall, *L'Illustration*.

69 Lorentz: "Mais c'est encore bien plus horriblement frappant; devant cette toile qui nous montre un squelette habillé par un maillot collant de plâtre, cerclé du noir, comme une armature de vitrail sans verrerie; et qui, à l'horrible de tant de sottise et de laideur, adjoint la disparition d'un doigt... qui appelle à grands cris l'examen des inspecteurs de la salubrité publique!"

70 Geronte (Fournel): "Ce Christ, insulté par des soldats vêtus en saltimbanques, et plus insulté encore par l'artiste lui-même; cette Vénus hottentote, au chat noir, exposée toute nue sur son lit, comme un cadavre sur les dalles de la Morgue, cette Olympia de la rue Mouffetard, morte de fièvre jaune et déjà parvenue à un état de décomposition avancée, seraient des impertinences envers le public, si ce n'étaient avant tout de colossales inepties, d'autant plus burlesques qu'elles sont plus sérieuses et plus convaincues. L'effet irrésistible que ces deux compositions produisent sur les rates les plus hypochondres provient surtout du contraste énorme qui existe entre l'attitude solennelle de l'artiste et la pauvreté de l'oeuvre, entre l'orgueil incommensurable et l'avortement piteux des prétentions qu'il affiche. Les roueries de M. Manet sont trop naïves; les maladresses et les gaucheries de son dessin trop grossières ou trop enfantines, pour qu'on les puisse croire aussi volontaires qu'il le souhaiterait. Son coloris au verjus, aigre et acide, pénètre dans l'oeil comme la scie d'un chirurgien dans les chairs. En regardant cette Olympia, comparée sur le livret au 'jour délicieux à voir,' et qualifiée par le poëte lyrique que M. Manet a appelé à son aide, d' 'auguste jeune fille, en qui la flamme veille,' il me prend ressouvenir de ces baraques de fêtes publiques, à la porte desquelles un Monsieur distingué vous promet, en langage élégant, des merveilles extraordinaires, incomparables, uniques, et où, dès que vous êtes entré, on vous montre un veau à deux têtes, dont l'une est en carton."

71 Saint-Victor: "La foule se presse, comme à la Morgue, devant l'*Olympia* faisandée et l'horrible *l'Ecce homo* de M. Manet. L'art descendu si bas ne mérite même plus qu'on le blâme. 'Ne parlons pas d'eux, regarde et passe,' dit Virgile à Dante en traversant un des bas-fonds de l'Enfer:

Non ragionam di lor ma guarda e passa

"Mais les caricatures de M. Manet reviendrait plutôt à l'Enfer de Scarron qu'à celui du Dante."

The morgue has occurred as a point of reference in Jankovitz, Ego, Geronte, and Saint-Victor. Its connotations are not quite so simple as they may seem. The word designated a building where the bodies of the unknown dead of Paris, fished from the river or found in the streets, were put on show in the hope that someone would identify them. It stood for nameless, specifically urban, and specially horrifying death. Haussmann had allowed the morgue to stay near its old place on the Ile de la Cité, though he provided it with a new Beaux-Arts building. *Morgue* also meant a kind of facial expression, intent, grim, rigid, and overbearing; some etymologies connect the two senses of the word via the look on the corpses' faces.

72 Deriège: "*Olympia* est couchée sur son lit, n'ayant emprunté à l'art d'autre ornement qu'une rose, dont elle a paré la filasse de ses cheveux. Cette femme rousse est d'une laideur accomplie. Sa face est stupide, sa peau cadavéreuse. Elle n'a pas forme humaine; M. Manet l'a tellement estropiée qu'il lui serait impossible de remuer ni bras ni jambes. A côté d'elle, on voit une négresse qui apporte un bouquet, et, à ses pieds, un chat qui s'éveille et s'étire, un chat ébouriffé qui semble venir du sabbat de Callot. Le blanc, le noir, le rouge, le vert font un vacarme affreux sur cette toile; la femme, la négresse, le bouquet, le chat, tout ce tohu-bohu de couleurs disparates, de formes impossibles, vous saisit le regard et vous stupéfie.

Quand, lasse de songer, [etc.]

"Telle est la stance que le livret ajoute à la mention d'Olympia. Ces vers valent la peinture.

"Un plaisant assurait que Mlle Olympia, engagée par un impresario pour aller représenter des tableaux vivants dans les foires, avait commandé le tableau de M. Manet comme enseigne."

73 The whole of Chesneau's entry—it comes at the end of a long discussion of Manet's aims, his previous successes (*L'Enfant à l'épée*; the still lifes shown *chez* Cadart, one of which Ches-

neau bought; the *Déjeuner sur l'herbe*; and the *Course de taureaux*), etc.—is a study in critical embarrassment. The problem is clear: to explain "les rires quasi-scandaleux qui attroupent les visiteurs au Salon devant cette créature *cocasse* (on me passera le mot) qu'il appelle Olympia." He is aware that the laughter has to do with both form and content: "d'abord . . . une ignorance presque enfantine des premiers éléments du dessin, ensuite . . . un parti pris de vulgarité inconcevable." But when he comes to *Olympia*, he finds words only for the formal insufficiencies—apart, that is, from the inadvertent "crapaud" and the clanking repetition of "auguste jeune fille":

"La construction baroque de 'l'auguste jeune fille,' sa main en forme de crapaud, causent l'hilarité et chez quelques-uns le fou rire. En ce cas particulier, le comique résulte de la prétention hautement affichée de produire une oeuvre noble ('l'auguste jeune fille' dit le livret), prétention déjouée par l'impuissance absolue de l'exécution; ne sourit-on pas en voyant un enfant se donner l'air important d'un homme? Dans cette *Olympia* tout ce qui est dessin est donc irrémissiblement condamné. La coloration générale elle-même est désagréable. En certaines parties seulement elle est juste: ainsi dans le ton des linges, dans les contrastes du drap, du cachemire et des fleurs. Mais si nous prenons au sérieux l'effort de M. Manet [i.e., his wish to reproduce tones in nature strictly and directly], nous devons lui dire que dans la nature les ombres charbonneuses sont rares, et qu'il n'en voit ou du moins qu'il n'en fait point d'autres. Il ne tient aucun compte des reflets, des contre-reflets; et ce n'est qu'en les étudiant qu'il peut réussir à donner à sa peinture l'harmonie que la nature possède toujours." Thus do "progressive" critics end by reproducing the wisdom of the schools! Chesneau claims to find *Jésus insulté* even worse, since there "les vulgarités de l'exécution sautent aux yeux." (Vulgarity is thus, in the end, securely a matter of *technique*.)

For Gautier, see note 24; the paragraph on *Olympia* follows four long ones—"Nous arrivons avec quelque répugnance aux étranges tableaux de M. Manet"—of evasive generality.

74 Aubert; see note 48.

75 Of the other experts, the efforts of Mantz, Du Camp, and Thoré are weaker still. Maxime Du Camp's passing reference, on p. 678 of his *Salon*, is so elliptical that Hamilton, in his *Manet and His Critics*, missed it altogether: "Dans cette sorte d'école nouvelle, outrageusement injurieuse pour l'art, il suffit donc de ne savoir ni composer, ni dessiner, ni peindre pour faire parler de soi; la recherche de sept *tons blancs* et de quatre *tons noirs* opposés les uns aux autres est le dernier mot du beau; le reste importe peu." Mantz has one phrase, "le prince des chimériques," and a lofty denial of Fantin and Deriège's claim that Manet is a Realist. Thoré has a dispirited aside on Manet's slavish quotations from past art—he connects *Jésus* with Van Dyck, and the previous year's *Course de taureaux* with the Pourtalès Velásquez, but no word of *Olympia*'s derivation—and then this mention, in a list of pictures he wishes he had more room to describe: "et l'Olympia de M. Manet, qui a fait courir tout Paris, pour voir cette drôle de femme, son bouquet splendide, sa négresse et son chat noir; les amis de M. Manet défient l'auteur des scarabées siamois [Gérôme] de peindre un bouquet aussi lumineux et un chat aussi hoffmannesque."

About Gonzague Privat it is possible to disagree. He certainly wishes to say something, and mostly something favourable, about Manet, and his general comments are effusively warm (see note 45 for a typical sentence). Hamilton is enthusiastic about the paragraph he produces on *Olympia*: "Dans l'*Olympia* de M. Manet, ne vous en déplaise, il y a plus que du bon, il y règne de solides et rares qualités de peinture. La jeune fille est d'un ton mat, ses chairs sont d'une délicatesse exquise, d'une finesse, d'un rapport juste sur les draps blancs. Le fond est charmant, les rideaux verts qui ferment le lit sont d'une couleur légère et aérienne. Mais le public, le gros public, qui trouve plus commode de rire que regarder, ne comprend rien du tout à cet art trop abstrait pour son intelligence" (pp. 63–64). Those readers less inclined to be impressed by the premonitory word "abstract" may be struck by the effort here to read out of the picture its rebarbative aspects and have it be unequivocally charming. Gonzague Privat offers no more detail on the picture in the three pages that follow, and when he returns to the question of *Olympia*'s effect, later in his *Salon* (p. 137), his answer again seems to me *preliminary* to a discussion which does not, in fact, follow: "Pourquoi certaines gens sont-ils effrayés par l'aspect de la jeune femme? pourquoi

en fait-elle rire d'autres? Parce qu'elle vit, que cette vie est sensible pour tout le monde; parce qu'on sent qu'elle pourrait remuer, cette femme que l'on trouve laide et mal faite, non sans quelque raison."

76 Charles Baudelaire, "Exposition Universelle de 1855," *Oeuvres complètes*, p. 963.

77 J.-F. Jeannel, *De la prostitution dans les grandes villes au dix-neuvième siècle*, pp. 247–48: "Il en est de même de ces *Panuches* qui s'attablent en hiver derrière les glaces, en été sous les vérandas des cafés luxueux. Rieuses et provocantes, elles se réunissent dans certains cafés des boulevards de Paris qui deviennent comme des bazars de prostitution. La police trop indulgente ferme les yeux sur ces exhibitions et trouve des raisons pour les tolérer. . . ."

78 Bernadille, *Le Français*, 13 April 1877: "M. Degas ne manque ni de fantaisie, ni d'esprit, ni d'observation dans ses aquarelles. Il a ramassé devant les tables d'estaminet, dans les cafés-concerts, dans le corps de ballet, des types d'une vérité cynique et quasi-bestiale, portant tous les vices de la civilisation écrits en grosses lettres sur leur triple couche de plâtre. Mais son esprit a la main lourde et l'expression crue."

79 Alexandre Pohey, *Le Petit Parisien*, 7 April 1877: "M. Degas semble avoir jeté un défi aux philistins, c'est-à-dire aux classiques. *Les Femmes devant un café, le soir* sont d'un réalisme effrayant. Ces créatures fardées, flétries, suant le vice, qui se racontent avec cynisme leurs faits et gestes du jour, vous les avez vues, vous les connaissez et vous les retrouverez tout à l'heure sur le boulevard. Et ces choristes hideux qui braillent à pleine bouche sont-ils assez vrais! Et cette danseuse qui balonne avec tant de grâce en jetant son dernier sourire aux spectateurs? Et la chanteuse du café-concert? C'est la nature prise sur le fait, dans un mouvement exact, vivante, empoignante, malgré sa crudité."

80 Jacques, *L'Homme Libre*, 12 April 1877: "Les études dans les cafés du boulevard ne sont pas moins finies ni moins curieuses, bien que cruelles—passablement. Il est permis de critiquer une certaine accentuation des détails. Mais l'ensemble constitue une page incomparable du livre anecdotique contemporain."

81 In my discussison of prostitution I am deeply indebted to Alain Corbin's excellent book, *Les Filles de noce: Misère sexuelle et prostitution aux*

19ᵉ et 20ᵉ siècles (hereafter referred to as Corbin). I have learnt a lot from work done, often from a feminist point of view, on prostitution in England and America, such as J. R. Walkowitz, *Prostitution and Victorian Society: Women, Class and the State*; F. Finnegan, *Poverty and Prostitution: A Study of Victorian Prostitutes in York*; and from S. H. Clayson, "The Representation of Prostitution in France During the Early Years of the Third Republic." Among briefer theoretical or polemical treatments I would single out Annie Mignard's "Propos élémentaires sur la prostitution," *Les Temps Modernes*, March 1976. One passage from it could have stood as a second epigraph for this chapter: "If prostitution can never leave women indifferent, that is because they know that men's relation to the prostitute is their relation to women in general, or rather to the image which men put in place of the various women of the Real. If women are often fascinated, even tempted, by prostitution, it is as the limiting case of a representation whose power and imposture only they can know" (pp. 1540–1).

82 Georg Simmel, *The Philosophy of Money*, p. 383: "With regard to prostitution we find that, beyond a certain quantity, money loses its dignity and ability to be the equivalent of individual values. The abhorrence that modern 'good' society entertains towards the prostitute is more pronounced the more miserable and the poorer she is, and it declines with the increase in the price for her services. . . . The basic and more fundamental reason is that the exorbitant price saves the object for sale from the degradation that would otherwise be part of the fact of being offered for sale." I am not suggesting that this passage's *bizarrerie* is characteristic of Simmel's rich discussion of the whole subject, though it represents, I think, a typical ideological terminus of such reflections.

83 I know Kraus's argument only via Walter Benjamin's citation and discussion of it, in "Karl Kraus," in *One-Way Street and Other Writings*, p. 276: "Contempt for prostitution? / Harlots worse than thieves? / Learn this: not only is love paid, / But payment, too, wins love!"

84 Honoré de Balzac, *Splendeurs et misères des courtisanes*, p. 290; cited in Corbin, p. 17.

85 Report cited in *De l'hygiène sociale à l'urbanisme: Etude des conditions politiques de la planification urbaine en région parisienne (1871–1940)*,

by A. Cottereau, pp. 74–75: "Paris, à propre-
ment parler, n'a pas d'habitants, ce n'est qu'une
population flottante, ou, pour mieux dire, no-
made."

86 Ibid.: "C'est le cas de faire remarquer ici qu'en
cela ce fonctionnaire a suivi l'exemple de cer-
tains journalistes qui, en parlant du Paris oisif
et interlope ont osé écrire: tout Paris.

"Nous avons plusieurs fois réduit à leur juste
valeur ces phrases vides de sens, qui feraient
croire à ceux qui ne connaissent guère notre
grande cité, qu'elle n'est composée que de gan-
dins et de cocottes.

"Pour ce qui est de notre sentiment, nous
avouons avec franchise que ce Paris du turf et
de la galanterie équivoque ne nous inspire que
du dégoût. Nous ne craignons pas non plus de
le dire: c'est une des hontes de notre époque. . . ."

87 Edmond and Jules de Goncourt, *Mémoires de
la vie littéraire*, 2:302 (5 December 1866).

88 Alexandre Dumas, "À propos de La Dame aux
camélias," in *Théâtre Complet*, 1:25.

89 Cited by H. Mitterand in *Les Rougon-Macquart*,
by Emile Zola, 2:1655 (notes on *Nana*).

90 C.-J. Lecour, *La Prostitution à Paris et à Londres*,
p. 145, cited in *De la prostitution*, by Jeannel,
pp. 182–83: "Les prostituées insoumises, c'est-
à-dire non-inscrites, forment à Paris la majorité
du personnel de la prostitution. Elles sont par-
tout, dans les cafés-concerts, les théâtres, les
bals. On les rencontre dans les éstablissement
publics, les gares de chemin de fer et même en
wagon. Il y en a sur toutes les promenades, aux
devantures de la plupart des cafés. Jusqu'à une
heure avancée de la nuit, elles circulent nom-
breuses sur les plus beaux boulevards, au grand
scandale du public, qui les prend pour des pros-
tituées inscrites en infraction aux réglements et
qui dès lors s'étonne de l'inaction de la police
à leur regard." On the fear of invasion by the
insoumise in the later 1860s and 1870s, see Cor-
bin, pp. 38–53, 190–220. Compare remarks on
the English case in K. Nield's introduction to
*Prostitution in the Victorian Age: Debates on the
Issue from 19th Century Critical Journals*, ed. K.
Nield (unpaginated).

91 F. Carlier, "Etude statistique sur la prostitution
clandestine à Paris de 1855 à 1870," *Annales
d'hygiène publique et de médecine légale*, 1871,
p. 293; cited in *De la prostitution*, by Jeannel,
p. 182: "La prostitution clandestine a changé

complètement d'allures; elle s'affiche et devient
arrogante: autant on se cachait autrefois, autant
on se montre aujourd'hui.

"La fille insoumise ne se livre plus à aucun
travail, elle ne vit plus que du produit de la
rue où elle est descendue, sur le même trottoir,
avec les mêmes costumes que les filles pu-
bliques." The ways in which this represented a
threat to the politics of invisibility described in
the previous chapter should be sufficiently clear.

92 On the numbers contest, see Corbin, p. 193.

93 P. Cère, *Les Populations dangereuses et les misères
sociales*, 1872, p . 231; cited in Corbin, p. 46.

94 Flévy d'Urville, *Les Ordures de Paris*, p. 40; cited
in Corbin, p. 46.

95 Parent-Duchâtelet, *Prostitution dans la ville*, 2:14.
A great deal of recent work centres on whether
this verdict was correct, and there is reason to
believe that Parent-Duchâtelet and his follow-
ers—everyone who discussed prostitution after
1836 *was* his follower—grossly exaggerated the
temporary nature of prostitution. They wished
to extract the phenomenon from its proper place
in an ordinary social geography of poverty,
criminality, and working-class womanhood.
(The forthcoming work of Jill Harsin, "Crime,
Poverty and Prostitution in Paris 1815–1848,"
part of which I was able to see in draft, will
correct a lot of *idées reçues*.) Of course, what is
most important from the point of view of this
chapter *is* this ideology of prostitution and its
effects on representation, verbal or visual.

96 Corbin, p. 130.

97 Behind Corbin's presentation of the *discours
réglementariste* lie Michel Foucault's ideas on
knowledge as a form of power and control in
the nineteenth century, on the drive to classify
and regulate more and more of previously
"marginal" behaviours, etc. (see Michel Fou-
cault, *Discipline and Punish*, and the whole pre-
vious series of Foucault's books.) The account
is surely compelling in this case. In general,
Foucault's work seems to me to provide further
reasons for finding the myth of modernity which
this book attacks a distinctly repellent trav-
esty—in particular its notion that the "modern"
is characterized by some special degree of *un-
control* in social relations generally.

98 See Corbin, p. 174.

99 Ibid., pp. 175, 285–314. Corbin himself makes
the link with Gaillard's work on Haussman-

nization, in the section entitled "'Ville extra-vertie' et femme-spectacle," pp. 301–3.

100 Edmond de Goncourt, *La Fille Elisa*, p. 64. "Ordinarily in Paris, it is the chance climb, by some drunkenness, of a staircase yawning in the night, the furious and unrepeated passage of a physical itch through the house of bad repute, the angry contact, as in a rape, of two bodies that will never meet again. The unknown man, come into the *fille*'s room for the first and last time, does not care what, on the body that gives itself, his eroticism spreads of grossness and contempt, of what is revealed in the mental delirium of a 'civilized' old man, of what ferocity emerges from certain male loves." (The literalness of this translation is deliberate.) See R. Ricatte, *La Genèse de "La Fille Elisa,"* for the Goncourts' documentary work for the novel.

101 E. Augier and E. Foussier, *Les Lionnes pauvres* (a play), p. 26.

102 *Westminster Review*, November 1868, p. 365; cited in "Late-Victorian Sexual Respectability and the Social System," by P. Cominos, *International Review of Social History* 8 (1963): 230.

103 Parent-Duchâtelet, *Prostitution dans la ville*, 1:363: "On arrivera au terme de la perfection et du possible en ce genre, en obtenant que les hommes, et en particulier ceux qui les recherchent, puissent les distinguer des femmes honnêtes; mais que celles-ci, et surtout leurs filles, ne puissent pas faire cette distinction, ou ne la fassent du moins qu'avec difficulté."

104 Joris-Karl Huysmans, *Marthe*, p. 140. (The last word is again *honnêteté*.)

105 Edmond and Jules de Goncourt, *Mémoires* 1:1354 (8 November 1863).

106 Jeannel, *De la prostitution*, p. 249: "de véritables chevaliers d'industrie de la jeunesse et de l'amour."

107 Nadar, "A une courtisane," *La Revue Moderne et Naturaliste*, 1878–79, pp. 408–9: "C'est toi ... c'est toi la vraie, la seule 'Classe Dirigeante,' car que ne conduis-tu pas, et de quelle bonne et âcre haine ne hais-tu le peuple pour son incommensurable mépris!" My thanks for this reference to S. H. Clayson.

108 Jeannel, *De la prostitution*, pp. 233–34: "Le plus souvent elles cherchent, dans leurs costumes pompeux et fripés, à suivre les dernières modes adoptées pour les bals et les soirées d'apparat! ...

"Leur langage, grossier comme celui de la lie du peuple, et qu'elles salissent naturellement de mots orduriers, qu'elles embrouillent de jargon et de patois ou qu'elles enrichissent d'argot; leurs voix enrouées, usées ou d'un timbre ignoble; ... leurs tutoiements et leurs jurons, leurs regards faussement lascifs, les surnoms qu'elles se donnent, tout cela forme un hideux contraste avec les toilettes ou les manières du grand monde, prétentieusement et gauchement contrefaites."

109 A. de Pontmartin, "Semaines littéraires," *La Gazette de France*, 11 June 1865: "toilette, jargon, curiosité, plaisir, cosmétiques, tout rapproche le demi-monde et le monde entier; tout permet de confondre ce qui ne devrait pas même se connaître. ... La patricienne du faubourg Saint-Germain se croise, dans l'escalier de Worth, avec l'élégante du quartier Bréda."

110 See Jean-Paul Sartre, *L'Idiot de la famille: Gustave Flaubert de 1821 à 1857*, 3: pp. 523–29, for a scathing discussion of the Second Empire intellectuals' involvement in this myth. The delight of such as Flaubert and the Goncourts ("les pisse-froid") in the *falsity* of Lagier or La Païva is part, Sartre argues, of the intellectuals' wish for a social reality which would prove as futile, derealized, and imaginary as themselves. The Second Empire was such a society, and the *courtisane* its perfect representative. These artists never recovered from its fall. See, for instance, pp. 547–78 and book 2, *passim*.

111 P. de Lano, *Courtisane*, p. vii; cited in Corbin, p. 200.

112 Gustave Flaubert, letter to Maxime Du Camp, *Correspondance*, 6:161 (29 September 1870); cited in *L'Idiot*, by Sartre, 3:616.

113 For instance, Amédée Cantaloube, *Lettre sur les Expositions et le Salon de 1861*, pp. 70–71: "Therefore one has to point out that Phryne would not have displayed the false modesty of a *parisienne* flaunting her charms, ogled by a crowd of burlesque and lascivious Areopagites. ... Aspasia would have borne no resemblance, no more than Phryne, to the women of Breda Street, and would not have given her body a licentious allure. ..."

114 Théophile Gautier, *Abécédaire du Salon de 1861*, p. 191: "The city, with its brightly lit palaces darting fascinating looks from all their win-

dows, spreads out its boulevards, its perspectives and its lines of gaslight in the depths of the abyss, at the left of the canvas."

115 Cited in *Le Salon de 1861*, by Maxime Du Camp, p. 138: "Combien de jeunes filles, délaissant le travail, se précipitent dans tous les vices que la débauche entraîne pour échapper à ce spectre (la misère), qui semble toujours les poursuivre?"

116 Ibid., pp. 136–37: "Ce tableau aurait pu s'appeler les vierges sages et les vierges folles. C'est la figuration allégorique de ce que nous voyons tous les jours sur nos promenades et dans nos théâtres, l'envahissement croissant des filles de mauvaise vie qui sont aujourd'hui un élément nouveau de notre société transitoire et qui, entre les mains toujours actives et toujours intelligentes de la civilisation, ne sont peut-être que des instruments d'égalité destinés à rendre l'héritage illusoire ou du moins à le réduire à une circulation forcée. En voyant ce mouvement ininterrompu de lorettes (il faut les appeler par leur nom), qui se succèdent incessamment parmi nous comme les vagues de la mer, je me suis souvent demandé si les classes inférieures de notre société ne perpétuaient pas, à leur insu, le combat commencé à la fin du siècle dernier et si, en produisant ces belles filles dont la mission paraît être de ruiner et de crétiniser la haute bourgeoisie et les débris de la noblesse, elles ne continuaient pas pacifiquement l'oeuvre des clubs les plus violents de 1793. Marat, aujourd'hui, ne demanderait plus la tête de deux cent mille aristocrates, il ferait décréter l'émission de deux cent mille filles entretenues nouvelles, et son but serait atteint."

117 See J. Whiteley, *The Revival in Painting of Themes Inspired by Antiquity in Mid-Nineteenth Century France*, p. 243. Whiteley's whole discussion of the *courtisane* theme in academic and official painting (p. 238 ff.) is excellent.

118 When the pair were printed in *L'Artiste* on 1 June 1868, an accompanying pair of sonnets interpreted the contrast of *courtisane* and *femme honnête* in terms of modern woman's susceptibility to the wrong kind of novel. Penelope's case is clear—"En vain le romancier va lui faire sa cour"—and Phryne's no less—"Elle a lu le matin Karr, Houssaye et Balzac."

119 Théophile Gautier, "Salon de 1869," in *Tableaux à la plume*, pp. 290–1: "C'est un cour des Miracles de millionaires. La courtisane les regarde sans effroi, sans dégoût, avec cette suprême indifférence pour la beauté et la laideur qui caractérise ces créatures, et de ses lèvres, avec une bouffée de cigarette, s'échappe ce mot, qui résume sa pensée: Pourquoi pas?"

120 See P. Vaisse, "Couture et le Second Empire," *La Revue de l'Art*, no. 37 (1977), p. 43, and p. 63, note 17.

121 For the picture's iconography, see Couture's letter in *Thomas Couture (1820–1897)*, by G. Bertauts-Couture, pp. 94–95, and discussion in Whiteley, *Revival in Painting*. The picture is dated 1873.

122 Camille Lemonnier, *Salon de Paris 1870*, pp. 76–77: "Les joues, blanches comme celles des filles d'amour, sont blairautées d'un fard rose et se plissent, aux coins des lèvres, d'un superbe sourire triomphante. . . . La chair, d'ailleurs, fatiguée et tapotée, a par elle-même, en sa moiteur malsaine et grasse, la lividité que les plaisirs empreignent sur la peau des courtisanes. . . . Je ne chicanerai pas M. Regnault sur la justesse des vêtements et des accessoires. Je ne vois pas le côté histoire: je regarde la côté femme. . . . Je trouve une Salomé: je ne cherche pas la Salomé. Il me suffit que l'artiste ait caractérisé avec un style pittoresque et vrai, en sa resplendissante guénille froissée, la fille d'amour."

123 Maxime Du Camp, *Les Beaux-Arts à l'Exposition Universelle et aux Salons de 1863–1867*, p. 31: "To these Venuses that one paints with such care one can pronounce Heinrich Heine's anathema: 'Venus Libitina, you have become no more than a goddess of death!,' for they are less than courtesans."

124 This was a standard part of the myth of the prostitute.

125 Lemonnier, *Salon de Paris 1870*, p. 76: "Elle sent le rut et la boucherie, féroce avec indifférence et lascive sans amour."

126 A. Delvau, *Les Plaisirs de Paris: Guide pratique*, p. 266: "Il importe ici de tracer une grande ligne de démarcation sur la carte de la galanterie. Les innombrables filles perdues qui errent dans ce grand désert d'hommes de Paris se divisent en deux classes. Il y a les pauvres misérables, dont Victor Hugo a parlé dans son roman, qui vivent au jour le jour et parcourent les rues à l'aventure, cherchant le même animal que Diogène, et comptant sur sa générosité pour faire face aux dépenses de leur loyer, de leur

repas et de leur toilette.

"Il y a des livres spéciaux, des livres de statistique qui vous raconteront l'existence atroce de ces filles de tristesse, comme M. Michelet les appelle. De pareilles turpitudes ne sauraient trouver place dans un livre consacré aux plaisirs parisiens. Il y a des plaies qu'il faut cacher et panser en secret. . . ."

127 J.-A. Castagnary, *Salons 1857–79*, 1:113–14: "Mais combien cette jolie femme avec son minois de modiste parisienne, serait mieux sur un sofa! Elle qui vivait si bien dans son riche appartement de la Chausée-d'Antin, elle doit se sentir bien mal à l'aise sur ce rocher dur, près de ces galets blessants, de ces coquillages hérissés.

"Mais une réflexion: que fait-elle à cette heure seule, ici roulant ses yeux d'émail et crispant ses mains coquettes? Guette-t-elle un millionnaire égaré dans cet endroit sauvage? Serait-elle non plus la Vénus des boudoirs, mais la Vénus des bains de mer?"

128 The most striking example is Amaury-Duval's *Naissance de Vénus*, in the Salon of 1863 alongside Baudry's and Cabanel's.

129 Du Camp, *Les Beaux-Arts*, p. 30: "L'art ne doit pas avoir plus de sexe que les mathématiques. . . ."

130 Ibid., p. 31: "L'être nu est l'être abstrait, il doit donc avant tout préoccuper et tenter l'artiste; mais vêtir le nu d'impudeur, rassembler dans les traits du visage toutes les expressions qu'on ne dit pas, c'est déshonorer le nu et faire l'acte blamable." A look at the use of the word "abstract" here should suggest why I doubt that Gonzague Privat meant anything very modern by it when discussing *Olympia*.

131 Ibid., p. 39: "je trouve que le nu cesse d'être honnête lorsqu'il est traité de façon à exagérer intentionnellement certaines formes aux dépens de certaines autres."

132 Ibid., p. 30: "Monsieur Ingres . . . has treated nudity in all its splendour, and never, in a single detail, has he strayed from the purest chastity."

133 Lemonnier, *Salon de Paris 1870*, pp. 80–81, 91–92: "Le nu n'est pas le déshabillé, et rien n'est moins nu qu'une femme qui sort de ses pantalons ou qui vient d'ôter sa chemise. Le nu n'a pudeur qu'à la condition de n'être pas un état transitoire. Il ne cache rien parce que rien n'est à cacher. Du moment qu'il cache quelque chose, il devient polisson, car c'est pour mieux

montrer. Le nu dans l'art, pour se garder vierge, doit être impersonnel et il lui est défendu de particulariser; l'art n'a que faire d'une mouche posée sur la gorge et d'un grain arrondi sous la hanche. Il ne cache rien et ne montre rien: il se fait voir en bloc. . . .

"Le nu a quelque chose de la pureté des petits enfants qui jouent chair contre chair sans se troubler. Le déshabillé, au contraire, me fait toujours sentir la femme qui s'étale pour quarante sous et travaille les poses plastiques."

134 Ibid., pp. 83–84: "La poitrine est bien sentie: on y voit de la lassitude, des marques d'étreintes, des traces de baisers, et la gorge pend, mordue par les voluptés. Une solidité réelle groupe les formes de la fille, et le grain de la peau, écrasé dans la pâte morbide, se masse en tissu serré sous la touche."

135 Edouard Hache, *Le Salon de 1869*, p. 241: "La pose est bizarre, je le veux; la tête horrible, soit; ajoutez encore que le corps ne vous séduit pas, si vous y tenez. Mais quel admirable dessin! Avec quelles richesses chromatiques le peintre a rendu les tons si changeants de la chair! Et le modelé, et les finesses du ventre, les délicatesses des bras, les plis nacrés qui creusent les seins! Comme le nu se fond grassement avec ces beaux coussins rouges! C'est bien là une femme d'Orient, dans sa mollesse et sa bestialité."

136 Cantaloube, *Lettre sur les expositions*, p. 65: "Monsieur Cabanel is one of those who stay true to the noble quest for the pagan ideal, . . . The scene is conceived from a purely artistic point of view. Monsieur Cabanel has stopped at just the moment when the work would have lost its nobility; and that was the danger; the idea of voluptuous beauty is indicated very well in this group."

137 Félix Jahyer, *Deuxième Etude sur les Beaux-Arts: Salon de 1866*, p. 155: "Le bambin est malin et pressant: tandis qu'il conte son dangereux secret, sa petite main se pose sur la poitrine de l'adolescente qui, par un mouvement d'une grâce exquise, porte elle-même la main à la même place, ce qui prouve qu'elle a à se défendre d'une sensation. Le profil délicieux de l'enfant se pose avec hardiesse sur la figure délicate de sa confidante, chez qui la pudeur et le plaisir se livrent un adorable combat."

138 Thoré, "Salon de 1865," in *Salons de W. Bürger*, 2:206: "Qui encourage l'art mythologique et

l'art mystique, les Oedipe et les Vénus, ou les madones et les saints en extase? ceux qui ont intérêt à ce que l'art ne signifie rien et ne touche pas aux aspirations modernes. Qui encourage les nymphes et les galantes scènes Pompadour? le Jockey-Club et le boulevard Italien. À qui vend-on ces tableaux? aux courtisans [*sic*] et aux enrichis de la Bourse, aux dissipateurs d'une aristocratie exceptionnelle."

139 Gille: "M. Manet s'est jeté, tête perdue, dans son sujet; de cette détermination, est résulté un affreux et indécent assemblage de tons crus, de lignes heurtées qui brisent les yeux, de blanc et noir étalés à la main et limités par le seul caprice."

140 Bonnin; note 15 above. Fillonneau: "Dans les deux tableaux, le dessin est à l'abri de la critique: il n'existe pas. Si de pareilles tendances triomphaient jamais, il n'y aurait aucun inconvénient à mettre le feu au Louvre et à quelques autres musées qui pourraient gêner le développement de ces singulières manifestations."

141 Deriège; note 72 above. Aubert and Cantaloube; note 48 above.

142 Deriège; note 72 above. About: "À peine a-t-il établi une couche de pâte sur sa toile, on lui saisit le bras: —Arrêtez! lui dit-on; un trait de plus et vous gâtez votre chef-d'oeuvre." Various others described Manet's works as mere sketches: Bonnin, Cantaloube, Bataille, Beaubleu, Rolland, Gautier.

143 Sigmund Freud, "Some Psychical Consequences of the Anatomical Distinction Between the Sexes," in *The Standard Edition of the Complete Psychological Works*, 19:252. My discussion of this passage in relation to representations of the nude is indebted to Stephen Heath's extraordinary article, "Difference," *Screen*, Autumn 1978 (see especially p. 53). I am aware that my use of this article is partial and unadventurous, but my treatment of the nude in art would have been even more limited without it.

144 Ravenel: "M. MANET—*Olympia*—Le bouc émissaire du Salon, la victime de la loi du Linch [*sic*] parisien. Chaque passant prend sa pierre et la lui jette à la face. *Olympia* est une folie d'Espagne très folle, qui vaut mille fois mieux que la platitude et l'inértie de tant de toiles qui s'étalent à l'Exposition.

"Insurrection armée dans le camp des bourgeois: c'est un verre d'eau glacée que chaque visiteur reçoit au visage lorsqu'il voit épanouir la BELLE courtisane.

"Peinture de l'école de Baudelaire exécutée largement par un élève de Goya; l'étrangeté vicieuse de la petite faubourienne, fille des nuits de Paul Niquet, des mystères de Paris et des cauchemars d'Edgar Poe. Son regard a l'âcreté d'un être prématuré, son visage le parfum inquiétant d'un fleur du mal; le corps fatigué, corrompu, mais peint sous une lumière unique et transparente, les ombres légères et fines, le lit et l'oreiller sont observés dans le gris des modelés moelleux. La négresse et les fleurs insuffisantes dans leur exécution, mais d'une réelle harmonie, l'épaule et le bras droit solidement affermis dans un jour franc et pur.—Le chat qui fait gros dos porte le visiteur à rire et à se défendre; c'est ce qui sauve M. Manet d'une exécution populaire.

"[From its black and brown fur / Comes a perfume so sweet, that one evening / I was overcome from having / Caressed it once . . . only once. / It is the familiar spirit of the place; / It judges, presides, inspires / Everything in its empire; / Perhaps it is a fairy, perhaps a god?]

"M. Manet, au lieu des vers de M. Astruc, aurait peut-être bien fait de prendre pour épigraphe le quatrain consacré à Goya par le peintre le plus *avancé* de notre époque:

"[GOYA—Nightmare full of unknown things, / Of fetuses cooked in the middle of witches' sabbaths, / Of old women at their mirrors and naked children, / To tempt demon women pulling up their stockings.]

"Ce n'est peut-être pas flatteur pour M. Manet que cette *olla podrida* de toutes les Castilles, mais enfin c'est encore quelque chose. Ne fait pas une *Olympia* qui veut.—Le *Christ* demanderait une certaine analyse technique que nous n'avons pas le temps de donner.—En résumé, c'est hideux, mais c'est encore quelque chose. Le peintre y apparaît et la lumière court sur ce groupe étrange."

145 The link between *Olympia* and Baudelaire was rather rarely made in 1865, though Baudelaire was quite a favourite point of (mostly burlesque) reference for critics—for instance, in discussions of Gustave Moreau (see Louis de Laincel, *L'Echo de France*, 6 August: "Il y a là-dedans un fantastique d'où se dégage le même malaise que l'on éprouve lorsque'on a lu, par hasard, *Les Fleurs du mal*, de M. Baudelaire,

ou bien les contes d'Edgar Poë"). The Laincel reference, along with the sarcastic question of Geronte (note 38 above) and the echo in Gille (note 42 above), represents quite fairly, I think, what Baudelaire *connoted* in 1865. Ravenel's text should be read in this light; also Leroy's passing mad invocation in *L'Universel* ("Et ce chat! noir comme la nuit! profond comme l'enfer! O chat! o chat! . . . O chat animé de Baudelaire! O chat de la courtisane Olympia [de l'auguste jeune fille en qui la flamme veille], sois fier, mon minet! tu souilles de tes petites pattes crottées la couche immaculée de celle pour qui l'on voudrait mourir, s'il n'etait plus doux de vivre pour elle!"); Cantaloube's description in *L'Illustrateur des Dames* ("Ce sont les fleurs moisies ou flétries d'un tableau qui a fait scandale! Une femme couchée, une négresse et un maigre chat noir, sortes de gnomes du sabbat qui composent avec les fleurs cette parodie de la nature"); and even the cryptic quatrain of Briolle ("Sur: *Olympia*, par M. Manet. No. 1428, / Astre qu'on éreinte, / Mais qui me toucha, / Tu n'es pas mal peinte, / Non, non,—c'est le chat!").

146 Ravenel, 1 May, 7 May; the whole discussion of landscape painting would be worth reprinting.

147 Ravenel, 17 May; using Amaury-Duval's *Daphnis et Chloé* in the salon as a pretext.

148 Ravenel: "M. Manet, une Olympia nue couchée sur un lit, près d'elle une négresse lui présente des fleurs, tableau capable d'exciter une sédition, si son voisin, un Christ, du même auteur, ne désarmait les furieux par un rire homérique. Ces deux toiles sont les victimes du Salon; rien ne peut exprimer l'étonnement d'abord, puis la colère ou l'effroi des spectateurs. Ces bonnes drôleries ne méritent certes pas cet excès de courroux; elles sont quelque peu audacieuses d'attitude, Olympia surtout! mais trop visiblement enfants naturels de Goya pour qu'on s'inquiète de leurs méfaits."

Compare Ravenel's remark in his conclusion, 8 July: "Ce qui perd les Salons, ce n'est pas les petits monstres de nos Narcisses ou les productions des artistes en démence: ce sont les platitudes et les ouvrages médiocres. Pour une *Olympia* de M. Manet ou un *Haras* de M. Brivet, oeuvres innocentes dans leur ridicule constitution, combien de machines académiques, de tristes tartines, de niaises ou de sottes combinaisons!"

149 The anonymity seems to have been carefully guarded: in the checklist of *Salons* published in *La Chronique des Arts* on 21 May, Ravenel's is the only pseudonym with a ? beside it; all the others are confidently identified.

Chapter Three: The Environs of Paris

1 Cited in *Grand Dictionnaire universel du dix-neuvième siècle*, by Pierre Larousse, 3:61 (in the entry "Café").

2 Edmond and Jules de Goncourt, *Mémoires de la vie littéraire*, 1:1085 (8 June 1862).

3 "Y," "Un Dimanche d'éte," *La Vie Parisienne*, 3 July 1875, pp. 375–76: "J'étais à la campagne depuis six jours, et je m'engourdissais, las de silence, lorsqu'enfin les cloches des villages annoncèrent le matin du septième jour, du jour de repos et de liesse. Puis bientôt un tressaillement se fit le long des bois et des prés, et l'écho des coteaux apporta un premier calembour.

"—Voilà les Parisiens qui commencent! m'écriai-je avec transport. La nature va quitter son rôle de nymphe mystérieuse et muette, elle va devenir une fille d'auberge à qui des commis-voyageurs font une cour quelque peu brutale.

"D'heure en heure l'invasion se répandit, prenant possession de la campagne comme d'une vaste guinguette, d'un café-concert plus grand que ceux des Champs-Elysées.

"Tous ces gens-là venaient tâter les collines comme des gorges, trousser la forêt jusqu'au genou et chiffonner la rivière.

"La brise se mit à souffler des *blagues* et des lazzis. Les odeurs de friture et de gibelotte s'élevèrent le long des berges et vinrent ramper sur les champs. Des bruits de bouchons qui sautent, de couteaux faisant tinter les verres, des chansons grivoises, ouvrirent le concert qui alla en grandissant jusqu'a la nuit. . . .

"Quand je vis la campagne ainsi livrée à ceux-là seuls qui la comprennent et savent en jouir, et m'étant repu de ce spectacle, j'allai prendre le chemin de fer pour revenir à Paris." (Cited in part in *Monet and Argenteuil*, by Paul Tucker, p. 118.)

4 Robert Caze, *La Foire aux Peintres. Extrait de Lutèce*, p. 15: "Oh! la pauvre petite Parisienne étonnante et étonnée au milieu de cette nature en toc de Sèvres ou de Ville d'Avray. Il faut être reconnaissant à M. Blanche d'avoir si bien vu les odieux gazons de villas hors murs, ces

gazons que les paquebots de Douvres et de Southampton apportent d'Angleterre et qui doivent nous arriver tous les matins avec le train de marée. Dans le paysage où essaie de s'ébattre le souffreteux modèle du peintre, je devine une très prochaine boule en verre étamée, un petit jet d'eau qui pisse une chanson monotone dans une vasque où baignent trois poissons rouges et un bourgeois—le propriétaire!—rapportant, *à la campagne*, après la fermeture de la Bourse, des fleurs achetées sur l'asphalte du marché de la Madeleine. Et c'est excellent de nous donner ainsi la sensation ou plutôt la senteur d'Asnières et de Bois-Colombes sans nous obliger à prendre le tramway. Si j'avais des économies, j'achèterais les *Pivoines* de M. Blanche, pour me dispenser d'aller aux champs où poussent les canotiers, où court le spirituel public des dimanches, aux champs où il y a des pianos, des cords de chasse, des cheminées d'usines et des parfums de poudrette."

5 Cited in Manè, *Le Paris viveur*, p. 247; it is the climax of a facetious discussion of the high-priced *courtisane*'s need for several houses in which to carry on her several affairs: "Which increases the number of these villas in miniature . . . And thanks to all this, the trains to the *banlieue* are flourishing, particularly on the Western line, whose station is located in such a convenient spot, in the heart of the Chaussée-d'Antin" [i.e., next door to the Rue de Bréda]. It was a stock manoeuvre of this kind of writing to picture the environs of Paris as overrun with prostitutes. Asnières was especially notorious, and the flavour of its reputation is well conveyed by a café-concert song from 1866, banned by the censor, entitled "Les Régates d'Asnières": "Je suis Cora, la canotière. . . . / Toujours Reine de la Régate, / Je trône encor', près de Vénus, / Et tour à tour l'gandin me flatte / Et l'Anglais m'offre des Écus. . . . / Je suis canotière, ah! Oui Da! / Et tout aussi bien qu'la grand' Biche / J'me pay' du luxe et du fla-fla!" The cheerful consciousness of class conflict *within* prostitution here (the *canotière*'s *chic* is described as offending "Plus d'un p'tit Dam' du demi-ton") is interesting with reference to *Olympia*—as is the censor's sensitivity on the subject. (The song is preserved in the Archives Nationales, F18. 1860.)

6 "La Petite Marquise," "Salon de 1877," *Le Monde Thermal*, 24 May 1877, on Jourdain's painting *Bougival*: "C'est bien là le ciel pâle des environs de Paris, ce ciel maladif, qui rappelle le teint des Parisiennes."

7 Victorien Sardou, "Louveciennes, Marly," in *Paris-Guide, par les principaux écrivains et artistes de la France*, 2:1455: "This is the real village! . . . Chatou is far away; and those little white flurries which the wind stirs up around you on the road, they are not rice powder . . . they are real dust."

8 Victor Fournel, "Etablissements de plaisir," in *Paris dans sa splendeur: Monuments, vues, scènes historiques, descriptions et histoire*, 2:19: "De Sceaux à Romainville, et d'Auteuil à Meudon, dans ces villages où, chaque dimanche, les bourgeois parisiens s'engouffrent par torrents joyeux, partout où il y a un chétif carré d'herbe avec une demi-douzaine d'arbres rachitiques, le propriétaire se hâte d'établir un café-restaurant ou un bal." Victor Fournel can be relied for the ultimate of scorn in such matters; a specially vitriolic picture of Asnières follows: "There are plenty of shopkeepers, *commis*, students, small investors, who would consider themselves disgraced if they spent a Sunday in summer without swallowing the dust of this appalling village . . ." and so on. This list of actors will become familiar in the pages that follow.

9 Victor Fournel, *Paris nouveau et Paris futur*, p. 91: "Ce qu'il trouve et ce qu'il lui plaît, dans ces campagnes étiolées de la banlieue, c'est un demi-Paris, avec des ombres d'arbres qui lui rappellent ceux de ses boulevards, des restaurants qui ressemblent à ceux de la Rue Montmartre. . . ."

10 Bernadille, "Le Parisien en villégiature," in *Esquisses et croquis parisiens: Petite Chronique du temps présent*, 1st ser., p. 350: "des marchands de coco et de plaisir, des jeux de macarons, des tirs, des balançoires, une population bariolée, grouillante et tapageuse, parlant l'argot parisien, émaillée de modistes, de commis en nouveautés, d'étudiants et de *reporters* . . ." "Modistes" is meant to be read with a snigger. Always economical, Fournel ("Bernadille" is one of his pseudonyms) introduces this sentence with a repeat of the one from ten years earlier just quoted.

11 H. Blondeau and H. Monréal, *Les Environs de Paris: Voyages d'agrément en quatre acts et huit tableaux*, p. 26:
 "BARTAVEL—Oui, mon ami . . . à part ça tout a bien été . . . désagréable! . . . et tu me vois

complètement désillusionné sur le compte des Environs de Paris! ...

"JOSEPH—Pourquoi ça? ...

"B. *se levant*—Pourquoi ça! ... Parce que je m'en étais fait un tableau qui ne ressemble en rien à celui que j'ai vu. En partant je m'étais dit: Là, j'aurai de l'air, du soleil et de la verdure! ... Ah! bien oui, de la verdure! Au lieu de bluets et de coquelicots, des prairies immenses toutes recouvertes de vieilles loques et de vieux faux-cols ... des blanchisseuses partout et pas de bergères ... des usines en guise de chalets ... trop de soleil ... pas d'ombre ... et pour couronner le tout, des grandes cheminées en briques rouges d'où s'échappe une fumée noire qui empoisonne et qui vous fait tousser! ... Des cochers qui vous gonaillent, des restaurateurs qui vous écorchent ... des pressoirs qui vous aplatissent les chapeaux ... des vignerons qui vous inondent de vin blanc ... des forêts où l'on perd sa fille ... des hôtels où l'on égare son gendre! ... Voilà, mon cher Joseph ... voilà la description fidèle de ce qu'on est convenu d'appeler ... les Environs de Paris! ..."

12 "Courrier de Paris," *Le Nain Jaune*, 13 May 1877 (the "Courrier" is subtitled "Le Parisien à la campagne ... Conversation du Parisien en allant à sa villa"): "Avance donc un peu par ici?—Pourquoi faire?—Tu verras la plus jolie vue. ... N'est-ce pas que c'est charmant? ... De chez moi on aperçoit une partie de ce panorama. ... Comment le trouves-tu?—Je n'y vois rien d'extraordinaire ... à part ces grands tuyaux avec cette fumée noire qui me gâtent le paysage. ...—Pour moi c'est une charme de plus. ... Eh! mon cher, c'est l'industrie qui vient jeter sa note. ... Mais nous voici arrivés. ... Prends garde à ce trou. ... Il ne sèche jamais, même au coeur de l'été. ..."

13 Bernadille, *Esquisses et croquis parisiens*, 2nd ser., p. 290: "Ce jour-là, c'est toute une population nouvelle qui prend possession de Paris, de ses spectacles, de ses cafés, de ses promenades, de ses jardins publics, de ses boulevards, de son Palais-Royal, de ses gares, de sa banlieue. Dans la semaine, vous aviez déjà pu l'apercevoir sans doute, mélangée au public ordinaire, mais en quelque sorte effacée par lui. Maintenant, elle s'étale sans alliage; elle coule à flots par les rues, elle déborde et recouvre Paris. La grande ville lui appartient pour tout le jour.

"D'où sort-elle? Des comptoirs des humbles boutiques, des bureaux d'employés, des administrations, des ministères. Ce n'est pas précisément un public populaire dans toute la force du terme, car le peuple de l'*Assommoir* célèbre le lundi de préférence au dimanche; c'est un public de petits bourgeois, de petits commerçants, mêlé de vrais ouvriers."

14 Gambetta's first speech on this subject was made at Grenoble in September 1872. Though he was clear in the following year that the new republic rested "on a pact of indissoluble alliance between the proletariat and the bourgeoisie," he did not usually care to analyze where his "nouvelles couches" belonged in that essential class structure. Historical discussion of the same subject is still remarkably sparse and uncertain. There is some good general analysis by Adeline Daumard, "Progrès et prise de conscience des classes moyennes" and "Diversité des milieux supérieurs et dirigeants" in *Histoire économique et sociale de la France*, ed. F. Braudel and E. Labrousse, vol. 3. She stresses the twofold aspect of the moyenne and petite bourgeoisie's "prise de conscience" in the 1870s: it was both a confident appropriation of new political and cultural places, and a defence against those economic processes—concentration of capital, shifts in the division of labour and the organization of the firm—which profoundly threatened their security and their sense of themselves (see pp. 929 ff.). There are interesting details on the *visibility* of the new *employée* in M.-H. Zylberberg-Hocquard's *Féminisme et syndicalisme en France*, pp. 49–50. But here, as elsewhere, the most useful studies seemed to me of the lower-middle class in other countries. See especially G. Crossick, ed., *The Lower Middle Class in Britain 1870–1914*, in particular the essays by Crossick and R. Q. Gray (they both connect with a more obsessive debate within British historiography over the "labour aristocracy"). See also G. Stedman Jones, "Working-Class Culture and Working-Class Politics in London, 1870–1900: Notes on the Remaking of a Working Class," *Journal of Social History*, Summer 1974. For a more general discussion, see A. Mayer, "The Lower Middle Class: A Historical Problem," *Journal of Modern History*, September 1975.

15 Saint-Valry, *Souvenirs et Réflexions politiques*, cited in *Les Débuts de la troisième république*, by J.-M. Mayeur, p. 51.

16 Jean Ajalbert, "Chromolithographie," in *Sur le*

vif: Vers impressionnistes, p. 108: "Once-a-week press of people across the suburbs! / Parisians! Looking for flowers between the paving stones! / They imagine they're thousands of miles away . . . / Because it's Sunday and they've had a wash."

17 There is some disagreement over whether the picture I show is the 1875 version. I see no reason that it should not be: the later date that is occasionally given it does not seem right.

18 The story is told in M. Phlipponneau's *La Vie rurale de la banlieue parisienne*, pp. 484–92, 501–2. The years 1875–76 were a time of particularly bitter controversy, as the city proposed extending the *champs d'épandage* across to Argenteuil and downstream. In the end, opposition forced the abandonment of the scheme. For the effect on Argenteuil, see Tucker, *Monet and Argenteuil*, pp. 149–53, 176–81.

19 Ajalbert, *Sur le vif*, pp. 130–32: "The sun is weary of lighting this sky, grey / With the opaque smoke from factory chimneys, / Which line the horizon towards Paris. / Towards Argenteuil, land of minuscule windmills, / There are terraces of meagre vine-poles, / Condemned, beneath the weight of the eternal twilight, / To furnish the market with acid white grapes. / Harvests have an impossible genesis here, / Peasants are more like sewer workers, / Putting on manure, and pulling obese vegetables /From a soil from which the Moon hides its phases, / And for which the sun has no light. /On the houses, roofs of 'vermilion' tiles . . . /It is the countryside, but without stubble fields or cottages, / Without a single swallow or a cricket."

20 D. Rouart, ed., *Correspondance de Berthe Morisot avec sa famille et ses amis*, p. 111.

21 "Clichy l'égout," *La Bataille*, 14 May 1884: "A l'heure actuelle, près de 120,000 mètres cubes sont accumulés à l'aval du collecteur; plusieurs centaines de mètres carrés sont couverts d'une végétation bizarre, qui répand une odeur repoussante. Par les chaleurs actuelles, la ville de Clichy possède de véritables marais pontins." The issue was given added urgency in the mid-1880s by renewed debate over whether Paris should convert to the *tout-à-l'égout* system. Guidebooks and suchlike disagreed totally over the character of the *grand égout collecteur* at Asnières. Louis Barron, in *Les Environs de Paris*, p. 38, paints quite a sunny picture. Gigault de Labédollière, in *Histoire des environs du nouveau*

Paris, p. 138, is already complaining of the effects of "cet exutoire." Most guidebooks were more anxious to warn visitors of the low company they risked keeping at the *bals publics*.

22 Anon., *The Art Journal* 38 (1876): 211 (on an exhibition of French painting at the Deschamps gallery): "The expounder of the new faith in the present exhibition is E. Manet, and the banner under which he and his fellow disciples propose marching to glory has inscribed on it the legend 'Impressionists'. 'Les Canotiers' (102), a couple of very ordinary-looking lovers sitting on the gunwale of a boat, with a piece of the most intensely-blue water we ever saw, is all the exposition we have of the school at present; and, consequently, we cannot speak judicially. But if these vulgar figures, this coarse brushwork, and this outrageously-crude colour, be the sort of 'impression' left on Monsieur Manet's mind, we would advise him to eschew impressions in future, and to sit down determinedly before concrete objective fact, and not leave it till he had mastered it."

23 My sampling of the critical reaction in 1875 was far from comprehensive, but enough to show how thin and formulaic that reaction was, even in comparison to 1865. The following items contained something on Manet (entries of any substance are marked*):
 *Anon., "Chronique du Jour," *La République Française*, 1 May [strongly in favour of "le groupe dit des Intransigeants," for clearly political reasons]; E. Bergerat, *Le Journal Officiel de la République Française*, 1 June, p. 3902; Bertall, "Revue Comique du Salon de 1875," *L'Illustration*, 22 May; A. Besnus, *Salon de 1875*, Paris 1875, pp. 42–43; C. Bigot, *La Revue Politique et Littéraire*, 15 May, p. 1092; E. Blavet, *Le Gaulois*, 22 June; *J.-A. Castagnary, *Salons (1857–1879)*, 2:178–80; Cham, "Revue comique du Salon," *L'Univers Illustré*; Cham, *Le Monde Illustré*, 5 June, p. 357; Cham, *Le Charivari*, 9 May and 6 June [none of these four renditions is interesting]; *Maurice Chaumelin, *Le Bien Public*, 30 May; C. Darcours, *Le Journal Illustré*, 9 May and 30 May; C. Desmarets, *Le Sifflet*, 16 May; Ernest Fillonneau, *Le Moniteur des Arts*, 14 May ["un homme et une femme à ce qu'on dit; tous les deux aussi sales l'un que l'autre"]; Francion, *L'Illustration*, 29 May; "Une Inconnue," *L'Univers Illustré*, 3 July, p. 423; L. Leroy, *Le Charivari*, 5 May, etc.; G. Le Vavasseur, *Le Français*, 9 May; *J. de Marthold, *Le*

Monde Thermal, 27 May [a long general defence by one of the Nouvelle-Athènes circle; has little or nothing to say about *Les Canotiers* itself]; O. Merson, *Le Monde Illustré*, 15 May, p. 306; *C. Pelletan, *Le Rappel*, 4th article of *Salon* [whole article in defence; not much to say of *Les Canotiers*; a Left-republican paper associated with Auguste Vacquerie]; Gonzague Privat, *L'Evénement*, 1 May [passing mention; Gonzague Privat had had a picture of his own rejected by the jury that year]; M. Proth, *Voyage au pays des peintres: Salon de 1875*, pp. 11–12; Baron Shop, *Le Petit National*, 3 and 8 May; A. Silvestre, *L'Opinion Nationale*, 7th article of "Salon"; P. Véron, *Le Journal Amusant*, 8 May. Various other critics, including A. de la Fizelière, F. de Lagenevais, A. Duparc, J. Guillemot (in the radical paper *Le Journal de Paris*) and L. Enault (in *Le Constitutionnel*) ignored Manet altogether.

Chaumelin: "Sous prétexte de représenter la nature et la société telles qu'elles se présentent, les réalistes se dispensent d'équilibrer les tableaux qu'ils en font. Mais, passons. Il y a, du moins, dans cette nature et dans cette société, des aspects plus agréables, des types plus séduisants les uns que les autres. M. Manet s'en va justement choisir les sites les plus plats, les types les plus grossiers. Il nous montre un garçon boucher, aux bras rougeauds, au profil épaté, qui canote sur un fleuve d'indigo, et se retourne, de l'air d'un marsouin amoureux, vers une donzelle horriblement fagotée et horriblement maussade, assise à ses côtés."

24 Shop, 8 May: "Ses *Canotiers d'Argenteuil* sont deux, dont une canotière. Ils se présentent de face, assis sur le même banc, l'air passablement ennuyé autant que permettent d'en juger les empâtements volontaires des figures."

25 Thorstein Veblen, *The Theory of the Leisure Class*; see, e.g., p. 55 ff.

26 Norbert Elias and E. Dunning, "The Quest for Excitement in Leisure," *Society and Leisure: Bulletin of the European Centre for Leisure and Education* 2 (1969):58–59 (the essay was first called "The Quest for Excitement in Unexciting Societies," which the authors subsequently thought too sardonic). Compare Norbert Elias and E. Dunning, "Leisure in the Sparetime Spectrum," in *Soziologie des Sports: Theoretische und methodische Grundlagen*, ed. R. Albonico and K. Pfister-Binz. The basic concept is de-veloped in Elias's *Über den Prozess der Zivilisation* (Basel, 1939), vol. 1 of which is now available in English as Norbert Elias, *The History of Manners: The Civilizing Process*, vol. 1.

27 On Saint-Denis and the arrival of *la grande industrie*, see J.-P. Brunet, "Aux origines de l'industrialisation de la région de Saint-Denis," *Etudes de la Région Parisienne*, April-July-October 1969, Jan.-April 1970; and M. Fauque, *L'Evolution économique de la grande industrie chimique en France*, pp. 119–21.

28 It was Robert Herbert who first suggested to me, in 1974, that the double aspect of Argenteuil would bear researching. I did some rather desultory work, and even some lectures on the subject, over the next few years. In the meantime, Herbert has published his own conclusions—R. L. Herbert, "Industry in the Changing Landscape from Daubigny to Monet," in *French Cities in the Nineteenth Century*, ed. J. Merriman—and a solidly researched study of the whole subject has appeared by Paul Tucker, *Monet and Argenteuil*. The present chapter was drafted before Tucker's book appeared, though he kindly let me see part of his argument in article form. I have tried to avoid merely duplicating his insights, and anyway approach the subject with slightly different questions in mind.

29 The fourth tableau of Blondeau and Monréal's *opéra-bouffe (Les Environs de Paris)* was entitled *Les Vendanges d'Argenteuil*; see p. 14.

30 Anglo-Parisian (Walter Francis Lonnergan), *Paris by Day and Night: A Book for the Exhibition*, p. 84.

31 See discussion in Phlipponneau, *La Vie rurale*, pp. 97–100, 503–5.

32 Tucker, *Monet and Argenteuil*, p. 15, gives 8,046 for 1871; J. Murray, ed., *A Handbook for Visitors to Paris; containing a description of the most remarkable objects . . .* for 1882 gives 11,876, which seems to tally with other evidence.

33 See Tucker, *Monet and Argenteuil*, pp. 15–18, 35–42, and *passim*, for thorough detailing of industrial development and suburban building. Where not otherwise indicated, dates and figures are taken from him.

34 H. Lemoine, *Le Département de Seine-et-Oise de l'an VII à 1871*, p. 49.

35 See E. Réthoré, *Argenteuil et son passé*, 3:243–47.

36 G. Poisson, *Evocation du Grand Paris: La Ban-

lieue nord-ouest, p. 254. The first rubber works was built in 1863.

37 Barron, *Les Environs de Paris*, p. 72: "par le chemin d'Argenteuil, on se hâte de fuir le spectacle monotone des carrières exploitées sur le flanc des collines aux larges sections jaunâtres, des plâtrières qui fixent dans la région toute une population d'ouvriers pauvres, des vignes, des interminables carrés de légumes dont la route est bordée." The Joanne guide *Environs de Paris* for 1878 describes the "carrières de plâtre" as employing 6,000 workers (p. 90), though this seems high. But given the itinerant character of this labour force, and of the pleasure seekers, population figures for Argenteuil do not give a good picture of the actual *occupation* of the land.

38 *Le Petit-Journal*, 27 May 1877: "*Argenteuil* (gare Saint-Lazare).—Continuation de la fête. A 2h.½, course de bicycles, organisée par l'Union vélocipédique avec la musique municipale; costume de rigueur—A neuf heures, grande retraite aux flambeaux avec la musique et les sapeurs-pompiers."

39 Louis Blairet, "Autour de Paris," *L'Opinion*, 8 June 1884: "Quand vient le dimanche, c'est une invasion à la gare Saint-Lazare; il n'y a pas une fruitière de la rue Saint-Denis, pas un ébéniste de la rue de Cléry, pas une chocolatière de la rue Vivienne, qui ne s'abatte sur le bord de la Seine, au pied du moulin d'Orgemont ou dans l'auberge des canotiers. Or, comme dit Amédée Achard, où trotte une Parisienne, passe un Parisien. Une femme représente toujours deux personnes. On chante, on crie, on danse, on court, on tombe, on s'égare. Tout commence par des entrecôtes au cresson et tout finit par des courbatures. Les bords de la Seine sont tout pleins de mystères ce jour-là, mystères de la vie intime et champêtre.

"On mange des salades de homards sur l'herbe, messieurs!"

40 See D. Wildenstein, *Claude Monet: Biographie et catalogue raisonné*, vol. 1, *1840–1881, Peintures*, nos. 370 and 337; also nos. 334, 336, 338, 368, 369. I notice since writing this that Robert L. Herbert, "Industry in the Changing Landscape," p. 269, proposes Wildenstein no. 227 as the picture on the easel. The relation of the tree and rigging to the picture's upper edge is not quite right, but it does look closer than any other. (I have heard this picture's authenticity

questioned, incidentally—even the suggestion made that it is a mock-up after the Manet!)

41 See Wildenstein, *Claude Monet*, nos. 316, 317, 334, 335.

42 See Robert L. Herbert, "Method and Meaning in Monet," *Art in America*, September 1979, for extensive discussion of how little spontaneity Monet's technique actually had—which still leaves us with the question of what the *illusion* of spontaneity was for.

43 Wildenstein, *Claude Monet*, nos. 221, 222, 223, 224.

44 Ibid., nos. 219; 327, 249; 314; 251, 354; 453.

45 Ibid., nos. 360; 242; 279.

46 See Monet's letter to Durand-Ruel, 15 February 1883, discussing a forthcoming exhibition:"If it's not too much trouble, try to see the picture of mine that Monsieur Hayem has, I have a good memory of it and it would strike a different note." In Wildenstein, *Claude Monet*, p. 447, Pièce justificative 56. Compare Tucker's very similar discussion of this picture, in *Monet and Argenteuil*, pp. 53–56, where the only point I cannot follow is the suggestion of catharsis in the final sentence.

47 See, for instance, Wildenstein, *Claude Monet*, nos. 271, 272, 201, or the distinctively unpicturesque *Moulin d'Orgemont, neige*, no. 254; the celebrated *Coqueliquots à Argenteuil*, no. 274, and nos. 220, 276, 341, 377, 379. The closest one comes to an exception is *La Plaine de Gennevilliers*, no. 437, looking back towards Argenteuil; in the foreground are piles of fresh-cut logs, and in the distance what appears to be a plough team. Compare my discussion of the related *Gelee blanche au Petit Gennevilliers*, no. 256. pp. 191–93.

48 There is disagreement between Wildenstein and Tucker about the precise motif; Tucker's comparison to the houses in Wildenstein no. 278 is surely right.

49 There is (understandably) very little literature on Ajalbert. The most useful account is R. Bernier, "Un Poète impressionniste: Jean Ajalbert," *La Revue Moderne* (Marseille), 20 January 1886.

50 Wildenstein, *Claude Monet*, nos. 348–62 (the most doubtful member of the series is the *Gelée blanche*, no. 361, though it seems thematically connected with the rest).

51 Tucker does not take them as a pair—he does not treat the Kansas City picture—but he and others provide the information which entitles one to do so. See *Monet and Argenteuil*, pp. 42, 47 (on the new house near the station), pp. 50–51 (on the proximity of the Joly ironworks), p. 52 (on the Boston picture of the Boulevard Saint-Denis). For further information, and photographs of Monet's house, see R. Walter, "Les Maisons de Claude Monet à Argenteuil," *La Gazette des Beaux-Arts*, December 1966, and the expanded version of this essay in Wildenstein, *Claude Monet*, p. 58 ff. There is brief mention of the Kansas City picture in Herbert, "Industry in the Changing Landscape," p. 155, again on its own.

52 Wildenstein, *Claude Monet*, nos. 281; 280; 282 (cf. the connected series nos. 383–86, 406, 411, 414, 415—the last two the dahlia pictures!); 285; 365. Tucker, *Monet and Argenteuil*, chap. 5, has much fuller discussion, though somewhat different emphases.

53 See Compact Edition of Oxford English Dictionary, 1971, 1:2023, "outing."

54 See, e.g., M. Marrus, ed., *The Emergence of Leisure*, for a representative selection of articles. E. P. Thompson's "Time, Work-Discipline, and Industrial Capitalism," *Past and Present*, no. 38 (1967), is the fundamental discussion of the changes brought by capitalism into the ordering of the work day and week, and the separation of activities—kinds of work and recreation—once bound up with each other. There is a growing literature on the organization of leisure in the new cities or the new edges of old ones; see, e.g., P. Bailey, *Leisure and Class in Victorian England: Rational Recreation and the Contest for Control 1830–1885*; H. Meller, *Leisure and the Changing City, 1870–1914*; H. McLeod, *Class and Religion in the Late Victorian City*; R. Q. Gray, *The Labour Aristocracy in Victorian Edinburgh*.

55 Léon Gambetta, *Discours et plaidoyers politiques*, 4:155 (speech at Auxerre, 1 June 1874): "Messieurs, j'ai dit les nouvelles couches, non pas les classes: c'est un mauvais mot que je n'emploie jamais."

Chapter Four: A Bar at the Folies-Bergère.

1 Verse 5 of "Ah! J'la Trouv' Trop Forte" ("Paroles et musique de Edouard Doyen. Chantée dans tous les Cafés Concerts"), preserved in the Archives Nationales (hereafter referred to as AN) F18 1680 (1867): "At the Ball Mabille [one of the leading dance halls of Paris in the period], between two dances, / A young man who said he was a Baron, / Offered me a townhouse and two carriages / As setting for my good taste. / Lowering my eyes, I went towards him, / But here's something new, / I see some scissors sticking out of his pocket. . . . / The Baron was only a shop assistant. . . ."

2 From a large and mostly uninformative literature on the painting, I should single out—as having at least provoked real disagreement—R. Mortimer, *Manet's "Un Bar aux Folies-Bergère"*; G. Busch, *Manet—Un Bar aux Folies-Bergère*; and André Malraux's typical addition to the *musée imaginaire*, "La Vénus des Folies-Bergère et celle de Titien," *Le Figaro Littéraire*, 28 April 1973. My previous discussion of this picture—which the present version largely disagrees with—appeared as T. J. Clark, "The Bar at the Folies-Bergère," in *The Wolf and the Lamb: Popular Culture in France, from the Old Regime to the Twentieth Century*, ed. J. Beauroy et al.

3 Edmond and Jules de Goncourt, *Mémoires de la vie littéraire*, 2:121. The French of the description of the crowd is worth giving: "des bonnets de femmes de la barrière; militaires: des enfants en képi, quelques chapeaux de putains avec des commis de magasins, quelques rubans roses de femmes aux loges . . ." The conjunction of "putain" and "commis" *is* modernity, we shall see. Compare a line from Ajalbert's "Chromolithographie" which comes just before the lines quoted in the previous chapter (in *Sur le vif: Vers impressionistes*, p. 108) and is the centrepiece of Ajalbert's description of the "cohue hebdomadaire à travers les banlieues"—"Des calicots en fête et des filles de joie." This book could be described as an attempt to explain what was meant by this pairing of terms for the "modern."

4 G. Claudin, in *Paris-Guide, par les principaux écrivains et artistes de la France*, p. 78: "A présent nous vivons beaucoup au dehors, nous fuyons tous plus ou moins l'intérieur et le foyer. . . ."

5 A. Delvau, *Les Plaisirs de Paris: Guide pratique*, p. 64: "Vivre chez soi, penser chez soi, boire et manger chez soi, aimer chez soi, souffrir chez soi, mourir chez soi, nous trouvons cela en-

nuyeux et incommode. Il nous faut la publicité, le grand jour, la rue, le cabaret, le café, le restaurant, pour nous témoigner en bien ou en mal. . . . Nous aimons à *poser*, à nous donner en spectacle, à avoir un public, une *galerie*, des témoins de notre vie."

6 C. Delon, *Notre Capitale Paris*, p. 371: "Personne n'y est chez soi: hélas! le Parisien n'a plus de chez soi. Tout le monde comme en *hôtel garni*. Si bien que l'intérieur n'ayant plus ni intimité, ni agrément, chacun est tenté de s'en dégoûter et de vivre au dehors le plus possible." (This was part of an attack on Haussmannization—even so late in the day!)

7 René Degas, letter of 17 July 1872, cited in *Degas et son oeuvre*, by P. A. Lemoisne, 1:71: "des chansons d'idiots . . . et autres bêtises absurdes."

8 Pierre Larousse, *Grand Dictionnaire universel du dix-neuvième siècle*, 3:62.

9 Ibid.; see Louis Veuillot, *Les Odeurs de Paris*, pp. 147–50. The baritone's song goes as follows: "A nest, it's a tender mystery, / A sky which springtime blesses. / To man, to the bird on the earth, / God says quietly: Build a nest!"

10 See AN F21 1338, report of November 1872, "Note sur les cafés-concerts," p. 3: "Quant aux chansons mauvaises qui auraient pu se glisser sur les programmes depuis les seize mois que fonctionne l'Inspection des théâtres, il est peut-être juste de faire observer qu'au lendemain de la Commune et de l'orgie de chants qui s'était produite pendant cette époque, il a fallu, pour la préfecture de Police, réorganiser lentement et avec peine un service complètement en désarroi et retrouver des agents suffissament capables. . . ." For a typical censor's view of the café-concert, see p. 2: "Le nombre des chansons que l'on soumet au visa est incalculable; on ne peut imaginer à quel degré de dévergondage en arrivent les auteurs de ces chansons, à tous les points de vue: morale, politique, religion, question sociale. Un très-grand nombre est refusé absolument; la plus grande partie de celles qui sont autorisées, ne le sont qu'après les plus sérieuses modifications. Quant aux chansons dont la presse s'est emparée dans ces derniers temps [i.e., complaining of Communard leftovers in the café-concert repertoire]: Les têtes de pipe, Les feignants, Les Misérables, etc. etc. . . . , elles n'ont jamais été soumises, et, par conséquent, jamais autorisées."

11 By far the best treatment of the café-concert seems to me J. Rancière, "Le Bon Temps ou la barrière des plaisirs," *Les Révoltes Logiques*, Spring-Summer 1978, which uses some of the same archival materials on which I in turn worked. Compare A. Rifkin, "Cultural Movements and the Paris Commune," *Art History*, June 1979; I especially tried to take heed of Rifkin's criticisms of my 1977 essay. The reader will find I disagree both with Rifkin's implacable view of the café-concert as a cog in the machine of social control, and with Rancière's picture of it as the site of real subversion. But I am deeply indebted to both readings. On the look of the places, see also M. Shapiro, "Degas and the Siamese Twins of the Café-Concert: The Ambassadeurs and the Alcazar d'Eté," *Gazette des Beaux-Arts*, April 1980; and (mostly dealing with the 1880s and 1890s) *Le Café-concert: Affiches de la Bibliothèque du Musée des Arts Décoratifs*, 1977.

12 See, e.g., the description in Victor Fournel's contribution to *Paris dans sa splendeur: Monuments, vues, scènes historiques, descriptions et histoire*, 2:25.

13 Camille Pissarro, letter to Octave Mirbeau, 24 November 1891, cited in "Des Lettres inédites de Camille Pissarro à Octave Mirbeau et à Lucien Pissarro," by C. Kunstler, *Revue de l'Art Ancien et Moderne*, March-April 1930, p. 187: "I count myself extremely fortunate not to have competed for the honour of daubing the walls of that edifice; I long ago visited that horrible café-concert!! . . ."

14 See, e.g., E. Lemoine, "Courrier de Paris," *L'Indépendance Belge*, 1 May 1865: " 'The future of Paris lies with the café waiter' . . . Go where you will in this Paris which Monsieur Haussmann puts up with one hand having knocked it down with the other. What is the greatest marvel you see? . . . The most marvellous thing about Paris is that as soon as a new café opens, a public is found to fill it. Houses are built which stay unoccupied, but wherever a café is opened there is an invasion." J. Gaillard points out that one of the reasons for the café boom, at least with the working class, was the increasing overcrowding at home—again helped along by Haussmannization. See Gaillard's intervention in the discussion of "La Commune et le problème de l'état," *Le Mouvement Social*, April-June 1974, p. 190.

15 Victor Fournel, *Ce qu'on voit dans les rues de Paris*, pp. 364–65.

16 The official statistic for 1872; see AN F21 1338, 1872. Maxime Du Camp offered the figure of 180 in his *Paris: Ses Organes, ses fonctions et sa vie dans la seconde moitié du dix-neuvième siècle*, 6:327 (basing himself, presumably, on the 1872 census). *Le Figaro Illustré* in 1896 gave the number as 274.

17 Veuillot, *Les Odeurs de Paris*. Bernadille, *Esquisses et croquis parisiens: Petite Chronique du temps présent*, 1st ser., p . 45, cited in note 23; Maurice Talmeyr, "Cafés-concerts et music-halls," *La Revue des Deux Mondes*, 1 July 1902, p. 178, cited in note 26.

18 J. Murray, ed., *A Handbook for Visitors to Paris; containing a description of the most remarkable objects* . . . , p. 32.

19 Admission charges are given in Murray and other guides. It seems that the Eldorado first insisted on "la renouvellement des consommations" in 1867, the year when the prefecture relaxed its regulation of the physical detail of the performances.

20 E. Drumont, *Mon Vieux Paris*, 2:213: "Le côté le plus curieux du tableau pour le flâneur qui observe, c'est l'assistance extérieure qui se donne le plaisir gratuit de saisir au vol la chanson nouvelle; ceux-là sont des Parisiens écoutant avec naïveté ces ineptes refrains qu'ils ont la prétention de répéter. Pas de risques qu'ils interrompent les chanteurs par un de ces chahuts formidables qu'organisent, c'est la mode, nos jeunes viveurs avec leurs compagnes. L'auditeur naïf ne comprend pas, s'indigne, et le provincial s'enfuit." There is the same kind of contrast pointed out in G. Coquiot, *Dimanches d'été* pp. 1–2.

21 *Mémoires de Thérésa écrits par elle-même*, pp. 232–34: "I set great store by the applause of the public in general, but I admit that I have a weakness for the less fortunate [*la partie malheureuse de la population*].

"Is it because I am a woman of the people and have been poor like them?

". . . Thus, to make up for the foreigners who don't understand a thing, in summer I have the *gamins* of Paris, who understand very well!

"There are five or six hundred of them, not inside the café-concert, but outside, gathered under the clumps of trees which surround us. . . .

". . . Among their number, there is more than one who perhaps has had no dinner.

"If we cannot appreciate him and give him enough to eat, let us give him songs to sing!"

And so on. See discussion by Rifkin, "Cultural Movements," pp. 210–12.

22 The last phrase is from L. Veuillot, *Les Odeurs de Paris*.

23 Bernadille, *Esquisses et croquis parisiens*, 1st ser., p. 35: "Trois mille personnes au moins étaient entassées là: bourgeois, petits commerçants, quelques ouvriers endimanchés, familles entières en partie de plaisir, provinciaux et étrangers."

24 H. Gardejann, *La Thérésiade: Poème en cinq chants, et en vers du huit pattes*, cited in "Cultural Movements," by Rifkin, p. 209. The passage describes Thérésa's debut at the Alcazar.

25 A. Sirven, "Les Abrutis. Quelques Types. Piliers de cafés-concert," *Le Hanneton*, 28 May 1865: "Habitués folâtres de ces établissements où la mélodie se vend et se mesure à la chope ou au petit verre, ils appartiennent en général à la caste spéciale des gandins qui ne sont gandins que le soir.

"Leur journée est occupée par un travail quelconque, bureaucratique ou commercial, et leur soirée est entièrement consacrée à l'amour platonique qu'ils ont voué à Mlle Pétronille. . . .

"Braves gens en somme pour la plupart, mais qui ont le tort, n'ayant pour humer un peu d'air et prendre la somme d'exercice nécessaire à la santé comme à l'intelligence, que les quelques heures qui suivent leur dîner, d'aller s'abrutir dans une atmosphère de fumée de tabac, aux émanations stupéfiantes de gaz, respirant à pleins poumons l'air méphitique d'une salle étroite où se pressent des centaines d'individus—Et cela pour entendre qui, je vous le demande!"

26 Maurice Talmeyr, "Cafés-concerts," p. 178 (the date of the article is very late, of course, but its terms and transitions are those established in discourse on the café-concert from the 1860s onward): "Puis, aux mêmes places, les coudoyant, beaucoup aussi de petites gens, des boutiquers, des commis, des valets de chambre, et les inévitables têtes bizarres, violentes, patibulaires. On sent là, sans barrière entre eux, dans un sans-gêne commun, la femme tarifée et la

mondaine, le repris de justice et le magistrat, les maîtres et les domestiques, les honnêtes gens et les filous."

27 Anon., "Chronique—Le Café-concert," *Le Réveil*, 29 September 1886.

28 See chapter one, note 88. For further *calicot* references, see this chapter's epigraph and the line from Ajalbert cited in note 3.

29 P. Véron, *Paris s'amuse*, p. 87: "Il y a des gens qui viennent ainsi chaque soir déposer leur tribut floral aux pieds d'une prima donna de plein vent. Ceux-là, vous les remarquerez aux tables près de l'orchestre. Ces adorateurs à vue d'oeil sont en général des *calicots* dont le magasin ferme de bonne heure, des clercs de notaire qui font l'étude buissonnière, des hommes mariés,—qui soit-disant vont au Cercle."

30 M. Vaucaire, "Café-chantant: A J. M. de Hérédia," in *Effets de théâtre*, p. 106: "They spend all their time laughing and clapping, / These bourgeois, counter-jumpers, and dandies, none of them very respectable / Who call out to the singer and beckon her. / Here one is happy, one drinks, one sings, one can smoke / And keep one's hat on so as not to catch cold."

31 G. Montorgueil, *Le Café-concert: Lithographies de H.-G. Ibels et de H. de Toulouse-Lautrec*, p. 11, on the Mirliton: "Les commis-voyageurs en bordée et les grandes dames en débauche." Compare Alphonse Daudet, *Fromont jeune et Risler aîné*, p. 368, on the café-concert audience: "des petits commerçants du quartier avec leurs dames et leurs demoiselles" (cited in "Degas," by Shapiro, p. 153).

32 Anglo-Parisian, *Paris by Day and Night*, p. 221. Guidebook writers were unable to make up their minds as to a convenient shorthand for the café-concert's public. Baedeker (*Paris and Its Environs: Handbook for Travellers*, p. 17) in 1872 said that the establishments on the Champs-Elysées "afford unbounded delight to the middling and lower classes of Parisians." *Galignani's Illustrated Paris Guide for 1879*, p. 236, avoided the issue: "Cafés-concerts or chantants are the favourite evening lounge of the Parisian *bourgeois*, who does not object to hearing favourite songs and other music, while regaling himself." Murray retreated from his 1872 verdict to this, in his 1882 *Handbook for Visitors* (p. 109): "*Café-Concerts* or *Chantants*. These are all of the 'Music-hall' order, both in the style

of their entertainment and in the class of their frequenters." Parallels between the café-concert and the music hall are real; see G. Stedman Jones, "Working-Class Culture and Working-Class Politics in London, 1870–1900," *Journal of Social History*, Summer 1974, pp. 490–97. The questions raised here about the music hall's place in a complex class culture very much influenced my approach to the French case.

33 From the growing literature on "popular culture," the following items were most helpful to my discussion: G. Stedman Jones, "Working-class Culture"; Clement Greenberg, "Avant-Garde and Kitsch," in *Art and Culture*; Theodor Adorno's various splenetic essays on jazz; Philip Cohen, "Sub-Cultural Conflict and Working Class Community," *Working Papers in Cultural Studies*, Spring 1972; S. Hall and T. Jefferson, eds., *Resistance Through Rituals: Youth Subcultures in Post-war Britain*; Roger Taylor's swingeing *Art: An Enemy of the People*, especially chap. four, on jazz; Tom Crow's "Modernism and Mass Culture in the Visual Arts," in *Modernism and Modernity*, ed. S. Guilbaut and D. Solkin. This is an oddly heterogeneous list, I realize, but that testifies to the healthy state of the subject. It has not yet (not quite) become a "field." A good essay I read after writing this chapter is S. Hall's "Notes on Deconstructing 'The Popular,' " in *People's History and Socialist Theory*, ed. R. Samuel. There is suggestive material also in R. Holt, *Sport and Society in Modern France*, and in some of the items on the petite bourgeoisie recommended in chapter three, notes 14 and 54, especially those by R. Q. Gray.

34 T. S. Eliot, "Marie Lloyd," in *Selected Essays*, pp. 456–58.

35 "Villanelle de Max Dapreval, Chantée par Mlle Thérésa de l'Alcazar Lyrique." The printed sheet music I used can be found in AN F18 1680 (1865), among other banned material, with the censor's "Non" scrawled across it. This does not mean it was never performed, of course, but is evidence that occasionally the censor was sensitive to its *doubles-entendres*. ("How I love to see your white breast / Whose whiteness rivals that of milk: / Its twin billows that swell and overflow, / And seek to escape from corset's confines. / —I know your refrain, come back on Sunday / Sir, paws down if you please! / —Look at the bowl from which you quench

your thirst, / One would say that its handle was broken. / Permit me to put the handle back on: / It's my trade, I've always been good at it," etc.) Sunday, by the way, turns out to be the day the couple will be married; so the song is "moralized" in the end, in a way that is typical of the official café-concert repertoire.

36 Veuillot, *Les Odeurs de Paris*, again quoted in Larousse's *Grand Dictionnaire*.

37 AN F18 1680 (1864), Alcazar.

38 Gustave Geffroy, *Yvette Guilbert*: "Pour les autres [those Parisians who are not content with the interior], l'important, qu'ils l'avouent donc, est de sortir de chez eux où ils s'ennuient, et de s'en aller n'importe où chercher la lumière, le bruit, et la complicité tacite de la foule, des êtres semblables à eux, de la cohue des ennuyés."

39 I realize the echoes here of Walter Benjamin's famous description of film: "Reception in a state of distraction, which is increasingly noticeable in all fields of art and is symptomatic of profound changes in apperception, finds in the film its true means of exercise. The film with its shock effect meets this mode of reception halfway. The film makes the cultic value [of art] recede into the background not only by putting the public in the position of the critic, but also by the fact that at the movies this position requires no attention. The public is an examiner, but an absent-minded one" ("The Work of Art in the Age of Mechanical Reproduction," in *Illuminations*, pp. 242–43).

40 Edgar Degas, letter to Lerolle, in *Lettres de Degas*, ed. M. Guérin, p. 57; cited in "Degas," by M. Shapiro, pp. 158–59. Compare Mallarmé's verdict in his newspaper, *La Dernière Mode*, "Chronique de Paris," 4 October 1874: "tout ce domaine de joie, de belle humeur, de gouaillerie magistrale, qu'installe autour d'elle, mais sans le partager avec aucun, cette femme toujours étonnante, Thérésa!" (Stéphane Mallarmé, *Oeuvres complètes*, p. 751).

41 J. Vallès, *Le Tableau de Paris*, p. 200; cited in "Le Bon Temps," by Rancière, p. 52. See Rancière's whole discussion of Thérésa, pp. 51–54.

42 Anon., *Le Réveil*, 29 September 1886: "J'ai eu autrefois pour Thérésa beaucoup d'admiration. Il me semblait que dans cette grosse voix aux notes graves vibrait une âme du peuple. Elle me remuait et me donnait le frisson; plus d'une fois, elle m'arracha des larmes. Depuis deux ans, je vais à ses rentrées comme vers une ancienne amie, cherchant cette impression passée qu'elle ne réveille plus. Sa belle diction si forte et si nette s'est gâtée par la prétention, la pompe et la solennité. Elle s'imagine sans doute qu'elle est maintenant une force sociale et que chacun des mots tombés de ses lèvres se répercute dans le monde. Elle accueille sans discernement des chansons ineptes et cherche à colorer ces paroles vides d'une sentimentalité redondante et d'un faux pittoresque. Au lieu de l'art brutal et sincère qui m'avait ravi, la chanteuse laisse voir un procédé uniforme et la recherche de l'effet violent." She sang "Le Sapeur," apparently, as if now a mere *gaudriole* was beneath her. The hall's verdict was that "elle *pontifiait* son sapeur."

43 The latter triumph is recounted in Gaston Jollivet, *Souvenirs de la vie de plaisir sous le Second Empire*, p. 252. Khalil-Bey, the Turkish admirer of Courbet's erotic art in the 1860s, was reputed to have given Thérésa two diamonds together worth 10,000 francs. But it would be wrong to paint her success as uncontested: there were plenty of people who followed Veuillot and Larousse in finding her "la muse de l'horrible" (L. Ulbach, "Courrier de Paris," *L'Indépendance Belge*, 6 May 1865). She provided a natural term of comparison in 1865 for critics wishing to abuse *Olympia*. Bertall in one cartoon imagined Manet repenting of his picture as follows: "M. Manet nettoie la place de son chat, envoie son bouquet à Thérésa, et sa charbonnière aux Batignolles" (*L'Illustration*, 17 June 1865, p . 389). Compare Olivier Merson's calling *Olympia* "l'enseigne de la Femme à Barbe"— one of the songs that had made Thérésa's name.

44 Impavidus, "Correspondance parisienne," *La Rive Gauche*, 18 June 1865: "Dernièrement, une rixe dont elle était le sujet, a eu lieu aux Champs-Elysées entre la police et la foule des badauds et de gandins venus pour l'entendre. Quelques sergents de ville ont reçu des horions, paraît-il, et ont du dégaîner, mais le sang n'a pas été répandu.

"Quel grand peuple que celui qui sait se battre pour une chanteuse de brasserie, et ne sait rien faire pour conquérir sa liberté!"

45 Hector Berlioz, *Le Figaro*, 4 April 1848: "You love music and have no fear of alcohol and the smell of tobacco. Then go to the Passage Jouf-

froy . . . around ten at night, when the crowd is as thick as the pipe smoke, if you manage to find a free seat in the house, you will see a strange man come on stage. . . . It is Darcier. . . . His face already expresses the character of the person whose grim or naïve or lamentable history he is about to sing. . . ."

46 Jollivet, *Souvenirs*, p. 253: "elle jetait, du creux de son magnifique contralto, son défi révolutionnaire aux patrons exploiteurs du 'pauvre peuple.' "

47 The evidence preserved in the Archives Nationales, especially the boxes F18 1338, 1350, 1680, 1681, affords quite a full picture of the censor's activities—the licensing regulations, the regular moves to tighten them, lists of censored songs, the song sheets of songs refused a license for performance at the main cafés-concerts, occasional reports of police spies, the censor's annual statement to the minister, etc. Rancière, "Le Bon Temps," has an incisive discussion, particularly of the political dimension of censorship, on pp. 38–42.

Cafés-concerts were supposed to submit copies of their programme *every morning* to the bureau, and no substitutions of any kind were permitted. Proprietors were not slow to point out the sheer impracticability of such a system. Nevertheless, it survived with very little modification: a letter of 25 April 1887, signed by the owners of the leading establishments, is still complaining of the old restrictions and inflexibilities (AN F18 1338).

48 Paulus, *Trente Ans de café-concert: Souvenirs recueillis par Octave Pradels*, pp. 70–71 ("Le Baptême du p'tit ébéniste, paroles Emile Durandeau, musique Charles Plantade"): "Over there, over there, at the end of the earth, / Over there, far away, close by the Luxembourg, / Was an old man, a popular songmaker / Béranger / O! that one, let's always hold him in high esteem. / How I love to see around this table / Sawyers, / Cabinetmakers, / Builders, / How like a bunch of flowers it is. / Little Léon, on your mother's breast / You have never known adversity: / You have not seen the flag of your fathers / Sullied with mud, covered with iniquity. . . . / But, without wishing to talk politics, / Let's all shed a tear for him who has gone; / The enemy shut him up on an island / Where he died! that great legislator. . . . Let's leave, let's leave to vulgar debauchees / The search for love in carnal

pleasures, / True love, ah! it's that of a father / Who gives to the world a little newborn child. . . . / And why are we not concerned for the mother / Who even now is still confined to her bed, / She has suffered much more than the father / Who has had all the joy. . . ."

49 AN F18 1680, "L'Etoile des concerts," submitted by the Eldorado and rejected 15 Feb. 1867: "Since it is necessary, and to please you, / I speak in argot like a ragpicker, / I adopt a fishwife's voice, / And the manners of a lackey; / I kick up my legs better than Clodoche, / I don't sing as well as Malibron, / I am as distinguished as Gavroche. . . . / Well, what do I care! I earn a hundred thousand francs."

50 See, e.g., AN F18 1338 (1853) for a "Liste des chansonnettes interdites, qui ne peuvent être chantées ni sur les Théâtres, ni dans les concerts, cafés concerts . . . ," from which my titles are drawn. (Among the others is an "Appel au Béranger," which goes to show, quite typically, that even the good Paulus's effects could be turned to bad uses. There is a distinctly Courbetiste flavour to many of the songs, not surprisingly at this date: "L'Aumône du pauvre," "Hymne aux paysans," "Jean raisin," "Le Médecin de campagne," "Le Rentier," "Le Vrai paysan," and even "La Noce de l'enterrement.") AN F18 1681 contains material showing the censor's renewed push against political material in the early 1870s, after the Commune. There are 187 censored songs in October–December 1872 alone, considerably more than in any whole year during the 1860s. Most of the censored songs are obscene or *revanchiste*—there is only a smattering of "social" ballads bewailing the poor worker's fate. But some extraordinary Communard songs do get as far as the censor's office, as Rancière points out in his discussion in "Le Bon Temps," pp. 38–42. (I think Rancière somewhat overestimates the political explosiveness of the café-concert repertoire on the basis of these exceptional post-Commune years; but he could reasonably counter that it is only in such periods that the always present political subtext of the "popular" bubbles up into the censorship records.)

51 See, e.g., AN F18 1338, file on the Café-concert de la Scala, April 1887, a spy's exultant transcription of an interpolated verse in "Le Piston d'Hortense": "Oh! je voudrais être l'étui / Où tu sers ce piston, j'te l'jure. / De cet instrument

si joli / Je voudrais être l'embouchure. . . ." The café was closed for one day for the offence.

52 Marc-Constantin, *Histoire des cafés-concerts et des cafés de Paris*, pp. 93–94.

53 Bernadille (Victor Fournel), "Le Café-concert de La Pègre: 2 Août 1872," in *Esquisses et croquis parisiens*, p. 50: "Rien de particulier à dire des chanteurs,—sinon qu'ils ont des gants blancs et des habits noirs, les malheureux,—cela flatte le public,—mais quels habits et quels gants!

"J'ai retenu les titres des principales chansons: . . .

"Dans cette dernière chanson, comme dans quelques autres, on n'a pas manqué d'intercaler un couplet patriotique, d'une monstrueuse ineptie, que le ténor débite avec une emphase ridicule et qui est accueilli par un tonnerre d'applaudissements. Cette façon d'accoler le patriotisme à l'obscénité fait souffrir comme la plus ignoble des profanations. Car est-il besoin de dire que toutes les chansons dont je viens de transcrire les titres ne sont que des tissus d'allusions et d'équivoques ordurières, bien dignes d'un tel public!"

54 Again, AN F21 1338 and F18 1680 are full of material, including titles of censored songs, for example—"Joli! mais trop p'tit" (4 May 1864, Alcazar), "La Moitié de ça suffit" (3 August 1864), "Tout ça c'est à moi" (16 August 1864, Alcazar), "Comment qu'ça s'fait?" (29 January 1865, by Suzanne Lagier, Eldorado), "Tu peux t'fouiller" (4 May 1865, Bastille), "C'est ma chandelle" (20 April 1866, Alhambra), "La Petite Flûte" (5 November 1866), and a regular diet of songs celebrating prostitution, such as "La Biche au Bois de Boulogne" (6 November 1865, Bastille), "La Ronde des cocottes" (28 December 1865, Dix-Neuvième Siècle), "La Batignollaise" (2 April 1869).

55 This typical note is struck in AN F18 1338 (Alhambra file), report of Philippe de Forges, 4 November 1867: "Samedi dernier, je suis entré au café-concert de l'Alhambra, situé rue du faubourg du Temple.

"J'ai entendu un morceau dont un couplet m'a paru d'une obscénité révoltant et, du reste, le public en a parfaitement saisi le côté dégoutant.

"J'ai alors demandé au régisseur de me montrer le visa du Ministère. Il ne m'a donné que de très mauvaises raisons et je n'ai pu obtenir que le titre de la chanson.

"Elle est intitulé: *le règne du garçon meunier*; et je l'ai vainement cherchée ce matin sur les registres de la Commission d'Examen. Elle est inconnue."

56 Bernadille, "Les Cafés-concerts," in *Esquisses et croquis parisiens*, p. 45: "La première partie de la soirée s'est terminée par une chanson très résolûment anti-socialiste dont j'ai retenu ces quatre vers: [Since all men are brothers, / I demand that those who haven't a sou / Receive a regular income / From those who sleep in luxury.]

"Les blouses blanches elles-mêmes riaient à ventre éboutonné, et je me suis levé alors, pour partir sur la bonne bouche."

57 See Marc-Constantin, *Histoire des cafés-concerts*, p. 98, on the crowd in Le Grand Café Parisien: "Les poings crispés et l'oeil hagard, elle préconisait *la Canaille*, dont le refrain était: J'en suis! J'en suis!"

58 O. Zunz, "The Organization of the American City in the Late 19th Century," *Journal of Urban History*, August 1977, p. 465.

59 Cited in "Religion, Culture and Social Class in Late 19th and Early 20th Century Edinburgh," by R. Q. Gray, in *The Lower Middle Class in Britain 1870–1914*, ed. G. Crossick, p. 143.

60 For example, by Gray, "Religion," pp. 147–51: "Large-scale business investment in leisure and communications media was thus associated with a transformation of popular forms, rendering them more acceptable to respectable audiences. The downward transmission of elements of high culture was another aspect of the same process." Such developments are seen by Gray as part of a complex reorganization of bourgeois hegemony, one in which a crucial separation was effected between the "lower-middle class" and its inferiors; cf. A. Mayer, "The Lower Middle Class," pp. 417–18: "Because of their high literacy, the new-fledged petits bourgeois, together with the traditional Kleinbürger—rather than the less educated industrial workers—became the first avid consumers of commercialized popular culture, made possible and profitable by ongoing advances in the technology of mass communications. Media and audience found each other. The penny press, followed by the illustrated periodical, the six-shilling book, the lantern slide, the radio, then the film, and finally television, catered to a mass audience of literate but essentially uncultivated petits bourgeois."

61 For the petit-bourgeois consumer of culture in the twentieth century, the available form of popular art has been black American music, and that is where my notion of collective vehemence was picked up—from kinds of blues singing and shouting, from improvised ensemble playing, from Charlie Parker's way with the themes and harmonies of white popular music, from Little Richard and Fats Domino. But this kind of list is more than usually misleading here: the effect we are talking about does not for the most part lead to "masterpieces," and can be found almost anywhere, often surrounded by pure shlock.

62 See chapter one, note 88. Compare A. Daumard, "Progrès et prise de conscience des classes moyennes," in Braudel, p. 777: "Studying the personnel of the Commune in 1871 one is struck by the way in which employees and workers to some extent join forces [*une certaine jonction qui s'opère entre les employés et les ouvriers*]. A phenomenon of crisis, no doubt, the causes of which are complex (economic, but also political and patriotic), but nonetheless one which deserves attention."

63 Veuillot and the Goncourts most insistently, but it was a constant theme. Consider, e.g., A. Chadourne, *Les Cafés-Concerts*, p. 7: "Is it having nothing better to do, or ennui, or indifference, or the pleasure of paying three francs for a glass of bad beer which makes people go in crowds to these places?"; T. Natanson, "Autour du café-concert d'été," in *Badauderies parisiennes: Les Rassemblements, physiologies de la rue*, ed. O. Uzanne, p. 143: "These people are too ordinary. Their uniform satisfaction prevents one from noticing anything about them."

64 Georg Simmel, "The Metropolis and Mental Life," *On Individuality and Social Forms: Selected Writings*, pp. 329–30. Compare Henry James's description of the telegraphist heroine of his "In the Cage," in *Eight Tales from the Major Phase*, p. 177: "The girl was *blasée*; nothing could belong more, as she perfectly knew, to the intense publicity of her profession; but she had a whimsical mind and wonderful nerves; she was subject, in short, to sudden flickers of antipathy and sympathy, red gleams in the grey, fitful needs to notice and to 'care', odd caprices of curiosity." The story was written in 1898.

65 The following list of criticisms is again far from complete. Items with some substantial or interesting discussion of *Un Bar* I have marked * (they are few), and I have also mentioned those which ignore Manet altogether.

Anon., *Le Courrier de l'Art*, 22 June, p. 292; Anon., *La Défense Sociale et Religieuse*, 3 May; Anon. [E. Soldi], *La Nouvelle Revue* 16: 690–91; Anon., *La Paix*, 11 June; Anon., *Le Petit National* (no mention); P. Burty [unsigned], L. Adam, *Le Carillon*, 10 June; *Paul Alexis, "Avant le salon," *Le Réveil*, 1 April (a radical paper, which published on 15 May and 6 June a brilliant attack on the salon, "La Salonnerie," by Jules Vallès); P. André, *Le Petit Caporal* (no mention); Caroline de Beaulieu, *Salon de 1882: Publié dans La Mode Actuelle*, Versailles 1882, pp. 1–2; Emile Bergerat, *Le Voltaire*, 10 May; D. Bernard, *L'Univers Illustré*, 27 May, p. 326; Emile Blémont, *Le Réveil*, 13 May; Bob, *La Vie Parisienne*, 6 May, p. 270 (caricature); P. Brill, *Le Français*, 1 May (duplicate of the unattributed text in *La Défense Sociale et Religieuse*); *La République Française*, 1 May; Carolus, *Le Corsaire*, 4 May; P. de Charry, *Le Pays* (9 long articles, no mention); *Ernest Chesneau, *Annuaire illustré des Beaux-Arts: 1882*, Paris 1882, p. 223; C. Clément, *Le Journal des Débats* (no mention); *Jules Comte, *L'Illustration*, 20 May, p. 335; G. Dargenty, *La Justice* (Clemenceau's paper; no mention in 7 articles); P. Demeny, *La Jeune France*, 1 June, p. 105; Draner, "A Travers les expositions," *L'Univers Illustré*, 27 May, p. 329; E. Drumont, *La Liberté* (no mention); *Dubosc de Pesquidoux, *L'Union*, 15 June; Maurice Du Seigneur, *L'Artiste*, June, pp. 648–49; "F," *La Vie Parisienne*, 13 May, p. 282; C. de Feir, *Guide du Salon de Paris 1882*, Paris 1882, p. 23; Fichtre, "L'Actualité, avant le Salon," *Le Réveil*, 30 April (identifies *Un Bar* as "le portrait d'une des boutiquières des Folies-Bergère, Mlle Vallentine"); H. Flamans, *La Vérité*, 9 June; Charles Flor, *Le National de 1869*, 10 May; J. Gautier, *Le Rappel* (no mention); A. Genevay, *Musée des Familles*, July, p. 267; Gros-Gnon, "La Revue," *L'Opinion Publique*, no. 198, May; E. Guillon, *L'Ordre*, 6 May; O. Havard, *Le Contemporain* 39: 1047–75 (no mention); A. Hepp, *Le Voltaire*, 2 May; E. Hoschedé, *Impressions de mon voyage au Salon de 1882*, Paris 1882, pp. 50–51 (pamphlet dedicated to Manet, with excellent colour plate of *Jeanne* on the cover); its entry on *Un Bar* is strikingly flimsy, concentrating on the "marvellous" painting of the fruit, flowers, flasks,

and champagne); *Henri Houssaye, "Le Salon de 1882," in *L'Art français depuis dix ans*, Paris 1883, pp. 241–42 (originally published in *La Revue des Deux Mondes*); A. Hustin, *L'Estafette*, 23 May; R. Kemp, *L'Opinion*, 29 April ("Manet, *le Bar au F-B*, que tout le monde s'accorde à trouver charmant"); P. Lafargue, "Les Femmes nues du Salon," *Le Citoyen*, 23 May (dazzling article by Marx's son-in-law, in Guesdist paper; no mention of Manet; cf. Vallès's "La Salonnerie"); P. Leroi, *L'Art* (no mention); L. Leroy, "La Révision du Salon de 1882," *Le Charivari*, 9 May; C. Le Senne, *Le Télégraphe*, 28 April and 2 May; Comtesse Louise, *La France Nouvelle*, 20 May; J. Mériem, *Tableaux et statues* (*Salon de 1882*), Paris 1882 (no mention); Gonzague Privat, *L'Evénement*, 30 April; Un Refusé, *Le Monde Parisien* (no mention); *Revue du Salon de 1882 par un comité d'artistes*, Paris 1882 (no mention); H. Rondel, *Lettres à une dame sur la peinture au Salon*, Paris 1882 (no mention); Saint-Juirs, *Guide critique du Salon de 1882*, Paris 1882, p. 9; A. Silvestre, *La Vie Moderne*, 3 June; H. de Sta, *1882 Comic-Salon*, Paris 1882, p. 31; Stop, *Le Journal Amusant*, 27 May, p. 5; Tamerlan, "Le Salon comique," *Le Clairon*, 13 May; M. de Thémines, *La Patrie*, 30 April, 9 May (this critic's attack on Manet and Antonin Proust elicits an anonymous letter, to which he duly replies on 15 May); Timoléon, "Notes critiques," in *1882 Comic-Salon*, by H. de Sta, p. 11; Jules Vallès (see Alexis); P. Véron, *Le Journal Amusant*, 6 May, p. 3.

The reader may notice some rough-and-ready correlation by now between radical political leanings and approval of Manet. It does exist in 1882, though there are notable exceptions: Hoschedé's enthusiasm, though vapid, is genuine and untainted by politics; Clemenceau's paper, in which one might have expected to see Geffroy expatiate on Manet's modernity, keeps silence; and so on. Certainly it was commonplace by now, and probably not mistaken, to regard Manet as a dreadful Gambettist.

66 Alexis: "Debout devant son comptoir, une belle fille, bien vivante, bien moderne, bien 'Folies-Bergère' par l'expression de son visage maquillé, se livre à son petit commerce. On la revoit de dos, dans la glace qui se trouve derrière le comptoir; glace qui reproduit toute la salle, avec ses lustres, la foule animée et grouillante, et, là-bas, bien au fond, un rougeoiement qui est le velours rouge des loges; glace, dans un coin de laquelle on voit encore reflété, le visage à favoris d'un client, d'un adorateur sérieux peut-être, qui parle de près à la jolie vendeuse. Enfin, au premier plan, sur le comptoir, éclate un amusant et bariolé étalage: flacons de liqueurs, bouteilles de champagne, mandarines sur une coupe en cristal, fleurs dans une verre, etc., le tout rendu comme Manet sait rendre les natures-mortes.

"Telle sera, pour moi, la grande curiosité du Salon, la plus exactement moderne et la plus typique des oeuvres exposées. Peut-être, et je ne crois pas me tromper en le lui prédisant, Manet va-t-il obtenir, en outre, un succès de public au moins égal à celui du *Bon Bock*" (the latter had been shown in the 1873 Salon, to a generally favourable reception).

67 Gonzague Privat's unkind description of the Pertuiset picture, which showed the hunter with the carcass of a lion: "Le *Bar des Folies-Bergère*, de Manet, est autrement intéressant. Quelle revanche du Pertuiset assassinant sa descente de lit au désert." (This is Privat's only mention of Manet in a series of twenty-five articles!) Several others critics in 1882 made jokes about the Pertuiset portrait and Proust's efforts for his friend; see, e.g., de Thémines, Timoléon, Genevay. On the Pertuiset picture, see E. Darragon, "Manet et la mort foudroyante," *Avant-Guerre*, no. 2 (1981). (My thanks to Theodore Reff for this reference.)

68 Comte: "Une jeune femme debout au comptoir d'un bar; devant elle les divers flacons et bouteilles qui attendent le consommateur; derrière, une glace dans laquelle se reflète la salle, et au premier plan, la figure d'un habitué qu'on aperçoit causant avec la même femme vue de dos, voilà le sujet, que nous prenons tel qu'il nous est donné, sans le discuter. Mais ce qui nous frappe tout d'abord, c'est que cette fameuse glace, indispensable à l'intelligence de tous ces reflets et de toutes ces perspectives, n'existe pas: M. Manet n'a-t-il pas su la faire, ou bien a-t-il trouvé que l'*impression* était suffisante? Nous n'aurons garde de répondre à cette question; nous notons seulement ce fait, que tout le tableau se passe dans une glace, et qu'il n'y a pas de glace. Quant aux incorrections de dessin, quant à l'insuffisance absolue de la figure de la femme qui est, en somme, le seul personnage, quant au manque de correspondance entre les objets réflétés et leur image, nous n'insisterons pas; ce sont lacunes familières à MM. les im-

pressionnistes, qui ont d'excellentes raisons pour traiter de haut le dessin, le modelé et la perspective. Du moins, nous avions toujours entendu raconter que le premier mérite de M. Manet avait été de montrer les hommes et les choses avec leur couleur vraie, dans l'atmosphère qui les environne; voyons comment ce beau principe est appliqué ici: le bar et la salle sont éclairés par deux globes de lumière électrique, de cette lumière blanche et aveuglante qu'on sait; or M. Manet a probablement choisi le moment où les appareils ne fonctionnaient pas, car jamais on ne vit lumière moins éclatante, les deux globes de verre dépoli ont l'air de lanternes aperçues au travers d'un brouillard d'hiver." Comte stresses that he has deliberately restricted himself to observations "qui portent sur des faits, non sur des appréciations"—see my discussion in the text.

69 Dubosc de Pesquidoux (this entry is worth quoting as a whole, coming as it does from an intelligent Catholic critic who had had his say in 1865): "M. Manet, qui a fondé sa réputation en renchérissant sur Courbet, se distingue dans le débordement actuel du réalisme, non par la superiorité du sujet, mais par l'excentricité de la facture et les bizarreries de l'exécution. Sa dame de comptoir au *Bar des Folies-Bergère* est une de ces amusantes fantaisies ou gageures dont l'auteur a le monopole. Vêtue d'un corsage bleu, faisant face aux chalands, elle se reflète dans la glace posée derrière son dos et cause avec un interlocuteur qu'on ne voit, lui, que dans le miroir. On juge de l'effet de ce trio d'images ainsi groupé. Rondement brossée, d'un cachet local irréprochable, cette dame de comptoir arrête tout le monde. Debout, ses cheveux blonds coupés ras sur le front, les mains appuyées contre la table, au milieu de bocaux, de bouteilles et de coupes remplies d'oranges, elle ressort sur le fourmillement des spectateurs. La lumière toutefois est tellement indécise qu'il est difficile de distinguer si elle est produite par le jour ou des flambeaux. Mais la réalité est pour ainsi dire palpable.

"La foule du fond, assise dans les galeries, ébauchées à la façon des tauromachies de Goya, s'agite et revit avec une étonnante intensité. En somme, le tableau, qui est une espèce de fantasmagorie picturale, obtient un joli succès de curiosité, et le mérite." The persistence of terms in the discourse on Manet is striking (Realism, Goya, "fantaisie," irreproachable grasp of par-

ticular tones and local colours), as is the modification of their overall meaning. The conjunction of "palpable reality" and "pictorial phantasmagoria" would have pleased Walter Benjamin.

70 Le Senne, 2 May: "Les mêmes Philistins se sont livrés hier à des plaisanteries d'un goût douteux devant les *Folies-Bergère* de M. Manet, mais l'impression générale a été excellente.

"La marchande, sa toilette collante faisant ressortir une anatomie médiocre et d'autant plus parisienne, sa coiffure basse, le miroitement du regard, la tension des bras, tout cela est d'une observation profonde et d'un heureux rendu. Ce qui reste condamnable et surtout regrettable, c'est la tonalité bleuâtre et trouble. La lumière de l'école Manet est une bulle d'eau de savon tamisant un rayon de lumière électrique."

71 Du Seigneur (follows a description of Ernest Duez's picture *Autour de la lampe*): "Ce tranquille intérieur bourgeois inspirera plus d'un François Coppée; la famille c'est excellent, mais on n'est pendu pour aller recueillir quelques documents humains ou féminins aux Folies-Bergère—*Le Bar* par M. Manet nous donne presque envie d'y aller, un de ces soirs, pour comprendre, sur nature, la vérité du reflet de la salle, dans la glace. Je ne nierai pas que M. Manet ne soit dans le vrai; la demoiselle de comptoir, avec ses cheveux coupés sur le front, son air embêté, les fioles de Champagne, les bouteilles de liqueurs multicolores, les oranges en pile, les sucres de pommes en faisceau, sont pris sur nature ... mais ce diable de reflet nous donne à réfléchir—'C'est crânement peint tout de même!' N'est-ce pas?"

72 Feir: "Manet: Effet de glace difficile à comprendre; la tête de la femme assez agréable."

73 E. Bergerat: "Voilà une chose vue, sincère, nouvelle et qui secoue nos routines! D'ailleurs la belle fille en robe noire-bleue qui tient le comptoir est excellemment dessinée, modelée sur un beau ton local, franche de coloris, naturelle de pose et tout pleine de caractère. Que vous faut-il donc? La plantation du tableau? Je n'en sais pas de plus spirituelle. J'accorde que l'effet de reflet dans la glace ne se comprend pas du premier coup. Mais quelle loi en art décrète que les effets doivent être saisis et perçus dès l'abord? Je suis demeuré trois jours à Amsterdam sans rien voir à la *Ronde de nuit*. Vous

pouvez bien donner trois minutes à Manet."

74 See Le Senne, 28 April: "La composition est originale et le rendu charmant. Une femme devant un comptoir; et, dans une glace, le théâtre venant se peindre tout entier. . . ." The blithe tone was widespread in 1882.

75 Stop: "(Son dos se reflète dans une glace; mais, sans doute par suite d'une distraction du peintre, un monsieur avec lequel elle cause et dont on voit l'image dans la glace, n'existe pas dans le tableau—Nous croyons devoir réparer cette omission.)"

76 Flor: "Le *Bar aux Folies-Bergère* est intéressant et ingénieux. La marchande est vue de face, et l'on aperçoit derrière elle, dans la glace à laquelle elle est adossée, toute la salle avec ses spectateurs, son mouvement pressé des pourtours, ses lumières aveuglantes. La femme est bien campée, dans un mouvement naturel un peu brutal. Les premiers plans sont tenus par des natures mortes magistralement traitées."

77 Beaulieu: "En France ce qui est ridicule ne dure pas. Aussi est-on frappé du petit nombre des toiles amidonnées de l'école impressionniste, dont le chef a daigné prendre le crayon et dessiner les accessoires du *Bar aux Folies-Bergères* [*sic*]; M. Manet lui-même a vraiment peint avec une sûreté et une vérité de ton remarquables, de nombreuses fioles fort bien distribuées, et une corbeille de mandarines tres réussie; la marchande en est tellement surprise qu'elle en est paralysée sur place. L'an prochain, les figures de M. Manet auront le mouvement et la grâce, croyez bien que cet artiste peindra comme l'*École*, maintenant qu'il est décoré."

78 Bergerat; see note 73 above.

79 Du Seigneur; see note 71 above.

80 Le Senne; see note 70 above.

81 Houssaye: "Il paraît que ce tableau représente un *bar* des Folies-Bergère; que cette robe bleu criard [*sic*], surmontée d'une tête de carton comme on en voyait jadis aux vitrines des modistes, représente une femme; que ce mannequin aux formes indécises et à la face sabrée de trois coups de brosse représente un homme, et que ce moignon qui tient une canne représente une main. Il paraît encore que les ombres vacillantes qui s'agitent dans le fond, devant la façade du nouvel Opéra, avec des ballons flottant au-dessus d'eux, représentent, réfléchis par une glace, le public des Folies-Bergère, la scène

où s'exercent les gymnastes et les globes de lumiere électrique. Nous serions bien tenté de feindre la foi du charbonnier et de passer tout de suite à une autre toile. Mais on nous dirait que notre critique n'est pas sérieuse. Comme si la peinture de M. Manet était sérieuse. De bonne foi, faut-il admirer la face plate et plâtreuse de la *bar-girl*, son corsage sans relief, sa couleur offensante? Faut-il admettre que le peintre a réussi, au moyen d'un peu de poussière blanche épandue sur le dos de la jeune femme, à donner l'illusion d'une scène réfléchie dans une glace? Ce tableau est-il vrai? Non. Est-il beau? Non. Est-il séduisant? Non. Mais alors qu'est-il?"

82 Chesneau (again worth quoting in full: the comparison with 1865 is interesting; by now a reading of Manet's art as essentially concerned not with "subject" but "vision" has been confidently stabilized, and it allows Chesneau to be quite pleased—as pleased as he is brief—about the former): "Ceux qui redoutent comme nous les niaiseries et les fadeurs où mène infailliblement la recherche des 'sujets distingués' en peinture, sont servis à souhait en ce dernier tableau de M. Manet. Il n'est pas permis d'être plus 'fille' que la créature installée par l'artiste derrière le marbre du bar chargé de fruit et de flacons. Ce n'est pas en quoi nous voyons l'essentiel mérite de son oeuvre. Ce mérite est dans la juste vision des choses, de leur coloration, de leur vibration lumineuse, de leur apparence ondoyante et passante si fugitive, si rapide. Là est le triomphe de M. Manet; il n'immobilise pas les formes, comme le fait M. Béraud en des sujets analogues, il les surprend en leur effective mobilité, et l'on ne garde pas de ses tableaux une impression plus arrêté, plus nette que de la réalité en mouvement. C'est une formule d'art très neuve, très personnelle, très piquante, conquête directe de l'artiste sur le monde des phénomènes extérieurs et qui ne sera point perdue pour l'avenir. . . ." Modernist discourse has arrived: the stab at prophecy in the last sentence sounds the distinctive note.

83 Tamerlan: "Une jeune personne préposée au bar—en français buffet—prend une figure des plus innocentes pour faire croire qu'elle ne sait pas que sa soeur jumelle s'en fait conter derrière elle, par un monsieur calé.—Hypocrisie! Tu te glisse donc jusque dans le sanctuaire des plaisirs faciles! s'écrie M. Joseph Prudhomme."

84 Saint-Juirs: "La jeune personne qui tient ga-

lamment ce bar, fait face au public. Elle a der-
rière elle une grande glace, où se reflète sa
personne d'abord, puis celle du monsieur avec
lequel elle flirte; puis, enfin, toutes les pre-
mières galeries, et la base du lustre. Tout cela
vibre et tremble dans la glace." Compare
Alexis's similar tone. Even Emile Blémont's
description of the woman as "la fille de comp-
toir" probably was meant to carry some such
message; see note 90 below for the "dame de
comptoir's" reputation.

85 Paul Alexis, *Le Figaro*, 12 March 1881; cited
in *Nana*, by Emile Zola, p. 439: "Avec *Nana*,
l'auteur des Rougon-Macquart se retrouvait dans
son élément: en plein casse-cou! Camper de-
bout la 'fille' moderne, produit de notre civi-
lisation avancée, agent destructeur des hautes
classes; écrire une page de l'histoire éternelle-
ment humaine de la courtisane; montrer, dans
une sorte de chapelle ardente, au fond d'un
tabernacle, le sexe de la femme et autour, un
peuple d'hommes, prosternés, ruinés, vidés ou
abêtis: tel était son sujet." It is worth pointing
out that Zola's fiction is one of the few things
we know Manet read. H. Mitterand notes an
unpublished letter from him to Zola in early
August 1876, saying he is reading *L'Assommoir*
in *La République des Lettres* and finds it "épa-
tant." See Emile Zola, *Les Rougon-Macquart*,
2:1663. Apart from *The Mystery of Marie Roget*,
the only other book I am aware Manet men-
tioned is another detective story, Pierre-Alexis
Ponson du Terrail's *Exploits de Rocambole*, which
he declared "extraordinaire" in a letter to Mal-
larmé, 1882 (in *Vie de Mallarmé*, by H. Mondor,
p. 422). Mallarmé in turn mentions that Manet
read Rousseau's *Confessions* (Stéphane Mal-
larmé, *Correspondance*, 2:231).

86 Baedeker, *Paris and Its Environs*, p. 56.

87 Guy de Maupassant, *Bel-Ami*, p. 16. The list of
types should be given in French: "Il y a de tout,
de toutes les professions et de toutes les castes,
mais la crapule domine. Voici des employés,
employés de banque, de magasin, de ministère,
des reporters, des souteneurs, des officiers en
bourgeois, des gommeux en habit. . . ."

88 Robert Caze, "Dame du Matin," in *Paris Vi-
vant*, pp. 153–54: "Maintenant qu'elle est dans
la rue sale et toute grise de brouillard, elle se
remémore un à un les incidents de la soirée
passée, la veille, aux Folies-Bergères [*sic*] où
elle a fait son petit persil au milieu d'un tas de

grues allemandes qui hachent de la paille avec
des juifs et des jeunes gens, commis dans les
maisons de gros de la rue Hauteville. Ça l'a
bassinée, ce monde-là. Elle ne les aime pas les
Allemands. Vrai! il fera chaud quand on la
repincera aux Folies."

89 C. Virmaitre, *Trottoirs et lupanars*, p. 115; cited
in *Les Filles de noce*, by A. Corbin, p. 209: "le
promenoir du bas, autrement dit le Marché aux
Veaux, est une foire permanente de putains."

90 For instance, in 1877; an article by "E. F" in
La Revue Parisienne, 23 November 1877, says
that the new owners of the establishment aim
to change the *côté moral*: "il tend à donner
moins d'importance à ses promenoirs." The
writer is confident that this will soon render
outdated a story entitled "Une Soirée aux Fo-
lies-Bergère," published in the same journal, in
which a Milord Williams had encountered a
variety of *filles*—including "les dames de comp-
toir." There is no evidence that the new pro-
prietors were successful.

91 *Guide secret de l'étranger célibataire à Paris*, p.
4: "célèbre par ses promenoirs, son jardin, ses
attractions toujours nouvelles et son public de
jolies femmes." This guide, published in Brus-
sels, is essentially a list of brothels.

92 Eugène Manet records his brother's workings
and reworkings in a letter to Berthe Morisot
in April 1882 (in *Correspondance de Berthe Mo-
risot avec sa famille et ses amis*, ed. D. Rouart,
p. 107): "Il se prépare un four pénible à l'Ex-
position. Il refait toujours le même tableau: une
femme dans un café. . . ."

93 Maupassant, *Bel-Ami*, p. 16.

94 See the critics' insistence on such facts: Du
Seigneur, Alexis, Houssaye, Le Senne.

95 On Degas's interest in physiognomy, see Theo-
dore Reff, *Degas: The Artist's Mind*, pp. 217–20;
Theodore Reff, *The Notebooks of Edgar Degas*,
1:117 (notebook 23, p. 44, on Lavater), 1:139–
40, and 2: notebook 33, head of criminal, car-
icatures, etc. Compare Edmond Duranty, *La
Nouvelle Peinture: A propos du groupe d'artistes
qui expose dans la Galerie Durand-Ruel*, and M.
Crouzet, *Un Méconnu du réalisme: Duranty
(1833–1880), L'Homme—Le Critique—Le Ro-
mancier*, pp. 331–44, on relations between De-
gas and Duranty in 1876; pp. 248–49 and 456–
57 on Duranty's 1867 article "Sur la physion-
omie." As late as the sixth Impressionist ex-

hibition, in 1881, Degas showed two "physiognomic" studies of criminals.

Conclusion

1 Camille Lemonnier, *Les Peintres de la vie*, p. 211: "Aucun d'eux ne paraît posséder *le sens du tableau*. Ils font des fragments; ils s'en tiennent à des certaines spécialités d'observation; ils ne sont familiarisés qu'avec de certains coins de l'humanité, les plus saillants par leur corruption étalée. Ils ont surtout la sensation de la femme malsaine. Il y a d'eux d'effroyables gesticulations de filles perdues. Ils hantent volontiers les exaspérés. Qu'ils prennent garde: ceci encore est une des formes de la virtuosité. Les fonds troubles auxquels ils s'attardent ont des côtés excessifs plus faciles à faire et d'un effet plus accessible que la simple ordonnance de la vie bourgeoise, si ardue à exprimer par cela qu'elle est sans surprises."

2 Willem de Kooning, "Content Is a Glimpse," *Location*, Spring 1963, pp. 45–48: "Content, if you want to say, is a glimpse of something, an encounter, you know, like a flash. It's very tiny—very tiny, content."

3 See Harrison and Cynthia White, *Canvases and Careers: Institutional Change in the French Painting World*, chap. 5.

4 Louis Barron, *Les Environs de Paris*, p. 30: "L'île de la Grande-Jatte, sans être un Eden champêtre, offre à la jeunesse parisienne des charmes que celle-ci est loin de dédaigner. Les jours fériés, les dimanches, un bal, dont la splendeur rivalise avec le luxe de l'Elysée-Montmartre, y retentit d'accords interminables, on y fait sur le sol dénudé des repas que l'on croit manger sur l'herbe, et les balançoires, les jeux de tonneau et de quilles fleurissent à la place des arbres absents."

5 *L'Illustration*, 15 June 1878, pp. 390–91: "C'est dans l'île de la Grande-Jatte, entre Neuilly et Asnières, que M. Jourdain est allé comparer les promeneurs du dimanche et ceux du lundi, nous apercevons les premiers, nombreux et endimanchés, qui circulent le long de la berge, tandis que dans l'île les favorisés de la fortune ont trouvé plus d'ombre et de solitude. Le gracieux canot d'acajou a été tiré sur l'herbe; on en a enlevé les coussins pour asseoir les dames qui redoutaient l'humidité pour leurs robes neuves; puis on a sorti les provisions, on a étalé une grande nappe sur l'herbe verte, on a ouvert le pâté réglementaire et décoiffé les bouteilles cachetées.

"On venait de loin, l'appétit était vif; on a fait honneur au déjeuner. . . . Mais le dessert a ses surprises: voici l'un des canotiers qui revient du bateau portant triomphalement deux bouteilles de champagne; on a encore le droit d'avoir soif. . . .

"Employés et commis sont rentrés au bureau et au magasin: nous sommes au jour de l'ouvrier. Le champagne de la veille a fait place au petit vin d'Argenteuil; on ne s'étend plus follement sur l'herbe, on se groupe devant de mauvaises tables, sur les bancs du cabaret.

"Les gens de la veille se sentaient le droit de s'amuser; les amateurs du lundi sont soucieux; le souvenir de l'atelier hante leur esprit; les reproches qui les attendent gênent la franchise de leur bonne humeur; il faudra vider plusieurs litres encore pour éloigner ces fantômes fâcheux."

The caption writer ends, incidentally, by describing the pictures' success in the salon, and claiming they are "appréciées par ceux du dimanche et par ceux du lundi." I owe this reference to Joan Weinstein, who presented pictures and caption in a paper to a graduate seminar at UCLA in 1975. The pictures, minus captions, were later reproduced in J. House's "Meaning in Seurat's Figure Painting," *Art History*, September 1980.

6 See the discussion of *saint lundi* in M. Perrot, *Les Ouvriers en grève: France 1871–1890*, 2:225–29.

7 P. Lelièvre, *Les Ateliers de Paris*, 1865, p. 35, cited in Perrot, *Les Ouvriers*, 2:226. (Lelièvre was a carpenter.)

8 Ibid., p. 48.

9 Of the criticisms I cite, one (Christophe) is not included in the valuable bibliography and collection of extracts in Henri Dorra and John Rewald, *Seurat: L'Oeuvre peint, biographie et catalogue critique*; two others (Ajalbert and Adam) are included but not cited. To this extent Dorra and Rewald's treatment somewhat underestimates the critics' interest in 1886 in the social detail of Seurat's painting, though it is clear that by this date a deliberate overlooking or downplaying of such detail is an established avant-garde critical strategy. Félix Fénéon and Emile Verhaeren employ it, but not Christophe and Ajalbert.

10 Jules Christophe, "Chronique: Rue Laffitte No. 1," *Le Journal des Artistes*, 13 June 1886, p. 194: "M. Georges Seurat, enfin, tempérament de martyr calviniste, qui a planté, avec la foi d'un Jean Huss, cinquante personnages de grandeur naturelle, sur le bord de la Seine, à la Grande-Jatte, un dimanche de l'an 1884, en essayant de saisir les attitudes diverses de l'âge, du sexe et du classement social: élégants et élégantes, soldats, bonnes d'enfants, bourgeois, ouvriers. C'est crâne cela. M. Georges Seurat a, encore, quatre pêcheurs près d'une barque qui sont d'une chimie très vraie, ainsi que des vues de mer fort justes et des dessins qui ont su plaire à l'auteur des *Soeurs Vatard*, honneur point mince." The conjunction in the last sentence of references to "chemistry" and Huysmans is typical of 1886.

11 Henry Fèvre, *La Revue de Demain*, May-June 1886, p. 149, cited in *Seurat*, by Dorra and Rewald, p. 160.

12 Jean Ajalbert, "Le Salon des Impressionnistes," *La Revue Moderne* (Marseille), 20 June 1886, p. 392: "M. Seurat peint par petites touches, mesurées; il en résulte une uniformité en rapport avec la façon de dessiner. D'un trait simple, il évoque l'attitude, le costume théorique de nos jours, les robes moulantes et tombant droit, les corsages ajustés, les vestons collants, les pantalons fourreaux. Il délaisse la fanfreluche, les breloques et toutes afféteries pour un schéma—bien suggestif.

"La première impression de surprise passée, la raideur exagérée des personnages s'amollit; les pointillés fatiguent moins et l'averse des rayons pleut à travers les feuillages.

"C'est bien des canotiers, de loin, cette fuite de vareuses blanches et de casquettes rouges dans une seule inclinaison, rosant l'eau, et tous ces gens différant à peine, vêtus sur le même patron, donnent bien l'impression de vie intense qui afflue, les dimanches d'été, de Paris aux banlieues."

13 Alfred Paulet, *Paris*, 5 June 1886, cited in *Seurat*, by Dorra and Rewald, p. 160.

14 Paul Adam, "Les Peintres impressionnistes," *La Revue Contemporaine, Littéraire, Politique et Philosophique* 4, no. 4 (1886): 550; the whole of Adam's entry is worth citing, to suggest the balance struck between "technical" discussion and "social" interpretation: "Personne ne comprit la beauté de ce dessin hiératique, la justesse des teintes jaunes où la foule des personnages se rapetisse graduellement vers les fonds. Le bois s'enfonce droit; ni bosquet, ni branche qui marquent les plans successifs, et les points de repère, ainsi que le veut, à tort, la coutume. Rien de factice dans cette profondeur obtenue sans même que les tons se dégradent: jusqu'aux dernières feuilles les valeurs sont maintenues. Tout apparaît clair, net, sans brumes où s'esquiveraient les points difficiles. Une extraordinaire gamme de tons. Des roses de soie sur la robe d'un baby, proches des roses de laine sur la robe de la mère; toute une différence supérieurement notée. Et même la raideur des gens, les formes à l'emporte-pièce contribuent à donner le son du moderne, lé rappel de nos costumes étriqués, collés au corps, la réserve des gestes, le cant britannique par tous imité. Nous prenons des attitudes pareilles à celles des personnages de Memling. Monsieur Seurat l'a parfaitement vu, compris, conçu et traduit avec le pur dessin des primitifs."

15 Félix Fénéon's phrase in "Le Néo-Impressionnisme," *L'Art Moderne de Bruxelles*, 1 May 1887, cited in *Oeuvres plus que complètes*, by Félix Fénéon, 1:74.

16 Compare Jules Vidal, "Les Impressionnistes," *La Lutèce*, 29 May–5 June: "J'aime moins les personnages un peu angulaires de son grand tableau! mais c'est bien la lourde après-dînée du dimanche d'été, à la Jatte, ses canotiers en plein soleil, son public baroque, son atmosphère de banlieue."

17 See Maurice Hermel, "L'Exposition de peinture de la rue Lafitte," *La France Libre*, 28 May 1886: "Le tableau-manifeste de M. Seurat, enseigne d'une école nouvelle, dite de la Grande-Jatte, avec son symbolisme moderne, ses nourrices, ses tourlourous [soldiers] et ses canotiers schématiques, ne manque ni de gaieté, ni de pédantisme, ni de valeur. Il proclame bien haut les droits de la peinture à la décomposition des tons, il est bourré d'intentions et de prétentions, il est extrêmement comique et non moins intéressant."

18 As reported by Gustave Kahn, "Chronique," *La Revue Indépendante*, Jan. 1888, p. 142.

19 Stéphane Mallarmé, "The Impressionists and Edouard Manet," *Art Monthly Review*, 30 September 1876, p. 122.

20 Ibid., p. 121–22.

BIBLIOGRAPHY

BIBLIOGRAPHY

This bibliography is limited to works directly referred to or cited in the text or notes, except in the case of a few works of history or criticism which have clearly influenced the book's particular arguments (e.g., the items by Bastié and Dubois). Full art-historical bibliographies can be found in John Rewald, *The History of Impressionism* and *Post-Impressionism: From van Gogh to Gauguin*. Articles and archival sources are cited in full where they occur in the notes. Salon criticism published in book form is listed here, except for items from 1865, 1875, and 1882, where full details are given in the bibliographical notes on the salon reaction to Manet (see chapter two, note 8; chapter three, note 23; chapter four, note 65).

Anon. *Lamentations d'un Jérémie haussmannisé.* Paris, 1864.

About, Edmond. *L'Homme à l'oreille cassée.* 2nd ed. Paris, 1862.

Adam, Paul. *Chair molle: Roman naturaliste.* Paris, 1885.

Adorno, Theodor W. *Prisms.* London, 1967.

Adorno, Theodor W. *Introduction to the Sociology of Music.* New York, 1976.

Ajalbert, Jean. *Sur le vif: Vers impressionnistes.* Paris, 1886.

Albonico, R., and Pfister-Binz, K., eds. *Soziologie des Sports: Theoretische und methodische Grundlagen.* Basel, 1971.

Alexis, Paul. *La Fin de Lucie Pellegrin.* Paris, 1880.

Amicis, E de. *Studies of Paris.* London, 1879. (Translated from Italian.)

Anderson, S., ed. *On Streets.* Cambridge, Mass., 1978.

Anglo-Parisian. *Paris by Day and Night: A Book for the Exhibition.* London, 1889.

Arato, A., and Gebhardt, E., eds. *The Essential Frankfurt School Reader.* New York, 1978.

Atget, Eugène. *La Vie à Paris, vers 1898–1900.* Paris: Bibliothèque Nationale, Estampes-photo album, n.d.

Augier, E., and Foussier, E. *Les Lionnes pauvres.* Paris, 1858.

Baedeker, K. *Paris and Its Environs: Handbook for Travellers,* Leipzig, 1878.

Bailey, P. *Leisure and Class in Victorian England: Rational Recreation and the Contest for Control 1830–1885.* London, 1978.

Balzac, Honoré de. *Splendeurs et misères des courtisanes.* Paris, 1966. (Originally published 1843; vol. 4 of *La Comédie humaine.*)

Barrell, John. *The Idea of Landscape and the Sense of Place: An Approach to the Poetry of John Clare.* London, 1972.

Barron, Louis. *Les Environs de Paris.* Paris, 1886.

Bastié, J. *La Croissance de la banlieue parisienne.* Paris, 1964.

Bataille, Georges. *Manet: Etude biographique et critique.* Geneva, 1955.

Bataille, M.-L., and Wildenstein, G. *Berthe Morisot: Catalogue des peintures, pastels et aquarelles.* Paris, 1961.

Baudelaire, Charles. *Correspondance générale.* 6 vols. Paris, 1947–53.

Baudelaire, Charles. *Oeuvres complètes.* Rev. ed. by C. Pichois. Paris, 1961.

Beauroy, J., Bertrand, M., and Gargan, E., eds. *The Wolf and the Lamb: Popular Culture in France, from the Old Regime to the Twentieth Century.* Saratoga, 1977.

Bellanger, C., Godechot, J., Guiral, P., and Terroul, F. *Histoire générale de la presse française.* Vol. 2, *De 1815 à 1871.* Paris, 1969. Vol. 3, *De 1871 à 1940.* Paris, 1972.

Benjamin, Walter. *Charles Baudelaire: A Lyric Poet in the Era of High Capitalism.* London, 1973.

Benjamin, Walter. *Gesammelte Schriften.* Vol. 5, *Das Passagen-Werk.* Edited by R. Tiedemann. Frankfurt am Main, 1982.

Benjamin, Walter. *Illuminations.* London, 1970.

Benjamin, Walter. *One-Way Street and Other Writings.* London, 1979.

Bernadille [Victor Fournel]. *Esquisses et croquis parisiens: Petite Chronique du temps présent.* 1st ser. Paris, 1876. 2nd ser. Paris, 1879. (Both series first published in *La France,* 1876–78.)

Bertauts-Couture, G. *Thomas Couture (1820–1879).* Paris, 1932.

Blanche, Jacques-Emile. *Manet.* Paris, 1924.

Blondeau, H., and Monréal, H. *Les Environs de Paris: Voyages d'agrément en quatre actes et huit tableaux.* Paris, 1877 (performed at Ambigu-Comique, 7

June).

Braudel, F., and Labrousse, E., eds. *Histoire économique et sociale de la France.* Vol. 3: *L'Avènement de l'ère industrielle.* Paris, 1976.

Buck-Morss, S. *The Origin of Negative Dialectics: Theodor W. Adorno, Walter Benjamin, and the Frankfurt Institute.* Hassocks, Sussex, 1977.

Busch, G. *Manet—Un Bar aux Folies-Bergère.* Stuttgart, 1956.

Le Café-Concert; Affiches de la Bibliothèque du Musée des Arts Décoratifs. Paris, 1977.

Gustave Caillebotte: A Retrospective Exhibition. Catalogue by K. Varnedoe and T. Lee. Museum of Fine Arts, Houston and Brooklyn Museum. New York, 1976–77.

Cantaloube, Amédée. *Lettre sur les expositions et le Salon de 1861.* Paris, 1861.

Castagnary, Jules Antoine. *Salons 1857–79.* 2 vols. Paris, 1892.

Caze, Robert. *La Foire aux peintres: Extrait de Lutèce.* Paris, 1885.

Caze, Robert. *Paris vivant.* Paris, 1885.

Cère, P. *Les Populations dangereuses et les misères sociales.* Paris, 1872.

Chadourne, A. *Les Cafés-concerts.* Paris, 1889.

Chesneau, Ernest. *L'Art et les artistes modernes en France et en Angleterre.* Paris, 1864.

Chevalier, Louis. *Classes laborieuses et classes dangereuses à Paris pendant la première moitié du dix-neuvième siècle.* Paris, 1958.

Chevalier, Louis. *Les Parisiens.* Paris, 1967.

Claretie, Jules. *L'Art et les artistes français contemporains.* Paris, 1876.

Clark, T. J. *The Absolute Bourgeois: Artists and Politics in France, 1848–51.* London, 1973.

Clark, T. J. *Image of the People: Gustave Courbet and the 1848 Revolution.* London, 1973.

Claudin, Georges. *Paris et l'Exposition Universelle.* Paris, 1867. Revised edition of *Paris,* published 1862.

Clayson, S. H. "The Representation of Prostitution in France During the Early Years of the Third Republic," Ph.D. diss., University of California, Los Angeles, 1984.

Coquiot, Gustave. *Concerts d'été (Impressions de Paris).* Paris, 1894.

Coquiot, Gustave. *Les Cafés-concerts.* Paris, 1896.

Coquiot, Gustave. *Dimanches d'été.* Paris, n.d. [late 1890s].

Corbin, Alain. *Les Filles de noce: Misère sexuelle et prostitution aux 19ᵉ et 20ᵉ siècles.* Paris, 1978.

Corbon, C. *Le Secret du peuple de Paris.* Paris, 1863.

Cottereau, A. *De l'hygiène sociale à l'urbanisme: Etude des conditions politiques de la planification urbaine en région parisienne (1871–1940).* Paris, 1975.

Crossick, G., ed. *The Lower Middle Class in Britain 1870–1914.* London, 1977.

Crouzet, M. *Un Méconnu du realisme: Duranty (1833–1880), L'Homme—Le Critique—Le Romancier.* Paris, 1964.

Daudet, Alphonse. *Fromont jeune et Risler ainé.* Paris, 1880.

Daulte, F. *Alfred Sisley: Catalogue raisonné de l'oeuvre peint.* Lausanne, 1959.

Debord, Guy. *La Société du spectacle.* Paris, 1967. (Translated as *Society of the Spectacle.* Rev. ed. Detroit, 1977.)

Delécluze, Etienne-Jean. *Dona Olympia.* 2 vols. Paris, 1842. (Further editions in 1862 and 1872.)

Delon Charles. *Notre Capitale Paris.* 2nd ed. Paris, 1888. (First published 1885.)

Delvau, Alfred. *Les Plaisirs de Paris: Guide pratique.* Paris, 1867.

Dorra, Henri, and Rewald, John. *Seurat: L'Oeuvre peint, biographie et catalogue critique.* Paris, 1959.

Drumont, E. *Mon Vieux Paris.* 2 vols. Paris, n.d. (Vol. 1 first published 1879, reprinted 1894; vol. 2, 1897.)

Dubois, J. *L'Assommoir de Zola: Société, discours, idéologie.* Paris, 1973.

Du Camp, Maxime. *Les Beaux-Arts à l'Exposition Universelle et aux Salons de 1863–1867.* Paris, 1867.

Du Camp, Maxime. *Paris: Ses Organes, ses fonctions et sa vie dans la seconde moitié du dix-neuvième siècle.* 6 vols. Paris, 1869–75.

Du Camp, Maxime. *Le Salon de 1861.* Paris, 1861.

Duchêne, Georges. *L'Empire industriel.* Paris, 1869.

Dumas Alexandre. *Théâtre complet.* Vol. 1, *La Dame aux camélias, Diane de Lys, Le Bijou de la reine.* Paris, 1868.

Duranty, Edmond. *La Nouvelle Peinture: A propos du groupe d'artistes qui expose dans la Galerie Durand-Ruel.* Ed. M. Guérin. Paris, 1946. (First published 1876.)

Durry, M.-J. *Flaubert et ses projets inédits.* Paris, 1950.

Duveau, Georges. *La Vie ouvrière en France sous le Second Empire.* Paris, 1946.

Elias, Norbert. *The History of Manners: The Civilizing Process.* Vol. 1. New York, 1978.

Eliot, T. S. *Selected Essays.* 3rd ed. London, 1951.

Elwitt, S. *The Making of the Third Republic: Class and Politics in France, 1868–1884.* Baton Rouge, 1975.

Engels, Friedrich. *The Condition of the Working Class in England in 1844.* London, 1958.

Evenson, N. *Paris, A Century of Change: 1878–1978.*

New Haven, 1979.

Farwell, B. *Manet and the Nude: A Study in Iconography in the Second Empire*. New York, 1981. (Originally Ph.D. dissertation, UCLA, 1973.)

Fauque, M. *L'Evolution économique de la grande industrie chimique en France*. Paris, 1932.

Fénéon, Félix. *Oeuvres plus que complètes*. 2 vols. Geneva-Paris, 1970.

Ferry, Jules. *Les Comptes fantastiques d'Haussmann*. Paris, 1868.

Finnegan, F. *Poverty and Prostitution: A Study of Victorian Prostitutes in York*. Cambridge, 1979.

Flaubert, Gustave. *Correspondance*. 9 vols. Paris, 1933.

Flescher, S. *Zacharie Astruc: Critic, Artist and Japoniste*. New York, 1978.

Flévy d'Urville. *Les Ordures de Paris*. Paris, 1874.

Foucault, Michel. *Discipline and Punish*. New York, 1978.

Foucault, Michel. *The History of Sexuality*. Vol. 1, *An Introduction*. New York, 1978.

Fournel, Victor. *Ce qu'on voit dans les rues de Paris*. Paris, 1858.

Fournel, Victor. *Paris nouveau et Paris futur*. Paris, 1865.

Fournier, E. *Enigmes des rues de Paris*. Paris, 1860.

Freud, Sigmund. *The Standard Edition of the Complete Psychological Works*. 24 vols. London, 1953–74.

Gaillard, Jeanne. *Paris, La Ville: 1852–1870*. Paris, 1977.

Galignani's Illustrated Paris Guide for 1879. Paris, 1879.

Gambetta, Léon. *Discours et plaidoyers politiques*. Ed. J. Reinach. 11 vols. Paris, 1880–85.

Gardejann, H. *La Thérésiade: Poème en cinq chants, et en vers du huit pattes*. Paris, 1868.

Gautier, Théophile. *Abécédaire du Salon de 1861*. Paris, 1861.

Gautier, Theophile. *Tableaux à la plume*. Paris, 1880.

Geffroy, Gustave. *Yvette Guilbert*. Paris, 1894.

Giedion, Siegfried. *Space, Time and Architecture*. 3rd ed. Cambridge, Mass., 1954.

Gigault de Labédollière, E. *Histoire des environs du Nouveau Paris*. Paris, n.d. [1861].

Girard, L. *La Politique des travaux publics du Second Empire*. Paris, 1952.

Exposition Norbert Goeneutte. Catalogue of exhibition at Ecole Nationale des Beaux-Arts. Paris, 1895.

Goncourt, Edmond de. *La Fille Elisa*. Paris, 1877.

Goncourt, Edmond and Jules de. *Journal des Goncourts: Mémoires de la vie littéraire*. 9 vols. Paris, 1912.

Goncourt, Edmond and Jules de. *Mémoires de la vie littéraire*. 4 vols. Monaco, 1956.

Gray, Christopher, ed. *Leaving the Twentieth Century: The Incomplete Work of the Situationist International*. London, 1974.

Gray, R. Q. *The Labour Aristocracy in Victorian Edinburgh*. Oxford, 1976.

Greenberg, Clement. *Art and Culture*. Boston, 1961.

Guérin, M., ed. *Lettres de Degas*. Paris, 1945.

Guide secret de l'étranger célibataire à Paris. Brussels, 1889.

Guilbaut, S., and Solkin, D., eds. *Modernism and Modernity*. Halifax, N.S., 1983.

Hache, Edouard. *Le Salon de 1869*. Paris, 1869.

Halbwachs, M. *Les Expropriations et les prix des terrains à Paris de 1800 à 1900*. Paris, 1909.

Halbwachs, M. *La Population et les tracés de voies à Paris depuis un siècle*. Paris, 1928.

Hall, S., and Jefferson, T., eds. *Resistance Through Rituals: Youth Subcultures in Post-war Britain*. London, 1976.

Hamilton, G. H. *Manet and His Critics*. 2nd ed. New York, 1969.

Hanson, Anne C. *Manet and the Modern Tradition*. New Haven, 1977.

Hatin, E. *Bibliographie historique et critique de la presse périodique française*. Paris, 1866. (Reprinted Paris, 1965.)

Hausenstein, W. *Der nackte Mensch in der Kunst aller Zeiten und Völker*. Munich, 1913.

Haussmann, Baron. *Mémoires*. 3 vols. Paris, 1890–93.

Herbert, Robert L. *Seurat's Drawings*. New York, 1962.

Hillairet, J. *L'Ile de la Cité*. Paris, 1969.

Hoffmann, E. T. A. *Contes d'Hoffmann*. 2nd ed. Paris, 1859.

Holt, R. *Sport and Society in Modern France*. London, 1981.

Hope, C. *Titian*. London, 1980.

Hugo, Victor. *Actes et paroles*. Paris, 1875–76.

Hugo, Victor. *Les Misérables*. 3 vols. Paris: Garnier-Flammarion, 1967. (First published 1862.)

Hugo, Victor. *Notre-Dame de Paris, 1482*. Paris: Garnier-Flammarion, 1967. (Complete edition first published 1832.)

Huysmans, Joris-Karl. *Marthe: Histoire d'une fille—Les Soeurs Vatard*. Paris, 1975. (*Marthe* first published 1876.)

Imbert, P.-L. *A Travers Paris inconnu*. Paris, 1876.

Internationale Situationniste 1958–69. Paris, 1975.

International Situationniste. *La Véritable scission dans l'Internationale*. Paris, 1972.

Jahyer, Félix. *Deuxième Etude sur les Beaux-Arts: Salon de 1866.* Paris, 1866.

James, Henry. *Eight Tales from the Major Phase.* New York, 1969.

Jeannel, J.-F. *De la prostitution dans les grandes villes au dix-neuvième siècle.* 2nd ed. Paris, 1874. (First published 1868.)

Jerrold, W. B., *Paris for the English.* London, 1867.

Joanne, A. *Environs de Paris.* Paris, 1878.

Jollivet, Gaston. *Souvenirs de la vie de plaisir sous le Second Empire.* Paris, 1927.

Knabb, Ken, ed. *Situationist International Anthology.* Berkeley, 1981.

Laforgue, Jules. *Mélanges posthumes.* Paris, 1903.

Lameyre, G.-N. *Haussmann: "Préfet de Paris."* Paris, 1958.

Lano, Paul de. *Courtisane.* Paris, 1883.

Larousse, Pierre. *Grand Dictionnaire universel du dix-neuvième siècle.* 17 vols. Paris, 1865–90.

Lavedan, P. *Histoire de l'urbanisme à Paris.* Paris, 1975.

Lazare, Louis. *Les Quartiers de l'Est de Paris et les communes suburbaines.* Paris, 1870.

Lecour, C.-J. *La Prostitution à Paris et à Londres.* 2nd ed. Paris, 1872.

Lelièvre, P. *Les Ateliers de Paris.* Paris, 1865.

Lemoine, H. *Le Département de Seine-et-Oise de l'an VII à 1871.* Largentière, Ardeche, 1943.

Lemoisne, P. A. *Degas et son oeuvre.* 4 vols. Paris, 1946.

Lemonnier, Camille. *Les Peintres de la vie.* Paris, 1888.

Lemonnier, Camille. *Salon de Paris 1870.* Paris, 1870.

Lethève, J. *Impressionnistes et symbolistes devant la presse.* Paris, 1959.

Locke, R. *French Legitimists and the Politics of Moral Order in the Early Third Republic.* Princeton, 1974.

Malet, H. *Le Baron Haussmann et la rénovation de Paris.* Paris, 1973.

Mallarmé, Stéphane. *Correspondance.* 3 vols. Paris, 1959–68.

Mallarmé, Stéphane. *Oeuvres complètes.* Paris: La Pléiade, 1945.

Manè. *Le Paris viveur.* Paris, 1862.

Marc-Constantin. *Histoire des cafés-concerts et des cafés de Paris.* New ed. Paris, 1872.

Marie, L. *De la décentralisation des Halles.* Paris, 1850.

Marrus, M., ed. *The Emergence of Leisure.* New York, 1974.

Maupassant, Guy de. *Bel-Ami.* Paris, 1959. Ed. G. Delaisement. (First published 1885.)

Mayeur, J.-M. *Les Débuts de la troisième république.* Paris, 1973.

McLeod, H. *Class and Religion in the Late Victorian City.* London, 1974.

Meier-Graefe, J. *Edouard Manet.* Munich, 1912.

Meller, H. *Leisure and the Changing City, 1870–1914.* London, 1976.

Merriman, J., ed. *1830 in France.* New York, 1975.

Merriman, J., ed. *French Cities in the Nineteenth Century.* London, 1982.

Miller, M. *The Bon Marché: Bourgeois Culture and the Department Store, 1869–1920.* Princeton, 1981.

Moltke, H. Graf von. *Moltke in seinen briefen.* Berlin, 1902.

Mondor, H. *Vie de Mallarmé.* Paris, 1941.

Montorgueil, Georges. *Le Café-concert: Lithographies de H.-G. Ibels et de H. de Toulouse-Lautrec.* Paris, 1893.

Morizet, A. *Du vieux Paris au Paris moderne: Haussmann et ses prédécesseurs.* Paris, 1932.

Mortimer, R. *Manet's "Un Bar aux Folies-Bergère,"* London, n.d. [1944].

Murray, J., ed. *A Handbook for Visitors to Paris; containing a description of the most remarkable objects . . .* London, 1872 and later editions.

Nield, K., ed. *Prostitution in the Victorian Age: Debates on the Issue from 19th Century Critical Journals.* Farnborough, 1973.

Ozouf, M. *La Fête révolutionnaire, 1789–1799.* Paris, 1976.

Parent-Duchâtelet, A.-J.-B. *De la prostitution dans la ville de Paris.* 2 vols. 3rd enlarged ed. Paris, 1857. (First published 1836.)

Paris dans sa splendeur: Monuments, vues, scènes historiques, descriptions et histoire. 3 vols. Paris, 1861.

Paris et les Parisiens au XIXᵉ siècle: Moeurs, arts et monuments. Paris, 1856. (Various authors.)

Paris-Guide, par les principaux écrivains et artistes de la France. 2 vols. Paris, 1867.

Pastor, L. *The History of the Popes, from the Close of the Middle Ages.* St. Louis, 1952.

Paulus, *Trente Ans de café-concert: Souvenirs recueillis par Octave Pradels.* Paris, n.d.

Pelletan, Eugène. *La Nouvelle Babylone: Lettres d'un provincial en tournée à Paris.* Paris, 1862.

Perrot, M. *Les Ouvriers en grève: France 1871–1890.* 2 vols. Paris and the Hague, 1974.

Phlipponneau, M. *La Vie rurale de la banlieue parisienne.* Paris, 1956.

Pichois, C., ed. *Lettres à Baudelaire.* IV-5 of *Langages: Etudes Baudelairiennes.* Neuchâtel, 1973.

Pinkney, D. H. *Napoleon III and the Rebuilding of Paris.* Princeton, 1958.

Plessis, A. *De la fête impériale au mur des fédérés:*

1852–1871. Paris, 1973.

Poisson, G. *Evocation du grand Paris: La Banlieue Nord-Ouest.* Paris, 1960.

Poulot, Denis. *Le Sublime, ou Le Travailleur comme il est en 1870 et ce qu'il peut être.* Paris, 1872.

Raison-Jourde, F. *La Colonie auvergnate de Paris au XIXᵉ siècle.* Paris 1976.

Reff, Theodore. *Degas: The Artist's Mind.* New York, 1976.

Reff, Theodore. *Manet and Modern Paris: One Hundred Paintings, Drawings, Prints and Photographs by Manet and His Contemporaries.* Washington, 1982.

Reff, Theodore, *Manet: Olympia.* New York, 1977.

Reff, Theodore. *The Notebooks of Edgar Degas.* 2 vols. London, 1976.

Réthoré, E. *Argenteuil et son passé.* 3 vols. Paris, 1967–74.

Reuterswärd, O. *Impressionisterna inför publik och kritik.* Stockholm, 1952.

Rewald, John. *The History of Impressionism.* 4th ed. New York, 1973.

Rewald, John. *Post-Impressionism: From van Gogh to Gauguin.* 3rd ed. New York, 1978.

Ricatte, R. *La Genèse de "La Fille Elisa."* Paris, 1960.

Rimbaud, Arthur. *Selected Verse.* Ed. O. Bernard. Harmondsworth, 1962.

Riou, A. *Propriété foncière et processus d'urbanisation.* Vol. 1, *Deux Quartiers parisiens à la "Belle Epoque."* Paris, 1973.

Rivière, Georges. *Renoir et ses amis.* Paris, 1921.

Rose, G. *The Melancholy Science: An Introduction to the Thought of Theodor Adorno.* London, 1978.

Rouart, D., ed. *Correspondance de Berthe Morisot avec sa famille et ses amis.* Paris, 1950.

Rougerie, J. *Paris libre 1871.* Paris, 1971.

Saint-Valry, Gaston de. *Souvenirs et réflexions politiques.* Paris, 1886.

Samuel, R., ed. *People's History and Socialist Theory.* London, 1981.

Sandblad, N. G. *Manet: Three Studies in Artistic Conception.* Lund, 1954.

Sardou, Victorien. *Maison neuve*, vol. 9 of *Théâtre complet de Victorien Sardou.* Paris, 1938.

Sartre, Jean-Paul. *L'Idiot de la famille: Gustave Flaubert de 1821 à 1857.* Vol. 3. Paris, 1972.

Schapiro, Meyer. *Modern Art: 19th and 20th Centuries.* New York, 1978.

Sennett, R. *The Fall of Public Man.* New York, 1977.

Sewell, W. *Work and Revolution in France: The Language of Labor from the Old Regime to 1848.* Cambridge, 1980.

Sheppard, N. *Shut Up in Paris.* Leipzig, 1874.

Simmel, Georg. *On Individuality and Social Forms: Selected Writings.* Chicago and London, 1971.

Simmel, Georg. *The Philosophy of Money.* London, 1978. (First published 1900.)

Soboul, Georges. *Les Sans-Culottes parisiens en l'an deux: Mouvement populaire et gouvernement révolutionnaire.* Paris, 1958.

Sorlin, P. *Waldeck-Rousseau.* Paris, 1966.

Stedman Jones, G. *Outcast London.* London, 1971.

Sutcliffe, A. *The Autumn of Central Paris: The Defeat of Town Planning 1850–1970.* London, 1970.

Tabarant, A. *Manet et ses oeuvres.* Paris, 1947.

Taylor, Roger. *Art: An Enemy of the People.* Hassocks, Sussex, 1978.

Texier, Edmond. *Tableau de Paris.* 2 vols. Paris, 1852.

Texier, E., and Kaempfen, A. *Paris, capitale du monde.* Paris, 1867.

Mémoires de Thérésa écrits par elle-même. Paris, 1865.

Thoré, Théophile. *Salons de W. Bürger, 1861 à 1868.* Paris, 1870.

Tucker, Paul. *Monet and Argenteuil.* New Haven and London, 1982.

Turot, Henri. *Le Prolétariat de l'amour.* Paris, 1904.

Uzanne, Octave, ed. *Badauderies parisiennes: Les Rassemblements: Physiologies de la rue.* Paris, 1896.

Vallès, Jules. *Le Tableau de Paris.* Paris, 1932. (First published 1883.)

Vaneigem, Raoul. *Traité de savoir-vivre à l'usage des jeunes générations.* Paris, 1967. (Translated as *The Revolution of Everyday Life.* London, 1983.)

Vanier, H. *La Mode et ses métiers 1830–70.* Paris, 1960.

Vaucaire, Maurice. *Effets de théâtre.* Paris, 1886.

Veblen, Thorstein. *The Theory of the Leisure Class.* New York: Penguin, 1979. (Originally published 1899.)

Véron, Pierre. *Paris s'amuse.* Paris, 1861.

Veuillot, Louis. *Les Odeurs de Paris.* Paris, 1867.

Virmaitre, Charles. *Trottoirs et lupanars.* Paris, 1873.

Walkowitz, J. R. *Prostitution and Victorian Society: Women, Class and the State.* New York, 1980.

Weill, André. *Qu'est-ce que le propriétaire d'une maison à Paris?* Paris, 1860.

Wethey, H. *The Paintings of Titian.* 3 vols. London, 1969–75.

White, Harrison and Cynthia. *Canvases and Careers: Institutional Change in the French Painting World.* New York, 1965.

Whiteley, J. "The Revival in Painting of Themes Inspired by Antiquity in Mid-Nineteenth Century France," D. Phil. thesis, Oxford University, 1972.

Wildenstein, D. *Claude Monet: Biographie et cata-

logue raisonné. Vol. 1, *1840–1881, Peintures*. Paris, 1974.

Zola, Emile. *L'Assommoir*. Paris: Garnier-Flammarion, 1969.

Zola, Emile, *Nana*. Notes and commentary by M. Le Blond. Paris, 1929.

Zola, Emile. *Oeuvres complètes*. 15 vols. Notes by H. Mitterand. Paris: Cercle du Livre Précieux, 1966–70.

Zola, Emile. *Les Rougon-Macquart*. Notes by H. Mitterand. Paris: La Pléiade, 1960–67.

Zylberberg-Hocquard, M.-H. *Féminisme et syndicalisme en France*. Paris, 1978.

INDEX

INDEX

Color illustrations are indicated by plate number, black-and-white illustrations by page number.